MINIMAL ART

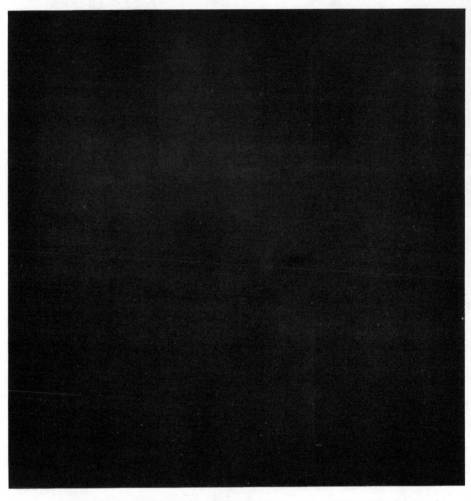

Ad Reinhardt: Untitled (Black). 1960–66. Oil on canvas. 60″ x 60″. Photograph courtesy of The Jewish Museum, New York.

MINIMAL ART
A Critical Anthology

Edited by GREGORY BATTCOCK

A Dutton
Paperback

New York / E. P. DUTTON & CO., INC.

Grateful acknowledgment is made to the following for permission to quote from copyright material:

Lawrence Alloway: "Systemic Painting." Reprinted from the exhibition catalogue *Systemic Painting*, published by The Solomon R. Guggenheim Foundation, New York, 1966, by permission of the author.

Michael Benedikt: "Sculpture as Architecture: New York Letter, 1966–67." Reprinted from *Art International*, Vol. 10, Nos. 7 and 10, and Vol. 11, Nos. 1, 2, and 4 by permission of the editor and author.

Mel Bochner: "Serial Art, Systems, Solipsism." Reprinted from *Arts Magazine*, Summer, 1967, by permission of the editor and author.

David Bourdon: "The Razed Sites of Carl Andre." Reprinted from *Artforum*, October, 1966, by permission of the editor and author.

Nicolas Calas: "Subject Matter in the Work of Barnett Newman." Reprinted from *Arts Magazine*, November, 1967, by permission of the editor and author.

Michael Fried: "Art and Objecthood." Reprinted from *Artforum*, June, 1967, by permission of the editor and author.

Bruce Glaser: "Questions to Stella and Judd." Reprinted from *Art News*, September, 1966, by permission of the editor and author.

E. C. Goossen: "Two Exhibitions." Reprinted by permission of the author.

Clement Greenberg: "Recentness of Sculpture." Reprinted from the exhibition catalogue *American Sculpture of the Sixties*, Los Angeles County Museum of Art, 1967, by permission of the author.

Peter Hutchinson: "Mannerism in the Abstract." Reprinted from *Art and Artists*, September, 1966, by permission of the author.

Gratitude is due Toby Mussman and Brian O'Doherty for their helpful suggestions. I wish also to thank Mario Amaya, David Tanner, James Fitzsimmons, and Philip Lieder for their kind permission to reprint material they published first.

GREGORY BATTCOCK, painter, is New York correspondent for *Arts Magazine*. He is lecturer in art history and criticism at Hunter and Queens Colleges and Assistant Professor of Art at Fairleigh Dickinson University. Mr. Battcock is editor of *The New Art: A Critical Anthology* (1966) and *The New American Cinema: A Critical Anthology* (1967). He has written criticism for several journals, including *Art and Literature, College Art Journal,* and *Film Culture.*

"I think both art and life are a matter of life and death."—Walter De Maria

CONTENTS

Introduction / 19

Lawrence Alloway: *Systemic Painting* / 37

Michael Benedikt: *Sculpture as Architecture: New York Letter, 1966–67* / 61

Mel Bochner: *Serial Art, Systems, Solipsism* / 92

David Bourdon: *The Razed Sites of Carl Andre* / 103

Nicolas Calas: *Subject Matter in the Work of Barnett Newman* / 109

Michael Fried: *Art and Objecthood* / 116

Bruce Glaser: *Questions to Stella and Judd* / 148

E. C. Goossen: *Two Exhibitions* / 165

Dan Graham: *Photographs* / 175

Clement Greenberg: *Recentness of Sculpture* / 180

Peter Hutchinson: *Mannerism in the Abstract* / 187

David Lee: *A Systematic Revery from Abstraction to Now* / 195

Allen Leepa: *Minimal Art and Primary Meanings* / 200

Lucy R. Lippard: *Eros Presumptive* / 209

Robert Morris: *Notes on Sculpture* / 222

Toby Mussman: *Literalness and the Infinite* / 236

Brian O'Doherty: *Minus Plato* / 251

John Perreault: *Minimal Abstracts* / 256

Yvonne Rainer: *A Quasi Survey of Some "Minimalist" Tendencies in the Quantitatively Minimal Dance Activity Midst the Plethora, or an Analysis of Trio A* / 263

Barbara Rose: *A B C Art* / 274

Harold Rosenberg: *Defining Art* / 298

Irving Sandler: *Gesture and Non-Gesture in Recent Sculpture* / 308

Willoughby Sharp: *Luminism and Kineticism* / 317

Elayne Varian: *Schemata 7* / 359

Samuel Wagstaff, Jr.: *Talking with Tony Smith* / 381

Richard Wollheim: *Minimal Art* / 387

Martial Raysse, Dan Flavin, Robert Smithson: *Writings* / 400

Index / 445

ILLUSTRATIONS

Ad Reinhardt: Untitled / *frontispiece*
Anastasi: *North Wall, Dwan Main Gallery* / 21
Ronald Bladen: *The X* / 22
Robert Duran: Untitled / 23
Dan Flavin: Installation, October 1967 / 23
Ellsworth Kelly: *White Angle* / 24
Ellsworth Kelly: *Black/White* / 27
Aaron Kuriloff: *Telephone* / 27
Sol LeWitt: Untitled / 28
Roy Lichtenstein: *White Brush Stroke, II* / 28
John McCracken: Untitled / 29
Claes Oldenburg: *Colossal Monument for Ellis Island: Hot Dog
 with Toothpick* / 30
Michelangelo Pistoletto: *Man Reading* / 33
Richard Van Buren: Untitled / 34
Jo Baer: *Grayed-yellow Vertical Rectangle* / 41
Dean Fleming: *2V Dwan 2* / 43
Al Held: *Clipper* / 43
Ralph Humphrey: Untitled / 44
Ellsworth Kelly: *Green/White* / 44
Barnett Newman: *Twelfth Station* / 47
Kenneth Noland: *Let Up* / 54
David Novros: Untitled / 54
Larry Zox: *Tyeen* / 57
Richard Artschwager: Untitled / 64
Robert Bart: Untitled / 65
John F. Bennett: *Liaison* / 66
Michael Bolus: Installation, October 1966 / 69
Lee Bontecou: Untitled / 70
Anthony Caro: *Carriage* / 75
Donald Judd: Untitled / 76
Sven Lukin: *Watusi* / 77

Robert Morris: Untitled / 83
Tony Smith: *Night* / 83
Michael Steiner: Installation, November 1966 / 84
Alan Cote: Untitled; Robert Wray: *Wing;* Frazer Dougherty: *Cathexis Mass*; Chris Wilmarth: *Enormous* / 84
Sol LeWitt: *Series A #7* / 95
Sol LeWitt: *Series A #8* / 96
Sol LeWitt: *Series A #9* / 97
Sol LeWitt: *Series A* / 98
Carl Andre: *Lever* / 105
Barnett Newman: *Thirteenth Station* / 111
Barnett Newman: *Here II* / 112
Anthony Caro: *Bennington* / 121
Anthony Caro: *Flax* / 121
Donald Judd: Untitled / 122
Robert Morris: Untitled / 132
Jules Olitski: *Bunga 45* / 133
Tony Smith: *The Black Box* / 133
Donald Judd: Untitled / 152
Kenneth Noland: *Dry Shift* / 152
Frank Stella: *Sanbornville III* / 153
Carl Andre: *Cedar Piece* / 170
Patricia Johanson: *Pompey's Pillar* / 171
Antoni Milkowski: *Hex* / 171
Dan Graham: Untitled photographs / 176–179
Charles Hinman: Untitled / 188
Dan Flavin: Untitled / 191
Larry Poons: *Wildcat Arrival* / 191
Robert Smithson: *Enantiomorphic Chambers* / 192
Leo Valledor: *Skeedo* / 192
Alberto Giacometti: *Disagreeable Object* / 213
Keith Sonnier: Untitled / 213
Charles Stark: *Painting* / 214
John Wesley: *Camel* / 219
Tom Wesselmann: *Seascape #17 (Two Tits)* / 219
Robert Morris: Untitled / 227
Robert Morris: Untitled / 227
Robert Morris: Untitled / 229

Robert Rauschenberg: *White Painting* / 239
Robert Rauschenberg: Untitled / 243
Robert Smithson: *Alogon #2* / 244
Robert Smithson: Installation, December 1966 / 244
Deborah Hay in "Rise" / 265
Yvonne Rainer, William Davis, and David Gordon in *The Mind Is a Muscle* / 268
"Rule Game 5" by Trisha Brown / 268
Richard Artschwager: Untitled / 276
Ronald Bladen: *Black Triangle* / 283
Allan D'Arcangelo: *Safety Zone* / 287
Michael Steiner: Untitled / 287
Anne Truitt: *Late Snow* / 288
Andy Warhol: *Brillo* / 288
Ronald Bladen: Untitled / 313
Mark di Suvero: *Loveseat* / 314
Laszlo Moholy-Nagy: *Light-Display Machine* / 331
Heinz Mack: *Light Tower* / 332
Dan Flavin: *Daylight and Cool White* / 333
Julio Le Parc: *Continual Light* / 334
Stephen Antonakos: *White Hanging Neon* / 335
Naum Gabo: *Kinetic Construction: Virtual Volume* / 336
Marcel Duchamp: *Rotative Demi-Sphere* / 337
Gianni Colombo: *Pulsating Structuralization* / 338
David Medalla: *Cloud Canyon* / 339
Hans Haacke: *Ice Stick* / 340
Takis: *Electro-magnetic Sculpture* / 341
Hans Haacke: *Floating Sphere* / 342
Zero Group: *Demonstration* / 343
Will Insley: Drawing for *Floor Structure* / 362
Michael Kirby: Drawing of elevation for *Window Piece, Floor Piece, and Collection Frames* / 362
Les Levine: *Star Machine* / 365
Ursula Meyer: *The Laws* / 366
Brian O'Doherty: *Pair* / 366
Charles Ross: *Islands of Prisms* / 375
Tony Smith: Model for *The Maze* / 376
Tony Smith: *Willy* / 383

Richard Artschwager: *High Rise Apartment* / 389
Marcel Duchamp: *Fontaine* / 390
Alex Hay: *Stenographer's Sheet* / 390
Martial Raysse: *Identity, You Are Now a Martial Raysse* / 403
Dan Flavin: Untitled / 404
Robert Smithson: *Tar Pool and Gravel Pit* / 404
Anastasi: *South Wall, Dwan Main Gallery* / 407
Anastasi: *Coincidence* / 407
Carl Andre: Installation, March 1967 / 408
Stephen Antonakos: *Red Neon from Wall to Floor* / 408
Stephen Antonakos: *Orange Vertical Floor Neon* / 409
Richard Artschwager: *Table with Tablecloth* / 410
Richard Baringer: Untitled / 411
Larry Bell: Untitled / 411
Donald Bernhouse: Untitled / 412
James Bishop: *Reading* / 412
Mel Bochner: *Three Drymounted Photographs and One Diagram* / 413
Mel Bochner: *Photo-Graph: Series "A" (Single Point, 60° Elevation)* / 414
Bill Bollinger: Installation, December 1966. / 414
Anthony Caro: *Eyelit* / 415
John Chamberlain: *Ray Charles* / 416
Chryssa: *Fragment for the Gates to Times Square* / 416
Allan D'Arcangelo: #5 / 417
Tony Delap: *Triple Trouble II* / 418
Walter De Maria: *Cage* / 418
James Dine: *A Color Chart* / 419
Tom Doyle: Installation, March 1966 / 420
Dean Fleming: *Malibu II* / 420
Peter Forakis: *Laser Lightning* / 421
Paul Frazier: *Dyadic Split* / 421
Judy Gerowitz: *Rainbow Picket* / 422
Robert Grosvenor: *Wedge* / 423
Al Held: *Blue Moon Meets Green Sailor* / 424
Peter Hutchinson: *Double Triangle* / 425
Patricia Johanson: *Minor Keith* / 426
Donald Judd: Untitled / 426

Craig Kauffman: Untitled / 428
Alex Katz: *Red Smile* / 429
Edward Kienholz: *The Cement Store #2* / 429
Edward Kienholz: *The State Hospital* (exterior) / 430
Edward Kienholz: *The State Hospital* (interior) / 430
Joseph Kosuth: *Art as Idea as Idea* / 431
Aaron Kuriloff: *File Cabinet* / 431
David Lee: *A Renewable Substitute: Bachelard, Badiou, Baudouin, Brunelle* / 432
Les Levine: *Plug Assist #1* / 432
Robert Mangold: *Pink Area* / 433
Brice Marden: *Study* / 433
Agnes Martin: Untitled / 434
Paul Mogensen: *Standard* / 434
Marc Morrel: *Hanging* / 435
Forrest Myers: *Buick '69* / 436
Robert Neuwirth: Untitled / 436
David Novros: Untitled / 437
Doug Ohlson: *Sparrow's Red Rose* / 438
Claes Oldenburg: Model for *Colossal Monument: Thames Ball* / 438
Claes Oldenburg: *Soft Tub* / 439
Jules Olitski: *Maximum* / 439
David Smith: *Zig VII* / 440
Michael Steiner: Untitled / 441
Frank Stella: *Conway I* / 442
Peter Tangen: *Incomplete Square: Orange* / 442
Paul Thek: Untitled / 443
Chris Wilmarth: *Enormous* / 444

INTRODUCTION

In 1960 the Mexican sculptor-architect Mathias Goeritz exhibited at the Carstairs Gallery in New York City proposals and drawings for huge structures of a grand architectural scale—works that apparently approximated the flat and sculptural style that has come to be known as Minimal Art. In 1954 this same artist had designed an experimental structure in Mexico City called *El Eco*. The walls and other architectural components of the building were conceived in conjunction with large, Minimal sculptural pieces that all but took over the interiors. He also proposed simple geometric monuments several hundred feet high to be built with satellite cities in the open country around the Federal District. He saw the similarity between Minimal-type statements and their architectonic structure on one hand, and the intrinsic nature of the monumental in art and architecture, on the other. In his various experiments, Goeritz touched upon much of what concerns the new Minimal artist—indeed, the very content of Minimal Art itself. In *El Eco* he explored successfully the problem of architectural enclosure (space) and the relationship of Minimal sculpture to the limitations of negative space— the floor, walls, and ceilings.

Although Goeritz seems to have anticipated certain ideas of the Minimal artists referred to in this book, he was in no sense the originator of this style, which some have equated, wrongly, with monumentality in art. Goeritz searched for the absolute, but in so doing proved the absence of universal, absolute values. The Minimal artist does not think in terms of absolute values. While his statement may be less equivocal and ambiguous than that of his predecessor, the Abstract Expressionist, he certainly does not support the tyranny of the *causa sui*. Goeritz elaborated upon his absolutism in a handbill he distributed outside the Museum of Modern Art in 1960, on the occasion of the exhibition of Jean Tinguely's self-destructive sculpture.[1] He wrote:

[1] Jean Tinguely, *Homage to New York*, exhibited at The Museum of Modern Art, New York, January, 1960.

It is not true that what we need is to "accept instability." That is again the easy way. We need STATIC VALUES! . . . we need faith! . . . we need God! . . . we need the very definite laws and commandments of God! We need cathedrals and pyramids! We need a greater, a meaningful art!

Clearly, Goeritz's statement is reactionary, and very much out of touch with the times. His ideas are contrary to the modern attitude toward existence and phenomena. When the artist indulges in large-scale construction, he does so in order to challenge prevailing rules concerning scale and proportion, rather than to affirm the "timelessness" of the ancient Egyptians. We no longer subscribe to the sort of permanence Goeritz pleads, and we prefer to make sure our modern monuments *don't* last. In this way at least, there is less likelihood they will obstruct the new of the future, as monuments of the past— or at least on occasion—seem to obstruct the new today.

The Minimal style in sculpture is an obvious step on the path toward a more rigid spatial structuralization within art as well as by art. The modern sculptor will move closer to an art style that deliberately structures, divides, and compartmentalizes all the available space of the interior. A good demonstration of this trend was shown in an exhibition at the Corcoran Gallery in Washington, D.C. The exhibition was entitled, perhaps erroneously, "Scale as Content."[2] Scale, as an artistic element, was not the exclusive content of the exhibition. Rather, the two large pieces exhibited within the gallery extended themselves outward to press against the walls and ceiling, thus creating a lively spatial chopping-up of the interior. One of the pieces, *The X,* by Ronald Bladen, reaches from the floor outward toward the walls and ceiling in the shape of a giant X, and was constructed in the very space it is exhibited. *Smoke,* by Tony Smith, echoes the Greco-Roman columns of the gallery, and is indicative of the new trend. In her introduction to the catalogue of the exhibition, Eleanor Green writes:

The kind of scale that acts as content is not simply a matter of size and proportion, it is a function of the way the forms appear to expand and continue beyond their physical limitations, acting

[2] "Scale as Content," The Corcoran Gallery of Art, Washington, D.C., October 7, 1967 to January 7, 1968.

Anastasi: *North Wall, Dwan Main Gallery.* 1967. Oil on canvas. 7'1½" x 7'¾".
Photograph courtesy of Dwan Gallery, New York.

Ronald Bladen: *The X*. 1967. Painted wood. 22′ x 26′ x 14′. Photograph courtesy of The Corcoran Gallery of Art, Washington, D.C.

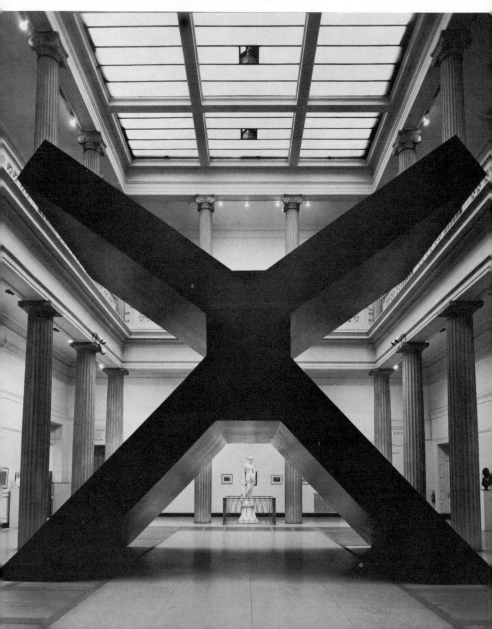

Robert Duran: Untitled. 1966–67. Masonite. 7'8" x 5'8" x 3". Photograph courtesy of Bykert Gallery, New York.

Dan Flavin: Installation, October 1967. Fluorescent fixtures. Each fixture: 8'6½". Photograph courtesy of Kornblee Gallery, New York.

Ellsworth Kelly: *White Angle*. 1966. Painted aluminum. 72″ x 36″ x 72″. Photograph courtesy of Sidney Janis Gallery, New York.

aggressively on the space around them, and compressing it. The intrusion of these forms into the surrounding space and their interaction with the architecture force the viewer to consider the environment in which they are placed in the context of the structure.

Thus, one result of a sculptural pattern that expands the abstract, non-emotional and non-expressionistic discoveries of the ancient Greeks, is a greater awareness of the negative space within the interior. In her introduction to the catalogue for the Minimal Art exhibition called "Schemata 7," Elayne Varian writes:

> The purpose of this exhibition is to show the attitude of contemporary sculptors to scale and enspheric space. . . . It is possible to have positive (enclosure) and negative (exclusion) attitudes to a defined space and each of the works represents a different attitude to what one might begin to call the art-artist intercurrent situation.[3]

In striking contrast to the work of the artists cited above is the sculpture of Claes Oldenburg, who exhibited drawings and maquettes of proposals for monuments at the Janis Gallery in 1967. Oldenburg suggests the construction of gigantic reproductions of objects such as *Drainpipe*, a floating toilet mechanism (*Thames Ball*), *Wing Nut*, and *Hot Dog with Toothpick*, to name only a few. Oldenburg's proposals are preposterous. They are all meant to be placed out doors, and perhaps represent the only solution to the problem of large-scale works placed outside, unenclosed by walls and ceilings. The objects are all completely familiar in their normal scale. Thus, when their size is immensely exaggerated the distortion can be appreciated without additional reference. Oldenburg's proposals are thus a kind of protest against the conventional idea of monumentality, as found in pyramids and cathedrals, as well as painting and sculpture. The objects the artist selects for such structuring obviously ridicule their own monumentality. A Minimal-type monumental structure, placed out-of-doors—similar to those proposed by Goeritz—cannot effectively deal with the problem of *scale*,

[3] Elayne Varian, in the exhibition catalogue *Schemata 7*, Finch College Museum of Art, New York, 1967.

while Oldenburg's plan to use objects of familiar scale in a monumental manner would seem to possess some validity.

A significant trend in modern art has been that of a closer interaction between art and criticism, between the artist as doer and the critic as interpreter. An investigation of this trend shows that the concerns of Minimal Art are both inevitable and consistent. Minimal Art is not a negation of past art, or a nihilistic gesture. Indeed, it must be understood that by *not* doing something one can instead make a fully affirmative gesture, that the Minimal artist is engaged in an appraisal of past and present, and that he frequently finds present aesthetic and sociological behavior both hypocritical and empty. One could object that this attitude is merely a rationalization of an art form involved with nothing, but this is not the case. Minimal style is extremely complex. The artist has to create new notions of scale, space, containment, shape, and object. He must reconstruct the relationship between art as object and between object and man. Negative space, architectural enclosure, nature, and the mechanical are all concerns of the Minimal artist, and as such become some of the characteristics that unify the movement. Necessarily, the definition of "movement" in art has changed. The Abstract-Expressionist "movement" in art was organized differently, and proceeded differently. The artists were geographically closer together. They communicated with each other in a more personal way. The art magazines and critics played a smaller role. Today, the artist is more immediately involved in daily concerns. Vietnam, technological development, sociology, and philosophy are all subjects of immediate importance.

In order to declare his intentions effectively, and to emphasize his achievements, the new artist has moved into a much closer working relationship with the art critic. Many of the new artists are both writing and talking more about their art in a highly articulate and critical manner. At the same time, the appraisals of critics go beyond mere judgment and evaluation; they provide a sympathetic contribution. Recent critical evaluations concerning "art as monument" and "art as object" may have been in the sculptor Tony Smith's mind when he replied to the following questions about his six-foot cube *Die:*

Ellsworth Kelly: *Black/White*. 1966. Oil on canvas. 70″ x 140″. Photograph courtesy of Sidney Janis Gallery, New York.

Aaron Kuriloff: *Telephone*. 1967. Foto-factual. 25½″ x 22½″. Photograph courtesy of Fischbach Gallery, New York.

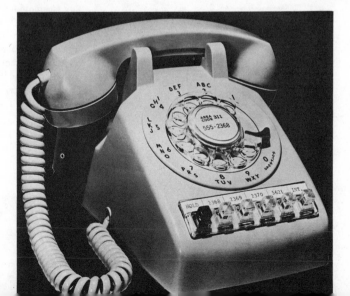

Above: Sol LeWitt: Untitled. 1966. Aluminum and flat enamel. 60″ square. Photograph courtesy of Dwan Gallery, New York. *Left:* Roy Lichtenstein: *White Brush Stroke, II.* 1965. Oil and magna on canvas. 48″ x 36″. In the collection of David Whitney. Photograph courtesy of Leo Castelli Gallery, New York.

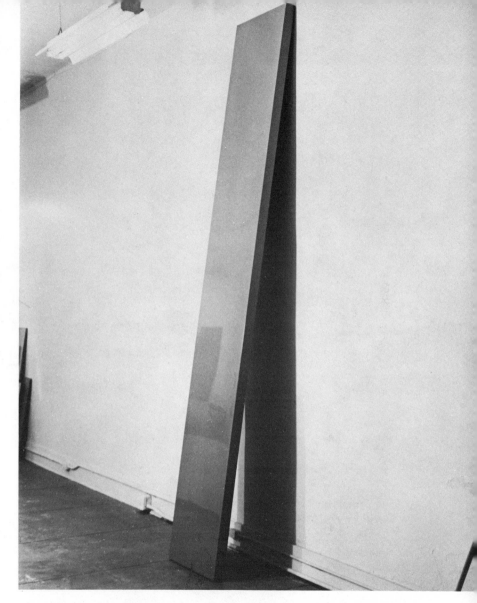

John McCracken: Untitled (Red Plank). 1966. Urethane foam, fiberglass. 144" x 24" x 3". Photograph courtesy of Robert Elkon Gallery, New York.

Claes Oldenburg: *Colossal Monument for Ellis Island: Hot Dog with Toothpick.*
1965. Drawing. Photograph courtesy of Sidney Janis Gallery, New York.

Q. Why didn't you make it larger so that it would loom over the observer?

A. I was not making a monument.

Q. Then why didn't you make it smaller, so that the observer could see over the top?

A. I was not making an object.[4]

Minimal artists who are writing about their art include Carl Andre, Dan Flavin, Robert Smithson, Robert Morris, and Mel Bochner, to name a few. Other artists, including such diverse personalities as Oldenburg, Anastasi, and Kelly refer in their art to contemporary critical realizations and philosophical discovery. For example, the painter William Anastasi shows clearly in his work that he is intensely aware of what is happening in art and art criticism at this time.

Paintings by Ellsworth Kelly also seem to allude to current critical ideas. For example, we know that the new Minimal style should not be considered a repudiation of the earlier Abstract-Expressionist aesthetic. Rather, modern artists, such as Ellsworth Kelly, emphasize the lingering vitality of certain Abstract-Expressionist discoveries, and at the same time acknowledge the legitimacy of that movement. In Kelly's new paintings[5] there is no formal distinction between line and edge—they are both the same. Nor is there the possibility of color as form because when a color ends, so does the edge of that particular panel. Line, in these works, is always real, since it is a physical reality as opposed to an abstracted one; although the outside edges of the painting are uninterrupted, each color within those edges is contained on a separately stretched piece of canvas. In addition, Kelly throws new light on various ideas in modern aesthetics, such as those proposed by Michael Fried, Barbara Rose, and Lawrence Alloway—including shape as form, color as shape, primacy of literal over depicted shape, illusion in art, image and theatricality, and system in art. Recent insights made by these and other writers cannot be discarded when evaluating Minimal paint-

[4] Quoted by Robert Morris as the epigraph to his "Notes on Sculpture," Part II (included in this anthology).

[5] Exhibited at the Sidney Janis Gallery, New York, 1967.

ings and sculptures. Kelly should be commended for an integrity that allows him to take his ideas to their logical conclusions.

An outstanding characteristic of Minimal Art is its clarity. In his essay "Post-Painterly Abstraction," Clement Greenberg observes: ". . . openness and clarity are more conductive to freshness in abstract painting at this particular moment . . ."[6] If art is ruled by ambiguity and not by clarity, as some will say, then a great deal of recent art is not art. There is no ambiguity in much of the art discussed in this book. The new clarity is in striking contrast to the indecision characteristic of Abstract Expressionism. Dore Ashton, for instance, has said that de Kooning's works ". . . described an abstraction; vacancy" and that ". . . the subject of the paintings was the void."[7] Another critic noted that de Kooning's paintings ". . . are based on contradictions kept contradictory. . . "[8]

The purpose and content of Minimal Art may be clearer than the art of its major predecessor, Abstract Expressionism. However, artists of both schools dem nstrate considerable authority and confidence. With a confidence that has rarely been seen since de Kooning and Kline, Minimal artists acknowledge both the viewer and the space of the gallery. They grasp aggressively at all available space, and in so doing point in every direction. They force the audience to an awareness of existence that goes beyond the presence of any particular art object. The audience is persuaded to walk about the newly defined and delineated space, and the path is determined by the art. In so doing, the artists allow no room for confusion or misrepresentation. A row of panels on a wall owe the possibility of their existence in the selected form to the presence of the wall, just as the pattern of our own existence is determined largely by environmental factors. The Minimal artist no longer questions—he challenges and observes.

The Jackson Pollock Exhibition at the Museum of Modern Art in 1967 illustrated the exceptionally perspicuous and consistent development of that artist over a twenty-two-year period. Pollock's rejec-

[6] Introduction to the exhibition catalogue *Post-Painterly Abstraction*, Los Angeles County Museum of Art, 1964.

[7] Dore Ashton, *The Unknown Shore*. Little, Brown & Co., Boston, 1962, p. 97.

[8] Thomas Hess, *Willem de Kooning*. George Braziller, New York, 1959, p. 7.

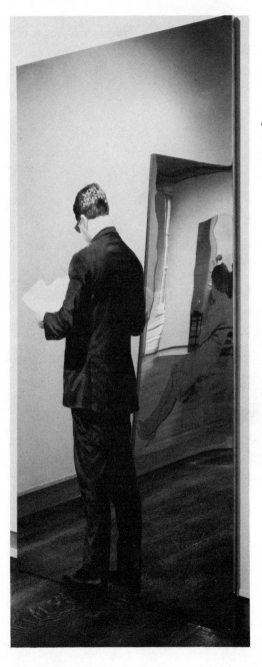

Michelangelo Pistoletto:
Man Reading. 1967. Collage
on stainless steel. 86" x 47".
Photograph courtesy of
Kornblee Gallery, New York.

Richard Van Buren: Untitled. 1967. Plywood covered with fiberglass. 154" x 62" x 36½". Photograph courtesy of Bykert Gallery, New York.

tion of the traditional relationship between brush and canvas in his famous drip paintings may be viewed as a prediction of the Minimal style. The Pollock revolution turns out to be more erudite, yet not less hair-raising than one might expect. The exhibition serves as a nagging reminder of how much popular taste has changed, though not matured, in a surprisingly short time. In the period since World War II, superficial popular acceptance of avant-garde art has been paralleled by a degree of similar apparent acceptance of political, social, and moral change; but in most cases that acceptance is both shallowly rooted and liable to disappear under pressure. As far as the arts are concerned, it is a change only in method and rationale, and not in effect. Later developments have only confirmed the vitality of Pollock's imagination. His challenges to the art process and method have been accepted by numerous Minimal artists and others, among them Malcolm Morley, Dan Flavin, Alex Hay, Richard Artschwager, Roy Lichtenstein, and Aaron Kuriloff.

An investigation into the tradition and background of these artists should emphasize two points; first, the enormous influence of Marcel Duchamp, and second, a complete awareness of the development of Western art by the artists. They take care to provide just the right *surface*—a *surface* without craft (indeed, without art); in this way rejecting those impulses that claim glory in manual work and nobility in craftsmanship. However, none of the works is entirely without art, though appearing so at first. In the *photo-factuals*[9] of Kuriloff, for instance, the control of the artist over the art object can be seen in several ways, including the heightened light-dark contrasts, photo touch-up here and there, almost compulsive framing of images within edges, and the removal, in several cases, of brand names from the faces of the object-images. Clearly, these works demand a sharp social awareness for their appreciation. Kuriloff's gesture in removing brand names requires an understanding of the nature of new concepts in industrial design and packaging technology, such as the incorporation of a brand name into the design scheme of a product in much the same way as a handle or dial. Of course, there are those who find this manipulation by the artist unnecessary and sentimental. The question is, does it contribute to the overall cerebral stimulation, or does it tend to lessen it? In these ways, the artist

[9] Exhibited at the Fischbach Gallery, New York, 1967.

provides a pertinent and immediate provocation against art as reproduction and imitation, art as craft, art as object, and artist as originator.

Another Minimal artist who goes far in overturning the established rules of art is Dan Flavin. Minimal artists in general project a revolutionary concept by means of traditional media, and thus can be viewed as classicists. In fact, few of the accepted rules of abstract sculpture and painting have been rejected by the bulk of the Minimalists. Twentieth-century abstract sculpture has generally failed to grasp ideas more complicated and advanced than those proposed by the ancient Greeks. Flavin may, indeed, be one of the first modern sculptors to expand the provocations and discoveries within the medium that were first stated by the Greeks, and varied to a greater or lesser degree by succeeding cultures. His works are not three-dimensional in the traditional sense. They tend to envelop the viewer totally. He has made a considerable contribution to the intellectual content of Minimal Art, and will, no doubt, influence its literature also. Flavin is an activist among pacifists in art.

Many of the articles in this book declare and define characteristics of the new Minimal style. The reader will note that from time to time contradictions appear. This is an inevitable aspect of any attempt to demarcate a style while it is still in its formative stage. Indeed, art is always in process of being determined and constantly in flux. Observations become obsolete simply by their existence.

That some of the artists discussed in this book have drastically reduced those pictorial elements and procedures typical of more traditional art is not really important; what really counts is that painters and sculptors today are continuing the twentieth-century trend toward greater acknowledgment and consciousness of all that isn't art. Logic and label no longer concern the artist, for art is now both logic *and* label. Art and idea are inseparable. In a sense, what is most important is what an artist *does*, rather than what he *is*, what the object *does*—in terms of response—rather than what it *is*.

GREGORY BATTCOCK

SYSTEMIC PAINTING* by Lawrence Alloway

In 1966 Lawrence Alloway organized an exhibition of paintings at the Guggenheim Museum called "Systemic Painting." The show contained numerous works that many critics today would consider part of the "Minimal" school. Elsewhere in this book John Perreault points out that the group of artists now considered Minimal includes ". . . undoubtably several who are as far apart from each other as we now understand de Kooning and Pollock to be and as far apart as Roy Lichtenstein and Andy Warhol."

In organizing the "Systemic Painting" exhibition, Alloway was very much aware of recent developments in painting and criticism, especially those ideas expounded by Greenberg (in "Modernist Painting" and "Post-Painterly Abstraction"), Fried, and Goossen (in "8 Young Artists," Hudson River Museum). In his introduction to the catalogue Alloway notes: ". . . paintings, such as those in this exhibition are not, as has been often claimed, impersonal. The personal is not expunged by using a neat technique; anonymity is not a consequence of highly finishing a painting."

Lawrence Alloway is former curator of the Guggenheim Museum, where his exhibitions included the now famous "Stations of the Cross" series of works of Barnett Newman. He is now Chairman of the Fine Arts Division at the School of Visual Arts, New York.

AUTHOR'S NOTE: On the cover of the exhibition catalogue *Systemic Painting* was a definition of *systemic* taken from the Oxford English Dictionary: "3 gen. Arranged or conducted according to a system, plan, or organized method; involving or observing a system." And *system* was defined in the same source as "a set or assemblage of things connected, associated, or interdependent so as to form a complex unity; a whole composed of parts in orderly arrangement according to some scheme or plan." Anatol Rapoport† uses the word "systemic" in opposition to "strategic," the latter being characterized in Game Theory by conflicts partly shaped by bluff and psychology, as defined by Von Neumann. Joseph H. Green-

* Introductory essay reprinted from the exhibition catalogue *Systemic Painting,* published by The Solomon R. Guggenheim Foundation, New York, 1966.

† Anatol Rapoport. "Systemic and Strategic Conflict." *Virginia Quarterly,* Charlottesville, Vol. 40, No. 3, 1964.

berg* uses "systemic" to mean "having to do with the formulation and discovery of rules" in "actually existing sign systems." That part of linguistics, however, that calls on psychology and the social sciences, he refers to as "pragmatic." In line with these usages, my attempt here is to provide a general theory, within objective limits, of the uses of systems by recent abstract artists.

The painting that made American art famous, done mostly in New York between 1947 and 1954, first appeared as a drama of creativity. The improvisatory capacity of the artist was enlarged and the materiality of media stressed. The process-record of the creative act dominated all other possibilities of art and was boosted by Harold Rosenberg's term Action Painting. This phrase, though written with de Kooning in mind, was not announced as such, and it got stretched to cover new American abstract art in general. The other popular term, Abstract Expressionism, shares with "action" a similar overemphasis on work-procedures, defining the work of art as a seismic record of the artist's anxiety. However, within this period, there were painters who never fitted the lore of violence that surrounded American art. The work of Clyfford Still, Barnett Newman, and Mark Rothko was clearly not offering revelatory brushwork with autobiographical implications. Not only that, but an artist like Pollock, who in his own time, seemed all audacious gesture, appears very differently now. His large drip paintings of 1950 have been, as it were, de-gesturized by a few years' passing: what once looked like impulsive directional tracks have condensed into unitary fields of color. This all-over distribution of emphasis and the consequent pulverizing of hierarchic form relates Pollock to Still, Newman, and Rothko.

Meyer Schapiro compared the nonexpressionistic, nongestural painting of Rothko to "an all-pervading, as if internalized, sensation of dominant color."[1] Later H. H. Arnason proposed the term Ab-

* Joseph H. Greenberg. *Essays in Linguistics*. University of Chicago Press, Chicago, 1963.

[1] Meyer Schapiro. "The Younger American Painters of Today," *The Listener*, London, No. 1404, January 26, 1956, pp. 146–47.

stract Imagist for those artists who were not expressionist.[2] This is a recognition of the fact that the unity of Action Painting and Abstract Expressionism was purely verbal, a product of generalization from incomplete data. (Obviously, any generalizations are subject to scepticism, revision, and reversal, but these two terms seem especially perfunctory.) It is the "sensational," the "Imagist," painters who have been ratified by the work of younger artists. Dissatisfaction with the expressionist bulk of New York painting was expressed by the number of young painters who turned away from gestural art or never entered it. Jasper Johns's targets from 1955, Noland's circles from late 1958, and Stella's symmetrical black paintings of 1958–59 are, it can now be seen, significant shifts from the directional brushwork and projected anxiety of the Expressionists. Rauschenberg's twin paintings, *Factum I* and *Factum II*, 1957, along with duplicated photographs, included almost identical paint splashes and trickles, an ironic and loaded image. A gestural mark was turned into a repeatable object. The changing situation can be well indicated by the opinions of William Rubin six years ago: he not only deplored "the poor quality of 'de Kooning style painting,'" he also assumed the failure of de Kooning himself and praised Clement Greenberg's "prophetic insight" in foreseeing the expressionist cul-de-sac.[3] It is symptomatic that three years later Ben Heller stated, "the widespread interest in de Kooning's ideas has been more of a hindrance than a help to the younger artists."[4] In fact, it was now possible for Heller to refer to "the *post*-de Kooning world" (my italics). In the late fifties de Kooning's example was oppressively accepted and alternatives to it were only fragmentarily visible. There was, 1) the work of the older Field painters; 2) the devel-

[2] The Solomon R. Guggenheim Museum, New York October–December 1961, *American Abstract Expressionists and Imagists*. Text by H. H. Arnason. Includes Held, Humphrey, Kelly, Noland, Smith, Stella, Youngerman. Bibliography.

[3] William Rubin. "Younger American Painters," *Art International*, Zürich, Vol. IV, No. 1, January 1960, pp. 24–31. Includes Kelly, Noland, Stella, Youngerman.

[4] The Jewish Museum, New York, May 19–September 15, 1963, *Toward a New Abstraction*. Introduction by Ben Heller. Includes text on Al Held by Irving Sandler; on Ellsworth Kelly by Henry Geldzahler; on Kenneth Noland by Alan R. Solomon; on Frank Stella by Michael Fried.

opment of stained as opposed to brushed techniques (Pollock 1951, Frankenthaler 1952, Louis 1954); and, 3) the mounting interest in symmetrical as opposed to amorphous formats, clear color as opposed to dirty, hard edges as opposed to dragged ones.

Barnett Newman's paintings have had two different audiences: first the compact group of admirers of his exhibitions in New York in 1950 and 1951. Second, the larger audience of the later fifties, with the shift of sensibility away from gestural art. As with any artist who is called "ahead of his time" he has a complex relation with subsequent history. On the one hand he has created his own audience and influenced younger artists; on the other hand, his art was waited for. There was talk and speculation about Newman even among artists who had not seen his work. Newman asserted the wholistic character of painting with a rigor previously unknown; his paintings could not be seen or analyzed in terms of small parts. There are no subdivisions or placement problems; the total field is the unit of meaning. The expressionist element in Still (who signed himself Clyfford in emulation of the Vincent signature of Van Gogh) and the seductive air of Rothko, despite their sense of space as field, meant less to a new generation of artists than Newman's even but not polished, brushed but not ostentatious, paint surface. In addition, the narrow canvases he painted in 1951, a few inches wide and closely related in height to a man's size, prefigure the development of the shaped canvas ten years later. Greenberg, considering the structural principles of Newman's painting in the absence of internal divisions and the interplay of contrasted forms, suggested that his vertical bands are a "parody" of the frame. "Newman's picture becomes all frame in itself," because "the picture edge is repeated inside, and *makes* the picture instead of merely being *echoed*."[5] This idea was later blown up by Michael Fried into deductive structure[6] and applied to

[5] Clement Greenberg. "American-type Painting," *Art and Culture*, Boston, Beacon Press, 1961, pp. 208–29.

[6] Fogg Art Museum, Harvard University, Cambridge, Massachusetts, April 21–May 30, 1965, *Three American Painters: Kenneth Noland, Jules Olitski, Frank Stella*. Text by Michael Fried. Two parts of the introduction appeared earlier in slightly different form: Section I in *American Scholar*, Vol. 33, No. 4, Autumn 1964, pp. 642–649, as "Modernist Painting and Formal Criticism"; Section III as the introduction to Kenneth Noland's retrospective exhibition at The Jewish Museum, New York, February 4–March 7, 1965.

Jo Baer: *Grayed-yellow Vertical Rectangle.* 1964–65. Oil with lucite on canvas. 60" x 48". In the collection of the Weatherspoon Art Gallery, University of North Carolina at Greensboro. Photograph courtesy of the artist.

Frank Stella's paintings in which the stretcher, as a whole, not just the sides, sets the limits for the development of the surface.[7] Although this idea is not central to the paintings of Newman, it is indicative of his continuous presence on the scene in the sixties that a proposed aesthetic should rest, at least partially, on his work.

Alternatives to Abstract Expressionism were not easily come by in the fifties and had to be formulated experimentally by artists on their own. Leon Smith, who had already suppressed modeling and textural variation in his painting, studied in 1954 the stitching patterns on drawings of tennis balls, footballs, and basketballs. These images laid the foundations of his continuous, flowing space, both in tondos, close to the original balls, and transferred to rectangular canvases. In France, Ellsworth Kelly made a series of panel paintings, in which each panel carried a single solid color. There is an echo of Neoplastic pinks and blues in his palette, but his rejection of visual variation or contrast was drastically fresh, at the time, 1952–53. Ad Reinhardt, after 1952, painted all red and all blue pictures on a strictly symmetrical layout, combining elements from early twentieth-century geometric art and mid-century Field painting (saturated or close-valued color). These three artists demonstrate an unexpected reconciliation of geometric art, as structural precision, and recent American painting, as colorist intensity. They showed at Betty Parsons Gallery and her adjunct Section Eleven, 1958–61, along with Alexander Liberman, Agnes Martin, and Sidney Wolfson. It is to this first phase of nonexpressionistic New York painting that the term Hard Edge applies. "The phrase 'hard-edge' is an invention of the critic, Jules Langsner, who suggested it at a gathering in Claremont in 1959 as a title for an exhibition of four nonfigurative California painters,"[9] records George Rickey. In fact, Langsner originally intended the term to refer to geometric abstract art in general, because of the ambiguity of the term "geometric," as he told me in conversation in 1958. Incidentally, the exhibition Rickey

[7] Deductive structure is the verbal echo and opposite of what William Rubin called " 'inductive' or indirect painting," ([8]) but the phrase (which meant painting without a brush) never caught on.

[8] Rubin, op. cit.

[9] George Rickey. "The New Tendency (Nouvelle Tendence Recherche Continuelle)," Art Journal, New York, Vol. XIII, No. 4, Summer 1964, p. 272.

Dean Fleming: *2V Dwan 2*. 1965–66. Acrylic on canvas. Three canvases: each 99″ x 66″. Photograph courtesy of Park Place Gallery, New York.

Al Held: *Clipper*. 1966. Acrylic on canvas. 4′ x 6′. Photograph courtesy of Andre Emmerich Gallery, New York.

Ralph Humphrey: Untitled. 1966. 72″ x 84″. Acrylic and day-glo on canvas. Photograph courtesy of Bykert Gallery, New York.

Ellsworth Kelly: *Green/White.* 1967. Oil on canvas. 85″ x 85″. Photograph courtesy of Sidney Janis Gallery, New York.

refers to was eventually called *Four Abstract Classicists.* The purpose of the term, as I used it 1959–60, was to refer to the new development that combined economy of form and neatness of surface with fullness of color, without continually raising memories of earlier geometric art. It was a way of stressing the wholistic properties of both the big asymmetrical shapes of Smith and Kelly and the symmetrical layouts of Liberman and Martin.

Hard Edge was defined in opposition to geometric art in the following way: "The 'cone, cylinder, and sphere' of Cézanne-fame have persisted in much twentieth-century painting. Even where these forms are not purely represented, abstract artists have tended toward a compilation of separable elements. Form has been treated as discrete entities," whereas "forms are few in hard-edge and the surface immaculate. . . . The whole picture becomes the unit; forms extend the length of the painting or are restricted to two or three tones. The result of this sparseness is that the spatial effect of figures on a field is avoided."[10] This wholistic organization is the difference that Field painting had made to the formal resources of geometric art.[11] The fundamental article on this phase of the development of systemic painting is Sidney Tillim's early "What Happened to Geometry?" in which he formulated the situation in terms of geometric art "in the shadow of abstract expressionism."[12]

The emerging nonexpressionist tendencies were often complimented as Timeless Form's latest embodiment, as in the West Coast

[10] Lawrence Alloway. "On the Edge," *Architectural Design,* London, Vol. XXX, No. 4, April 1960, pp. 164–165.

[11] The formal difference between wholistic and hierarchic form is often described as "relational" and "nonrelational." Relational refers to paintings like that of the earlier geometric artists, which are subdivided and balanced with a hierarchy of forms, large-medium-small. Nonrelational, on the contrary, refers to unmodulated monochromes, completely symmetrical layouts, or unaccented grids. In fact, of course, relationships (the mode in which one thing stands to another or two or more things to one another) persist, even when the relations are those of continuity and repetition rather than of contrast and interplay. (For more information on Hard Edge see John Coplans: "John McLaughlin, Hard Edge, and American Painting" *Artforum,* San Francisco, Vol. II, No. 7, January, 1964, pp. 28–31.

[12] Sidney Tillim. "What Happened to Geometry: An Inquiry into Geometrical Painting in America," *Arts,* New York, Vol. 33, No. 9, June 1959, pp. 38–44.

group of Abstract Classicists. Jules Langsner defined Abstract Classicism as form that is "defined, explicit, ponderable, rather than ambiguous or fuzzily suggestive," and equated this description with the "enduring principles of Classicism."[13] It is a tribute to the prestige of the Expressionist-Action cluster of ideas that it was assumed any artist who did not belong there must, of necessity, be a classicist. Langsner wrote in 1959 but, as late as 1964, E. C. Goossen could refer, when discussing symmetry, to its "underlying classical conventions."[14] Whereas Mondrian and Malevich, in the formative period of their ideas, believed in absolute formal standards, of the kind a definition of Classicism requires, American artists had more alternatives. The 1903–13 generation, by stressing the existential presence of the artist in his work, had sealed off the strategies of impersonality and timelessness by which earlier artists had defined and defended their work. Now, because of the intervening generation of exploratory artists, the systematic and the patient could be regarded as no less idiosyncratic and human than the gestural and cathartic. Only defenders of the idea of classicism in modern life resisted this idea of the arbitrariness of the systemic.

Alexander Liberman produced paintings in which the immaculate finish associated with international geometric art was taken up to a physical scale and fullness comparable to the work of the 1903–13 generation of Americans. The completeness of symmetry in his paintings of 1950, the random activation of a field without gestural traces in 1953, are remarkably early. A symmetrical and immaculate painting of his was seen at the Guggenheim Museum in 1951, where its total absence of touch was remarked on by, among others, Johns and Rauschenberg. Several of Liberman's paintings of this period were designed by him and executed by workmen, an anticipation of much later practice. Here is a real link with Malevich, incidentally, though not one likely to have occurred to Liberman at the time; in Malevich's book *The Non-Objective World*, his Suprematist compositions are rendered by pencil drawings, not by reproductions of paintings. The conceptual act of the artist, that is to say, not his

[13] The Los Angeles County Museum of Art, July, 1959, *Four Abstract Classicists*. Text by Jules Langsner.

[14] E. C. Goossen. "Paul Feeley," *Art International*, Lugano, Vol. 8, No. 10, December 1964, pp. 31–33.

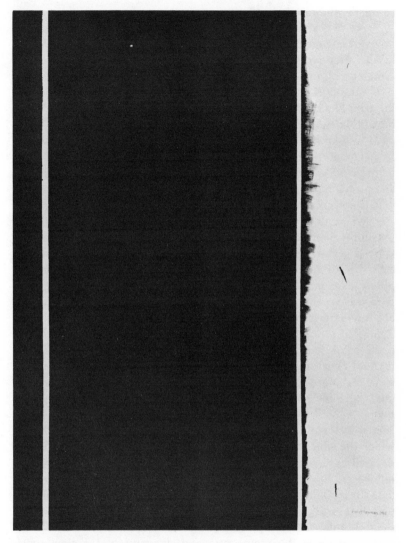

Barnett Newman: *Twelfth Station*, 1965, of *The Stations of the Cross: Lema Sabachthani.* Acrylic polymer on canvas. 78" x 60." Photograph courtesy of The Solomon R. Guggenheim Museum, New York.

physical engagement with a medium, is the central issue. Ad Reinhardt, after working as a traditional geometric artist, began his symmetrical, one-color paintings in 1953, which darkened progressively through the fifties, culminating in 1960 in the series of identical near-black squares. His numerous statements, dramatic, flamboyant, in catalogues or even in Action Painting-oriented *Art News*, were well known. "No accidents or automatism"; "Everything, where to begin and where to end, should be worked out in the mind beforehand"; "No symbols, images, or signs"[15] are characteristic, and prophetic (the date is 1957).

It is not necessary to believe in the historical succession of styles, one irrevocably displacing its predecessor, to see that a shift of sensibility had occurred. In the most extreme view, this shift destroyed gestural painting; in a less radical view, it at least expanded artists' possible choices in mid-century New York, restoring multiplicity. Newman's celebrated exhibition at Bennington College in 1958 was repeated in New York the following year, and the echoes of his work were immense. In 1960 Noland's circles, which had been somewhat gestural in handling, became tighter and, as a result, the dyed color became disembodied, without hints of modeling or textural variation. Stella's series of copper paintings in 1961 were far more elaborately shaped than the notched paintings of the preceding year; now the stretchers were like huge initial letters. In 1962 Poons painted his first paintings in which fields of color were inflected by small disks of color; Noland painted his first chevrons, in which the edges of the canvas, as well as the center, which had been stressed in the circles, became structurally important; and Downing, influenced he has said by Noland, painted his grids of two-color dots. In 1963 Stella produced his series of elaborately cut-out purple paintings and Neil Williams made his series of sawtooth-edged shaped-canvases. Other examples could be cited, but enough is recorded to show the momentum and diversity of the new sensibility.

A series of museum exhibitions reveals an increasing self-awareness among the artists, which made possible group appearances and public recognition of the changed sensibility. The first of these

[15] Ad Reinhardt. "Twelve Rules for a New Academy," *Art News*, New York, Vol. 56, No. 3, May, 1957, pp. 37–38, 56.

exhibitions was *Toward a New Abstraction* (The Jewish Museum, Summer 1963), in which Ben Heller proposed, as a central characteristic of the artists, "a conceptual approach to painting."[16] In the following year there was *Post-Painterly Abstraction* (The Los Angeles County Museum of Art, Spring), in which Clement Greenberg proposed that the artists included in the show revealed a "move toward a physical openness of design, or toward linear clarity, or toward both."[17] Heller and Greenberg, the former no doubt affected by Greenberg's earlier writing, were antiexpressionist. In the fall of 1964 The Hudson River Museum put on a significant, though at the time little-noticed, exhibition of 8 *Young Artists,* among them Robert Barry and Robert Huot. E. C. Goossen described the group characteristics as follows: "None of them employs illusion, realism, or anything that could possibly be described as symbolism," and stressed the artists' "concern with conceptual order."[18] Noland occupied half the U.S. Pavilion at the Venice Biennale in 1964 and had a near retrospective at The Jewish Museum in the following year. In the summer of 1965 the Washington Gallery of Modern Art presented *The Washington Color Painters,* which included Noland, Downing, and Mehring. Finally, in the spring of 1966 The Jewish Museum put on a sculpture exhibition, *Primary Structures.*[19] This list of museum exhibitions shows that critical and public interest in the early sixties had left Abstract Expressionism, and the main area of abstract art on which it now concentrated can be identified with Clement Greenberg's aesthetics.

Greenberg's *Post-Painterly Abstraction* was notable as a consolidation of the null-expressionist tendencies so open in this critic's

[16] The Jewish Museum, *op. cit.*

[17] The Los Angeles County Museum of Art, Los Angeles, April 23–June 7, 1964, *Post-Painterly Abstraction.* Text by Clement Greenberg. Includes Downing, Feeley, Held, Kelly, Krushenick, Mehring, Noland, Stella.

[18] The Hudson River Museum, Yonkers, New York, October 11–25, 1964, *8 Young Artists.* Text by E. C. Goossen. Includes Barry, Huot.

[19] When the present exhibition was proposed originally in June, 1964, it was intended to show painting and sculpture, but *Primary Structures* covered the ground too closely to repeat it. The reasons for planning to show flat and 3D work are 1) analogies between work in both media and 2) the number of artists who combine the technology of one with the formal characteristics of the other. The shaped canvases in this exhibition are those with lateral variations rather than with volumetric projections; that is to say, closer to painting.

later work. He sought an historical logic for "clarity and openness" in painting by taking the cyclic theory of Wölfflin, according to which painterly and linear styles alternate in cycles. Translated into present requirements, Abstract Expressionism figures as painterly, now degenerated into mannerism, and more recent developments are equated with the linear. These criteria are so permissive as to absorb Frankenthaler's and Olitski's free-form improvisation and atmospheric color, on the one hand, and Feeley's and Stella's uninflected systemic painting as well. It is all Post-Painterly Abstraction, a term certainly adapted from Roger Fry's Post-Impressionism which similarly lumped together painters as antithetical as Van Gogh, Gauguin, Seurat, and Cézanne. The core of Post-Painterly Abstraction is a technical procedure, the staining of canvas to obtain color uninterrupted by pressures of the hand or the operational limits of brush work. Poured paint exists purely as color, "freed" of drawing and modeling; hence the term Color Painting for stain painting.[20] It is characteristic of criticism preoccupied with formal matters that it should give a movement a name derived from a technical constituent. The question arises: are other, less narrow, descriptions of post-expressionist art possible than that proposed by Greenberg? It is important to go into this because his influence is extensive, unlike that of Harold Rosenberg (associated with Action Painting), but there is a ceiling to Greenberg's aesthetic which must be faced.

The basic text in Greenberg-influenced criticism is an article, written after the publication of *Art and Culture,* but on which the essays in his book rest, called "Modernist Painting."[21] Here he argues for self-criticism within each art, "through the procedures themselves of that which is being criticized." Thus "flatness, two-dimen-

[20] Optical has, at present, two meanings in art criticism. In Greenberg's aesthetics color is optical if it creates a purely visual and nontactile space. It is one of the properties of "Color" Painting, the term Greenberg applied to Louis and Noland in 1960 (which has been widely used, including adaptations of it such as William Seitz's "Color Image"). It is curious, since color is mandatory for all painting, that one way of using it should be canonized. The other meaning of optical, and its best known usage, is as the optical in Op Art, meaning art that shifts during the spectator's act of perception.

[21] Clement Greenberg. "Modernist Painting," *Arts Yearbook 4,* New York, 1961, pp. 101–108.

sionality, was the only condition shared with no other art, and so modernist painting oriented itself to flatness." This idea has been elaborated by Michael Fried as a concentration on "problems intrinsic to painting itself."[22] This idea of art's autonomy descends from nineteenth-century aestheticism. "As the laws of their Art were revealed to them (artists), they saw, *in the development of their work*, that real beauty, which, to them was as much a matter of certainty and triumph as is to the astronomer the verification of the result, foreseen with the light given to him alone."[23] Here Whistler states clearly the idea of medium purity as operational self-criticism, on which American formalist art criticism still rests. Whistler typifies the first of three phases of art for art's sake theory: first, the precious and, at the time, highly original aestheticism of Walter Pater, Whistler, and Wilde; second, a classicizing of this view in the early twentieth century, especially by Roger Fry, stressing form and plasticity with a new sobriety; and, third, Greenberg's zeal for flatness and color, with a corresponding neglect of nonphysiognomic elements in art.

What is missing from the formalist approach to painting is a serious desire to study meanings beyond the purely visual configuration. Consider the following opinions, all of them formalist-based, which acknowledge or suppose the existence of meanings/feelings. Ben Heller writes that Noland "has created not only an optical but an expressive art"[24] and Michael Fried calls Noland's paintings "powerful emotional statements."[25] However, neither writer indicated what was expressed nor what emotions might be stated. Alan Solomon has written of Noland's circles, which earlier he had called "targets"[26]: "some are buoyant and cheerful . . . others are sombre, brooding, tense, introspective,"[27] but this "sometimes-I'm-happy, sometimes-I'm-blue" interpretation is less than one hopes for. It amounts to a reading of color and concentric density as symbols of

[22] Fogg Art Museum, *op. cit.*

[23] James A. McNeill Whistler. *Ten O'Clock*, Portland, Maine, Thomas Bird Mosher, 1925.

[24] The Jewish Museum, *op. cit.*

[25] Fogg Art Museum, *op. cit.*

[26] The Jewish Museum, *op. cit.*

[27] *XXXII International Biennial Exhibition of Art*, United States Pavilion, Venice, June 20–October 18, 1964. Text by Alan R. Solomon, pp. 275–276.

emotional states, which takes us back to the early twentieth-century belief in emotional transmission by color-coding.

According to Greenberg the Hard-Edge artists in his *Post-Painterly Abstraction* exhibition "are included because they have won their 'hardness' from the softness of Painterly Abstraction."[28] It is certainly true that "a good part of the reaction against Abstract Expressionism is . . . a continuation of it," but to say of the artists, "they have not inherited it (the hard edge) from Mondrian, the Bauhaus, Suprematism, or anything that came before," is exaggerating. Since Greenberg believes in evolutionary ideas, and his proposal that Hard-Edge artists come out of gestural ones shows that he does, it is unreasonable to sever the later artists from the renewed contact with geometric abstract art which clearly exists. If we omit Greenberg's improvisatory painters, such as Francis, Frankenthaler, Louis, and Olitski, and attend to the more systemic artists, there are definite connections to earlier geometric art. Kelly, Smith, and Poons had roots in earlier geometric art, for example, and it is hard to isolate modular painting in New York from international abstract art. What seems relevant now is to define systems in art, free of classicism, which is to say free of the absolutes which were previously associated with ideas of order. Thus, the status of order as human proposals, rather than as the echo of fundamental principles, is part of the legacy of the 1903–1915 generation. Their emphasis on the artist as a human being at work, however much it led, in one direction, to autobiographical gestures, lessened the prestige of art as a mirror of the absolute. Malevich, Kandinsky, and Mondrian, in different ways, universalized their art by theory, but in New York there is little reliance on Platonic or Pythagorean mysteries. A system is as human as a splash of paint, more so when the splash gets routinized.

Definitions of art as an object, in relation to geometric art, have too often consolidated it within the web of formal relations. The internal structure, purified of all reference, became the essence of art. The object quality of art is stressed in shaped-canvas paintings, but without a corresponding appeal to idealism. When the traditional rectangle is bitten into or thrust outward, the spectator obviously has an increased consciousness of the ambience. The wall may

[28] The Los Angeles County Museum of Art, *op. cit.*

appear at the center of the painting or intersect the painted surface. Despite the environmental space of the shaped canvas, however, it has also a great internal solidity, usually emphasized by thick stretchers (Stella, Williams). The bulk of the painting is physical and awkward, not a pure essence of art. On the contrary, the contoured edges are highly ambiguous: the balance of internal and outside space is kept in suspense so that there are connections with painting (color), sculpture (real volume and shaping,) and craft (the basic carpentry). Shaped canvases tend to mix these possibilities. Another nonformal approach is indicated by Robert Smithson's reaction to Stella's "impure-purist surface," especially the purple, green, and silver series: "like Mallarmé's *Héodiade,* these surfaces disclose a 'cold scintillation'; they seem to 'love the horror of being virgin.'"[29] Mallarmé is being quoted, not to take possession of the work in literary terms, but to indicate experiences beyond the eyeball. It is a reminder that shaped blocks of one color have the power of touching emotion and memory at the same time that they are being seen.

Stella's recent paintings (started in the fall of 1965 from drawings made in 1962) are asymmetrical and multicolored, compared to the symmetrical and/or one-color paintings done since 1958. The change is not a move to a world full of possibilities from one that was constricted. Simplicity is as sustaining in art as elaboration. It is more probable that the new work is prompted aggressively, as a renewal of the problematic, for the style change came at a time when an aesthetic for minimal, cool, or ABC art (to which his earlier work is central) was out in the open. The new paintings are a kind of two-level image, with the contoured stretcher providing one kind of definition and the painted forms, cued by the stretcher but not bound to it, making another. Color is bounded by painted bands or by the edge of the canvas, which has the effect of scrambling the spatial levels of the painting. This act of superposition disregards the idea of deductive structure which Michael Fried proposed as the present historical necessity of "modernist" painting in which the painted image is obedient to the shape of the perimeter.

[29] Robert Smithson. "Entropy and the New Monuments," *Artforum,* Los Angeles, Vol. IV, No. 10, June 1966, pp. 26–31.

Kenneth Noland: *Let Up*. 1966. Acrylic on canvas. 2' x 8'. Photograph courtesy of Andre Emmerich Gallery, New York.

David Novros: Untitled. 1967. Acrylic lacquer on dacron. 112" x 144". Photograph courtesy of Bykert Gallery, New York.

Each of Stella's new shaped canvases exists in four permutations, with alternate colors though with fixed boundaries.

Kenneth Noland painted a series of square canvases in 1964, a shape that is more in use now than at any other time in the twentieth century. Presumably its nondirectional character, with neither east–west nor north–south axes, accounts for its currency. However, Noland, who laid in bars of color parallel to the sides of his squares, was oppressed by the sense of the edge. For this reason he turned the squares 45°, making them diamonds; this led to the long diamond format, reminiscent of the field of vision. The points of the diamond are the farthest points from the center, a format which frees Noland from his sense of confinement by the edge. The edge is reduced to a functional oblique, linking the most distant parts of the painting. Thus, the diamond format is not so much a shaped canvas, with consequent connections to the pictorial and to the objectlike, but the discovery of a format highly suited to the "disembodied" color effects of staining.

The essentializing moves made by Newman to reduce the formal complexity of the elements in painting to large areas of a single color have an extraordinary importance. The paintings are a saddle-point between art predicated on expression and art as an object. Newman's recently completed *Stations of the Cross* represent both levels: the theme is the Passion of Christ, but each Station is apparently noniconographical, a strict minimal statement. Levels of reference and display, present in all art, are presented not in easy partnership but almost antagonistically. When we view art as an object we view it in opposition to the process of signification. Meaning follows from the presence of the work of art, not from its capacity to signify absent events or values (a landscape, the Passion, or whatever). This does not mean we are faced with an art of nothingness or boredom as has been said with boring frequency. On the contrary, it suggests that the experience of meaning has to be sought in other ways.

First is the fact that paintings such as those in this exhibition are not, as has been often claimed, impersonal. The personal is not expunged by using a neat technique; anonymity is not a consequence of highly finishing a painting. The artist's conceptual order is just as personal as autographic tracks. Marcel Duchamp reduced the

creative act to choice and we may consider this its irreducible personal requirement. Choice sets the limits of the system, regardless of how much or how little manual evidence is carried by the painting. Second is the fact that formal complexity is not an index of richness of content. "I am using the same basic composition over and over again," Howard Mehring has said; "I never seem to exhaust its possibilities."[30] A third related point is that most of the artists in this exhibition work in runs, groups, or periods. The work that constitutes such runs or periods is often less outwardly diverse than, say, the work of other artists' periods.

A possible term for the repeated use of a configuration is One-Image art (noting that legible repetition requires a fairly simple form). Examples are Noland's chevrons, Downing's grids, Feeley's quatrefoils, and Reinhardt's crosses. The artist who uses a given form begins each painting further along, deeper into the process, than an expressionist, who is, in theory at least, lost in each beginning; all the One-Image artist has to have done is to have painted his earlier work. One-Image art abolishes the lingering notion of History Painting, that invention is the test of the artist. Here form becomes meaningful, not because of ingenuity or surprise, but because of repetition and extension. The recurrent image is subject to continuous transformation, destruction, and reconstruction; it requires to be read in time as well as in space. In style analysis we look for unity within variety; in One-Image art we look for variety within conspicuous unity. The run of the image constitutes a system, with limits set up by the artist himself, which we learn empirically by seeing enough of the work. Thus the system is the means by which we approach the work of art. When a work of art is defined as an object we clearly stress its materiality and factualness, but its repetition, on this basis, returns meaning to the syntax. Possibly, therefore, the evasiveness about meaning in Noland, already mentioned, may have to do with the expectation that a meaning is complete in each single painting rather than located over a run or a set.

The application of the term systemic to One-Image painting is obvious, but, in fact, it is applied more widely here. It refers to paintings which consist of a single field of color, or to groups of such

[30] Leslie Judd Ahlander. "An Artist Speaks: Howard Mehring," *Washington Post*, Washington, D.C., September 2, 1962, p. 67.

Larry Zox: *Tyeen*. 1966. Acrylic on canvas. 6' x 7'. Photograph courtesy of Kornblee Gallery, New York.

paintings. Paintings based on modules are included, with the grid either contained in a rectangle or expanding to take in parts of the surrounding space (Gourfain and Insley respectively). It refers to painters who work in a much freer manner, but who end up with either a wholistic area or a reduced number of colors (Held and Youngerman respectively). The field and the module (with its serial potential as an extendable grid) have in common a level of organization that precludes breaking the system. This organization does not function as the invisible servicing of the work of art, but is the visible skin. It is not, that is to say, an underlying composition, but a factual display. In all these works, the end-state of the painting is known prior to completion (unlike the theory of Abstract Expressionism). This does not exclude empirical modifications of a work in progress, but it does focus them within a system. A system is an organized whole, the parts of which demonstrate some regularities. A system is not antithetical to the values suggested by such art world word-clusters as humanist, organic, and process. On the contrary, while the artist is engaged with it, a system is a process; trial and error, instead of being incorporated into the painting, occur off the canvas. The predictive power of the artist, minimized by the prestige of gestural painting, is strongly operative, from ideas and early sketches, to the ordering of exactly scaled and shaped stretchers and help by assistants.

The spread of Pop Art in the sixties coincided with the development of systemic abstract painting, and there are parallels. Frank Stella's paintings, with their bilateral symmetry, have as much in common with Johns's targets as with Reinhardt and, if this is so, his early work can be compared to Yves Klein's monochromes, which were intentionally problematic. The question "What is art?" is raised more than the question "Is this a good example of art?" This skeptical undercurrent of Stella's art, in which logic and doubt cohabit, is analogous to those aspects of Pop Art which are concerned with problems of signification. Lichtenstein's pointillism and Warhol's repetitive imagery, is more like systemic art in its lack of formal diversity than it is like other styles of twentieth-century art. A lack of interest in gestural handling marks both this area of Pop Art and systemic abstract art. In addition, there are artists who have made a move to introduce pop references into the bare halls of abstract art

theory. One way to do this is by using color in such a way that it retains a residue of environmental echoes; commercial and industrial paint and finishes can be used in this way. For example, Al Brunelle has written of this painting in the present exhibition: *"Jayne* has a blue edge on the left, superimposed upon the underlying scheme. On this side she does not silhouette as brightly as on the right, nor do the edges on left 'track' as they do so nicely within the painting The blue line does not remedy any of this. It has a function similar to eyeliner."[31] The reference to eyeliner, combined with the "cobra skin" finish, the crystals, and the pink plastic surfaces, raises an association of Pop culture that is hard to shake.

Irving Sandler's term for systemic painting, both abstract and Pop, is "Cool-Art,"[32] as characterized by calculation, impersonality, and boredom. "An art as negative as Stella's cannot but convey utter futility and boredom"; he considers conceptual art as merely "mechanistic." What Sandler has done is to take the Abstract-Classicist label and then attack it like a Romantic, or at least a supporter of Abstract-Expressionist art, should. He is against "one-shot art" because of his requirement of good artists: "They have to grope." This quotation is from a catalogue of *Concrete Expressionism,* his term for a group of painters including Al Held. He argues that theirs is struggle painting, like expressionism, but that their forms are "disassociated," his term for nonrelational. Thus Sandler locates an energy and power in their work said to be missing from hollow and easy "Cool-Art." The difference between so-called Concrete-Expressionist and Abstract-Expressionist paintings, however, is significant; they are flatter and smoother. Al Held's pictures are thick and encrusted with reworkings, but he ends up with a relatively clear and hard surface. The shift of sensibility, which this exhibition records, is evident in his work. Held may regard his paintings as big forms, but when the background is only a notch at the picture's margin, he is virtually dealing with fields.

The pressing problem of art criticism now is to reestablish abstract art's connections with other experience without, of course,

[31] Al Brunelle. "The Envy Thing," in *A Pamphlet of Essays Occasioned by an Exhibition of Paintings at the Guggenheim Museum, Fall 1966, New York.*

[32] Leob Student Center, New York University, New York, April 6–29, 1965, *Concrete Expressionism.* Text by Irving Sandler.

abandoning the now general sense of art's autonomy. One way is by the repetition of images, which without preassigned meanings become the record and monument of the artist. Another way is by the retention of known iconography, in however abbreviated or elliptical form. Priscilla Colt, referring to Ad Reinhardt's basic cross noted: "In earlier paintings it assumed the elongated proportions of the crucifix; in the black squares the pointedness of the reference is diminished, since the arms are equal, but it remains." Miss Colt also notes the expressive connotations of Reinhardt's "pushing of the visible toward the brink of the invisible."[33] Noland's circles, whatever he may have intended, never effaced our knowledge, built-in and natural by now, of circular systems of various types. Circles have an iconography; images become motives with histories. The presence of covert or spontaneous iconographic images is basic to abstract art, rather than the purity and pictorial autonomy so often ascribed to it. The approach of formalist critics splits the work of art into separate elements, isolating the syntax from all its echoes and consequences. The exercise of formal analysis, at the expense of other properties of art, might be called formalistic positivism.[34] Formal analysis needs the iconographical and experiential aspects, too, which can no longer be dismissed as "literary" except on the basis of an archaic aestheticism.

[33] Priscilla Colt. "Notes on Ad Reinhardt," *Art International*, Lugano, Vol. VIII, No. 8, October 20, 1964, pp. 32–34.

[34] Adapted from Leo Spitzer's "imagistic positivism" by which he deplored literary critics' overemphasis on imagery at the expense of a poem as a whole.

SCULPTURE AS ARCHITECTURE: NEW YORK LETTER, 1966–67* by Michael Benedikt

In the following notes Michael Benedikt discusses Minimalist sculpture with particular references to what he sets forth as its architectural aspects. He contrasts the new British sculpture with developments in America and considers the recent backgrounds of the new style.

In addition to having written critical articles for *Art News* and *Art International* during the past five years, Benedikt has edited four anthologies of modern plays, the most recent being *Theatre Experiment*, a volume emphasizing the relationship of the Happening and traditional theatre; he is currently compiling an anthology of Surrealist writings. His poems appear in *The Young American Poets*, and are collected in his own volume, *The Eye*.

Some Recent British and American Sculpture

At the Emmerich Gallery Anthony Caro showed his new painted steel sculpture, all of it dating from 1966, with the exception of one piece, *Lal*, from 1965. The major change from his previous work is modest, involving the use of a newish material in three of the pieces: wire mesh of various kinds. Its use doesn't really change the idea Caro is involved with. On the other hand, thanks to certain recent public discussions regarding the relationship of American color-painting and Caro's sculpture, this artist's direction has been increasingly obscured. He is said to have suppressed composition, concentrating his imagery in a way suggestive of the colorists; yet what happens in his work would actually appear to be the opposite of this. The most instantly striking aspect of the work is that it is, indeed, composed; in fact, composition is required as it has seldom been. Two characteristics help create the necessity. Caro's sculpture tends to be dispersive in format; it builds horizontally rather than vertically, so that instead of mounding, as is the hallowed sculptural

*Selected reviews, slightly revised, from "New York Letter," published in *Art International*, Vol. 10, Nos. 7, 10, and Vol. 11, Nos. 1, 2, 4.

tradition, it scatters centerlessly. Though the work is without center, it doesn't necessarily lack composition; composition may even be called upon to become more intricate. Caro's sculpture is about as "compositionless" as Bonnard. Aside from the fact that they are spread out, the individual units of the work are exceedingly diverse, involving a great miscellany of abruptly and oddly shaped beams, pipes, slabs, couplings, and the like—and now, of course, netting. A piece like *Horizon*, for example, is a row of items that may be inventoried, roughly, as: a pole, two arcs, a pole with a little blade, a thin slab, a pole, an arc, a pole, and a slab hooked at the very end. The elements differ in size, even when they are alike in shape. This piece may be irregular, yet it is not without composition: there is a rhythmic progression of forms down the line along which its parts are deployed, and at the same time a cross-rhythm resulting from the *correspondences* set up among similar or identical forms.

The function of color is clear. Caro's use of a single color in each piece works to tie the diversity together, helping to relate even dissimilar shapes. Color also has a second, equally important role. The components of the brown *Horizon* are connected more by their juxtaposition with one another, and by compositional coherence, than by any welding or other affixing process—indeed, when in late 1959 Caro's interest shifted from the traditional "worked-over" sculpture to flat work, such signs of struggle were the first to be concealed. Though affixing is still employed, it is color that ostensibly welds. The most uncanny example of this is *Red Splash*, in which four poles of different heights are joined by a great mesh X. The mesh doesn't grip or even run head-on into any of the poles; it is just tangent to them. And the affixing process is concealed. What color takes the place of in Caro's work, is not traditional composition, but obviousness of engineering.

Perhaps one really ought to talk about the excellence of this show, since it *is* so excellent. One also ought perhaps to mention what seems to be Caro's actual concern—the theories of Americans aside. I think it is an ideal of lightness, weightlessness, and seemingly offhand openness (as I have remarked in these pages before). To this, the new use of netting and grillwork contributes, of course. The use of mesh-shapes where slab-shapes might once have been employed

is very effective. *Span*, the most netted, as well as the largest and most elaborately composed work in this thoroughly successful show, seems to me one of Caro's best.

Caro's widespread influence in Great Britain can be traced to his teaching of some classes there (at St. Martin's School of Art), where several young sculptors of considerable talent attended his classes, so that his good ideas fell on good ears. The remarkable company of his ex-students includes David Annesley, Michael Bolus, Phillip King, Tim Scott, William Tucker, and Isaac Witkin. Three of the last four were seen in one-man shows here earlier this year; this month Annesley and Bolus also were seen in one-man shows. Annesley, showing at the Poindexter Gallery, seems closest to Caro's ideas: lightness, structural power even in structures that are anchor-less—centerless—are ideas at, or near the center of, Annesley's work. Annesley's painted metals are thinner than Caro's, being in sheet format—lately he has turned from sheet steel to sheet alumi-num. In one work in this four-piece show, a big metal circle is cut by a metal plank, which supports a smaller, inner circle. The plank seems to be caught in a system of tensions set off between large and small circles. The simplest work in the show is another large circle, with a smallish blade appendage. Tension, the possible motion or straining toward motion, is only hinted at by the vestigial tail, but the hint is sufficient. In the first of the works shown here (from 1965) two leaning forms are intersected by a rectangle that remains at right angles to the floor, for all the obvious tiltedness of the forms surrounding it. The work is a little like Annesley's much-reproduced *Swing Low* (1964), in which two boxes sit on a wriggle of metal as frail-looking as a ribbon and painted just as gaily (not much color in *this* show), but which is clenched in apparent comfort. A similar display of ribbon appears in the latest piece: a monochromatic metal ribbon, lying on its side. It is a powerful wriggle, but at its center, where the rhythm is most marked, there is an abrupt, neat cleft. This version of sculptural lightness, of deceptive strength, might be described as a visual and material equivalent to the cele-brated goal of Hemingway: "Grace Under Pressure." Sculpturally, the moral is fresh.

Richard Artschwager: Untitled. 1966. Formica on wood. 48" x 72" x 12". Photograph courtesy of Leo Castelli Gallery, New York.

Robert Bart: Untitled. 1965. Cast aluminum. 96" x 66" x 85". In the collection of Mrs. Vera List. Photograph courtesy of Leo Castelli Gallery, New York.

John F. Bennett: *Liaison*. 1966. Polychromed wood and vinyl hoses. Photograph courtesy of Fischbach Gallery, New York.

There were also four pieces in the Michael Bolus show at Kornblee; here, too, the components are primarily thin. But Bolus appears to be basically more eclectic than Annesley—in this show, he certainly is. Currently, Bolus is concerned with the sculptural use of modules, an interest that places a specific emphasis on ingenuity and formal wit. This show is structured around two basic units. One is a flat shape, like a *U* with its wings curled outward. The other is a solid pyramid, with a rocker-base. Two of the pieces are composed of the solid pyramids. One consists of ten solid pyramids barely joined at the base-tips; the other is a set of six, modified so that they are fused rather than juxtaposed; they sit stiffly on their bases. The other two use *U*'s. In one, the *U*'s are welded into four groups of three, forming the corners of a big, openwork pyramid. The final piece, and the one I liked the best, was made up of one of the small solid pyramids, three *U* modules, and a form like a squashed square—a little like an Annesley box to which the worst (collapse) has occurred. The light, easy-going elegance of Bolus's work is continued in his use of color: while Caro keeps each piece monochromatic, and Annesley colors so as to set off forms within other forms, or to stress possible systems of tensions, Bolus colors more or less decoratively. Each of his components is apt to be painted a different jolly, primary hue. In the big *U*–pyramid, for example, each of the corner modules is painted contrastingly; in the group of ten, six of the shapes are white, but four are inexplicably yellow, colored according to no particular pattern, though the overall structural plan (triangular) is quite consistent. All this suggests that though Bolus's work has a strict structural logic, and a highly experimental basis, he is not at all averse to the idea of charm. Playfulness is a quality close to the heart of all the new thin British weightless sculpture; Bolus's show brought this playfulness out.

The difference between the work of the current new British sculptors and that of the more successful of the American Primary Structurists (the values in this style are so honed, that when work in this manner misses, there is almost nothing present, even for the purpose of comparisons) is that whereas the former tends to be thinnish, glossy, bright, and emphatic in its concern for design, the American

work tends to be fat, matte, monochromatic, and somewhat more concealed in its implications. This distinction applies widely, but it was prompted by Michael Steiner's show, seen at the Dwan Gallery. There were five pieces in his exhibition, all large, bulky, and finished in the same gray. There were 1) a row of twenty identical upright beams, 2) three squarish floor boxes with three elongated little boxes extending out of the three on the same side, 3) a piece composed of two fused *U*'s with their wings at right angles, and with their ends rising to the ceiling, 4) a pair of *E*-shaped pipes lying on the tips of their crossbars; and, my favorite, 5) a row of twenty shapes resembling the numeral *four*, hung on the wall at eye-height. The strangeness of this, and other American Minimalist shows (including those of Morris and Judd) stems from the fact that the effect of the whole show tends to be more than the sum of the parts: seen *en groupe* there is an air of the mysterious, even of the environmental. The shapes in Steiner's pieces are abrupt and machine-like (I have already remarked here on the relationship of this work to the metaphor of the factory), but the proportions are so plump, so softly echoing as to deserve characterization as soporific. One was in an environment that soothed; one felt, finally, that there was the presence of a fresh ideal of elegance. As I have also suggested here before, I think that this aspect of the work of Steiner, Morris, and Judd bears implications of the transitional. One reason why this show worked so well was that it was installed beautifully with respect to the irregularities of the gallery-shape. As not only Steiner's but many other recent shows suggest, American Minimalist work is distinguished only from the best current British sculpture by its dramatically environmental quality; it may eventually distinguish itself even from itself by becoming architectural.

At the Cordier-Ekstrom Gallery Walter De Maria was seen in an exhibition of his *relatively* Minimal sculpture. From the point of view of British sculpture, certainly, De Maria's work is in the same mysterious, rather designlike area as that of Steiner, with environmental and other overtones. De Maria's environment is more theatrical, however. The show's centerpiece was a black ziggurat, with many dozens of tiny steps: at the very top, head-high, was a shiny vinyl chair, with chrome frame. It was like a throne. A theatrical

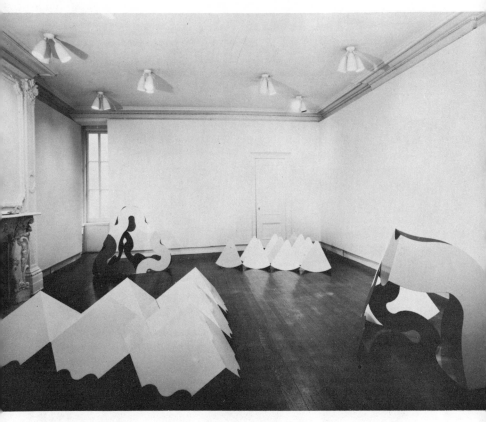

Michael Bolus: Installation, October 1966. Painted aluminum. Photograph courtesy of Kornblee Gallery, New York.

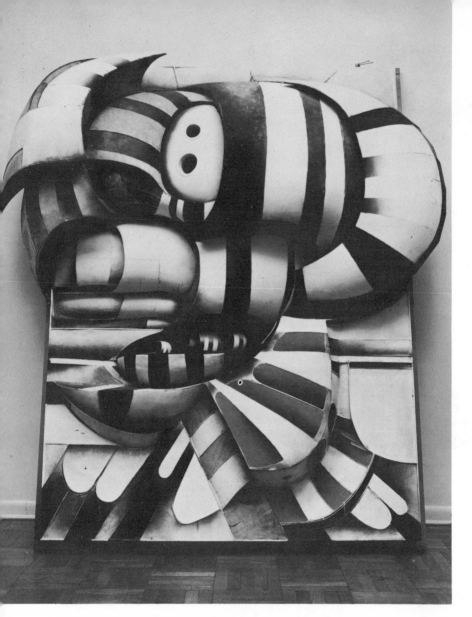

Lee Bontecou: Untitled. 1966. Mixed media. 99½″ x 90″ x 26″. In the collection of The Art Commission for the South Mall Project. Photograph courtesy of Leo Castelli Gallery, New York.

tension entered through the fact that the feet of the chair were at the corner-tips of the base upon which it stood. There was drama in the imminent falling-off. This kind of black wit was also present in a series of drawings. Large, beautifully framed, each contained only a single, shakily lettered word: "sky" or "mountain" or "river," etc. The theatrical overtones here were not tragic (with implications of descending kings) but comedic. De Maria has actually been involved in theatre—not the traditional theatre of tragedy or comedy, but that of Happenings—intimately participating in those of Oldenburg and Robert Whitman, among others.* The balance of the show consisted of a series of rather Duchampian follies involving small chromed objects—mostly in the shape of hollowed-out, cheeseboxlike shapes. One of these was in the shape of a Christian cross, and had a ball in it, evoking both piety and the pinball-machine. The largest of all consisted of two long rows of chromed brick shapes. From the top of each, three chromed poles protruded, some round, some hexagonal, some high, some low, in unpredictable patterns. One walked into De Maria's show through them, as if down a long avenue of sphinxes reinterpreted.

The latest work of Lee Bontecou at the Castelli Gallery reminded one of just how much a certain weirdness and romanticism has been distilled from and been discarded from the shaped-canvas idea by its recent practitioners. From the point of view of an artist like Bontecou, much of contemporary sculptural accomplishment must seem to be in the extracting of elements of complexity, both emotional and structural, one by one. It is curious that the foreshadowing of so much new cool work should lie somewhere back in the throes of an intensely personal lyricism. In Bontecou, there is no sense of research, but rather of a dramatically expressive channeling

* De Maria's direct association with Happenings notwithstanding, it seems apparent that insofar as any Minimalist art is architectural, it shares with the Happening a theatrical quality: the activation of an environmental space. Not only later work by De Maria himself, but subsequent shows such as those by Robert Whitman, Robert Breer, and David Jacobs on the one hand and such newly performed "slow" Happenings as Allan Kaprow's *Push and Pull* and *Moving* on the other, suggest a convergence of the Happening and the Architecturalist esthetic. [M. B.]

of emotion. The craters, pits, holes, and stitched leather, cloth, or metal fragments made their appearance with the force of nightmare fantasy. Technically, one could see in them connections with the waves of junk sculpture that were beginning to flow in the fifties—even now there are hints of references to monstrous American autobody designs—but the relationship, for the most part, remained and remains oblique and submerged; it is mostly the emotions one felt, and still feels. As for her surfaces, Bontecou has not altered their original essentials much, and it is probably our own familiarity with it that is to blame if the work has stopped looking powerful and horrible and started looking powerful and venerable. The show at Castelli included four large pieces, the best of which seemed to me to be the three "framed" and paintinglike structures. One of the artist's darker visions was a formally impeccable construction in which a tight surface of regular strips was penetrated by several hard-rimmed, anthropomorphic orifices. There was even a suggestion of zipperlike teeth. Another piece was in a lighter, whiter style, with craters that were gradually built up with long cones of stitched-up substances. On one of the two occasions I saw the show this piece had a light inside it, which seemed completely unnecessary; it was either burnt out or thrown out before my second visit. The largest work (99½" x 90" x 26") I found a remarkably powerful piece, and I think it is one of Bontecou's all-time best. Flat at the bottom, it builds up gradually to an enormous multilayered bulge at the top. The architecture that supports its mass rises in an irregular—but fairly trustworthy—way until it reaches a point just below the mass; then it converges in a little hollow, which, instead of providing the expected support, loses itself in complicated systems of exfoliations and other perversely self-preoccupied detailing. As if to help, systems of reddish stripes of fairly regular shape rise to meet the big bulges from below; but these wide stripes only break into huge, swoopingly generous paths upon the bulges—all of which serves to amplify the feeling of the precarious weightiness up there. For relief from her depending swords of Damocles, one turned to a series of Bontecou's drawings, 1964–66, which were executed in a soft-pencil technique, occupying an ambiguous realm somewhere between dashboard and landscape.

Isaac Witkin, who shows at the Elkon Gallery, is an English sculptor whose main aim seems to be the creation of forms unlike any previously seen 1) in sculpture, 2) on earth. The twinness of this concern is important since it sets Witkin aside from the current crop of American "cool" sculptors, whose works draw strength specifically from the idea of their earthly ordinariness. Witkin works in the British cool sculptural style, which is not all *that* cool, and which tends to forgo the heady pleasures of perfect bareness and the visual conundrum for those of elaboration and variety. Evolved from British Constructivism and probably post-1960 Anthony Caro, its productions fuse logic, and a concern with new, unluscious materials, with improvisatory structure and a certain degree of plain decorativeness. The present show consists mainly of work in molded and painted fiber glass, but the material is not by any means explored entirely for its own sake. A fairly early and also entirely typical piece, entitled *Alter Ego* (1963), is in painted wood. It consists of a dock-piling-like post in dark blue, against which a thin, propellor-like shape is propped up. Like another of the five pieces on view, an untitled work of 1966 in fiber glass, the piece generates its energy from the comparison of two differing components. Though there is a freshness in the mere fact of the bi-polarity present in these works, what sustains interest is the way the two pieces relate, rather than in any *Ding an sich* peculiarity. The late 1966 two-part work is an upright yellow slab, perhaps suggesting ordinary wood except for its curved base, and accompanied by a parallel descending slab in blue, which is twisted like a maypole ribbon. Touring these pieces, there is much abstract sculptural interest. In two other pieces Witkin explores figure and ground relationships fused in single pieces—there is probably as much connection here with an abstract painter like Jack Youngerman as there is with Caro. *Fall* is in red with a green cleft, and lies down, like a sinister mound. Its companion is in yellow, with a purple, inset section, and stands on its end, so that the ground is doubled as both incision and elevation, depending on which side of the work one stands on. The inset sections are more or less regularly wavy in outlines, as are the perimeters of the larger expanses in which they are set; as one views these two, fresh vistas and unpredictable combinations of ripplings keep

animating the work in a kind of irregular counterpoint. The surprising and distinctive thing about Witkin's sculpture is that there is so much happening in it that is new and blatant, yet that is at the same time subtly engaging. Unlike another fine sculptor who studied with Caro, Phillip King (on view practically across the street from Elkon at Feigen), Witkin generally goes his way without much reference to outright Surrealism. It would be interesting to see him continuing to steer his work according to his own unique brand of decorative, modest, and unmodish outlandishness.

The Dwan Ten

At the Dwan Gallery, a show entitled "Ten Sculptors" presented Robert Morris, Sol LeWitt, Dan Flavin, Donald Judd, Ad Reinhardt, Jo Baer, Michael Steiner, Carl Andre, Agnes Martin, and Robert Smithson. The point was evidently Minimalness. However, as both the "Primary Structures" exhibition at the Jewish Museum and the recent "Systemic Painting" exhibition at the Guggenheim indicate, things are moving a bit too quickly and even too distinctly for much light to be shed on the new sculpture if viewed *entirely* on the basis of Minimalness, as useful a perspective as this is. I was mainly interested in the Morris and Judd, perhaps because, though bare, these pieces are sufficiently bulky not to be overwhelmed by the rug fuzz (truly: when showing only things reductive and mainly black and white, it seems to me that no gray-brown textured rug should have been left around, as at the Dwan). They related across the room, like congenial monoliths. The Morris was a big, dozen-foot-across, eye-high white block, pared slightly toward the top and at the corners. It threw a particular weight of interest (as I have perhaps suggested with my rug remark) on the gallery boundaries, especially the walls, which it closely resembled. Although grayish, the row of six waist-high galvanized-iron boxes by Judd also seemed to sculpt space outward, throwing as much interest on the space around it as it attracted to itself. In both cases one felt as if one were strolling around inside an important aspect of the work. Along with such disarming shows earlier this year as that by Mangold at Fischbach (pastel, matte-surfaced wall-slabs) and McCracken at Elkon (brightly colored, glossy metal steles), these two pieces from two different minds made a forthright gesture in the direction of a not

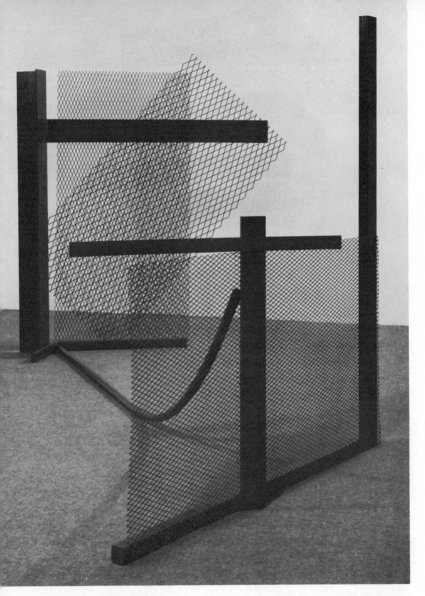

Anthony Caro: *Carriage*. 1966. Steel painted blue. 6'5" x 6'8" x 13'. Photograph courtesy of Andre Emmerich Gallery, New York.

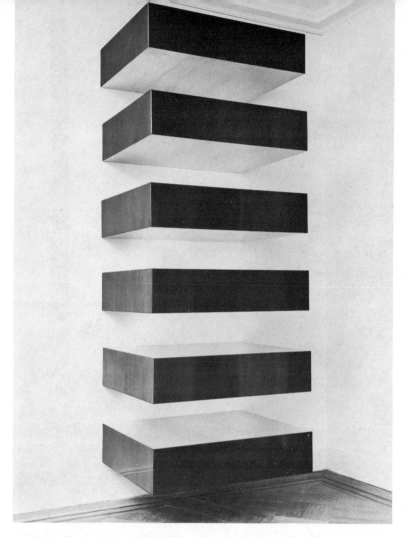

Donald Judd: Untitled. 1966. Galvanized iron. Each section: 9″ x 40″ x 31″. Photograph courtesy of Leo Castelli Gallery, New York.

Sven Lukin: *Watusi*. 1965. Wood, canvas, acrylic. Photograph courtesy of Pace Gallery, New York.

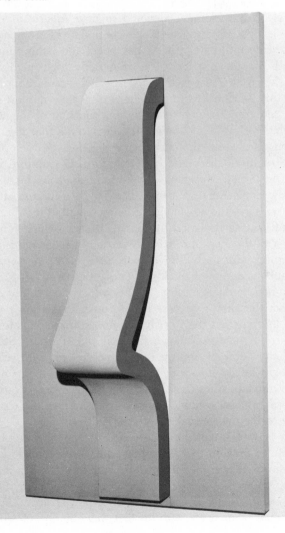

merely Minimal, but a more completely architectural variety of sculpture. Not even the "Primary Structure" sculpture show at the Jewish Museum, for all the miscellaneous rebuses of smallish plain forms it cavernously contained, had a corner this fresh and effective.

The Whitney Annual: 1966

This year's Whitney Annual, devoted to new American sculpture and prints, is a peculiarly successful event and one encompassing, at least in its sculptural part, quite a few novel and I think important issues. With all due respect to the frequently high quality of the sculpture shown, it is necessary to start out by remarking that the success of this year's show, to a greater extent than in most shows I can recall, sculptural or not, tends to be a function of the structure in which the work is being shown. It seems to me that it is ironical indeed that the work, though often reflecting characteristics of "Primary Structure," the genre of simple-formed sculpture recently shown at the Jewish Museum, is more impressive by far than was similar work shown in that locale. The Jewish Museum show did not, of course, have the advantage of being mounted in a brand new architectural setting designed by Marcel Breuer, which functioned quite well with the work, probably because of Breuer's fine and efficient structure, with its bulky, clunkily *brut* surfaces (very unlike the neo-Bauhaus design of the Museum of Modern Art, for example, or the neo-neo-Bauhaus design of the reconditioned Jewish Museum). Also, the show's success had to do with certain details of mounting. But whereas the Jewish Museum surroundings tended to be set off from the work shown there at the "Primary Structure" exhibition, the Whitney setting tends to interlock with, continue, and even help justify the work shown. Doubtless, architecturalness is about as good a rationale as any for the new work—certainly as good as "primariness," a value that tends to sacrifice the visual side too readily to the conceptual.

Nowhere is the sense of the architectural in the new sculpture felt more forcefully than on the floor upon which one is apt to begin to view the show (it occupies floors four and three, and a sculpture court sunk below the entranceway): I mean floor four. Grouped here is an exceptionally strong and well-displayed array, including work by a man who, at 55, with his first show finally scheduled (at

Fischbach) is beginning to look like a patriarchal figure with respect to all this new work. This is Tony Smith, whose *Amaryllis* is a vast regular rectangle from which is upraised an asymmetrical wing. All is in steel, and in black. *Amaryllis* sets the tone for this most remarkable of all floors, which contains work that is not only architectural but that seems to be straining beyond that toward the monumental (indeed, Smith's work has most often been displayed outdoors). Opposite it, equally prominent as one entered, is Lyman Kipp's equally vast (and specifically dolmenesque) *Titicus*, which seems like many of Kipp's works to be a paraphrase of the forms of Stonehenge, albeit from a highly contemporary perspective. Colored yellow, red, and blue, this work also paraphrases a big tinkertoy or building-block construction. Scale is also the issue in a 144-inch long red plank by John McCracken. Set casually against the wall, its enormousness gives its casualness an air of the sinister and overbearing, a feeling strengthened by the brilliant glossiness with which McCracken customarily invests his pieces. A similarly sinister casualness obtains in Ronald Bladen's untitled piece in painted wood, a 20-foot wide, 10-foot high, 10-foot deep object in white wood. The point here was the slight angle of the work to the ground, driving a little wedge of space in between the floor and the rectangular bulk. This tampering with the angularity of the floor (by Bladen) is complemented by McCracken's tampering with the wall; and confirmed by Bladen's apparent inspiration, Robert Morris, whose contribution tampers with the floor in a side chamber on floor three. It consists of four white squares, set together, but so that bevelings appear at their junctures. Finally, an assault on the ceiling occurs in George Rickey's *Four Planes, Hanging*. This might have been a version of the Morris, except that the four planes are chromed and suspended so that passing breezes (from fans mounted overhead) shift the dislocations among the quarters.

Other architectural dislocations of floor four are more explicit in their assaults. One of Michael Todd's strongest works to date, *Swain's Song*, consists of a series of beams in red, balls in yellow, and near-triangles in black. Beginning on the floor, they are strung out toward the wall; bridging the right angle of floor and wall, they leap over to the wall from a point near it, and crawl up it. This crazy, insidiously architecture-involving crankshaft is complemented

by Paul Frazier's *Space Manifold #5*. It looks like a stack of blocks, set slightly off one another, so that the four of them form a precarious and yet elegant structure. The setbacks formed by the dislocations of the blocks might well be emblems of the many shifts of structure effected by most of the works on this amazing sculptural stage. On this part of floor four a weak work by Alfonso Ossorio, a very weak work by the ordinarily interesting Mark di Suvero, and a fine, mysterious sculptural wall by Louise Nevelson more or less behave themselves and do not tamper with the architecture by becoming, themselves, neo-architecture. Ellsworth Kelly's *Blue White Angle*, a thin steel right angle, confirms the shape of the interior, if anything—mounting it a bit closer to the walls would have made this confirmation clearer, and thus somewhat more structurally relevant. On the other hand, Donald Judd's untitled work consisting of ten blue picture-frame-like structures arranged upright and congruent is nowhere near the walls, and is strong enough to dislocate one's sense of the interior space. The top of the tunnel they form is at chest height, leaving one with the dilemma of whether the sculpture should have been higher, or whether one should, oneself, have been designed for easier lookings-in; or, indeed, entering. Finally, as a pendant to the determinedly geometric, tilted work on this floor, there is Giora Novak's *Links*, nine approximately two-foot-wide black plastic rings, which actually dangle down from the ceiling. Robert Smithson's *Alogon* is set just below the ceiling and against the wall, and suggests one more possible shift in the room's geometry—shelves. Down below in the sculpture court is Tony Berlant's *Temple*, a man-high buildinglike structure in much-dented (to represent the effort of construction and fabrication, no doubt) aluminum. At the center of this structure is a square shaft upon which is nailed and knurled the scarcely discernible outline of a man.

Although most of what has been seen in the neo-architectural sculptural area hereabouts has been without color, and smooth-surfaced, and generally geometric in emphasis, there is another style that has been quietly available for some time. This unnamed manner is a matter of more amorphous forms, color (especially tints of the pastel variety), and greater compositional self-containment. It also

tends to be somewhat smaller than work in the neo-architectural area. (This is an interesting tendency observable throughout the new sculpture: reversing the usual rules of good design, the smaller the work gets the more complex the forms become.) The larger of the works in this particular category, especially, seem to belong to a tendency much like that represented by British post-Caro sculpture. Among the contributions here I would list Christopher Wilmarth's *Wet*, which resembles two inverted *U*'s placed side by side, with one leg reaching out as if to take a step. As with much recent British sculpture, the breaking of the forms where they are elaborated is made more emphatic and distinct through the addition of color. The two outer sides of the *U*'s are orange; the bulk of the work is green; a purplish hue is introduced where the two *U*'s touch. Moreover, a plate extends the lower part of one of *U*'s, breaking into a rainbow of red, purple, and blue.* Tom Doyle's *La Vergne*, which is a 7-shaped mast around which a saillike shape is wrapped, conveys a feeling of weightlessness that is as rare in the context of American sculpture as it is frequent among recent British work. Fractures, ledges, color, asymmetry, if not lightness, are qualities also to be found in Sven Lukin's untitled blue piece, in which a radically rippling center section is sandwiched between two more regular dorsal divisions. Pink and orange articulate the "breaks" here.

There is very little figurative work in the exhibition, among the younger artists especially. Even Anthony Padovano's *Maja* seems to relate in its formalized wavyness, its colored highlights and details, more to an effort like Lukin's than to that of any other devotee of the figure. The dangers of forcing the figure out of one's feeling for material is illustrated, I think, by a disappointing Ernest Trova. *Large Landscape* is a sort of stage squared and studded as if to suggest a machine setting; atop it stand three stylized figures facing each other, with Trova's usual machine parts sticking out of them. Its air of sour allegorical humanism seemed to me mostly to abuse

* Visually and in spirit, Wilmarth is a member of an important New York gallery that should certainly be mentioned in connection with architectural tendencies: the now defunct Park Place Gallery. It specialized in shaped-canvas versions of this activity, and has on occasion also shown the work of such sculptors as Robert Grosvenor, who has created pieces designed not only to engage, but to penetrate and thus re-structure gallery limits. [M. B.]

the integrity of the (bronze) material. (I've been trying in this cataloguing to note mainly pieces that seemed to me really to work; but not to mention this Trova, which is virtually the centerpiece of floor three, the heaviest piece in the show, and one of the most photographed and reproduced, seems an overindulgence in pleasure to the detriment of reportage. It was, for me, a big dud.) Nowhere near Trova's piece in terms of the figure, but close to it in their enthusiasm for the feel of material, are Tony Delap's *Modern Times III*, in glossily finished wood, Duane Hatchett's *Summer Solstice*, in beautifully textured aluminum, and Douglas Huebler's *Truro Series I*, in formica. All three have roughly zig-zag shapes and are, indubitably, Primary Structures, with no architectural strings attached. But a love of material, combined with the inclination to make simple shapes intricate rather than primary, is observable in the big untitled piece by Robert Bart. It is a more than 12-foot-in-diameter ball, whose skin is made out of hundreds of little tangential compartments, all bolted together. It was mounted by being held out sideways from three curved aluminum rods, also executed in this rather ironically mechanical technique. On the whole, the regularity is not only irregular, but verges on the zany. One more tendency that sets off most of the new American work we have been gingerly exploring (and for which the adjective "British" is certainly inapt) is that its usual structural direction is not up, but creepingly lateral.

With work that is primary and, at least in its Whitney mutation, monumental and architectural; with work in the more asymmetrically structural vein (is the Pisa campanile a Primary Structure?), a third field seems to be what Lucy Lippard has usefully termed Eccentric Abstraction. The term, though loosely intended, can I think be drafted here. It seems plain to me that both Robert Hudson's kaleidoscope of forms, *Space Wrap with a Western Cut* (though Hudson hasn't been listed in the E.A. camp), and Gary Kuehn's untitled bipartite work yoking a cornice piece with a flowing, tonguey shape, both belong roughly in this category. And if Claes Oldenburg, represented by a small and disappointing floppy auto from his *Soft Airflow* series, can be seen as central to the approach, certainly Edward Kienholz, with the disgusting pillows and

Robert Morris: Untitled. 1965. Fiberglass. 8' x 8' x 2' (two pieces). Photograph courtesy of Leo Castelli Gallery, New York.

Tony Smith: *Night*. 1966. Plywood mock-up to be made in steel. 12' x 16' x 12'. Photograph courtesy of Fischbach Gallery, New York.

Michael Steiner: Installation, November 1966. All pieces aluminum. Foreground: 12' x 2' with 6" square tube. Left wall: 103" x 120". Background (center): 8' x 10'. Right wall: 103" x 31" off wall. Photograph courtesy of Dwan Gallery, New York.

Invitational Exhibition (partial view), Park Place Gallery. Paintings (l. to r.)—Alan Cote: Untitled; Robert Wray: *Wing*; Frazer Dougherty: *Cathexis Mass*. All 1967. Foreground sculpture—Chris Wilmarth: *Enormous*. 1966. Photograph courtesy of Park Place Gallery, New York.

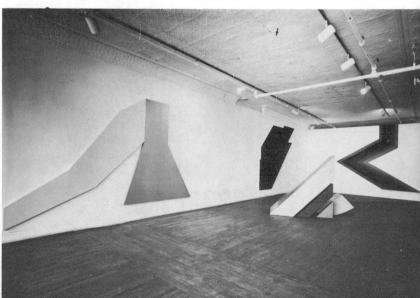

pots and curettes and lamp of his *The Illegal Operation* (all blood-stained) belongs among the eccentrics too, although his forms are not abstract. (Indeed, his is the most effective and unschmaltzy example of social criticism in the show.) Jean Linder's *The Booth* is also a loose, floppy form, a cross between a wedding train and a phone booth, with oozy or sexy devices painted here and there on its transparent vinyl. Ceramicist James Melchert's *Silvery Heart* seems a little crowded in the auricles and ventricles, and unarticulated somewhat, but an arm that comes out of one side of the heart and props it up disposes one to overlook this. Harold Paris also certainly belongs in this field (or mood) with his perfect, leather-covered, triangular object whose sides bulge in two places with mysterious shapes. *Peter Rabbit* by Sasson Soffer tries to join black fur and chromed abstract shapes, and seems to exemplify the abyss into which this particular camp can most easily sink: cuteness.

A restraining factor here may be that there is as yet no formal or informal group, consciously developing a style, as there appears to be with the work discussed earlier. Much of it lacks a certain assurance, an assurance about the legitimacy of uncertainty, I suppose. At best this informal exposure may be seen as an early phase of what this writer, too, hopes will turn into something, sometime. Where else can one turn for really relevant, new, middle-sized work?

As we have perhaps already suggested sufficiently, one of the best achievements in this strong show is the exhibition of *new* work, on a scale and in a manner that plainly demonstrates its interest. The new orientation leaves earlier modes behind somewhat, but this perhaps is acceptable, especially in view of a few key links with earlier work and earlier modes. Box sculpture may well have reached a *ne plus ultra* with Joseph Cornell, represented by a *Celestial Box* of more than familiar star/goblet iconography. The recent work of Larry Bell (seen here in one of his icily elegant empty boxes, untitled) and perhaps even that of Sol LeWitt (on view with one of his glassless, multicompartmented boxes, *A 8*) are, I think, as close to Cornell as to the abstract Primary Structure. They have a Cornell-like care for construction, and for hermetic self-containment; they have a mystery of their own, though it is not that mys-

tery featured by the master box-maker. Somewhere between these antipodes are John Willenbecher with his elegantly glassy *Four Comets*, its four painted and streaming comet-shapes side by side surrounding four steel balls; Leroy Lamis with his totem-format boxes, little boxes inside big ones, *Construction #94;* and Leo Rabkin, with his *Shadow Box.* All three attempt to substitute an interplay of impeccable construction and refinements of light for hermetic mysteriousness; and all three I think would have benefited had some element of movement been introduced. Lucas Samaras's *Box #40*, despite the woolly exterior peculiar to his creations, might have been a direct homage to Cornell, with its central section of a skull X-ray, combined with a photograph of the Milky Way. The connection to Cornell is close enough for it to be sufficient without movement; and the piece is inventive enough (in the two fold-out sections contiguous with the skull X-ray section) to be striking in its own right. Jim Dine's *Ribbon Machine* seems a cross between Primary Structure and something more germane to Dine's usual line of thought—it's like a tierack; Lee Bontecou's untitled 99½" high piece seems equally excellent and personal (I have already singled out these two, and for extended description, in *Art International* XI/1 and X/10, respectively). Some sculptures that seem almost entirely irrelevant to the general thrust of things, and merely beautiful in themselves, are Alexander Liberman's *Converging*, a cat's cradle of steel rods that detour around each other at the point of collision, and make lively forms; Peter Agostini's *B—Dock*, a table covered with plaster balloon shapes that divide themselves into two parts, linked and anchored by a red-and-white striped pipe; George Ortman's *Metallurgy*, a wall-hanging that is an aluminum embodiment of his usually wood paintings with inserted playblocks bearing symbols (and one of the better Ortmans, I think); George Segal's *Walking Man*, a bleak portrait of a figure seen against an unusually bleak, regularly screened backdrop, but set off by a bright red behind the backdrop; Larry Rivers's cautionary tablet in which a cut-out of a child outlined in neon is about to descend into a drawn bathtub lined with a real bathmat: below this, in the artist's elegantly smudged lettering, appears the work's title, *Don't Fall.*

Other interesting basic comparisons might have been set up had

stronger works been picked to represent the few pre-fifties sculptors who were included. This lack of concern with earlier sculptors seems to me to be shown by the inappropriateness of the selections and even by a certain casualness of placement. David Hare's big *Blind Head*, which aspires to and achieves nothing if not grandeur of scale, was placed in a corner and suffered there. Herbert Ferber's *Homage to Piranesi*, in his usual recent form-and-frame structuring, provided an interesting comment with its semiarchitectural box, and might have been placed more suggestively. Also, I thought that one of the late David Smith's later sculptures from the permanent collection, a genuine *Cubi*, might have been brought in from the outdoor sculpture court, for obvious reasons and better comparisons.

The Whitney show is impressive enough in its inclusions to permit one to touch only lightly on its exclusions. Its primary lack, quite clearly, is in the area of light and kinetic sculpture. One feels this despite the presence of a fine Chryssa, *Fragment for the Gates to Times Square II*, a large opaque black box that becomes transparent every thirty seconds or so, when its neon contents (Chryssa's usual letters and letter-fragments) are briefly illuminated; a highly original and dainty Ronald Mallory (a neat box faced with a black matte; and through the framed opening one sees a pattern of slowly oozing mercury); a quietly effective John Goodyear, in which his usual racks activated a lit, rather than painted, pattern; the aforementioned George Rickey; a charming James Seawright, *Eight*, which presents this figure in a series of eight boxes set side by side and includes the use of oscilloscope and audio-speaker; a Sheldon Machlin that seems rather ponderous in execution despite the simplicity of its basic idea, which is to suspend weights that bounce unpredictably at different points along a spring plumb-line; a Fletcher Benton that seems inappropriately shaped and moves uninterestingly, and that I wouldn't mention but for the sparsity of the work in this vein. And indeed, works in the areas of light and motion are much less frequent in America than in Europe.

Even in the area of light sculpture there seems to be considerable connection with the Minimal ideal. Because of the smallish sizes of the light works seen here, no obvious connection with the architec-

tural may appear; and yet it is evident that the structural framework of most recent American-based light sculpture is that of the chamber. This point has been made most dramatically of late by two works that space alone might have excluded from this crowded show: Lucas Samaras's *Mirrored Room* (1966), a man-high rectangular room entirely walled in mirror, in which visitors are reflected to infinity; and Yayoi Kusama's *Peep-Show* (1965), a hexagonal room roofed in flashing bulbs, in which luminosity is reflected to infinity. Both pieces remind us that just as most Primary Structures with their smallish everyday shapes relate to the rather weary *objet trouvé* aesthetic, most of the larger, geometrically conceived pieces relate to a fresher class of creation: the environmental.

Architecturalism aside, monumentality aside, one of the most interesting qualities to be found in much of the best new sculpture is a shift from the question *how* to the question *what*. Much of the effort implied by the new work is not of the kind that is wrought, but rather of the kind that is conceived. The smoothness and general uninflectedness of surface in a good many of the pieces might stand as a metaphor for the general smoothing over of details of execution —a metaphor that becomes richer in light of the fact that some of the new work is produced according to specifications at a factory (one sculptor, rampant rumor tells us, works almost entirely by telephone). The energy of elaboration seems to have gone into overall design; so that actually, despite the "simplicity" of much of the work, the variations from sculptor to sculptor are considerable, perhaps greater than ever before. It is the impression of variety within broad categories that makes this show memorable, and reflective of the sculpture today.

Indeed, this show may be more than simply "representative." The variation from work to work is apt, in one-man gallery shows, to prove somewhat monotonous. It is as if, having produced a single more or less unique and distinct image, sculptors now concentrate on creating sequences of work that, though unique in comparison with the work of other men, is not so different inside the sequences themselves. A group museum show, which can pluck work from many men, is thus in a position to be an unusually attractive accounting of sculpture at this time—and this the Whitney was.

Tony Smith

In the middle of Bryant Park, adjoining the New York Public Library, Tony Smith had a show of sculpture—his first full-scale show of sculpture here to date. (This was also one of the last of a series of "events" that Thomas Hoving, departing Parks Commissioner of New York City, arranged here; hopefully his successor, August Heckscher, will continue Hoving's policy, which has resulted in some of the liveliest things in the public art life of this City in many years.) Coming from the bustle of the surrounding streets and onto the Smith site was, indeed, an event in itself. The works have an enormous, calming "presence"—this word is reportedly Smith's favorite word for describing his sculptural work. As everyone must know by now, Smith is a sort of grandparent of much new Minimalist sculpture, having been producing it since 1960, when he abandoned his career as a painter. Though Smith's works have connections with the sculpture of the Morris and Judd direction, they provide other pleasures still. Although he builds his work from the same geometric, box-like units, coloring uniformly (in black), the work strikes one for its qualities of variety; he resists symmetry, which Morris and Judd seldom do. His simplest pieces have proportions extreme enough to shift radically as one moves around them; his more complicated ones are constructed of several slabs of boxes, and are modified modules, being beveled, sliced, angled, tilted. In this exhibit, most of them were set well apart from the viewer by the balustrades around the inner court of Bryant Park, and this effect could be particularly savored. The difference between Smith's work and that of most Minimalists seen here so far is, in fact, so great that one begins to search for something like a definitively dividing principle. Perhaps it has something to do with the fact that Smith, before he abandoned painting, first abandoned the trade of architecture, in which he had been trained. Whereas most Minimalists seem to have gallery space at heart, Smith clearly doesn't. He seems to want to engage, not rectilinear box structures (the most "primary" of Primary Structures I have ever seen are empty galleries; and Yves Klein showed one of these a half-decade ago), but the irregular outdoors, with its rolling ground, indeterminate lateral spaces, skies. One cannot, after all, leave a mark in the world outside the gallery solely with Minimal preoccupation. The success of Smith's beautiful

show supports one's inklings that all Minimalists are also, to some extent, incipient monumentalists. N.B.: Michael Steiner's recent remark, that he could show in the gallery no longer, already suggests a certain discomfort with gallery limitations. So does the recent Architectural Monument Designs show at the Dwan (Steiner's gallery), which consisted simply of models for proposed structures to be built outdoors and everywhere; or, indeed, the designs for architectural monuments that Claes Oldenburg showed recently at the Janis Gallery. P.S.: The Smith works were all plywood mockups of works intended for eventual rendering in metal; one hopes this plan will carry before long.

Ad Reinhardt
The difference between the Tony Smith show and that of Ad Reinhardt at the Jewish Museum is slim, from one point of view. Actually, the forms that Reinhardt has been using since the early fifties— the blocky double-barred grids that he spreads over his canvases, barely contrasting with the backgrounds—are very much like the basic units of the Smith pieces. Even their color was similar in this show: the Museum omitted the red and blue paintings shown so widely over the past few years here, in favor of a full representation of the black. This was reasonable; Reinhardt's black work alone carries the essential message. The black work, starting in the early fifties, was preceded by an intelligently selected sampling of work from the late 1930's on, showing how Reinhardt moved from a mode somewhere between Stuart Davis and Niles Spencer, yet still somewhat representational, to the later styles. The Davis-period paintings are succeeded by paintings that are still small, and tightly packed with detail, but abstract. The entire forties is a period in which, simultaneously, the scale increases, the iconographical events become sparse; toward the end of the forties the forms cease in intricacy, and begin to assume the blocky look of the rest of the show. Reinhardt suggests in a catalogue statement that he was razzed quite a bit by the Action Painters of the fifties, and one can see why; his emphasis on the evolving act is certainly light, if present at all. One might even say that, around 1950, the events of the canvases stop being generated from within, and begin being generated by the shape of the canvas and the outlines of the frame. Instead of

painting-acts, Reinhardt in the fifties produced a single Act: arriving
at this style. Even the occasionally remarked relationship to Rothko
seems to me superficial; there isn't much of the joy in sensuous
applications of paint, in sheer pulsation, which is of course one of
the great pleasures of Rothko's work. What Reinhardt's paintings
seem to me to do is provide a pleasure that is not essentially paint-
erly, but architectural. For all the long-standing fuss about his mas-
terly "touch," he seems to me to be painting now much better than
he did in the 1950's; now there is more of the much-discussed "deli-
cacy of vibration." Not only does his "touch" seem to be of relatively
scant interest in the 1950's context, but his forms do also. Symmetry
and all, they look rather fabricky-modernistic, especially during the
first half of the decade. As what his paintings first appear to be—
architectural panels—they seem to me to have sufficient strength as
such for us to concentrate our attention on them as such. Created
when they were, playing the historical role that they do, Reinhardt's
paintings deserve to be where they are—but, statements by Rein-
hardt "touch" enthusiasts to the contrary, I doubt that, had they
been produced in the forthcoming ten years, they would have
landed in a museum like the Jewish Museum in twenty. It is as
spiritual worker, if that doesn't sound too creepy, and as one of the
first of a unique *kind* of painter, that we ought to respect Reinhardt,
it seems to me. Surely one of the messages of the success of this
seminal artist is that changing painting styles is not enough; the
change must be complemented by shifts of attitude in other depart-
ments of art, the showing of painting and sculpture included. I dis-
trust those who praise Reinhardt yet conservatively place emphasis
on the "beauty" of his work in traditional terms. To begin with, it
violates Reinhardt's own concept of the absolute refreshment of art.

SERIAL ART, SYSTEMS, SOLIPSISM* by Mel Bochner

An interest in systems and serial methods has characterized some recent art. One writer, Lawrence Alloway, writes that the word *serial* ". . . can be used to refer to the internal parts of a work when they are seen in uninterrupted succession."† Another point of view is taken in this essay by Mel Bochner, an artist working with series, who defines *serial* as a procedure. He points out that "Individual parts of a system are not in themselves important but are relevant only in how they are used in the enclosed logic of the whole." The work of Carl Andre, Dan Flavin, and Sol LeWitt is discussed in this article, but a number of artists are working in similar areas.

Mel Bochner was represented in the Finch College Museum "Art in Series" exhibition in 1967. He was born in Pittsburgh and has written for *Artforum, Arts Magazine,* and *Art and Artists.* He is now teaching at the School of Visual Arts in New York City.

"Go to the things themselves."—Husserl

"No object implies the existence of any other."—Hume

"There is nothing more to things than what can be discovered by listing the totality of the descriptions which they satisfy."

—A. J. Ayer

If it can be safely assumed that all things are equal, separate, and unrelated, we are obliged to concede that they (things) can be named and described but never defined or explained. If, further-more, we bracket-out all questions that, due to the nature of lan-guage, are undiscussible (such as why did this or that come to exist, or what does it mean) it will then be possible to say that the entire

* Revised version of the article "Serial Art, Systems, Solipsism" which ap-peared in *Arts Magazine,* Summer, 1967.

† "Serial Forms," in the exhibition catalogue *American Sculpture of the Sixties,* Los Angeles County Museum of Art, 1967.

being of an object, in this case an art object, is in its appearance. Things being whatever it is they happen to be, all we can know about them is derived directly from how they appear.

What is thought about art is usually only thought about because it has been thought about that way before. Whatever art is, it is, and criticism, which is language, is something different. Language comes to terms with art by creating parallel structures or transposing, both of which are less than adequate. (That doesn't mean, however, I think that it is true that nothing can be said except about language itself.)

Criticism has traditionally consisted of one of three approaches: "impressionistic" criticism, which has concerned itself with the effects of the work of art on the observer—individual responses; "historical" criticism, which has dealt with an *a posteriori* evolution of forms and techniques—what is between works; and "metaphorical" criticism, which has contrived numerous analogies—most recently to scientism. What has been generally neglected is a concern with the object of art in terms of its own material individuality—the thing itself.

Two criteria are important if such an attempt is to be made. First, the considerations should be concrete (deal with the facts of the thing itself). Second, they should be simplificatory (provide an intellectually economic structure for the group of facts obtained). The latter is necessary because description alone can never adequately locate things. In fact, it very often confers upon them an enigmatic position. Nonetheless it offers more interesting possibilities than the impressionistic, historic, or metaphoric approach.

Everything that exists is three-dimensional and "takes up" space (space considered as the medium in which the observer lives and moves). Art objects are qualitatively different from natural life yet are coextensive with it. This "intrusion factor" is the basis of the *unnaturalness* of all art.

The above is relevant to an examination of certain art being done today. This work cannot be discussed on either stylistic or metaphoric grounds. What it can be said to have in common, though, is a heightened artificiality because of the clearly visible and simply ordered structure it uses. For some artists order itself is the work of art. Others manipulate order on different levels creating both con-

ceptual and perceptual logic. These different kinds of order and the way in which resultant works of art exist in their environments are what I would like to examine.

Carl Andre works within a strict, self-imposed modular system. He uses convenient, commercially available objects like bricks, Styrofoam planks, ceramic magnets, cement blocks, wooden beams. Their common denominators are density, rigidity, opacity, uniformity of composition, and roughly geometric shape. A number of *a priori* decisions govern his various pieces. One and only one kind of object is used in each. Individual pieces are specifically conceived for the conditions of the place in which they are to occur. The arrangement of the designated units is made on an orthogonal grid by use of simple arithmetic means. (The word "arrangement" is preferable to "composition." "Composition" usually means the adjustment of the parts, i.e., their size, shape, color, or placement, to arrive at the finished work, whose exact nature is not known beforehand. "Arrangement" implies the fixed nature of the parts and a preconceived notion of the whole.) The principal means of cohesion in Andre's pieces is weight (gravity), the results of another *a priori*: no use of adhesives or complicated joints. This necessitates their appearance on the floor in horizontal configurations, like rows or slabs. Although earlier pieces made of Styrofoam planks are large and space consuming (a principal quality of Styrofoam being its "bloatedness"), recently Andre's work has tended to be more unassuming. Height is a negligible dimension in these recent pieces, probably partly because of the instability of unadhered stacks. At any rate this causes the pieces to exist below the observer's eye-level. They are made to be "looked down upon," impinging very slightly on common space. It is, however, just this persistent slightness that is essentially unavoidable and their bald matter-of-factness that makes them in a multiple sense *present*.

Artists like Andre are further differentiated (as all artists are) by their individual methodology, which in relation to the methodology of the past can only be termed systematic. Systematic thinking has generally been considered the antithesis of artistic thinking. Systems are characterized by regularity, thoroughness, and repetition in execution. They are methodical. It is their consistency and the continu-

Sol LeWitt: *Series A #7.* 1967. Baked enamel on aluminum. Inside: 1½″ x 28″ x 28″. Outside: 81″ x 81″ x 81″. Photograph courtesy of Dwan Gallery, New York.

Sol LeWitt: *Series A #8*. 1967. Baked enamel on aluminum. Inside: 28″ x 28″ x 28″. Outside: 81″ x 81″ x 81″. Photograph courtesy of Dwan Gallery, New York.

Sol LeWitt: *Series A #9*. 1967. Baked enamel on aluminum. Inside: 81″ x 28″ x 28″. Outside: 81″ x 81″ x 81″. Photograph courtesy of Dwan Gallery, New York.

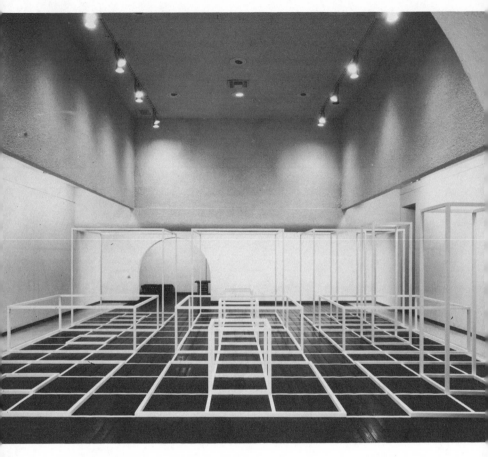

Sol LeWitt: *Series A.* 1967. Installation view. Baked enamel on aluminum. Photograph courtesy of Dwan Gallery, New York.

ity of application that characterizes them. Individual parts of a system are not in themselves important but are relevant only in the way they are used in the enclosed logic of the whole.

One of the first artists to make use of a basically progressional procedure was Dan Flavin. A salient example of this is his 1964 *Nominal Three—to Wm. of Ockham.* ("Posit no more entities than are necessary."—William of Ockham.) The simple series involved can be graphically visualized as $(1 + [1 + 1] + [1 + 1 + 1])$.

Flavin, however, is difficult to come to terms with in even a quasi-objective discussion. For, although his placement of fluorescent lamps parallel and adjacent to one another in varying numbers or sizes is "flat-footed" and obvious, the results are anything but. It is just these "brilliant" results that confound and compound the difficulties.

Although in no way involved with environmental art, both Andre and Flavin exhibit acute awareness of the phenomenology of rooms. Andre's false floors, Flavin's demolished corners convert the simple facts of "roomness" into operative artistic factors. In Flavin's most recent exhibition (January, 1967) he restricted his modules to cool-white lamps in 8-foot, 6-foot, and 2-foot lengths. These, in various combinations, were placed in the corners or directly in the center of the walls. The fixtures themselves were obliterated by cross shadows, and the light, which also intensely accentuated all the phenomena of the gallery—the tilted floor, false wall, leaning door, excessively baroque fireplace. Consequently the room seemed dematerialized and a vacancy ensued that was as much part of the work as the arrangement of the fixtures. Flavin's gaseous light is indescribable except as *space*, if, once again, we consider space as a medium. Flavin "fills" the space in direct proportion to his illumination of it.

Up until about fifteen years ago all light came as points. All sources of illumination, including the sun, were singular and radiated from a point source. With the proliferation of fluorescent lighting a perceptual revolution occurred with probably deeper significance than the invention of the light bulb (which still created chiaroscuro shadows). Light now occurs in long straight lines obliterating shadows. It can, in effect, surround. For Flavin (who does not "use" light in the sense of the so-called "light artists") this is an

important fact. It is due to this that he attains such a high degree of artificiality and unnaturalness (what Bertolt Brecht referred to as "the alienation effect").

"It is, of course, a misnomer to speak of my experience. Experience is simply whatever experiential facts there happen to be. It is quite impersonal and is not in any sense mine. In fact, except in the sense that 'I' am a certain configuration of experience, the word 'I' has no significance."—J.R. WEINBERG

For the solipsist reality is not enough. He denies the existence of anything outside the self-enclosed confines of his own mind. (Sartre refers to solipsism as "the reef," for it "amounts to saying that outside me nothing exists." Schopenhauer speaks of the solipsist as "a madman shut up in an impregnable blockhouse.") Viewed within the boundaries of thought, the random dimensions of reality lose their qualities of extension. They become flat and static. Serial art in its highly abstract and ordered manipulation of thought is likewise self-contained and nonreferential. Such diverse artists as Edward Muybridge, Jasper Johns, Larry Poons, Sol LeWitt, Don Judd, Jo Baer, Robert Smithson, Hanne Darbroven, Dorothea Rockburne, Ed Ruscha, Eva Hesse, Paul Mogensen, Dan Graham, Alfred Jensen, William Kolakoski, and myself have used serial methodology. Seriality is premised on the idea that the succession of terms (divisions) within a single work is based on a numerical or otherwise predetermined derivation (progression, permutation, rotation, reversal) from one or more of the preceding terms in that piece. Furthermore the idea is carried out to its logical conclusion, which, without adjustments based on taste or chance, is the work. No stylistic or material qualities unite the artists using this approach because what form the work takes is unimportant (some of these artists have ceased to make "things"). The only artistic parallel to this procedure would be in music. J.S. Bach's *Art of the Fugue* or works by Schoenberg, Stockhausen, and Boulez exhibit similar ideas about how works of art can be made based on the application of rigorous governing logics rather than on personal decision making.

Sol LeWitt's serial work takes a particularly flat, nonemphatic position. His complex, multipart structures are the consequence of a rigid system of logic that excludes individual personality factors as much as possible. As a system it serves to enforce the boundaries of his work as "things-in-the-world" separate from both maker and observer.

LeWitt's recent West Coast exhibition (one-quarter of the proposal he exhibited at the Dwan Gallery, New York City, "Scale Models" exhibition) is an interesting example of seriality. First, a governing set of decisions are made. The first cause is an open frame square placed on the floor in the center of a larger square, ratio 1:9, which in extension becomes a cube within a cube, ratio 1:27. The next limitation that is made are the three height variables:

1) LOW—the height of the cross-section of the bar of which the entire ensemble is constructed.
2) MEDIUM—the height of one cube (arbitrary).
3) HIGH—three times the height of 2).

Then the variable combinations of open frame and/or closed volume are considered in the four binomial possibilities: open inside–open outside; open inside–closed outside; closed inside–open outside; closed inside–closed outside. No mathematics are involved in operations like these. Happily there seems to be little or no connection between art and mathematics. When numbers are used it is generally as a convenient regulating device, a logic external to both the time and place of application.

When one encounters a LeWitt, although an order is immediately intuited, how to apprehend or penetrate it is nowhere revealed. Instead one is overwhelmed with a mass of data—lines, joints, angles. By controlling so rigidly the conception of the work and never adjusting it to any predetermined ideas of how a work of art should look, LeWitt arrives at a unique perceptual breakdown of conceptual order into visual chaos. The pieces situate in centers usurping most of the common space, yet their total volume (the volume of the bar itself) is negligible. Their immediate presence in reality as separate and unrelated things is asserted by the demand that we go around them. What is most remarkable is that they are

seen moment to moment spatially (due to a mental tabulation of the entirety of other views), yet do not cease at every moment to be flat.

Some may say, and justifiably, that there is a "poetry" or "power" or some other quality to this work that an approach like the above misses. But aspects like those exist for individuals and are difficult to communicate using conventional meanings for words. Others may claim that given this they are still bored. If this is the case, their boredom may be the product of being forced to view things not as sacred but as they probably are—autonomous and indifferent.

THE RAZED SITES OF CARL ANDRE* by David Bourdon

The sculpture of Carl Andre is more than simply flat. In the pieces discussed in this article Andre demonstrates a new use, or possibly non-use of space. Several conclusions can be drawn from these sculptures: that it is the lowest level of space that counts most; that the space above that level can be filled without being enclosed; and that, ultimately, it is human scale that determines sculptural scale.

David Bourdon was born in Los Angeles in 1934. He is a graduate of Columbia University, and a former art critic for *The Village Voice*. He has written for many publications including *Art News, Artforum, Art and Artists, Domus,* and *Konstrevy.* He is an Assistant Editor at *Life* magazine.

One of the most drastic works in the Jewish Museum's "Primary Structures" show last season was Carl Andre's *Lever*—a single line of 139 unjoined firebricks. This brick causeway, meeting one wall perpendicularly, ran across the middle of the floor for 34½ feet, stopping short of a doorway. Like most of Andre's work, *Lever* was designed for a specific area. Andre deliberately chose a room with two entrances, so that from one entrance the spectator had a vista of an unbroken line of bricks, while from the other entrance he confronted its terminus. The title referred ironically to the French infinitive "to raise" as well as the English word denoting a rigid bar. Though *Lever* was singled out by critics as one of the half-dozen key works in the Jewish Museum show, Andre had already razed structure to practice the art of zoning. His own terse account of modern sculpture goes like this:

> The course of development
> Sculpture as form
> Sculpture as structure
> Sculpture as place.

* Reprinted from *Artforum*, October, 1966.

"All I'm doing," says Andre, "is putting Brancusi's *Endless Column* on the ground instead of in the sky. Most sculpture is priapic with the male organ in the air. In my work, Priapus is down on the floor. The engaged position is to run along the earth." Rhetoric aside, he denies emphatically that his work has even implicit sexual meaning. But as originally planned, *Lever* was not without sexual connotations, coursing through the doorway like a 34½-foot erection.

To appreciate Carl Andre's history of assiduous renunciation, one should start at the beginning. He began sculpture as a wood-carving disciple of Brancusi, whose influence is clearly evident in Andre's early work of the late fifties, in which he regularly notched or serrated beams of wood. He subjected his woods to drilling, burning, sanding, and other abuses until they emerged as weathered as driftwood. He soon abandoned these artificial textural effects for unmarred plane surfaces. (As he had never applied color, he never had to renounce it.)

Later, he realized he was doing the *Endless Column* in negative with a cutout beam. "Up to a certain time I was cutting into things. Then I realized that the thing I was cutting was the cut. Rather than cut into the material, I now use the material as the cut in space." To expedite the cuts in space, he began to stack readymade materials—aluminum channel, glass prisms, and honing stones—to form simple geometric shapes like cubes and pyramids. At this time he made a number of pyramidal forms of mortised wood. Each pyramid was self-sufficient, but like the *Endless Column,* all could have been stacked base-to-base to infinity.

From 1960 to 1964 Andre worked as a freight conductor and brakeman for the Pennsylvania Railroad in Newark. Though he had already begun to work with preexisting, standardized materials, four years of coupling and uncoupling freight cars confirmed him in his use of regimented, interchangeable units. Because any part could replace any other part, the materials did not lend themselves to relational structures. In refusing to determine the mutual relations of forms, he suppressed his desire to compose—leaving the pursuit of "dynamic rhythms" to other sculptors. Standardized units made it possible for external surfaces to be no different than concealed inner surfaces, and Andre's structures are "clastic" in the sense that outer and inner surfaces are identical. Andre has always shown a

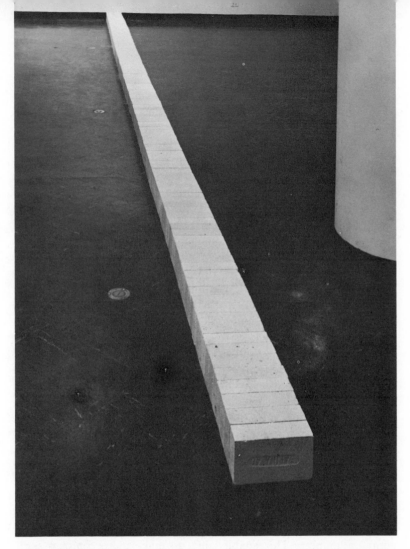

Carl Andre: *Lever.* 1966. Firebrick. 400″. In the collection of the artist. Photograph courtesy of The Jewish Museum, New York, "Primary Structures" exhibition.

preference for solid materials, of the same consistency or substance, from outer facets to innermost core. Whatever the material (almost always in bar form) it is usually the largest facet that is oriented parallel to the ground in passive submission to gravitational forces.

Oddly enough, his experience as a railroad conductor gave Andre no immediate insight into the inflated role in sculpture of the dimension of height. He continued to build vertically as though his sights were still trained on the *Endless Column*. This direction culminated in his first one-man show at the Tibor de Nagy Gallery (in April, 1965) where he enlarged his scale, if not his concept. Andre jammed the main gallery with three monumental constructions made up of nine-foot-long Styrofoam beams or girders. The marshmallow-white girders were stacked to make a right-angled wall about six feet high (*Coin*), the quoined corner resulting in a notched edge at either end. Easily the most impressive work was the immense, six-layered *Crib*, a square, latticed framework that permitted one to see through its 500 cubic feet of enclosed space. The massive scale of this work was mitigated by the Styrofoam's buoyant aspect. The white plastic slabs had curved sides and a porous texture that radiantly diffused the light. Resembling quarry-fresh Pentelic columns, the Styrofoam proved to be a kind of lightweight miracle marble, suggesting resilience as well as an ability to float or levitate. The third work, *Compound*, was a two-foot-high solid wall, penning in an open square. It was most emphatic in its demarcation of space and the work that was to indicate Andre's future direction.

The Styrofoam structures appeared radically simple at the time. In retrospect, they were needlessly complex, employing as they did such ancient if elementary construction techniques as cribbing and quoining. Andre decided to abandon these techniques in favor of simple alignment. This enabled him to make more compact statements with condensed forms of even greater solidity and gravitational weight. There was no more need for spatial interstices between parallel facets. Andre's cuts in space had been compromised by the alternating negative—positive shapes within the work, which had given his work a louvered airiness. Militant alignment led to concise straight-edged shapes, permitting no more overlapping, staggered layers or notched edges.

For some time it had been apparent to Andre that his sculpture

should be low. In Summer, 1965, while canoeing on a New Hampshire lake, he realized his sculpture had to be as level as water. For his second show at the Tibor de Nagy Gallery in March, 1966, Andre created an astringent environment by setting eight rectilinear mounds of 120 bricks each on the gallery's parquet floor. "120 is the number richest in factors," says Andre, cautioning that "arithmetic is only the scaffolding or armature of my work." He had to stack the sand-lime bricks in two layers "to avoid drift." Thus the topside of each mound had only 60 bricks. The bricks were assembled in only four out of six possible combinations: 3 x 20, 4 x 15, 5 x 12, and 6 x 10 bricks. Each combination appeared in two shapes, the bricks having been aligned either on their short side or their long side. The same 6 x 10 brick combination, for example, could be either an elongated rectangle or a near square, depending on the orientation of the bricks. Although each of the eight shapes was different, they all occupied the same amount of space in square inches, which accounted for their visual equivalence.

The deployment of the mounds suggested an orderly Japanese rock garden, conducive to contemplation. Andre had wanted to drive the spectator back to his own sensibility, but instead he had transformed the room—itself a Golden Rectangle—into an archipelago of Euclidean isles. This astonishing show seemed to be a crystal-clear argument for transcendentalism. But it was not, according to Andre. "My work is atheistic, materialistic, and communistic. It's atheistic because it's without transcendent form, without spiritual or intellectual quality. Materialistic because it's made out of its own materials without pretension to other materials. And communistic because the form is equally accessible to all men."

When an artist sees sculpture as place, there is no room for actual sculptures to accumulate. Andre's works come into existence only when necessary. When not on exhibition, the pieces are dismantled and cease to exist except as ideas. The dematerialization of his sculptures makes it impossible for Andre to indulge himself in wasteful activities like polishing and shining and leaves him more time for the creation of his "shaped" poetry, analogous to his sculpture in that it consists of monosyllabic words blocked out in regular, orderly arrangements. Revivifying the syntax of Gertrude Stein, Andre strips words of contextual significance and gives to each monosyllable

equal stress and importance. He permits the shape to be determined by the systematic ordering of the words. "By making us 'look' at what we 'read,'" as poet Charles Boultenhouse has written, "the shaped poem reminds us that the poem as such is an object among other objects in the world. . . . Since we are made to *look* at shaped poems even before we are persuaded to read them, they actually begin before their first word is read." In Andre's poetry, the non-verbal experience not only precedes but often supersedes the verbal experience.

Andre's evolutionary view of art was summed up years ago by Mondrian, who said: "True art like true life takes a single road." "Actually," says Andre, "my ideal piece of sculpture is a road." He thinks of roads that are leisurely walked upon or looked at, not as the shortest distance between two points quickly traversed by automobile (he does not drive). In the future, his ideal sculpture will not necessarily remain on ground level. He likes digging very much and awaits commissions to create "negative sculptures," earth cavities that probably will resemble the troglodytic homes in the Chinese loess belt.

SUBJECT MATTER IN THE WORK OF BARNETT NEWMAN* by Nicolas Calas

A Minimal Art statement need not be minimal in terms of subject matter. Nicolas Calas sees Barnett Newman's *Stations of the Cross* paintings, as well as that artist's recent sculpture, as ultimate existential gestures. Calas's observations are based upon the art works themselves, and are supported by Newman's own writings. Newman's sculpted stripes, according to Calas, represent acephalous crosses; thus they are for ". . . those who have been cut off from the hope of immortality. In the Now man is alone. His cry for help cannot reach the Above, for there is no above and no beyond. Man is alone in the Now."

Calas realizes that existential content was primarily an Abstract-Expressionist concern, and he points out that "the Impressionists were the first to isolate light and the Abstract Expressionists the first to isolate existence."

Nicolas Calas is Contributing Editor for *Arts Magazine,* and he recently published in collaboration with Elena Calas a book on *The Peggy Guggenheim Collection of Modern Art.*

Barnett Newman's series of monochrome fields divided from top to bottom by a vertical line, when first shown in 1950 (at the Betty Parsons Gallery), struck this writer as a major artistic achievement. At last an artist had come forth to state in an abstract style that the Being is an "all in the now."

Statements do not have to be explained, they must be understood. Gazing at a *kouros* we feel the impact of Parmenides's dictum that man is an "all in the now." The *kouros*, Hermes or Apollo, is the image of idealized man. In our time the Being who sees himself as an "all in the now" is agnostic and views his solitude as inherent to the condition of man. Let us compare the advancing *kouros* to Giacometti's dissolving figure to understand more fully the difference between Parmenides and Kierkegaard. Both the ancient statue and the modern one belong in a limited space. The Apollo advances

* Reprinted from *Arts Magazine,* November, 1967.

toward us from the depth of a cella encased in a jewel-like temple. (To our mind's eye even a ruined temple is a self-contained entity in the now of sunrays.) The sense of remaining within clearly defined grounds is epigrammatically expressed in modern terms by Mondrian. How carefully he located the position of a chosen one in a tiny rectangle of color!

In a series of paintings called *Onement* Barnett Newman separates the Now into left and right.[1] But who in the Now can assume the responsibility of dividing space into two separate parts, a left one and a right one? Only one who has doubted that the all is in the Here.

The sensation that the Now spreads beyond the finite is suggested in Sung paintings where the human figure is engulfed in an endless space, one which for the Taoist constitutes the absolute reality. Were Barnett Newman an orientalizing Westerner he would not have chosen the Fourteen Stations of the Cross as subject matter for his latest paintings, nor would he have written for their exhibition at the Guggenheim Museum his comments on the meaning of the last words of Jesus.

Perhaps Barnett Newman's poetic dissertation on the theme could be dismissed, since he freely acknowledges the relation of his work to the Passion of the Cross occurred to him only after he had started painting the Fourth in this series.[2] This position would involve a refusal to view Picasso's *Guernica* in relation to the city's bombing on the grounds that the painting had been started before the disaster of Guernica. But the artist works by association, not chronologically.

To the fourteen paintings of the Passion of the Cross begun in 1958 and completed in 1966 we should add Newman's sculpture *Here II* of 1965. It consists of three thin metal verticals solidly implanted in individual trapezoid mounts on a common ground. They appear as acephalous crosses since no transversal bars limit their

[1] In some works the pictorial plane is divided horizontally. These are less convincing for they suggest landscapes rather than portraits with the implication that the line dividing land and sky should be curved.

[2] This part of his statement, which appeared in *Art News*, May, 1966, was not included in the catalogue to his exhibition at the Guggenheim Museum.

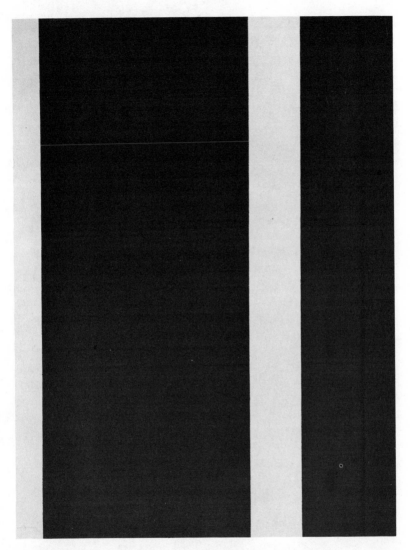

Barnett Newman: *Thirteenth Station,* 1966, of *The Stations of the Cross: Lema Sabachthani.* Acrylic polymer on canvas. 78″ x 60″. Photograph courtesy of The Solomon R. Guggenheim Museum, New York.

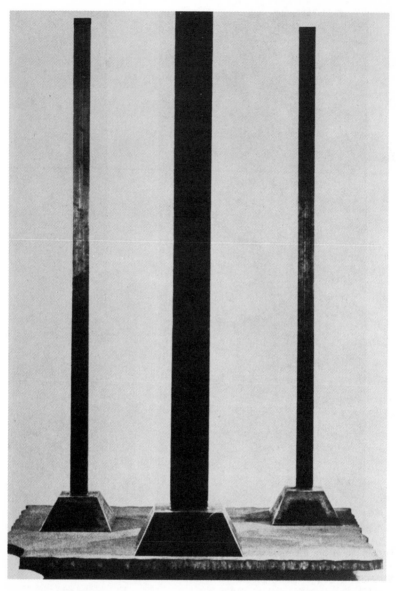

Barnett Newman: *Here II.* 1965. Steel. In the collection of Philip Johnson.

upward thrust. It is as if Barnett Newman was saying that we are not "all in the now."

Most movingly King David conveys the idea that man is not all in the now when he exclaims in Psalm 22: "My God, my God, why hast Thou forsaken me? I cry in the daytime but Thou hearest not and in the nighttime and am not silent." For the Psalmist, man is not at all in the now because the now is part of eternity. When the Crucified Jesus repeated, "My God, why hast Thou forsaken me," his followers interpreted these words as the outcry of a human being who is simultaneously mortal and immortal, in the Now and in Eternity and never all in the Here.

Newman's crosses have not been contained in the Here by lines stretching out like arms across the horizon. Newman's crosses are crossless since the cross, besides being the symbol of the crucified, is also the emblem of a God. Barnett Newman identifies himself with the agony of a compassionate man who was crucified, not with the transfiguration of a mortal being. Acephalous crosses are for those who have been cut off from the hope of immortality. In the Now man is alone. His cry for help cannot reach the Above, for there is no above and no beyond. Man is alone in the Now.

In his statement on the Stages of the Passion Barnett Newman says: "*Lema Sabachthani?* Why did you forsake me? Why forsake me? To what purpose? Why? This is the Passion. This outcry of Jesus. Not the terrible walk up the Via Dolorosa, but the question has no answer." David spoke in anguish because he was not hearing the voice of God: "O my God, I cry in the daytime but Thou hearest not, and in the night season and I am not silent." In the night the agony grows worse for we do not see. For the poet-painter, convinced of his solitude, an agonizing situation is best evoked through an awareness of the limitations of sight: "I do not see because it is too dark to distinguish objects; I do not see because nothing is there. I do not see because all is black. I do not see because all is blank." Unable to see he feels out of place. Through the will to see what cannot be seen he reaches a point where he finds himself in ecstasy —a word that means out of place.

In the hour of crisis no right place can be found; we waver, doubt, shift position from left to right and back again.

The engaged viewer watches for variations in the series of four-

teen paintings: the expansion or contraction of the white/black areas, the increase or decrease of verticals, the reversal of the left to right movement. Jesus's Passion begins when he knows that he is condemned. The Fourteen Stages of his Passion could be represented by fourteen states of ecstasy. From the moment we know ourselves to be lost we are in ecstasy and out of place in the Here, albeit still in the Now.

Suspended between life and death is an experience that can be communicated to others in terms of an insoluble black and white contradiction. Ecstasy is a confrontation with reality: in ecstasy there is no room for illusion, everything has to be reduced to an immediacy felt in the tension between lines and planes, raw canvas and/or white and black surfaces, or twilight zones of gray.

Twelve out of fourteen of Newman's Stations are divided into four by vertical lines. Like Zurbarán with his twelve pictures of the Apostles, Newman is a master of serialization. We move back and forth from Station One to Station Fourteen enriching our understanding of each single painting through confrontation with the others. Sometimes the strongest side of the painting lies on the left, occupied by a vast area buttressed by a forceful margin, while a narrow median line divides vertically the plane into unequal sections. Sometimes the divided plane is more clearly visualized as an uninterrupted ground upon which two verticals have been traced. The combination of two vertical lines and one plane evokes the Trinity while the double set of two lines and two planes recalls the Pythagorean tetractys. The position of the signature varies: in some it is placed in the lower left corner, in others in the lower right, and in a few at some distance from the end. Some lines are blurred, others vertically subdivided. In Station Four, the black bleeds, falling on the immaculate plane in a shower. In Station Five, the black margin is torn by spreading Expressionist stains. In Station Twelve tears and trembling shake the right end with delicate convulsions. Man can rise above his destiny and face the impossible. Black is set against white, black and white confront us with the dullness of raw canvas. Black lifts the raw canvas to the purity of white.

What is the painter trying to see. What else but light? The poet knows that the word is light. So is vision. Speech created man different from other species. Created man formed himself in the image of

his God. Out of images we cannot make flesh. Out of sound the musician cannot create solidity. Out of colors the artist cannot bring forth light. Barnett Newman added a fifteenth painting to the series. In it he contrasts the orange of dawn to the blackness of night by a thin margin on the left and a thin margin on the right.

The Impressionists were the first to isolate light and the Abstract Expressionists the first to isolate existence. Pollock and de Kooning achieved their goal by reducing painting to a handwriting of gestures and Barnett Newman by reducing the image to a divided monochrome field. To the Expressionist's calligraphy of gestures he opposes the typography of the vertical. Handwriting is personal, typography impersonal. Pleasure can be found both in deciphering the expression and in detecting variations in repetition. Through series of gestures the Existentialist expresses himself, through the repetition of stereotypes the Empiricist manifests himself.

After being viewed for so long as a pioneer of Expressionism, Barnett Newman emerges as a forerunner of systemic art.

Systemic painting substitutes redundancy for contradiction. In the Stages of the Cross, despite the repetition of the pattern fourteen times, the antithesis between white and black areas, narrow and broad fields, strong and weak lines, is never annihilated. Each painting is at a climax. An image of tension is lifted by the mind from the surface where lies that literal meaning scribes excel in describing. And what Jesus thought of scribes is well known.

ART AND OBJECTHOOD* by Michael Fried

In this essay Michael Fried criticizes Minimal Art—or as he calls it, "literalist" art—for what he describes as its inherent theatricality. At the same time, he argues that the modernist arts, including painting and sculpture, have come increasingly to depend for their very continuance on their ability to *defeat* theatre. Fried characterizes the theatrical in terms of a particular relation between the beholder *as subject* and the work *as object*, a relation that takes place in time, that has duration. Whereas defeating theatre entails defeating or suspending both objecthood and temporality.

Fried was born in New York City in 1939. He took his B.A. at Princeton University and was a Rhodes Scholar at Merton College, Oxford. He is a Contributing Editor for *Artforum*, and he organized the *Three American Painters* exhibition at the Fogg Art Museum, Harvard University, in 1965. He is currently a Junior Fellow in the Harvard Society of Fellows.

Edwards's journals frequently explored and tested a meditation he seldom allowed to reach print; if all the world were annihilated, he wrote . . . and a new world were freshly created, though it were to exist in every particular in the same manner as this world, it would not be the same. Therefore, because there is continuity, which is time, "it is certain with me that the world exists anew every moment; that the existence of things every moment ceases and is every moment renewed." The abiding assurance is that "we every moment see the same proof of a God as we should have seen if we had seen Him create the world at first."—Perry Miller, *Jonathan Edwards*

I

The enterprise known variously as Minimal Art, ABC Art, Primary Structures, and Specific Objects is largely ideological. It seeks to declare and occupy a position—one that can be formulated in

* Reprinted from *Artforum*, June, 1967.

words, and in fact has been formulated by some of its leading practitioners. If this distinguishes it from modernist painting and sculpture on the one hand, it also marks an important difference between Minimal Art—or, as I prefer to call it, *literalist* art—and Pop or Op Art on the other. From its inception, literalist art has amounted to something more than an episode in the history of taste. It belongs rather to the history—almost the *natural* history—of sensibility; and it is not an isolated episode but the expression of a general and pervasive condition. Its seriousness is vouched for by the fact that it is in relation both to modernist painting and modernist sculpture that literalist art defines or locates the position it aspires to occupy. (This, I suggest, is what makes what it declares something that deserves to be called a position.) Specifically, literalist art conceives of itself as neither one nor the other; on the contrary, it is motivated by specific reservations, or worse, about both; and it aspires, perhaps not exactly, or not immediately, to displace them, but in any case to establish itself as an independent art on a footing with either.

The literalist case against painting rests mainly on two counts: the relational character of almost all painting; and the ubiquitousness, indeed the virtual inescapability, of pictorial illusion. In Donald Judd's view,

> when you start relating parts, in the first place, you're assuming you have a vague whole—the rectangle of the canvas—and definite parts, which is all screwed up, because you should have a definite *whole* and maybe no parts, or very few.[1]

[1] This was said by Judd in an interview with Bruce Glaser, edited by Lucy R. Lippard and published as "Questions to Stella and Judd," *Art News,* Vol. LXV, No. 5, September 1966. The remarks attributed in the present essay to Judd and Morris have been taken from this interview, from Judd's essay "Specific Objects," *Arts Yearbook,* No. 8, 1965, or from Robert Morris's essays, "Notes on Sculpture" and "Notes on Sculpture, Part 2," published in *Artforum,* Vol. IV, No. 6, February 1966, and Vol. 5, No. 2, October 1966, respectively. (I have also taken one remark by Morris from the catalogue to the exhibition "Eight Sculptors: the Ambiguous Image," held at the Walker Art Center, October–December 1966.) I should add that in laying out what seems to me the position Judd and Morris hold in common I have ignored various differences between them, and have used certain remarks in contexts for which they may not have been intended. Moreover, I have not always indicated which of them actually said or wrote a particular phrase; the alternative would have been to litter the text with footnotes.

The more the shape of the support is emphasized, as in recent modernist painting, the tighter the situation becomes:

> The elements inside the rectangle are broad and simple and correspond closely to the rectangle. The shapes and surface are only those that can occur plausibly within and on a rectangular plane. The parts are few and so subordinate to unity as not to be parts in an ordinary sense. A painting is nearly an entity, one thing, and not the indefinable sum of a group of entities and references. The one thing overpowers the earlier painting. It also establishes the rectangle as a definite form; it is no longer a fairly neutral limit. A form can be used only in so many ways. The rectangular plane is given a life span. The simplicity required to emphasize the rectangle limits the arrangements possible within it.

Painting is here seen as an art on the verge of exhaustion, one in which the range of acceptable solutions to a basic problem—how to organize the surface of the picture—is severely restricted. The use of shaped rather than rectangular supports can, from the literalist point of view, merely prolong the agony. The obvious response is to give up working on a single plane in favor of three dimensions. That, moreover, automatically

> gets rid of the problem of illusionism and of literal space, space in and around marks and colors—which is riddance of one of the salient and most objectionable relics of European art. The several limits of painting are no longer present. A work can be as powerful as it can be thought to be. Actual space is intrinsically more powerful and specific than paint on a flat surface.

The literalist attitude toward sculpture is more ambiguous. Judd, for example, seems to think of what he calls Specific Objects as something other than sculpture, while Robert Morris conceives of his own unmistakably literalist work as resuming the lapsed tradition of Constructivist sculpture established by Tatlin, Rodchenko, Gabo, Pevsner, and Vantongerloo. But this and other disagreements are less important than the views Judd and Morris hold in common. Above all they are opposed to sculpture that, like most painting, is "made part by part, by addition, composed" and in which "specific elements . . . separate from the whole, thus setting up relationships

within the work." (They would include the work of David Smith and Anthony Caro under this description.) It is worth remarking that the "part-by-part" and "relational" character of most sculpture is associated by Judd with what he calls *anthropomorphism:* "A beam thrusts; a piece of iron follows a gesture; together they form a naturalistic and anthropomorphic image. The space corresponds." Against such "multipart, inflected" sculpture Judd and Morris assert the values of wholeness, singleness, and indivisibility—of a work's being, as nearly as possible, "one thing," a single "Specific Object." Morris devotes considerable attention to "the use of strong gestalt or of unitary-type forms to avoid divisiveness"; while Judd is chiefly interested in the kind of wholeness that can be achieved through the repetition of identical units. The order at work in his pieces, as he once remarked of that in Stella's stripe paintings, "is simply order, like that of continuity, one thing after another." For both Judd and Morris, however, the critical factor is *shape.* Morris's "unitary forms" are polyhedrons that resist being grasped other than as a single shape: the gestalt simply *is* the "constant, known shape." And shape itself is, in his system, "the most important sculptural value." Similarly, speaking of his own work, Judd has remarked that

> the big problem is that anything that is not absolutely plain begins to have parts in some way. The thing is to be able to work and do different things and yet not break up the wholeness that a piece has. To me the piece with the brass and the five verticals is above all *that shape.*

The shape *is* the object: at any rate, what secures the wholeness of the object is the singleness of the shape. It is, I believe, this emphasis on shape that accounts for the impression, which numerous critics have mentioned, that Judd's and Morris's pieces are *hollow.*

II

Shape has also been central to the most important painting of the past several years. In several recent essays[2] I have tried to show

[2] "Shape as Form: Frank Stella's New Paintings," *Artforum,* Vol. V, No. 3, November 1966; "Jules Olitski," the catalogue introduction to an exhibition of his work at the Corcoran Gallery, Washington, D.C., April–June, 1967; and "Ronald Davis: Surface and Illusion," *Artforum,* Vol. V, No. 8, April 1967.

how, in the work of Noland, Olitski, and Stella, a conflict has gradu-
ally emerged between shape as a fundamental property of objects
and shape as a medium of painting. Roughly, the success or failure
of a given painting has come to depend on its ability to hold or
stamp itself out or compel conviction as shape—that, or somehow to
stave off or elude the question of whether or not it does so. Olitski's
early spray paintings are the purest example of paintings that either
hold or fail to hold as shapes; while in his more recent pictures, as
well as in the best of Noland's and Stella's recent work, the demand
that a given picture hold as shape is staved off or eluded in various
ways. What is at stake in this conflict is whether the paintings or
objects in question are experienced as paintings or as objects: and
what decides their identity as *painting* is their confronting of the
demand that they hold as shapes. Otherwise they are experienced as
nothing more than objects. This can be summed up by saying that
modernist painting has come to find it imperative that it defeat or
suspend its own objecthood, and that the crucial factor in this under-
taking is shape, but shape that must belong to *painting*—it must be
pictorial, not, or not merely, literal. Whereas literalist art stakes
everything on shape as a given property of objects, if not, indeed,
as a kind of object in its own right. It aspires, not to defeat or
suspend its own objecthood, but on the contrary to discover and
project objecthood as such.

In his essay "Recentness of Sculpture" Clement Greenberg dis-
cusses the effect of *presence*, which, from the start, has been associ-
ated with literalist work.[3] This comes up in connection with the
work of Anne Truitt, an artist Greenberg believes anticipated the
literalists (he calls them Minimalists):

> Truitt's art did flirt with the look of non-art, and her 1963 show
> was the first in which I noticed how this look could confer an
> effect of *presence*. That presence as achieved through size was
> aesthetically extraneous, I already knew. That presence as
> achieved through the look of non-art was likewise aesthetically

[3] Published in the catalogue to the Los Angeles County Museum of Art's
exhibition, "American Sculpture of the Sixties." The verb "project" as I have
just used it is taken from Greenberg's statement, "The ostensible aim of the
Minimalists is to 'project' objects and ensembles of objects that are just nudge-
able into art."

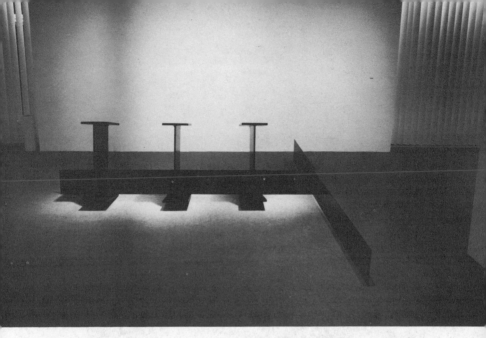

Anthony Caro: *Bennington*. 1964. Steel painted black. 3'4" x 13' x 11'. In the collection of Jules Olitski. Photograph courtesy of Andre Emmerich Gallery, New York.

Anthony Caro: *Flax*. 1966. Steel painted blue. 2'1" x 6'9" x 5'4". In the collection of Mr. and Mrs. Henry Feiwell. Photograph courtesy of Andre Emmerich Gallery, New York.

Donald Judd: Untitled. 1966. Galvanized steel. Each box: 40″ x 40″ x 40″ for a total length of 25′4″. Photograph courtesy of Dwan Gallery, New York.

extraneous, I did not yet know. Truitt's sculpture had this kind of presence but did not *hide* behind it. That sculpture could hide behind it—just as painting did—I found out only after repeated acquaintance with Minimal works of art: Judd's, Morris's, Andre's, Steiner's, some but not all of Smithson's, some but not all of LeWitt's. Minimal art can also hide behind presence as size: I think of Bladen (though I am not sure whether he is a certified Minimalist) as well as of some of the artists just mentioned.

Presence can be conferred by size or by the look of non-art. Furthermore, what non-art means today, and has meant for several years, is fairly specific. In "After Abstract Expressionism" Greenberg wrote that "a stretched or tacked-up canvas already exists as a picture—though not necessarily as a *successful* one."[4] For that reason,

[4] "After Abstract Expressionism," *Art International*, Vol. VI, No. 8, October 25, 1962, p. 30. The passage from which this has been taken reads as follows:

> Under the testing of modernism more and more of the conventions of the art of painting have shown themselves to be dispensable, unessential. But now it has been established, it would seem, that the irreducible essence of pictorial art consists in but two constitutive conventions or norms: flatness and the delimitation of flatness; and that the observance of merely these two norms is enough to create an object that can be experienced as a picture: thus a stretched or tacked-up canvas already exists as a picture—though not necessarily as a *successful* one.

In its broad outline this is undoubtedly correct. There are, however, certain qualifications that can be made.

To begin with, it is not quite enough to say that a bare canvas tacked to a wall is not "necessarily" a successful picture; it would, I think, be less of an exaggeration to say that it is not *conceivably* one. It may be countered that future circumstances might be such as to *make* it a successful painting; but I would argue that, for that to happen, the enterprise of painting would have to change so drastically that nothing more than the name would remain. (It would require a far greater change than that that painting has undergone from Manet to Noland, Olitski, and Stella!) Moreover, seeing something as a painting in the sense that one sees the tacked-up canvas as a painting, and being convinced that a particular work can stand comparison with the painting of the past whose quality is not in doubt, are altogether different experiences: it is, I want to say, as though unless something compels conviction as to its quality it is no more than trivially or nominally a painting. This suggests that flatness and the delimitation of flatness ought not to be thought of as the "irreducible essence of pictorial art" but rather as something like the *minimal conditions for something's being seen as a painting*; and that the crucial question is not

as he remarks in "Recentness of Sculpture," the "look of non-art was no longer available to painting." Instead, "the borderline between art and non-art had to be sought in the three-dimensional, where sculpture was, and where everything material that was not art also was." Greenberg goes on to say:

> The look of machinery is shunned now because it does not go far enough towards the look of non-art, which is presumably an "inert" look that offers the eye a minimum of "interesting" incident—unlike the machine look, which is arty by comparison (and when I think of Tinguely I would agree with this). Still, no matter how simple the object may be, there remain the relations and interrelations of surface, contour, and spatial interval. Minimal works are readable as art, as almost anything is today—including a door, a table, or a blank sheet of paper. . . . Yet it would seem that a kind of art nearer the condition of non-art could not be envisaged or ideated at this moment.

what these minimal and, so to speak, timeless conditions are, but rather what, at a given moment, is capable of compelling conviction, of succeeding as painting. This is not to say that painting *has no* essence; it *is* to claim that that essence—i.e., that which compels conviction—is largely determined by, and therefore changes continually in response to, the vital work of the recent past. The essence of painting is not something irreducible. Rather, the task of the modernist painter is to discover those conventions that, at a given moment, *alone* are capable of establishing his work's identity as painting.

Greenberg approaches this position when he adds, "As it seems to me, Newman, Rothko, and Still have swung the self-criticism of modernist painting in a new direction simply by continuing it in its old one. The question now asked through their art is no longer what constitutes art, or the art of painting, as such, but what irreducibly constitutes *good* art as such. Or rather, what is the ultimate source of value or quality in art?" But I would argue that what modernism has meant is that the two questions—What constitutes the art of painting? And what constitutes *good* painting?—are no longer separable; the first disappears, or increasingly tends to disappear, into the second. (I am, of course, taking issue here with the version of modernism put forward in my *Three American Painters*.)

For more on the nature of essence and convention in the modernist arts see my essays on Stella and Olitski mentioned above, as well as Stanley Cavell, "Music Discomposed," and "Rejoinders" to critics of that essay, to be published as part of a symposium by the University of Pittsburgh Press in a volume entitled *Art, Mind and Religion*. Cavell's pieces will also appear in *Must We Mean What We Say?*, a book of his essays to be published in the near future by Scribner's.

The meaning in this context of "the condition of non-art" is what I have been calling objecthood. It is as though objecthood alone can, in the present circumstances, secure something's identity, if not as non-art, at least as neither painting nor sculpture; or as though a work of art—more accurately, a work of modernist painting or sculpture— were in some essential respect *not an object.*

There is, in any case, a sharp contrast between the literalist espousal of objecthood—almost, it seems, as an art in its own right— and modernist painting's self-imposed imperative that it defeat or suspend its own objecthood through the medium of shape. In fact, from the perspective of recent modernist painting, the literalist position evinces a sensibility not simply alien but antithetical to its own: as though, from that perspective, the demands of art and the conditions of objecthood are in direct conflict.

Here the question arises: What is it about objecthood as projected and hypostatized by the literalists that makes it, if only from the perspective of recent modernist painting, antithetical to art?

III

The answer I want to propose is this: the literalist espousal of objecthood amounts to nothing other than a plea for a new genre of theatre; and theatre is now the negation of art.

Literalist sensibility is theatrical because, to begin with, it is concerned with the actual circumstances in which the beholder encounters literalist work. Morris makes this explicit. Whereas in previous art "what is to be had from the work is located strictly within [it]," the experience of literalist art is of an object *in a situation*— one that, virtually by definition, *includes the beholder:*

> The better new work takes relationships out of the work and makes them a function of space, light, and the viewer's field of vision. The object is but one of the terms in the newer aesthetic. It is in some way more reflexive because one's awareness of oneself existing in the same space as the work is stronger than in previous work, with its many internal relationships. One is more aware than before that he himself is establishing relationships as he apprehends the object from various positions and under varying conditions of light and spatial context.

Morris believes that this awareness is heightened by "the strength of the constant, known shape, the gestalt," against which the appearance of the piece from different points of view is constantly being compared. It is intensified also by the large scale of much literalist work:

> The awareness of scale is a function of the comparison made between that constant, one's body size, and the object. Space between the subject and the object is implied in such a comparison.

The larger the object the more we are forced to keep our distance from it:

> It is this necessary, greater distance of the object in space from our bodies, in order that it be seen at all, that structures the nonpersonal or public mode [which Morris advocates]. However, it is just this distance between object and subject that creates a more extended situation, because physical participation becomes necessary.

The theatricality of Morris's notion of the "nonpersonal or public mode" seems obvious: the largeness of the piece, in conjunction with its nonrelational, unitary character, *distances* the beholder—not just physically but psychically. It is, one might say, precisely this distancing that *makes* the beholder a subject and the piece in question . . . an object. But it does not follow that the larger the piece the more securely its "public" character is established; on the contrary, "beyond a certain size the object can overwhelm and the gigantic scale becomes the loaded term." Morris wants to achieve presence through objecthood, which requires a certain largeness of scale, rather than through size alone. But he is also aware that this distinction is anything but hard and fast:

> For the space of the room itself is a structuring factor both in its cubic shape and in terms of the kind of compression different sized and proportioned rooms can effect upon the object–subject terms. That the space of the room becomes of such importance does not mean that an environmental situation is being established. The total space is hopefully altered in certain desired ways

by the presence of the object. It is not controlled in the sense of being ordered by an aggregate of objects or by some shaping of the space surrounding the viewer.

The object, not the beholder, must remain the center or focus of the situation; but the situation itself *belongs to* the beholder—it is *his* situation. Or as Morris has remarked, "I wish to emphasize that things are in a space with oneself, rather than . . . [that] one is in a space surrounded by things." Again, there is no clear or hard distinction between the two states of affairs: one is, after all, *always* surrounded by things. But the things that are literalist works of art must somehow *confront* the beholder—they must, one might almost say, be placed not just in his space but in his *way*. None of this, Morris maintains,

> indicates a lack of interest in the object itself. But the concerns now are for more control of . . . the entire situation. Control is necessary if the variables of object, light, space, body, are to function. The object has not become less important. It has merely become less self-important.

It is, I think, worth remarking that "the entire situation" means exactly that: *all* of it—including, it seems, the beholder's *body*. There is nothing within his field of vision—nothing that he takes note of in any way—that, as it were, declares its irrelevance to the situation, and therefore to the experience, in question. On the contrary, for something to be perceived at all is for it to be perceived as part of that situation. Everything counts—not as part of the object, but as part of the situation in which its objecthood is established and on which that objecthood at least partly depends.

IV

Furthermore, the presence of literalist art, which Greenberg was the first to analyze, is basically a theatrical effect or quality—a kind of *stage* presence. It is a function, not just of the obtrusiveness and, often, even aggressiveness of literalist work, but of the special complicity that that work extorts from the beholder. Something is said to have presence when it demands that the beholder take it into account, that he take it *seriously*—and when the fulfillment of that

demand consists simply in being *aware* of it and, so to speak, in acting accordingly. (Certain modes of seriousness are closed to the beholder by the work itself, *i.e.*, those established by the finest painting and sculpture of the recent past. But, of course, *those* are hardly modes of seriousness in which most people feel at home, or that they even find tolerable.) Here again the experience of being distanced by the work in question seems crucial: the beholder knows himself to stand in an indeterminate, open-ended—and unexacting—relation *as subject* to the impassive object on the wall or floor. In fact, being distanced by such objects is not, I suggest, entirely unlike being distanced, or crowded, by the silent presence of another *person;* the experience of coming upon literalist objects unexpectedly— for example, in somewhat darkened rooms—can be strongly, if momentarily, disquieting in just this way.

There are three main reasons why this is so. First, the size of much literalist work, as Morris's remarks imply, compares fairly closely with that of the human body. In this context Tony Smith's replies to questions about his six-foot cube, *Die*, are highly suggestive:

Q: Why didn't you make it larger so that it would loom over the observer?
A: I was not making a monument.
Q: Then why didn't you make it smaller so that the observer could see over the top?
A: I was not making an object.[5]

One way of describing what Smith *was* making might be something like a surrogate person—that is, a kind of *statue.* (This reading finds support in the caption to a photograph of another of Smith's pieces, *The Black Box*, published in the December 1967 issue of *Artforum*, in which Samuel Wagstaff, Jr., presumably with the artist's sanction, observed, "One can see the two-by-fours under the piece, which keep it from appearing like architecture or a monument, and set it off as sculpture." The two-by-fours are, in effect, a rudimentary *pedestal,* and thereby reinforce the statue-like quality of the piece.) Second, the entities or beings encountered in everyday experience in terms

[5] Quoted by Morris as the epigraph to his "Notes on Sculpture, Part 2."

that most closely approach the literalist ideals of the nonrelational, the unitary and the wholistic are *other persons*. Similarly, the literalist predilection for symmetry, and in general for a kind of order that "is simply order . . . one thing after another," is rooted, not, as Judd seems to believe, in new philosophical and scientific principles, whatever he takes these to be, but in *nature*. And third, the apparent hollowness of most literalist work—the quality of having an *inside*—is almost blatantly anthropomorphic. It is, as numerous commentators have remarked approvingly, as though the work in question has an inner, even secret, life—an effect that is perhaps made most explicit in Morris's *Untitled* (1965–66), a large ringlike form in two halves, with fluorescent light glowing from within at the narrow gap between the two. In the same spirit Tony Smith has said, "I'm interested in the inscrutability and mysteriousness of the thing."[6] He has also been quoted as saying:

> More and more I've become interested in pneumatic structures. In these, all of the material is in tension. But it is the character of the form that appeals to me. The biomorphic forms that result from the construction have a dreamlike quality for me, at least like what is said to be a fairly common type of American dream.

Smith's interest in pneumatic structures may seem surprising, but it is consistent both with his own work and with literalist sensibility generally. Pneumatic structures can be described as hollow with a vengeance—the fact that they are not "obdurate, solid masses" (Morris) being *insisted on* instead of taken for granted. And it reveals something, I think, about what hollowness means in literalist art that the forms that result are "biomorphic."

V

I am suggesting, then, that a kind of latent or hidden naturalism, indeed anthropomorphism, lies at the core of literalist theory and practice. The concept of presence all but says as much, though rarely so nakedly as in Tony Smith's statement, "I didn't think of

[6] Except for the Morris epigraph already quoted, all statements by Tony Smith have been taken from Samuel Wagstaff, Jr.'s, "Talking to Tony Smith," *Artforum*, Vol. V, No. 4, December 1966.

them [*i.e.*, the sculptures he "always" made] as sculptures but as presences of a sort." The latency or hiddenness of the anthropomorphism has been such that the literalists themselves have, as we have seen, felt free to characterize the modernist art they *oppose*, *e.g.*, the sculpture of David Smith and Anthony Caro, as anthropomorphic—a characterization whose teeth, imaginary to begin with, have just been pulled. By the same token, however, what is wrong with literalist work is not that it is anthropomorphic but that the meaning and, equally, the hiddenness of its anthropomorphism are incurably theatrical. (Not all literalist art hides or masks its anthropomorphism; the work of lesser figures like Steiner wears anthropomorphism on its sleeve.) *The crucial distinction that I am proposing so far is between work that is fundamentally theatrical and work that is not.* It is theatricality that, whatever the differences between them, links artists like Bladen and Grosvenor,[7] both of whom have allowed "gigantic scale [to become] the loaded term" (Morris), with other, more restrained figures like Judd, Morris, Andre, McCracken, LeWitt and—despite the *size* of some of his pieces—Tony Smith.[8] And it is in the interest, though not explicitly in the *name*, of theatre that literalist ideology rejects both modernist painting and, at least in the hands of its most distinguished recent practitioners, modernist sculpture.

In this connection Tony Smith's description of a car ride taken at night on the New Jersey Turnpike before it was finished makes compelling reading:

> When I was teaching at Cooper Union in the first year or two of the fifties, someone told me how I could get onto the unfinished New Jersey Turnpike. I took three students and drove from somewhere in the Meadows to New Brunswick. It was a dark

[7] In the catalogue to last spring's Primary Structures exhibition at the Jewish Museum, Bladen wrote, "How do you make the inside the outside?" and Grosvenor, "I don't want my work to be thought of as 'large sculpture,' they are ideas that operate in the space between floor and ceiling." The relevance of these statements to what I have adduced as evidence for the theatricality of literalist theory and practice seems obvious.

[8] It is theatricality, too, that links all these artists to other figures as disparate as Kaprow, Cornell, Rauschenberg, Oldenburg, Flavin, Smithson, Kienholz, Segal, Samaras, Christo, Kusama . . . the list could go on indefinitely.

night and there were no lights or shoulder markers, lines, railings, or anything at all except the dark pavement moving through the landscape of the flats, rimmed by hills in the distance, but punctuated by stacks, towers, fumes, and colored lights. This drive was a revealing experience. The road and much of the landscape was artificial, and yet it couldn't be called a work of art. On the other hand, it did something for me that art had never done. At first I didn't know what it was, but its effect was to liberate me from many of the views I had had about art. It seemed that there had been a reality there that had not had any expression in art.

The experience on the road was something mapped out but not socially recognized. I thought to myself, it ought to be clear that's the end of art. Most painting looks pretty pictorial after that. There is no way you can frame it, you just have to experience it. Later I discovered some abandoned airstrips in Europe—abandoned works, Surrealist landscapes, something that had nothing to do with any function, created worlds without tradition. Artificial landscape without cultural precedent began to dawn on me. There is a drill ground in Nuremberg large enough to accommodate two million men. The entire field is enclosed with high embankments and towers. The concrete approach is three sixteen-inch steps, one above the other, stretching for a mile or so.

What seems to have been revealed to Smith that night was the pictorial nature of painting—even, one might say, the conventional nature of art. And *this* Smith seems to have understood not as laying bare the essence of art, but as announcing its end. In comparison with the unmarked, unlit, all but unstructured turnpike—more precisely, with the turnpike as experienced from within the car, traveling on it—art appears to have struck Smith as almost absurdly small ("All art today is an art of postage stamps," he has said), circumscribed, conventional. . . . There was, he seems to have felt, no way to "frame" his experience on the road, that is, no way to make sense of it in terms of art, to make *art* of it, at least as art then was. Rather, "you just have to experience it"—as it *happens*, as it merely *is*. (The experience *alone* is what matters.) There is no suggestion that this is problematic in any way. The experience is clearly regarded by Smith as wholly accessible to everyone, not just in princi-

Robert Morris: Untitled. 1965. Gray fiberglass with light. 24″ x 96″ diameter. In the collection of the Dwan Gallery. Photograph courtesy of Leo Castelli Gallery, New York.

Jules Olitski: *Bunga 45*. 1967. Aluminum painted with acrylic resin. 10′ x 44″. In the collection of Robert Rowan. Photograph courtesy of Andre Emmerich Gallery, New York.

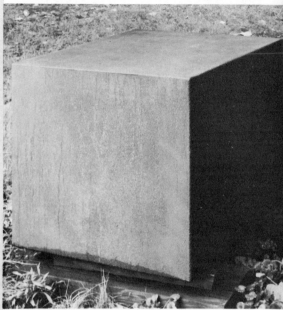

Tony Smith: *The Black Box.* 1963–65. Painted wood. 2½′ x 3′. Photograph courtesy of Fischbach Gallery, New York.

ple but in fact, and the question of whether or not one has really *had* it does not arise. That this appeals to Smith can be seen from his praise of Le Corbusier as "more available" than Michelangelo: "The direct and primitive experience of the High Court Building at Chandigarh is like the Pueblos of the Southwest under a fantastic overhanging cliff. It's something everyone can understand." It is, I think, hardly necessary to add that the availability of modernist art is not of this kind, and that the rightness or relevance of one's conviction about specific modernist works, a conviction that begins and ends in one's experience of the work itself, is always open to question.

But what *was* Smith's experience on the turnpike? Or to put the same question another way, if the turnpike, airstrips, and drill ground are not works of art, what *are* they?—What, indeed, if not empty, or "abandoned", *situations?* And what was Smith's experience if not the experience of what I have been calling *theatre?* It is as though the turnpike, airstrips, and drill ground reveal the theatrical character of literalist art, only without the object, that is, *without the art itself*—as though the object is needed only within a *room*[9] (or, perhaps, in any circumstances less extreme than these). In each of the above cases the object is, so to speak, *replaced* by something: for example, on the turnpike by the constant onrush of the road, the simultaneous recession of new reaches of dark pavement illumined by the onrushing headlights, the sense of the turnpike itself as something enormous, abandoned, derelict, existing for Smith alone and for those in the car with him. . . . This last point is important. On the one hand, the turnpike, airstrips, and drill ground belong to no one; on the other, the situation established by Smith's presence is in each case felt by him to be *his*. Moreover, in each case being able to go on and on indefinitely is of the essence. What replaces the object— what does the same job of distancing or isolating the beholder, of making him a subject, that the object did in the closed room—is above all the endlessness, or objectlessness, of the approach or on-rush or perspective. It is the explicitness, that is to say, the sheer

[9] The concept of a room is, mostly clandestinely, important to literalist art and theory. In fact, it can often be substituted for the word "space" in the latter: something is said to be in my space if it is in the same *room* with me (and if it is placed so that I can hardly fail to notice it).

persistence, with which the experience presents itself as directed at him from outside (on the turnpike from outside the *car*) that simultaneously makes him a subject—makes him subject—and establishes the experience itself as something like that of an object, or rather, of objecthood. No wonder Morris's speculations about how to put literalist work outdoors remain strangely inconclusive:

> Why not put the work outdoors and further change the terms? A real need exists to allow this next step to become practical. Architecturally designed sculpture courts are not the answer nor is the placement of work outside cubic architectural forms. Ideally, it is a space, without architecture as background and reference, that would give different terms to work with.

Unless the pieces are set down in a wholly natural context, and Morris does not seem to be advocating this, some sort of artificial but not quite architectural setting must be constructed. What Smith's remarks seem to suggest is that the more effective—meaning effective *as theatre*—the setting is made, the more superfluous the works themselves become.

VI

Smith's account of his experience on the turnpike bears witness to theatre's profound hostility to the arts, and discloses, precisely in the absence of the object and in what takes its place, what might be called the theatricality of objecthood. By the same token, however, the imperative that modernist painting defeat or suspend its objecthood is at bottom the imperative that it *defeat or suspend theatre*. And *this* means that there is a war going on between theatre and modernist painting, between the theatrical and the pictorial—a war that, despite the literalists' explicit rejection of modernist painting and sculpture, is not basically a matter of program and ideology but of experience, conviction, sensibility. (For example, it was a particular experience that *engendered* Smith's conviction that painting—in fact, that the arts as such—were finished.)

The starkness and apparent irreconcilability of this conflict is something new. I remarked earlier that objecthood has become an issue for modernist painting only within the past several years. This, however, is not to say that *before* the present situation came into

being, paintings, or sculptures for that matter, simply *were objects*. It would, I think, be closer to the truth to say that they *simply* were not.[10] The risk, even the possibility, of seeing works of art as *nothing more* than objects did not exist. That this possibility began to present itself around 1960 was largely the result of developments within modernist painting. Roughly, the more nearly assimilable to objects certain advanced painting had come to seem, the more the entire history of painting since Manet could be understood— delusively, I believe—as consisting in the progressive (though ultimately inadequate) revelation of its essential objecthood,[11] and the more urgent became the need for modernist painting to make explicit its conventional—specifically, its *pictorial*—essence by defeating or suspending its own objecthood through the medium of shape. The view of modernist painting as tending toward objecthood is implicit in Judd's remark, "The new [*i.e.*, literalist] work obviously resembles sculpture more than it does painting, but it is nearer to painting"; and it is in this view that literalist sensibility in general is grounded. Literalist sensibility is, therefore, a response to the *same* developments that have largely compelled modernist painting to undo its objecthood—more precisely, the same developments *seen differently,* that is, in theatrical terms, by a sensibility *already* theatrical, already (to say the worst) corrupted or perverted by theatre.

[10] Stanley Cavell has remarked in seminar that for Kant in the *Critique of Judgment* a work of art is not an object. I will take this opportunity to acknowledge the fact that without numerous conversations with Cavell during the past few years, and without what I have learned from him in courses and seminars, the present essay—and not it alone—would have been inconceivable. I want also to express my gratitude and indebtedness to the composer John Harbison, who, together with his wife, the violinist Rosemary Harbison, has given me whatever initiation into modern music I have had, both for that initiation and for numerous insights bearing on the subject of this essay.

[11] One way of describing this view might be to say that it draws something like a false inference from the fact that the increasingly explicit acknowledgment of the literal character of the support has been central to the development of modernist painting: namely, that literalness *as such* is an artistic value of supreme importance. In "Shape as Form" I argued that this inference is blind to certain vital considerations; and implied that literalness—more precisely, the literalness of the support—is a value only *within* modernist painting, and then only because it has been *made* one by the history of that enterprise.

Similarly, what has compelled modernist painting to defeat or suspend its own objecthood is not just developments internal to itself, but the same general, enveloping, infectious theatricality that corrupted literalist sensibility in the first place and in the grip of which the developments in question—and modernist painting in general— are seen as nothing more than an uncompelling and presenceless kind of theatre. It was the need to break the fingers of this grip that made objecthood an issue for modernist painting.

Objecthood has also become an issue for modernist sculpture. This is true despite the fact that sculpture, being three-dimensional, resembles both ordinary objects and literalist work in a way that painting does not. Almost ten years ago Clement Greenberg summed up what he saw as the emergence of a new sculptural "style," whose master is undoubtedly David Smith, in the following terms:

> To render substance entirely optical, and form, whether pictorial, sculptural, or architectural, as an integral part of ambient space— this brings anti-illusionism full circle. Instead of the illusion of things, we are now offered the illusion of modalities: namely, that matter is incorporeal, weightless, and exists only optically like a mirage.[12]

Since 1960 this development has been carried to a succession of climaxes by the English sculptor Anthony Caro, whose work is far more *specifically* resistant to being seen in terms of objecthood than that of David Smith. A characteristic sculpture by Caro consists, I want to say, in the mutual and naked *juxtaposition* of the *I*-beams, girders, cylinders, lengths of piping, sheet metal, and grill that it comprises rather than in the compound *object* that they compose. The mutual inflection of one element by another, rather than the identity of each, is what is crucial—though of course altering the identity of any element would be at least as drastic as altering its placement. (The identity of each element matters in somewhat the same way as the fact that it is an *arm*, or *this* arm, that makes a particular gesture; or as the fact that it is *this* word or *this* note and not another that occurs in a particular place in a sentence or melody.) The individual elements bestow significance on one an-

[12] "The New Sculpture," *Art and Culture,* Boston, 1961, p. 144.

other precisely by virtue of their juxtaposition: it is in this sense, a sense inextricably involved with the concept of meaning, that everything in Caro's art that is worth looking at is in its syntax. Caro's concentration upon syntax amounts, in Greenberg's view, to "an emphasis on abstractness, on radical unlikeness to nature."[13] And Greenberg goes on to remark, "No other sculptor has gone as far from the structural logic of ordinary ponderable things." It is worth emphasizing, however, that this is a function of more than the lowness, openness, part-by-partness, absence of enclosing profiles and centers of interest, unperspicuousness, etc., of Caro's sculptures. Rather they defeat, or allay, objecthood by imitating, not gestures exactly, but the *efficacy* of gesture; like certain music and poetry, they are possessed by the knowledge of the human body and how, in innumerable ways and moods, it makes meaning. It is as though Caro's sculptures essentialize meaningfulness *as such*—as though the possibility of meaning what we say and do *alone* makes his sculpture possible. All this, it is hardly necessary to add, makes Caro's art a fountainhead of antiliteralist and antitheatrical sensibility.

There is another, more general respect in which objecthood has become an issue for the most ambitious recent modernist sculpture and that is in regard to *color*. This is a large and difficult subject, which I cannot hope to do more than touch on here.[14] Briefly, however, color has become problematic for modernist sculpture, not because one senses that it has been *applied,* but because the color of a given sculpture, whether applied or in the natural state of the material, is identical with its surface; and inasmuch as all objects have surface, awareness of the sculpture's surface implies its objecthood—thereby threatening to qualify or mitigate the undermining

[13] This and the following remark are taken from Greenberg's essay, "Anthony Caro," *Arts Yearbook,* No. 8, 1965. Caro's first step in this direction, the elimination of the pedestal, seems in retrospect to have been motivated not by the desire to present his work without artificial aids so much as by the need to undermine its objecthood. His work has revealed the extent to which merely putting something on a pedestal *confirms* it in its objecthood; though merely removing the pedestal does not in itself undermine objecthood, as literalist work proves.

[14] See Greenberg's "Anthony Caro" and the last section of my "Shape as Form" for more, though not a great deal more, about color in sculpture.

of objecthood achieved by opticality and, in Caro's pieces, by their syntax as well. It is in this connection, I believe, that a very recent sculpture, *Bunga*, by Jules Olitski ought to be seen. *Bunga* consists of between fifteen and twenty metal tubes, ten feet long and of various diameters, placed upright, riveted together and then sprayed with paint of different colors; the dominant hue is yellow to yellow-orange, but the top and "rear" of the piece are suffused with a deep rose, and close looking reveals flecks and even thin trickles of green and red as well. A rather wide red band has been painted around the top of the piece, while a much thinner band in two different blues (one at the "front" and another at the "rear") circumscribes the very bottom. Obviously, *Bunga* relates intimately to Olitski's spray paintings, especially those of the past year or so, in which he has worked with paint and brush at or near the limits of the support. At the same time, it amounts to something far more than an attempt simply to make or "translate" his paintings into sculptures, namely, an attempt to establish surface—the surface, so to speak, of *painting* —as a medium of sculpture. The use of tubes, each of which one sees, incredibly, as *flat*—that is, flat but *rolled*—makes *Bunga*'s surface more like that of a painting than like that of an object: like painting, and unlike both ordinary objects and other sculpture, *Bunga* is *all* surface. And of course what declares or establishes that surface is color, Olitski's sprayed color.

VII

At this point I want to make a claim that I cannot hope to prove or substantiate but that I believe nevertheless to be true: *viz.*, that theatre and theatricality are at war today, not simply with modernist painting (or modernist painting and sculpture), but with art as such—and to the extent that the different arts can be described as modernist, with modernist sensibility as such. This claim can be broken down into three propositions or theses:

1) *The success, even the survival, of the arts has come increasingly to depend on their ability to defeat theatre.* This is perhaps nowhere more evident than within theatre itself, where the need to defeat what I have been calling theatre has chiefly made itself felt as the need to establish a drastically different relation to its audience. (The

relevant texts are, of course, Brecht and Artaud.[15]) For theatre *has* an audience—it *exists for* one—in a way the other arts do not; in fact, this more than anything else is what modernist sensibility finds intolerable in theatre generally. Here it should be remarked that literalist art, too, possesses an audience, though a somewhat special one: that the beholder is confronted by literalist work within a situation that he experiences as *his* means that there is an important sense in which the work in question exists for him *alone*, even if he is not actually alone with the work at the time. It may seem paradoxical to claim both that literalist sensibility aspires to an ideal of "something everyone can understand" (Smith) *and* that literalist art addresses itself to the beholder alone, but the paradox is only apparent. Someone has merely to enter the room in which a literalist work has been placed to *become* that beholder, that audience of one— almost as though the work in question has been *waiting for* him. And inasmuch as literalist work *depends on* the beholder, is *incomplete* without him, it *has* been waiting for him. And once he is in the room the work refuses, obstinately, to let him alone—which is to say, it refuses to stop confronting him, distancing him, isolating him. (Such isolation is not solitude any more than such confrontation is communion.)

It is the overcoming of theatre that modernist sensibility finds most exalting and that it experiences as the hallmark of high art in our time. There is, however, one art that, by its very nature, *escapes* theatre entirely—the movies.[16] This helps explain why movies in

[15] The need to achieve a new relation to the spectator, which Brecht felt and which he discussed time and again in his writings on theatre, was not simply the result of his Marxism. On the contrary, his discovery of Marx seems to have been in part the discovery of what this relation might be like, what it might mean: "When I read Marx's *Capital* I understood my plays. Naturally I want to see this book widely circulated. It wasn't of course that I found I had unconsciously written a whole pile of Marxist plays; but this man Marx was the only spectator for my plays I'd ever come across." (*Brecht on Theater*, edited and translated by John Willett, New York, 1964, pp. 23–24.)

[16] Exactly how the movies escape theatre is a beautiful question, and there is no doubt but that a phenomenology of the cinema that concentrated on the similarities and differences between it and the theatre—e.g., that in the movies the actors are not physically present, the film itself is projected *away* from us, the screen is not experienced as a kind of object existing, so to speak, in a specific physical relation to us, etc.—would be extremely rewarding. Cavell,

general, including frankly appalling ones, are acceptable to modern-
ist sensibility whereas all but the most successful painting, sculpture,
music, and poetry is not. Because cinema escapes theatre—auto-
matically, as it were—it provides a welcome and absorbing refuge to
sensibilities at war with theatre and theatricality. At the same time,
the automatic, guaranteed character of the refuge—more accurately,
the fact that what is provided is a refuge from theatre and not a
triumph over it, absorption not conviction—means that the cinema,
even at its most experimental, is not a *modernist* art.

2) *Art degenerates as it approaches the condition of theatre.*
Theatre is the common denominator that binds a large and seem-
ingly disparate variety of activities to one another, and that distin-
guishes those activities from the radically different enterprises of the
modernist arts. Here as elsewhere the question of value or level is
central. For example, a failure to register the enormous difference in
quality between, say, the music of Carter and that of Cage or be-
tween the paintings of Louis and those of Rauschenberg means that
the real distinctions—between music and theatre in the first instance
and between painting and theatre in the second—are displaced by
the illusion that the barriers between the arts are in the process of
crumbling (Cage and Rauschenberg being seen, correctly, as simi-
lar) and that the arts themselves are at last sliding towards some
kind of final, implosive, hugely desirable synthesis.[17] Whereas in

again, has called attention, in conversation, to the sort of *remembering* that
goes into giving an account of a movie, and more generally to the nature of
the difficulties that are involved in giving such an account.

[17] This is the view of Susan Sontag, whose various essays, collected in
Against Interpretation, amount to perhaps the purest—certainly the most
egregious—expression of what I have been calling theatrical sensibility in
recent criticism. In this sense they are indeed the "case studies for an aesthetic,
a theory of my own sensibility" that she takes them to be. In a characteristic
passage Miss Sontag contends:

> Art today is a new kind of instrument, an instrument for modifying con-
> sciousness and organizing new modes of sensibility. And the means for
> practicing art have been radically extended. . . . Painters no longer feel
> themselves confined to canvas and paint, but employ hair, photographs,
> wax, sand, bicycle tires, their own toothbrushes, and socks. . . . All kinds
> of conventionally accepted boundaries have thereby been challenged: not
> just the one between the "scientific" and the "literary–artistic" cultures, or

fact the individual arts have never been more explicitly concerned with the conventions that constitute their respective essences.

3) *The concepts of quality and value—and to the extent that these are central to art, the concept of art itself—are meaningful, or wholly meaningful, only* within *the individual arts. What lies be*tween *the arts is theatre.* It is, I think, significant that in their various statements the literalists have largely avoided the issue of value or quality at the same time as they have shown considerable uncertainty as to whether or not what they are making is art. To describe their enterprise as an attempt to establish a *new* art does not remove the uncertainty; at most it points to its source. Judd himself has as much as acknowledged the problematic character of the literalist enterprise by his claim, "A work needs only to be interesting." For Judd, as for literalist sensibility generally, all that matters is whether or not a given work is able to elicit and sustain (his) *interest.* Whereas within the modernist arts nothing short of *conviction*—specifically, the conviction that a particular painting or sculpture or poem or piece of music can or cannot support comparison with past work within that art whose quality is not in doubt—matters at all. (Literalist work is often condemned—when it *is* condemned—for being boring. A tougher charge would be that it is merely interesting.)

The interest of a given work resides, in Judd's view, both in its character as a whole and in the sheer *specificity* of the materials of which it is made:

> Most of the work involves new materials, either recent inventions or things not used before in art. . . . Materials vary greatly and are simply materials—formica, aluminum, cold-rolled steel, plexiglas, red and common brass, and so forth. They are specific. If

the one between "art" and "non-art"; but also many established distinctions within the world of culture itself—that between form and content, the frivolous and the serious, and (a favorite of literary intellectuals) "high" and "low" culture. (pp. 296–97)

The truth is that the distinction between the frivolous and the serious becomes more urgent, even absolute, every day, and the enterprises of the modernist arts more purely motivated by the felt need to perpetuate the standards and values of the high art of the past.

they are used directly, they are more specific. Also, they are usually aggressive. There is an objectivity to the obdurate identity of a material.

Like the shape of the object, the materials do not represent, signify, or allude to anything; they are what they are and nothing more. And what they are is not, strictly speaking, something that is grasped or intuited or recognized or even seen once and for all. Rather, the "obdurate identity" of a specific material, like the wholeness of the shape, is simply stated or given or established at the very outset, if not before the outset; accordingly, the experience of both is one of endlessness, of inexhaustibility, of being able to go on and on letting, for example, the material itself confront one in all its literalness, its "objectivity," its absence of anything beyond itself. In a similar vein Morris has written:

> Characteristic of a gestalt is that once it is established all the information about it, *qua* gestalt, is exhausted. (One does not, for example, seek the gestalt of a gestalt.) . . . One is then both free of the shape and bound to it. Free or released because of the exhaustion of information about it, as shape, and bound to it because it remains constant and indivisible.

The same note is struck by Tony Smith in a statement the first sentence of which I quoted earlier:

> I'm interested in the inscrutability and mysteriousness of the thing. Something obvious on the face of it (like a washing machine or a pump) is of no further interest. A Bennington earthenware jar, for instance, has subtlety of color, largeness of form, a general suggestion of substance, generosity, is calm and reassuring—qualities that take it beyond pure utility. It continues to nourish us time and time again. We can't see it in a second, we continue to read it. There is something absurd in the fact that you can go back to a cube in the same way.

Like Judd's Specific Objects and Morris's gestalts or unitary forms, Smith's cube is *always* of further interest; one never feels that one has come to the end of it; it is inexhaustible. It is inexhaustible,

however, not because of any fullness—*that* is the inexhaustibility of art—but because there is nothing there to exhaust. It is endless the way a road might be: if it were circular, for example.

Endlessness, being able to go on and on, even having to go on and on, is central both to the concept of interest and to that of object-hood. In fact, it seems to be the experience that most deeply excites literalist sensibility, and that literalist artists seek to objectify in their work—for example, by the repetition of identical units (Judd's "one thing after another"), which carries the implication that the units in question could be multiplied *ad infinitum*.[18] Smith's account of his experience on the unfinished turnpike records that excitement all but explicitly. Similarly, Morris's claim that in the best new work the beholder is made aware that "he himself is establishing relationships as he apprehends the object from various positions and under vary-ing conditions of light and spatial context" amounts to the claim that the beholder is made aware of the endlessness and inexhaustibility if not of the object itself at any rate of his experience of it. This awareness is further exacerbated by what might be called the *inclu-siveness* of his situation, that is, by the fact, remarked earlier, that everything he observes counts as part of that situation and hence is felt to bear in some way that remains undefined on his experience of the object.

Here finally I want to emphasize something that may already have become clear: the experience in question *persists in time,* and the presentment of endlessness that, I have been claiming, is central to literalist art and theory is essentially a presentment of endless, or indefinite, *duration.* Once again Smith's account of his night drive is relevant, as well as his remark, "We can't see it [*i.e.*, the jar and, by implication, the cube] in a second, we continue to read it." Morris, too, has stated explicitly, "The experience of the work necessarily exists in time"—though it would make no difference if he had not.

[18] That is, the *actual* number of such units in a given piece is felt to be arbi-trary, and the piece itself—despite the literalist preoccupation with wholistic forms—is seen as a fragment of, or cut into, something infinitely larger. This is one of the most important differences between literalist work and modernist painting, which has made itself responsible for its physical limits as never be-fore. Noland's and Olitski's paintings are two obvious, and different, cases in point. It is in this connection, too, that the importance of the painted bands around the bottom and the top of Olitski's sculpture, *Bunga,* becomes clear.

The literalist preoccupation with time—more precisely, with the *duration of the experience*—is, I suggest, paradigmatically theatrical: as though theatre confronts the beholder, and thereby isolates him, with the endlessness not just of objecthood but of *time;* or as though the sense which, at bottom, theatre addresses is a sense of temporality, of time both passing and to come, *simultaneously approaching and receding,* as if apprehended in an infinite perspective . . .[19] This preoccupation marks a profound difference between literalist work and modernist painting and sculpture. It is as though one's experience of the latter *has no* duration—not because one *in fact* experiences a picture by Noland or Olitski or a sculpture by David Smith or Caro in no time at all, but because *at every moment the work itself is wholly manifest.* (This is true of sculpture despite the obvious fact that, being three-dimensional, it can be seen from an infinite number of points of view. One's experience of a Caro is not incomplete, and one's conviction as to its quality is not suspended, simply because one has seen it only from where one is standing. Moreover, in the grip of his best work one's view of the

[19] The connection between spatial recession and some such experience of temporality—almost as if the first were a kind of natural metaphor for the second—is present in much Surrealist painting (e.g., De Chirico, Dali, Tanguy, Magritte . . .). Moreover, temporality—manifested, for example, as expectation, dread, anxiety, presentiment, memory, nostalgia, stasis—is often the explicit subject of their paintings. There is, in fact, a deep affinity between literalists and Surrealist sensibility (at any rate, as the latter makes itself felt in the work of the above painters), which ought to be noted. Both employ imagery that is at once wholistic and, in a sense, fragmentary, incomplete; both resort to a similar anthropomorphizing of objects or conglomerations of objects (in Surrealism the use of dolls and mannikins makes this explicit); both are capable of achieving remarkable effects of "presence"; and both tend to deploy and isolate objects and persons in *situations*—the closed room and the abandoned artificial landscape are as important to Surrealism as to literalism. (Tony Smith, it will be recalled, described the airstrips, etc., as "Surrealist landscapes.") This affinity can be summed up by saying that Surrealist sensibility, as manifested in the work of certain artists, and literalist sensibility are both *theatrical.* I do not wish, however, to be understood as saying that because they are theatrical, all Surrealist works that share the above characteristics fail as art; a conspicuous example of major work that can be described as theatrical is Giacometti's Surrealist sculpture. On the other hand, it is perhaps not without significance that Smith's supreme example of a Surrealist landscape was the parade ground at Nuremberg.

sculpture is, so to speak, *eclipsed* by the sculpture itself—which it is plainly meaningless to speak of as only *partly* present.) It is this continuous and entire presentness, amounting, as it were, to the perpetual creation of itself, that one experiences as a kind of *instantaneousness:* as though if only one were infinitely more acute, a single infinitely brief instant would be long enough to see everything, to experience the work in all its depth and fullness, to be forever convinced by it. (Here it is worth noting that the concept of interest implies temporality in the form of continuing attention directed at the object, whereas the concept of conviction does not.) I want to claim that it is by virtue of their presentness and instantaneousness that modernist painting and sculpture defeat theatre. In fact, I am tempted far beyond my knowledge to suggest that, faced with the need to defeat theatre, it is above all to the condition of painting and sculpture—the condition, that is, of existing in, indeed of secreting or constituting, a continuous and perpetual *present*— that the other contemporary modernist arts, most notably poetry and music, aspire.[20]

[20] What this means in each art will naturally be different. For example, music's situation is especially difficult in that music shares with theatre the convention, if I may call it that, of duration—a convention that, I am suggesting, has itself become increasingly theatrical. Besides, the physical circumstances of a concert closely resemble those of a theatrical performance. It may have been the desire for something like presentness that, at least to some extent, led Brecht to advocate a nonillusionistic theatre, in which for example the stage lighting would be visible to the audience, in which the actors would not identify with the characters they play but rather would show them forth, and in which temporality itself would be presented in a new way:

> Just as the actor no longer has to persuade the audience that it is the author's character and not himself that is standing on the stage, so also he need not pretend that the events taking place on the stage have never been rehearsed, and are now happening for the first and only time. Schiller's distinction is no longer valid: that the rhapsodist has to treat his material as wholly in the past: the mime his, as wholly here and now. It should be apparent all through his performance that 'even at the start and in the middle he knows how it ends' and he must 'thus maintain a calm independence throughout.' He narrates the story of his character by vivid portrayal, always knowing more than it does and treating 'now' and 'here' not as a pretence made possible by the rules of the game but as something to be distinguished from yesterday and some other place, so as to make visible the knotting together of the events. (p. 194.)

VIII

This essay will be read as an attack on certain artists (and critics) and as a defense of others. And of course it is true that the desire to distinguish between what is to me the authentic art of our time and other work, which, whatever the dedication, passion, and intelligence of its creators, seems to me to share certain characteristics associated here with the concepts of literalism and theatre, has largely motivated what I have written. In these last sentences, however, I want to call attention to the utter pervasiveness—the virtual universality—of the sensibility or mode of being that I have characterized as corrupted or perverted by theatre. We are all literalists most or all of our lives. Presentness is grace.

But just as the exposed lighting Brecht advocates has become merely another kind of theatrical convention (one, moreover, that often plays an important role in the presentation of literalist work, as the installation view of Judd's six-cube piece in the Dwan Gallery shows), it is not clear whether the handling of time Brecht calls for is tantamount to authentic presentness, or merely to another kind of *presence*—i.e., to the presentment of time itself as though it were some sort of literalist object. In poetry the need for presentness manifests itself in the lyric poem; this is a subject that requires its own treatment.

For discussions of theatre relevant to this essay see Cavell's essay on Beckett's *End-Game,* "Ending the Waiting Game," and "The Avoidance of Love: A Reading of King Lear," to be published in *Must We Mean What We Say?*

QUESTIONS TO STELLA AND JUDD* Interview by Bruce Glaser Edited by Lucy R. Lippard

This discussion was broadcast on WBAI-FM, New York, February, 1964, as "New Nihilism or New Art?" It was one of a series of programs produced by Bruce Glaser. Glaser has lectured on art at Hunter College and Pratt Institute, and is now the director of the Art Gallery of the America-Israel Cultural Foundation in New York City.

The material of the broadcast was subsequently edited by Lucy R. Lippard, and was published in *Art News,* September, 1966. In her introduction to the text, Miss Lippard wrote that it contains "the first extensive published statement by Frank Stella, a widely acknowledged source of much current structural painting, and Donald Judd, one of the earliest exponents of the sculptural primary structure, in which the artists themselves challenge and clarify the numerous prevailing generalizations about their work."

BRUCE GLASER: There are characteristics in your work that bring to mind styles from the early part of this century. Is it fair to say that the relative simplicity of Malevich, the Constructivists, Mondrian, the Neo-Plasticists, and the Purists is a precedent for your painting and sculpture, or are you really departing from these earlier movements?

FRANK STELLA: There's always been a trend toward simpler painting and it was bound to happen one way or another. Whenever painting gets complicated, like Abstract Expressionism, or Surrealism, there's going to be someone who's not painting complicated paintings, someone who's trying to simplify.

GLASER: But all through the twentieth century this simple approach has paralleled more complicated styles.

STELLA: That's right, but it's not continuous. When I first showed, Coates in *The New Yorker* said how sad it was to find somebody so young right back where Mondrian was thirty years ago. And I really didn't feel that way.

* Reprinted from *Art News,* September, 1966.

GLASER: You feel there's no connection between you and Mondrian?
STELLA: There are obvious connections. You're always related to something. I'm related to the more geometric, or simpler, painting, but the motivation doesn't have anything to do with that kind of European geometric painting. I think the obvious comparison with my work would be Vasarely, and I can't think of anything I like less.

GLASER: Vasarely?

STELLA: Well, mine has less illusionism than Vasarely's, but the Groupe de Recherche d'Art Visuel actually painted all the patterns before I did—all the basic designs that are in my painting—not the way I did it, but you can find the schemes of the sketches I made for my own paintings in work by Vasarely and that group in France over the last seven or eight years. I didn't even know about it, and in spite of the fact that they used those ideas, those basic schemes, it still doesn't have anything to do with my painting. I find all that European geometric painting—sort of post-Max Bill school—a kind of curiosity—very dreary.

DONALD JUDD: There's an enormous break between that work and other present work in the U.S., despite similarity in patterns or anything. The scale itself is just one thing to pin down. Vasarely's work has a smaller scale and a great deal of composition and qualities that European geometric painting of the 20's and 30's had. He is part of a continuous development from the 30's, and he was doing it himself then.

STELLA: The other thing is that the European geometric painters really strive for what I call relational painting. The basis of their whole idea is balance. You do something in one corner and you balance it with something in the other corner. Now the "new painting" is being characterized as symmetrical. Ken Noland has put things in the center and I'll use a symmetrical pattern, but we use symmetry in a different way. It's nonrelational. In the newer American painting we strive to get the thing in the middle, and symmetrical, but just to get a kind of force, just to get the thing on the canvas. The balance factor isn't important. We're not trying to jockey everything around.

GLASER: What is the "thing" you're getting on the canvas?

STELLA: I guess you'd have to describe it as the image, either the

image or the scheme. Ken Noland would use concentric circles; he'd want to get them in the middle because it's the easiest way to get them there, and he wants them there in the front, on the surface of the canvas. If you're that much involved with the surface of anything, you're bound to find symmetry the most natural means. As soon as you use any kind of relational placement for symmetry, you get into a terrible kind of fussiness, which is the one thing that most of the painters now want to avoid. When you're always making these delicate balances, it seems to present too many problems; it becomes sort of arch.

GLASER: An artist who works in your vein has said he finds symmetry extraordinarily sensuous; on the other hand, I've heard the comment that symmetry is very austere. Are you trying to create a sensuous or an austere effect? Is this relevant to your surfaces?

JUDD: No, I don't think my work is either one. I'm interested in spareness, but I don't think it has any connection to symmetry.

STELLA: Actually, your work is really symmetrical. How can you avoid it when you take a box situation? The only piece I can think of that deals with any kind of asymmetry is one box with a plane cut out.

JUDD: But I don't have any ideas as to symmetry. My things are symmetrical because, as you said, I wanted to get rid of any compositional effects, and the obvious way to do it is to be symmetrical.

GLASER: Why do you want to avoid compositional effects?

JUDD: Well, those effects tend to carry with them all the structures, values, feelings of the whole European tradition. It suits me fine if that's all down the drain. When Vasarely has optical effects within the squares, they're never enough, and he has to have at least three or four squares, slanted, tilted inside each other, and all arranged. That is about five times more composition and juggling than he needs.

GLASER: It's too busy?

JUDD: It is in terms of somebody like Larry Poons. Vasarely's composition has the effect of order and quality that traditional European painting had, which I find pretty objectionable. . . . The objection is not that Vasarely's busy, but that in his multiplicity there's a certain structure that has qualities I don't like.

GLASER: What qualities?

JUDD: The qualities of European art so far. They're innumerable and complex, but the main way of saying it is that they're linked up with a philosophy—rationalism, rationalistic philosophy.

GLASER: Descartes?

JUDD: Yes.

GLASER: And you mean to say that your work is apart from rationalism?

JUDD: Yes. All that art is based on systems built beforehand, *a priori* systems; they express a certain type of thinking and logic that is pretty much discredited now as a way of finding out what the world's like.

GLASER: Discredited by whom? By empiricists?

JUDD: Scientists, both philosophers and scientists.

GLASER: What is the alternative to a rationalistic system in your method? It's often said that your work is preconceived, that you plan it out before you do it. Isn't that a rationalistic method?

JUDD: Not necessarily. That's much smaller. When you think it out as you work on it, or you think it out beforehand, it's a much smaller problem than the nature of the work. *What* you want to express is a much bigger thing than *how* you may go at it. Larry Poons works out the dots somewhat as he goes along; he figures out a scheme beforehand and also makes changes as he goes along. Obviously I can't make many changes, though I do what I can when I get stuck.

GLASER: In other words, you might be referring to an antirationalist position before you actually start making the work of art.

JUDD: I'm making it for a quality that *I* think is interesting and more or less true. And the quality involved in Vasarely's kind of composition isn't true to me.

GLASER: Could you be specific about how your own work reflects an antirationalistic point of view?

JUDD: The parts are unrelational.

GLASER: If there's nothing to relate, then you can't be rational about it because it's just there?

JUDD: Yes.

GLASER: Then it's almost an abdication of logical thinking.

JUDD: I don't have anything against using some sort of logic. That's simple. But when you start relating parts, in the first place, you're

Donald Judd: Untitled. 1965. Painted galvanized iron. 5" x 69" x 8¾". Photograph courtesy of Leo Castelli Gallery, New York.

Kenneth Noland: *Dry Shift*. 1967. Acrylic on canvas. 2' x 8'. Photograph courtesy of Andre Emmerich Gallery, New York.

Frank Stella: *Sanbornville III*. 1966. Fluorescent alkyd and epoxy paint on canvas. 104" x 146". Photograph courtesy of Leo Castelli Gallery, New York.

assuming you have a vague whole—the rectangle of the canvas—and definite parts, which is all screwed up, because you should have a definite *whole* and maybe no parts, or very few. The parts are always more important than the whole.

GLASER: And you want the whole to be more important than the parts?

JUDD: Yes. The whole's it. The big problem is to maintain the sense of the whole thing.

GLASER: Isn't it that there's no gestation, that there's just an idea?

JUDD: I do think about it, I'll change it if I can. I just want it to exist as a whole thing. And that's not especially unusual. Painting's been going toward that for a long time. A lot of people, like Oldenburg for instance, have a "whole" effect to their work.

STELLA: But we're all still left with structural or compositional elements. The problems aren't any different. I still have to compose a picture, and if you make an object you have to organize the structure. I don't think our work is that radical in any sense because you don't find any really new compositional or structural element. I don't know if that exists. It's like the idea of a color you haven't seen before. Does something exist that's as radical as a diagonal that's not a diagonal? Or a straight line or a compositional element that you can't describe?

GLASER: So even your efforts, Don, to get away from European art and its traditional compositional effects, is somewhat limited because you're still going to be using the same basic elements that they used.

JUDD: No, I don't think so. I'm totally uninterested in European art and I think it's over with. It's not so much the elements we use that are new as their context. For example, they might have used a diagonal, but no one there ever used as direct a diagonal as Morris Louis did.

STELLA: Look at all the Kandinskys, even the mechanical ones. They're sort of awful, but they have some pretty radical diagonals and stuff. Of course, they're always balanced.

JUDD: When you make a diagonal clear across the whole surface, it's a very different thing.

STELLA: But none the less, the idea of the diagonal has been around for a long time.

JUDD: That's true; there's always going to be something in one's work that's been around for a long time, but the fact that compositional arrangement isn't important is rather new. Composition is obviously very important to Vasarely, but all I'm interested in is having a work interesting to me as a whole. I don't think there's any way you can juggle a composition that would make it more interesting in terms of the parts.

GLASER: You obviously have an awareness of Constructivist work, like Gabo and Pevsner. What about the Bauhaus? You keep talking about spareness and austerity. Is that only in relation to the idea that you want your work "whole," or do you think there was something in Mies's Bauhaus dictum that "less is more"?

JUDD: Not necessarily. In the first place, I'm more interested in Neo-Plasticism and Constructivism than I was before, perhaps, but I was never influenced by it, and I'm certainly influenced by what happens in the United States rather than by anything like that. So my admiration for someone like Pevsner or Gabo is in retrospect. I consider the Bauhaus too long ago to think about, and I never thought about it much.

GLASER: What makes the space you use different from Neo-Plastic sculpture? What are you after in the way of a new space?

JUDD: In the first place, I don't know a heck of a lot about Neo-Plastic sculpture, outside of vaguely liking it. I'm using actual space because when I was doing paintings I couldn't see any way out of having a certain amount of illusionism in the paintings. I thought that also was a quality of the Western tradition and I didn't want it.

GLASER: When you did the horizontal with the five verticals coming down from it, you said you thought of it as a whole; you weren't being compositional in any way or opposing the elements. But, after all, you are opposing them because vertical and horizontal are opposed by nature; and the perpendicular *is* an opposition. And if you have space in between each one, then it makes them parts.

JUDD: Yes, it does, somewhat. You see, the big problem is that anything that is not absolutely plain begins to have parts in some way. The thing is to be able to work and do different things and yet not break up the wholeness that a piece has. To me the piece with the brass and the five verticals is above all *that shape*. I don't think

of the brass being opposed to the five things, as Gabo or Pevsner might have an angle and then another one supporting it or relating on a diagonal. Also the verticals below the brass both support the brass and pend from it, and the length is just enough so it seems that they hang, as well as support it, so they're caught there. I didn't think they came loose as independent parts. If they were longer and the brass obviously sat on them, then I wouldn't like it.

GLASER: You've written about the predominance of chance in Robert Morris's work. Is this element in your pieces too?

JUDD: Yes. Pollock and those people represent actual chance; by now it's better to make that a foregone conclusion—you don't have to mimic chance. You use a simple form that doesn't look like either order or disorder. We recognize that the world is ninety percent chance and accident. Earlier painting was saying that there's more order in the scheme of things than we admit now, like Poussin saying order underlies nature. Poussin's order is anthropomorphic. Now there are no preconceived notions. Take a simple form—say a box—and it does have an order, but it's not so ordered that that's the dominant quality. The more parts a thing has, the more important order becomes, and finally order becomes more important than anything else.

GLASER: There are several other characteristics that accompany the prevalence of symmetry and simplicity in the new work. There's a very finished look to it, a complete negation of the painterly approach. Twentieth-century painting has been concerned mainly with emphasizing the artist's presence in the work, often with an unfinished quality by which one can participate in the experience of the artist, the process of painting the picture. You deny all this, too; your work has an industrial look, a non-man-made look.

STELLA: The artist's tools or the traditional artist's brush and maybe even oil paint are all disappearing very quickly. We use mostly commercial paint, and we generally tend toward larger brushes. In a way, Abstract Expressionism started all this. De Kooning used house painters' brushes and house painters' techniques.

GLASER: Pollock used commercial paint.

STELLA: Yes, the aluminum paint. What happened, at least for me, is that when I first started painting I would see Pollock, de Kooning, and the one thing they all had that I didn't have was an art school·

background. They were brought up on drawing and they all ended up painting or drawing with the brush. They got away from the smaller brushes and, in an attempt to free themselves, they got involved in commercial paint and house-painting brushes. Still it was basically drawing with paint, which has characterized almost all twentieth-century painting. The way my own painting was going, drawing was less and less necessary. It was the one thing I wasn't going to do. I wasn't going to draw with the brush.

GLASER: What induced this conclusion that drawing wasn't necessary any more?

STELLA: Well, you have a brush and you've got paint on the brush, and you ask yourself why you're doing whatever it is you're doing, what inflection you're actually going to make with the brush and with the paint that's on the end of the brush. It's like handwriting. And I found out that I just didn't have anything to say in those terms. I didn't want to make variations; I didn't want to record a path. I wanted to get the paint out of the can and onto the canvas. I knew a wise guy who used to make fun of my painting, but he didn't like the Abstract Expressionists either. He said they would be good painters if they could only keep the paint as good as it is in the can. And that's what I tried to do. I tried to keep the paint as good as it was in the can.

GLASER: Are you implying that you are trying to destroy painting?

STELLA: It's just that you can't go back. It's not a question of destroying anything. If something's used up, something's done, something's over with, what's the point of getting involved with it?

JUDD: Root, hog, or die.

GLASER: Are you suggesting that there are no more solutions to, or no more problems that exist in painting?

STELLA: Well, it seems to me we have problems. When Morris Louis showed in 1958, everybody (*Art News,* Tom Hess) dismissed his work as thin, merely decorative. They still do. Louis is the really interesting case. In every sense his instincts were Abstract Expressionist, and he was terribly involved with all of that, but he felt he had to move, too. I always get into arguments with people who want to retain the old values in painting—the humanistic values that they always find on the canvas. If you pin them down, they always end up asserting that there is something there besides the paint on

the canvas. My painting is based on the fact that only what can be seen there *is* there. It really is an object. Any painting is an object and anyone who gets involved enough in this finally has to face up to the objectness of whatever it is that he's doing. He is making a thing. All that should be taken for granted. If the painting were lean enough, accurate enough, or right enough, you would just be able to look at it. All I want anyone to get out of my paintings, and all I ever get out of them, is the fact that you can see the whole idea without any confusion. . . . What you see is what you see.

GLASER: That doesn't leave too much afterwards, does it?

STELLA: I don't know what else there is. It's really something if you can get a visual sensation that is pleasurable, or worth looking at, or enjoyable, if you can just make something worth looking at.

GLASER: But some would claim that the visual effect is minimal, that you're just giving us one color or a symmetrical grouping of lines. A nineteenth-century landscape painting would presumably offer more pleasure, simply because it's more complicated.

JUDD: I don't think it's more complicated.

STELLA: No, because what you're saying essentially is that a nineteenth-century landscape is more complicated because there are two things working—deep space and the way it's painted. You can see how it's done and read the figures in the space. Then take Ken Noland's painting, for example, which is just a few stains on the ground. If you want to look at the depths, there are just as many problematic spaces. And some of them are extremely complicated technically; you can worry and wonder how he painted the way he did.

JUDD: Old master painting has a great reputation for being profound, universal, and all that, and it isn't necessarily.

STELLA: But I don't know how to get around the part that they just wanted to make something pleasurable to look at, because even if that's what I want, I also want my painting to be so you can't *avoid* the fact that it's supposed to be entirely visual.

GLASER: You've been quoted, Frank, as saying that you want to get sentimentality out of painting.

STELLA: I hope I didn't say that. I think what I said is that sentiment wasn't necessary. I didn't think then, and I don't now, that it's necessary to make paintings that will interest people in the sense

that they can keep going back to explore painterly detail. One could stand in front of any Abstract-Expressionist work for a long time, and walk back and forth, and inspect the depths of the pigment and the inflection and all the painterly brushwork for hours. But I wouldn't particularly want to do that and also I wouldn't ask anyone to do that in front of my paintings. To go further, I would like to prohibit them from doing that in front of my painting. That's why I make the paintings the way they are, more or less.

GLASER: Why would you like to prohibit someone from doing such a thing?

STELLA: I feel that you should know after a while that you're just sort of mutilating the paint. If you have some feeling about either color or direction of line or something, I think you can state it. You don't have to knead the material and grind it up. That seems destructive to me; it makes me very nervous. I want to find an attitude basically constructive rather than destructive.

GLASER: You seem to be after an economy of means, rather than trying to avoid sentimentality. Is that nearer it?

STELLA: Yes, but there's something awful about that "economy of means." I don't know why, but I resent that immediately. I don't go out of my way to be economical. It's hard to explain what exactly it is I'm motivated by, but I don't think people are motivated by reduction. It would be nice if we were, but actually, I'm motivated by the desire to make something, and I go about it in the way that seems best.

JUDD: You're getting rid of the things that people used to think were essential to art. But that reduction is only incidental. I object to the whole reduction idea, because it's only reduction of those things someone doesn't want. If my work is reductionist it's because it doesn't have the elements that people thought should be there. But it has other elements that I like. Take Noland again. You can think of the things he doesn't have in his paintings, but there's a whole list of things that he *does* have that painting didn't have before. Why is it necessarily a reduction?

STELLA: You want to get rid of things that get you into trouble. As you keep painting you find things are getting in your way a lot and those are the things that you try to get out of the way. You might be spilling a lot of blue paint and because there's something wrong

with that particular paint, you don't use it any more, or you find a better thinner or better nails. There's a lot of striving for better materials, I'm afraid. I don't know how good that is.

JUDD: There's nothing sacrosanct about materials.

STELLA: I lose sight of the fact that my paintings are on canvas, even though I know I'm painting on canvas, and I just see my paintings. I don't get terribly hung up over the canvas itself. If the visual act taking place on the canvas is strong enough, I don't get a very strong sense of the material quality of the canvas. It sort of disappears. I don't like things that stress the material qualities. I get so I don't even like Ken Noland's paintings (even though I like them a lot). Sometimes all that bare canvas gets me down, just because there's so much of it; the physical quality of the cotton duck gets in the way.

GLASER: Another problem. If you make so many canvases alike, how much can the eye be stimulated by so much repetition?

STELLA: That really is a relative problem because obviously it strikes different people different ways. I find, say, Milton Resnick as repetitive as I am, if not more so. The change in any given artist's work from picture to picture isn't that great. Take a Pollock show. You may have a span of ten years, but you could break it down to three or four things he's done. In any given period of an artist, when he's working on a particular interest or problem, the paintings tend to be a lot alike. It's hard to find anyone who isn't like that. It seems to be the natural situation. And everyone finds some things more boring to look at than others.

GLASER: Don, would it be fair to say that your approach is a nihilistic one, in view of your wish to get rid of various elements?

JUDD: No, I don't consider it nihilistic or negative or cool or anything else. Also I don't think my objection to the Western tradition is a positive quality of my work. It's just something I don't want to do, that's all. I want to do something else.

GLASER: Some years ago we talked about what art will be, an art of the future. Do you have a vision of that?

JUDD: No, I was just talking about what my art will be and what I imagine a few other people's art that I like might be.

GLASER: Don't you see art as kind of evolutionary? You talk about what art was and then you say it's old hat, it's all over now.

JUDD: It's old hat because it involves all those beliefs you really can't accept in life. You don't want to work with it any more. It's not that any of that work has suddenly become mad in itself. If I get hold of a Piero della Francesca, that's fine.

I wanted to say something about this painterly thing. It certainly involves a relationship between what's outside—nature or a figure or something—and the artist's actually painting that thing, his particular feeling at the time. This is just one area of feeling, and I, for one, am not interested in it for my own work. I can't do anything with it. It's been fully exploited and I don't see why the painterly relationship exclusively should stand for art.

GLASER: Are you suggesting an art without feeling?

JUDD: No, you're reading me wrong. Because I say that is just one kind of feeling—painterly feeling.

STELLA: Let's take painterly simply to mean Abstract Expressionism, to make it easier. Those painters were obviously involved in what they were doing as they were doing it, and now in what Don does, and I guess in what I do, a lot of the effort is directed toward the end. We believe that we can find the end, and that a painting can be finished. The Abstract Expressionists always felt the painting's being finished was very problematical. We'd more readily say that our paintings were finished and say, well, it's either a failure or it's not, instead of saying, well, maybe it's not really finished.

GLASER: You're saying that the painting is almost completely conceptualized before it's made, that you can devise a diagram in your mind and put it on canvas. Maybe it would be adequate to simply verbalize this image and give it to the public rather than giving them your painting?

STELLA: A diagram is not a painting; it's as simple as that. I can make a painting from a diagram, but can you? Can the public? It can just remain a diagram if that's all I do, or if it's a verbalization it can just remain a verbalization. Clement Greenberg talked about the ideas or possibilities of painting in, I think, the *After Abstract Expressionism* article,[1] and he allows a blank canvas to be an idea for a painting. It might not be a *good* idea, but it's certainly valid.

[1] Clement Greenberg, "After Abstract Expressionism," *Art International*, V. 7, No. 8, 1962.

Yves Klein did the empty gallery. He sold air, and that was a conceptualized art, I guess.[2]

GLASER: *Reductio ad absurdum.*

STELLA: Not absurd enough, though.

JUDD: Even if you can plan the thing completely ahead of time, you still don't know what it looks like until it's right there. You may turn out to be totally wrong once you have gone to all the trouble of building this thing.

STELLA: Yes, and also that's what you want to do. You actually want to see the thing. That's what motivates you to do it in the first place, to see what it's going to look like.

JUDD: You can think about it forever in all sorts of versions, but it's nothing until it is made visible.

GLASER: Frank, your stretchers are thicker than the usual. When your canvases are shaped or cut out in the center, this gives them a distinctly sculptural presence.

STELLA: I make the canvas deeper than ordinarily, but I began accidentally. I turned one-by-threes on edge to make a quick frame, and then I liked it. When you stand directly in front of the painting it gives it just enough depth to hold it off the wall; you're conscious of this sort of shadow, just enough depth to emphasize the surface. In other words, it makes it more like a painting and less like an object, by stressing the surface.

JUDD: I thought of Frank's aluminum paintings as slabs, in a way.

STELLA: I don't paint around the edge; Rothko does, so do a lot of people; Sven Lukin does and he's much more of an object painter than I am.

GLASER: Do you think the frequent use of the word "presence" in critical writing about your kind of work has something to do with the nature of the objects you make, as if to suggest there is something more enigmatic about them than previous works of art?

STELLA: You can't say that your work has more of this or that than somebody else's. It's a matter of terminology. De Kooning or Al Held paint "tough" paintings and we would have to paint with "presence," I guess. It's just another way of describing.

[2] Yves Klein's exhibition, Iris Clert Gallery, Paris, April, 1958, consisted of an empty, white-walled gallery.

GLASER: Nobody's really attempted to develop some new terminology to deal with the problems of these paintings.

STELLA: But that's what I mean. Sometimes I think our paintings *are* a little bit different, but on the other hand it seems that they're still dealing with the same old problems of making art. I don't see why everyone seems so desperately in need of a new terminology, and I don't see what there is in our work that needs a new terminology either to explain or to evaluate it. It's art, or it wants to be art, or it asks to be considered as art, and therefore the terms we have for discussing art are probably good enough. You could say that the terms used so far to discuss and evaluate art are pretty grim; you could make a very good case for that. But nonetheless, I imagine there's nothing specific in our work that asks for new terms, any more than any other art.

GLASER: Meyer Schapiro once suggested that there might be an analogy between, say, a Barnett Newman with a field of one color and one simple stripe down the middle and a mosaic field of some Byzantine church, where there was a completely gold field and then a simple vertical form of the Madonna.

JUDD: A lot of things look alike, but they're not necessarily very much alike.

STELLA: Like the whole idea of the field. What you mean by a field in a painting is a pretty difficult idea. A mosaic field can never have anything to do with a Morris Louis field.

JUDD: You don't feel the same about a Newman and a gold field because Newman's doing something with his field.

STELLA: Newman's is in the canvas and it really does work differently. With so-called advanced painting, for example, you should drop composition. That would be terrifically avant-garde; that would be a really good idea. But the question is, how do you do it? The best article I ever read about pure painting and all that was Elaine de Kooning's *Pure Paints a Picture*.[3] Pure was very pure and he lived in a bare, square white loft. He was very meticulous and he gave up painting with brushes and all that and he had a syringe loaded with a colorless fluid, which he injected into his colorless,

[3] Elaine de Kooning. "Pure Paints a Picture," *Art News*, V. 56, No. 4, Summer, 1957, pp. 57, 86–87.

odorless foam rubber. That was how he created his art objects—by injecting colorless fluid into a colorless material.

JUDD: Radical artist.

STELLA: Well, Yves Klein was no doubt a radical artist, or he didn't do anything very interesting.

JUDD: I think Yves Klein to some extent was outside of European painting, but why is he still not actually radical?

STELLA: I don't know. I have one of his paintings, which I like in a way, but there's something about him . . . I mean what's not radical about the idea of selling air? Still, it doesn't seem very interesting.

JUDD: Not to me either. One thing I want is to be able to see what I've done, as you said. Art is something you look at.

GLASER: You have made the point that you definitely want to induce some effective enjoyment in your work, Frank. But the fact is that right now the majority of people confronted by it seem to have trouble in this regard. They don't get this enjoyment that you seem to be very simply presenting to them. That is, they are still stunned and taken aback by its simplicity. Is this because they are not ready for these works, because they simply haven't caught up to the artist, again?

STELLA: Maybe that's the quality of simplicity. When Mantle hits the ball out of the park, everybody is sort of stunned for a minute because it's so simple. He knocks it right out of the park, and that usually does it.

TWO EXHIBITIONS by E. C. Goossen

The two pieces that follow were written about two exhibitions selected and hung by the author. The first show included eight young, unknown artists whose work appealed because it was new and strong, and because it suggested the first clarification of what seemed to be a broad trend toward an overall style. This exhibition was held at the Hudson River Museum in Yonkers, New York, in October, 1964, under the aegis of Martin Ries, Assistant Director of the Museum. It included works by Carl Andre, Darby Bannard, Robert Barry, Robert Huot, Patricia Johanson, Antoni Milkowski, Douglas Ohlson, and Terrence Syverson, none of whom had previously exhibited in New York. It was probably the first exhibition devoted strictly to what is now called "Minimal" art. The second show, called "Distillation," was held at the Tibor de Nagy and Stable Galleries in September, 1966. Goossen's essays were attempts to elucidate some of the meanings and characteristics of the new trend.

E. C. Goossen has written essays for many leading art journals, and is author of a monograph on Stuart Davis. He is Professor and Chairman of the Department of Art at Hunter College, New York City.

8 Young Artists

The paintings and sculptures in this exhibition are the works of very young artists, all of whom are between twenty-four and twenty-nine years of age. However, it was not their youth that suggested the exhibition. It was rather that the approach each has taken toward present-day problems in art has certain characteristics common to the others. Undoubtedly there are many more young artists of talent and potentialities who could or should have been included. But for reasons of sheer manageability and the desire to show enough of each so that none would be lost in a crowd, limitation was necessary. Moreover, the selection was necessarily bounded by the seriousness and the quality eminently demanded by the very nature of the style itself, a style that will permit no cleverness or hi-jinks to cover up weak talent or weak conceptions. If a few of these works have not lived up to all their possibilities, they are still valuable

evidence of the courage it takes to be simple and direct and to go for all or nothing in the quest for high art.

The degree of originality here is variable. But originality in art is, after all, a relative matter, even among the most experienced and mature practitioners. It is also true, however, that young artists often see beyond those who have influenced them and discover something that was missed or too hastily passed over. And they often note a principle of consistency in the works of their elders that their elders would deny. The critic or connoisseur who fails to keep one eye on the young may well go blind in his other eye. What is original or at least new here is perhaps too subtle and too dispersed in its ramifications across the group to be thought of as shared as an idea is shared. It derives from personal and selective taste, and probably from intuition as well. This was the reason for grouping these artists even though they are not a "group," and hardly know each other.

All of these works are, obviously, totally abstract. And except for having selected a particular set of simple and more or less conventional forms for particular explorations, none of these artists engages in the biographical mannerism associated with Abstract Expressionism. Indeed, in such matters as the handling of paint and texture, of design and composition, or any of the usual dynamics of spatial tensions, they seem to seek anonymity as well as neutrality. None of them employs illusion, realism, or anything that could possibly be described as symbolism. Their use of subject matter, if one can make such a distinction within this approach, has little or no intention of drawing the viewer into an empathic or intimate relation to something going on within the work. In fact, in the more advanced paintings in this show, even the color-shapes are clearly separated from each other so that no accidental optical mixture can disturb our experience of each shape as such. The conceptual precision of these shapes also helps to insure the absolute identification of the shape with its color and the color with its shape.

The optical mixture referred to above is not that which is deliberately employed by such painters as Anuszkiewicz and Vasarely, who seek to achieve a dazzling hypnotic effect. Such effects cannot interest us very long. There is, however, another subtler optical mixture that occurs along the common boundary between two

colors, a primary and secondary, for example, or two colors of the same intensity, which tends to break down the distinction between juxtaposed shapes. The Hard-Edge painters, by sharp definition of shape, have tried to overcome this optical mixture. They often succeed to the point of losing overall clarity by establishing an inner–outer oscillation, or a disturbing spatial ambiguity. Visual uncertainties in a painting, however amusing at first sight, are ultimately boring.

Color, disposed upon the two-dimensional surface, as Hegel noted over one hundred and thirty years ago, is the prime characteristic that distinguishes painting from its sister arts. Color presents few problems as long as it is rationalizable in terms of represented objects. The farther these objects are removed from those of our everyday experience, and the closer color comes to sheer color, the more an underlying structural order is required. Kandinsky prophesied the coming importance of color when he released it from representational forms. But most of his pictures, whether from 1912 or 1924, are pure chaos. He was unable to find a way to raise color to the place he wanted for it because he was confused as to whether or not it was symbolic or real. This confusion is common to the romantic mentality, which fails to appreciate experience for its own intrinsic value and is forever trying to elevate it by complications and associations. Red cannot simply be red, but must be lips, or blood, or fire. And even when it is accepted that red might be red, it must still be presented as dynamic, involved in tensions, in conflict with yellow or blue, etc. In other words, the romantic prejudice seeks everywhere to find "subject matter."

With the advent of Abstract Expressionism in the 1940's and until very recently, various methods, of applying the paint—dripping, pouring, scumbling, spraying, and soaking—were brought into use, not only to justify an art of nearly pure abstraction but also to free color finally from the tyranny of associations with subject matter. Pollock, Still, Rothko, and later, Frankenthaler and Louis, to name but a few, are immediately identifiable by their techniques. But ironically a new subject matter appeared in the form of the personalism of the method—signature painting as it has been called—resuscitating romantic subjectivism to an exaggerated degree. The parade of "second generation" personalities produced an immense

ennui and exposed the inadequacy of a stylistic principle based on unbridled egoism.

Two therapeutic reactions were forthcoming. One was Pop Art, wherein objective subject matter was embraced wholeheartedly and its banality (comic strips, hamburgers, movie stars, etc.) was intended to be impersonal and nonaesthetic. But as the Abstract Expressionists staked out personal approaches, Pop Artists staked out subjects. Moreover, because Pop Art depended on the "idea" and sources of motivation outside art, it had a built-in obsolescence from the outset. The other reaction has been growing more naturally and logically out of a direct confrontation with the real pictorial problem.

To clear away the boring display of personality as such, techniques for applying color have been reduced to those that call as little attention to themselves as possible. The anonymity of the industrial paint-job is the desire. Maximum control is demanded, harking back to the American Precisionists, the European Constructivists, and the later Stuart Davis. The increasing appreciation of Davis, as the artist who fell neither into the subjectivity of the romantics nor into the designiness of the Bauhaus Constructivists, is both a consequence and a cause of the newest attitudes in painting.

Consistent with the reduction of evident mannerism in treatment has been the development of a more and more static picture. To emphasize color, to evoke from it its maximum peculiar quality seems to require not only the perfect adjustment to the area or shape it occupies, but also the de-emphasis of distracting inner–outer pulls and arbitrary lateral tensions.

In their solution to this problem, these young artists have found precedents in Barnett Newman's pure rectangles of evenly distributed color of 1950–51 and in the axial substructure of Jackson Pollock's drip pictures of the same period. The late Morris Louis, Kenneth Noland, Frank Stella, and Paul Feeley have all worked within the limitations of symmetrical organization over the past six or seven years. One of the young artists shown here, Walter Darby Bannard, was himself working with the centered circle and square as early as 1959. Symmetry, the intuitive or calculated use of the grid, circular or squared organization, and a maximum concern with proportional relations . . . in other words . . . clearly established

principles, are qualities essential to this approach. As a style it may not yet satisfy all its own pretensions, but there is ample evidence here (and elsewhere) that painting is still articulate in its own right and that a period of a conceptually ordered abstraction is nothing to fear. The emphasis is now on color, in itself the most sensuous and the least intellectual of the various pictorial means. All that is peculiar to the art of painting is still amply present, and in the least adulterated state up to now.

A Note on the Sculpture in this Exhibition:

The inclusion of the work of two young sculptors is intended to provide a broader vision of the principles inherent in the present concern with conceptual order. Regularity of the parts, symmetrical or grid organization, careful ordering of proportional relations and the free acceptance of modules provided by the underlying classical conventions of the Western tradition together result in a sculpture of enviable clarity and monumentality. Their work derives from the same principles that have for many years governed the sculpture and architectural design of one of their elders, namely Tony Smith, whose influence and art will one day be known as among the most original and sound of our time. A less generation-conscious show would of necessity include his sculpture.

Like the painters, these sculptors reject personal mannerisms and seek the same sort of intentional anonymity. In doing so, they also reject romantic egoism. And here again we are presented with the possibility of the direct experience of the most concrete of all the arts.

Distillation

An increasing number of artists are now working close to the core of the continuing process that is twentieth-century art. That process, at work in other areas as well, is one of distillation. As such, it has put more and more limitations on the mannerist and psychological escape routes available to anyone hoping to make a satisfactory work of art in our time. Increasingly the demand has been for an honest, direct, unadulterated experience in art (any art), minus symbolism, minus messages, and minus personal exhibitionism.

Carl Andre: *Cedar Piece*. 1960–64. Wood. 70″ x 36¼″.

Antoni Milkowski: *Hex*. 1967. Steel. Photograph courtesy of Tibor de Nagy Gallery, New York.

Patricia Johanson: *Pompey's Pillar*. 1964. Oil on canvas. 80'' x 80''. Photograph courtesy of Tibor de Nagy Gallery, New York.

There have been, of course, continuous reactions to this process, none of which has been able to supplant it because they were more dependent on it than it on them. Dadaism, Surrealism, "action painting," Pop, the New Realism, etc., could almost be called "applied art" since they have used the tough-minded, hard-won accomplishments of the core art without making direct contributions to its development. This is not to say that they have contributed nothing at all. At the very least, by their often shrill opposition, catering to a slow-moving popular taste, they have helped to identify negatively the real direction and necessity of the stylistic backbone. That backbone has been created by individual artists whose work cannot be classified in any strict way.

A list of such key artists, until recently dominated by painters, would include those as apparently separate and individualistic as Kandinsky, the later Monet, Matisse, O'Keeffe, Dove, Stuart Davis, Mondrian, Still, Pollock, Newman, Kelly, Feeley, Louis, Stella, and Noland. Thus, to untutored eyes, it would seem that the twentieth century had neither a tradition nor a process. Yet the effective art of the immediate present must have come from somewhere and it obviously did not come from the movements or the "schools." It is possible, however, to find a principle of unity in the work of the artists named. In every case the evidence of the work reveals a drive to simplify the pictorial means and to eliminate the extraneous, particularly those ideas and props generated outside art itself that had led to the adulteration of forms within it. Chronologically, each of them has left essentially less of the baggage of past art for the rest to deal with. This has not been, however, a process of diminution, but of intentional distillation aimed at more potent results.

The distillation process, of course, puts more strain on the artist and his means. No wonder that we have witnessed every form of evasion, every imaginable distraction dragged across the scene. And no wonder that most of these herrings smell of the literary swamp that has overwhelmed Western sensibilities since the Renaissance. It will probably take the rest of this century to find out what this essentialization has meant to the history of style as a whole. One thing we can see now is that this process is part of art's search for total control over itself for the first time in Western history. At-

tached to the dignity of that situation, however, go responsibilities . . .

Because sculpture has continued to follow the lead of painting through the first half of this century few sculptors, other than Brancusi, have been engaged in the direct distillation of sculptural art. Representationalism and pictorialism have contaminated even the most abstract works of Picasso, Giacometti, and David Smith. Even Brancusi pilfered architecture, another art (his *Endless Column* is a Romanian house-post), to assuage a conscience trained to think of nature as the starting point. Duchamp, too, could not invent his sculpture, but had to find it in the world of functional objects.

Nor has the interbreeding of sculpture and painting in recent years particularly assisted sculpture in keeping up with painting. The rush to employ painting-type color in sculpture, as refreshing as it might momentarily seem, has more often than not removed the possibility of the sculptural experience from the work at hand. Moreover, all the radiant color in the world cannot camouflage weak form. And the tendency toward intentional camouflage is tantamount to a return to illusionism.

Yet the kind of painting engaged in the reductive process has by example afforded sculpture a standard of value and, hopefully, the courage to affirm that the sculptural experience by itself is more than enough. The problem now is to try to distinguish between display art and its salesmanship and a basically true piece of sculpture. Newness of form is not nearly so important as some of the younger British and American sculptors seem to think it is. Our long deprivation of true sculpture has left us with a weak sense of real form. We need the shock of the real, not the adulterated version. . . .

The fact that twentieth-century art has reached the point where its underlying principles have become clearer does not mean we are in for a bout with academic art. The process is still at work. Despite the accepted limitation of means, and ends, it is clear from the work of many young artists that there is ample room for variety and individual responses to the challenge. Each is submitting his vision to the alembic in order to reduce it to its best essence. They are

proving that there is no "less" or "more" in art. Whatever it takes to do it, whether it is the seventeen syllables of the *haiku* or the twelve books of *The Aeneid,* is what it takes. A work of art cannot be subjected to quantitative analysis. It is not the time it takes to read it that counts, but the time it takes to forget it.

August, 1966

PHOTOGRAPHS by Dan Graham

This selection of photographs by Dan Graham illustrates Minimal-type surfaces and structures as they are found by the artist in nature—particularly in the suburban landscape. They suggest that Minimal forms are not totally divorced from nature, and that they are subjective and social. In the words of Marcel Duchamp, Graham is a "photo journalist."

Dan Graham was born in Illinois in 1942. He has written criticism for *Arts Magazine*, and the *West Side News*. In 1965 he founded the now-defunct John Daniels Gallery in New York City.

RECENTNESS OF SCULPTURE* by Clement Greenberg

Mr. Greenberg criticizes Minimal Art in this essay, finding that "Minimal works are readable as art, as almost anything is today—including a door, a table, or a blank sheet of paper." He points out that the Minimalists may not have escaped the pictorial context, and that they commit themselves to three-dimensional expression because it is a coordinate that art has to share with non-art. Frank Stella, a leading Minimalist painter, has said: ". . . we're all still left with structural or compositional elements. The problems aren't any different. I still have to compose a picture, and if you make an object you have to organize the structure. I don't think our work is that radical in any sense, because you don't find any really new compositional or structural element."

Clement Greenberg is author of numerous essays on the New Art, including "Modernist Painting" and "Post-Painterly Abstraction." His collected essays have been published in the book *Art and Culture,* and he has written books on Miró and Matisse.

Advanced sculpture has had more than its share of ups and downs over the last twenty-five years. This is especially true of abstract and near-abstract sculpture. Having gathered a certain momentum in the late thirties and early forties, it was slowed down in the later forties and in the fifties by the fear that, if it became markedly clean-drawn and geometrical, it would look too much like machinery. Abstract-Expressionist painting, with its aversion to sharp definitions, inspired this fear, which for a time swayed even the late and great David Smith, a son of the "clean-contoured" thirties if there ever was one. Not that "painterly" abstract sculpture was necessarily bad; it worked out as badly as it did in the forties and fifties because it was too negatively motivated, because too much of it was done in the way it was done out of the fear of not looking enough like art.

* Reprinted from the exhibition catalogue *American Sculpture of the Sixties,* Los Angeles County Museum of Art, 1967.

Painting in that period was much more self-confident, and in the early fifties one or two painters did directly confront the question of when painting stopped looking enough like art. I remember that my first reaction to the almost monochromatic pictures shown by Rollin Crampton in 1951 (at the Peridot Gallery) was derision mixed with exasperation. It took renewed acquaintance with these pictures (which had a decisive influence on Philip Guston at that time) to teach me better. The next monochromatic paintings I saw were completely so—the all-white and all-black paintings in Rauschenberg's 1953 show (at the Stable). I was surprised by how easy they were to "get," how familiar-looking and even slick. It was no different afterwards when I first saw Reinhardt's, Sally Hazlett's, and Yves Klein's monochromatic or near-monochromatic pictures. These, too, looked familiar and slick. What was so challenging in Crampton's art had become almost overnight another taming convention. (Pollock's and Tobey's "all-overness" probably helped bring this about too.) The look of accident was not the only "wild" thing that Abstract Expressionism first acclimatized and then domesticated in painting; it did the same to emptiness, to the look of the "void." A monochromatic flatness that could be seen as limited in extension and different from a wall henceforth automatically declared itself to be a picture, to be art.

But this took another ten years to sink in as far as most artists and critics in New York were concerned. In spite of all the journalism about the erased difference between art and non-art, the look of both the accidental and the empty continued to be regarded as an art-denying look. It is only in the very last years, really, that Pollock's achievement has ceased being controversial on the New York scene. Maybe he had "broken the ice," but his all-over paintings continued to be taken for arbitrary, aesthetically unintelligible phenomena, while the look of art as identifiable in a painter like de Kooning remained the cherished look. Today Pollock is still seen for the most part as essentially arbitrary, "accidental," but a new generation of artists has arisen that considers this an asset rather than a liability. By now we have all become aware that the far-out is what has paid off best in avant-garde art in the long run—and what could be further out than the arbitrary? Newman's reputation has likewise benefited recently from this new awareness and from a similar failure

of comprehension—not to mention Reinhardt and his present flourishing.

In the sixties it has been as though art—at least the kind that gets the most attention—set itself as a problem the task of extricating the far-out "in itself" from the merely odd, the incongruous, and the socially shocking. Assemblage, Pop, Environment, Op, Kinetic, Erotic, and all the other varieties of Novelty Art look like so many logical moments in the working out of this problem, whose solution now seems to have arrived in the form of what is called Primary Structures, ABC, or Minimal Art. The Minimalists appear to have realized, finally, that the far-out in itself has to be the far-out as end in itself, and that this means the furthest-out and nothing short of that. They appear also to have realized that the most original and furthest-out art of the last hundred years always arrived looking at first as though it had parted company with everything previously known as art. In other words, the furthest-out usually lay on the borderline between art and non-art. The Minimalists have not really discovered anything new through this realization, but they have drawn conclusions from it with a new consistency that owes some of its newness to the shrinking of the area in which things can now safely be non-art. Given that the initial look of non-art was no longer available to painting, since even an unpainted canvas now stated itself as a picture, the borderline between art and non-art had to be sought in the three-dimensional, where sculpture was, and where everything material that was not art also was. Painting had lost the lead because it was so ineluctably art, and it now devolved on sculpture or something like it to head art's advance. (I don't pretend to be giving the actual train of thought by which Minimal Art was arrived at, but I think this is the essential logic of it.)

Proto-Pop (Johns and Rauschenberg) and Pop did a lot of flirting with the third dimension. Assemblage did more than that, but seldom escaped a stubbornly pictorial context. The Shaped-Canvas school has used the third dimension mainly in order to hold on to light-and-dark or "profiled" drawing: painters whose canvases depart from the rectangle or tondo emphasize that kind of drawing in determining just what other inclosing shapes or frames their pictures are to have. In idea, mixing the mediums, straddling the line be-

tween painting and sculpture, seemed the far-out thing to do; in actual aesthetic experience it has proven almost the opposite—at least in the context of painting, where even literal references to the third dimension seem inevitably, nowadays if not twenty-five years ago, to invoke traditional sculptural drawing.

Whether or not the Minimalists themselves have really escaped the pictorial context can be left aside for the moment. What seems definite is that they commit themselves to the third dimension because it is, among other things, a coordinate that art has to share with non-art (as Dada, Duchamp, and others already saw). The ostensible aim of the Minimalists is to "project" objects and ensembles of objects that are just nudgeable into art. Everything is rigorously rectilinear or spherical. Development within the given piece is usually by repetition of the same modular shape, which may or may not be varied in size. The look of machinery is shunned now because it does not go far enough toward the look of non-art, which is presumably an "inert" look that offers the eye a minimum of "interesting" incident—unlike the machine look, which is arty by comparison (and when I think of Tinguely I would agree with this). Still, no matter how simple the object may be, there remain the relations and interrelations of surface, contour, and spatial interval. Minimal works are readable as art, as almost anything is today—including a door, a table, or a blank sheet of paper. (That almost any nonfigurative object can approach the condition of architecture or of an architectural member is, on the other hand, beside the point; so is the fact that some works of Minimal Art are mounted on the wall in the attitude of bas-relief. Likeness of condition or attitude is not necessary in order to experience a seemingly arbitrary object as art.) Yet it would seem that a kind of art nearer the condition of non-art could not be envisaged or ideated at this moment.

That, precisely, is the trouble. Minimal Art remains too much a feat of ideation, and not enough anything else. Its idea remains an idea, something deduced instead of felt and discovered. The geometrical and modular simplicity may announce and signify the artistically furthest-out, but the fact that the signals are understood for

what they want to mean betrays them artistically.[1] There is hardly any aesthetic surprise in Minimal Art, only a phenomenal one of the same order as in Novelty Art, which is a one-time surprise. Aesthetic surprise hangs on forever—it is still there in Raphael as it is in Pollock—and ideas alone cannot achieve it. Aesthetic surprise comes from inspiration and sensibility as well as from being abreast of the artistic times. Behind the expected, self-canceling emblems of the furthest-out, almost every work of Minimal Art I have seen reveals in experience a more or less conventional sensibility. The artistic substance and reality, as distinct from the program, turns out to be in good safe taste. I find myself back in the realm of Good Design, where Pop, Op, Assemblage, and the rest of Novelty Art live. By being employed as tokens, the "primary structures" are converted into mannerisms. The third dimension itself is converted into a mannerism. Nor have most of the Minimalists escaped the familiar, reassuring context of the pictorial: wraiths of the picture rectangle and the Cubist grid haunt their works, asking to be filled out—and filled out they are, with light-and-dark drawing.

All of which might have puzzled me more had I not already had the experience of Rauschenberg's blank canvases, and of Yves Klein's all-blue ones. And had I not seen another notable token of far-outness, Reinhardt's shadowy monochrome, part like a veil to reveal a delicate and very timid sensibility. (Reinhardt has a genuine if small gift for color, but none at all for design or placing. I can see why he let Newman, Rothko, and Still influence him toward close and dark values, but he lost more than he gained by the desperate extreme to which he went, changing from a nice into a trite artist.) I had also learned that works whose ingredients were notionally "tough" could be very soft as wholes; and vice versa. I remember hearing Abstract-Expressionist painters ten years ago talking about how you had to make it ugly, and deliberately dirtying their color, only to render what they did still more stereotyped. The

[1] Darby Bannard, writing in *Artforum* of December, 1966, has already said it: "As with Pop and Op, the 'meaning' of a Minimal work exists outside of the work itself. It is a part of the nature of these works to act as *triggers* for thought and emotion preexisting in the viewer. . . . It may be fair to say that these styles have been nourished by the ubiquitous question: 'but what does it mean?' "

best of Monet's lily-pad paintings—or the best of Louis's and Olit-
ski's paintings—are not made any the less challenging and arduous,
on the other hand, by their nominally sweet color. Equations like
these cannot be thought out in advance, they can only be felt and
discovered.

In any case, the far-out as end in itself was already caught sight
of, in the area of sculpture by Anthony Caro in England back in
1960. But it came to him as a matter of experience and inspiration,
not of ratiocination, and he converted it immediately from an end
into a means—a means of pursuing a vision that required sculpture
to be more integrally abstract than it had ever been before. The far-
out as end in itself was already used up and compromised by the
time the notion of it reached the Minimalists: used up by Caro and
the other English sculptors for whom he was an example; compro-
mised by Novelty Art.

Still another artist who anticipated the Minimalists is Anne Truitt.
And she anticipated them more literally and therefore, as it seems to
me, more embarrassingly than Caro did. The surprise of the boxlike
pieces in her first show in New York, early in 1963 (at Emmerich's),
was much like that which Minimal Art aims at. Despite their being
covered with rectilinear zones of color, I was stopped by their dead-
pan "primariness," and I had to look again and again, and I had to
return again, to discover the power of these "boxes" to move and
affect. Far-outness here was stated rather than merely announced
and signaled. It was hard to tell whether the success of Truitt's best
works was primarily sculptural or pictorial, but part of their success
consisted precisely in making that question irrelevant.

Truitt's art did flirt with the look of non-art, and her 1963 show
was the first occasion on which I noticed how this look could confer
an effect of *presence*. That presence as achieved through size was
aesthetically extraneous, I already knew. That presence as achieved
through the look of non-art was likewise aesthetically extraneous, I
did not yet know. Truitt's sculpture had this kind of presence but
did not *hide* behind it. That sculpture could hide behind it—just as
painting did—I found out only after repeated acquaintance with
Minimal works of art: Judd's, Morris's, Andre's, Steiner's, some but
not all of Smithson's, some but not all of LeWitt's. Minimal Art can
also hide behind presence as size: I think of Bladen (though I am

not sure whether he is a certified Minimalist) as well as of some of the artists just mentioned. What puzzles me, if I am puzzled, is how sheer size can produce an effect so soft and ingratiating, and at the same time so superfluous. Here again the question of the phenomenal as opposed to the aesthetic or artistic comes in.

Having said all this, I won't deny that Minimal Art has brought a certain negative gain. It makes clear as never before how fussy a lot of earlier abstract sculpture is, especially that influenced by Abstract Expressionism. But the price may still not be worth it. The continuing infiltration of Good Design into what purports to be advanced and highbrow art now depresses sculpture as it does painting. Minimal follows too much where Pop, Op, Assemblage and the rest have led (as Darby Bannard, once again, has already pointed out). Nevertheless, I take Minimal Art more seriously than I do these other forms of Novelty. I retain hope for certain of its exponents. Maybe they will take still more pointers from artists like Truitt, Caro, Ellsworth Kelly, and Kenneth Noland, and learn from their example how to rise above Good Design.

MANNERISM IN THE ABSTRACT* by Peter Hutchinson

Peter Hutchinson believes Minimal Art to be a new Mannerism, thus demanding a new sensibility. Elsewhere in this anthology Clement Greenberg has written: "By being employed as tokens, the 'primary structures' are converted into mannerisms." But, he goes on to note: "Minimal Art . . . reveals in experience a more or less conventional sensibility." In his well-known essay, "The Anti-Mannerist Style," the late Walter Friedlaender distinguishes Mannerism from "mannered," and notes that when a "mannered" style ". . . utilizes forms or formulae inherited from a style already abstract, anormative, and remote from nature, the result must necessarily be something merely decorative or ornamental."

Peter Hutchinson was born in 1930 in London. He is a sculptor and has exhibited at the A. M. Sachs Gallery in New York. His critical articles have been published in *Art and Artists, Art in America*, and *Arts Magazine*.

Elegance, high technique, acid color, drama, use of the cliché: these are, according to Wylie Sypher, some of the elements of Mannerism. In much current painting and sculpture, we find the same elements reappearing, but this time within the abstract. Is there a new artistic sensibility occurring within the abstract, new because it radically departs from purist abstract painting in a neo-Mannerist way, and neo-Mannerism because it lies within the abstract frame of reference?

This new sensibility looks at first sight remarkably like the purist painting and sculpture from which it departs. It appears to the casual viewer as a second wind to Hard Edge. It is disguised as referential, shrugged off as plagiaristic. But is this not exactly how a mannerism, in this case Abstract Mannerism, works, from within? According to Sypher, it is. Behind the charming but "impure" mask are great disquiet, turmoil, cynicism, and self-doubt.

These feelings, intellectually activated, give great tension when combined in a mannerist technique. Yet, acting within the purist

* Reprinted from *Art and Artists,* September, 1966.

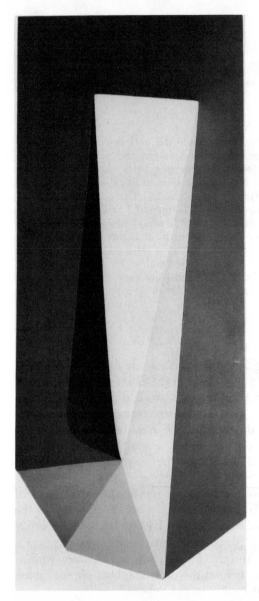

Charles Hinman: Untitled. 1966. Acrylic on shaped canvas. 34" x 14½" x 6".
Photograph courtesy of Richard Feigen Gallery, New York.

movement, the movement it actually questions, the new Mannerism avoids the generation of a defensive response. So far the attack seems unnoticed. Paradoxically, this cynicism and self-doubt, this seeking, may alter Mannerism itself as easily as the movement it questions. This is acceptable, since Mannerism seeks not to rule, but to change.

Purist abstraction, and its attendant scientism, is necessarily questioned when science itself is undergoing a mannerist dilemma. Currently, we view the universe as based on probabilities, contingencies, chances, and cosmic breakdown. Scientific discoveries only uncover larger gaps in knowledge. Spaceships grow more complicated and achieve less. How can everything be all right in a world destined for Norbert Wiener's heat death?

This new mannerist sensibility has its seeds even in color Op Art, a movement supposedly so closely allied to scientism. As an example, Larry Poons's ovals, while strongly suggesting an undiscovered, perhaps musical symmetry, refuse to rely on such symmetry. Instead they leap across the surface. The eye jumps from one oval to the next, as the eye jumps from detail to detail in a Mannerist (Giacomo della Porta?) façade. In other words, the purist philosophy of absolute "rightness" is already breaking down in Poons's work. Similarly, Anuszkiewicz destroys the extreme classicality of his compositions simply by causing the eye to jolt back and forth rather than follow the logical conclusions of the formal symmetry. Op color is sometimes used in the new mannerist paintings. It effectively destroys symmetry by refusing to allow the eye to rest. This is a much more dramatic yet subtle way to parody symmetry than the use of asymmetry. One feels that only a Mannerist would want to be dramatic and subtle at the same time.

Cold elegance and emphasis of disproportionate height and length are other Mannerist techniques. A case in point is a sort of inverted ziggurat that Irwin Fleminger has made. It is about nine feet high. It has curved "steps" and lacks the solid structural proportion of the traditional ziggurat. In polished aluminium, it stands upright while mentally, because of the reversal of proportion, we expect it to topple. No one could climb this ziggurat—the steps are pointing downward. A feeling of vertigo makes us reconsider our position. That is, the contemporary Mannerist attempts, in seem-

ingly classical work, actually to make us reconsider Purism. Vertigo subverts balance, and leads to doubt and anguish.

Abstract Mannerism, conceived of as a disquiet with the *status quo*, creates its own style while it strengthens during periods of change and dissolution. Devices used originally to parody become extreme and stylistic in themselves. An example is the framing edge. An original reaction to Mondrian's seemingly unanswerable art (everything is answerable if you only wait a while) was Reinhardt's denial of content, his use of the Bauhaus theory that "less is more." This again seemed unanswerable until the exaggeration of the framing edge, which accentuated the nothingness contained within, made Reinhardt's paintings, by comparison, seem full of detail (Stella). Smithson's krylon-sprayed metal frames contain nothing but mirrorized plastic. But now the mirrors reflect everything. The edge contains everything and nothing. "More" becomes "less," a true Mannerist reversal of values. There is no limit to the number of times Mannerism can reverse values.

Leo Valledor continues by extending his edges asymmetrically into space. But ironically at this stage the painting has begun to be about other things and the exaggerated edge is kept on as a stylistic structure.

The sixteenth-century painters must have felt extreme when they painted highly-decorated frames within their paintings, to the point where these frames outweighed the content of the painting; this initial Mannerism, itself pure parody, had a long way to go.

Space itself, which Patrick Heron regards as the only real concern of painting, is attacked by the contemporary Mannerism. Space becomes shallow as surfaces and structures assert themselves. In this non-painting, structures are added beneath continuous surfaces and the canvas contorts and pushes out. Chuck Hinman's convoluted canvases have a curving diagonal space plunging out at the viewer, who must retreat. This space might perhaps be compared to Tintoretto's space.

Non-sculpture also attacks formal spatial ideas by eliminating volume in the use of planes, curvilinear often, and non-Cubist. Chuck Ginnever's green and black sculpture appears voluminous. Seen from the side, it reveals itself as a superstructure, a false-front. Peter Forakis' hanging, paper-thin aluminum structures do the same

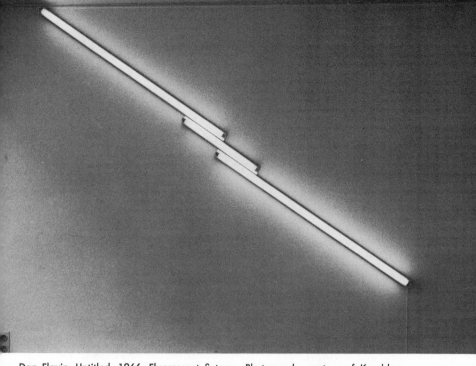

Dan Flavin: Untitled. 1966. Fluorescent fixtures. Photograph courtesy of Kornblee Gallery, New York.

Larry Poons: *Wildcat Arrival*. 1966. Acrylic on canvas. 110" x 190". In the collection of Mr. and Mrs. Albert List. Photograph courtesy of Leo Castelli Gallery, New York.

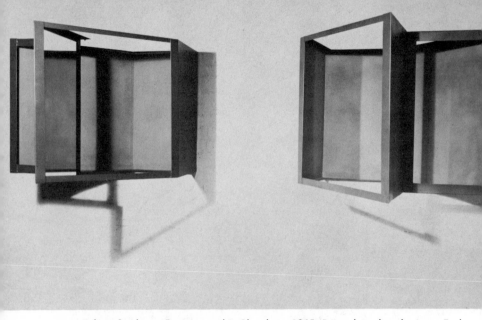

Robert Smithson: *Enantiomorphic Chambers*. 1965. Painted steel and mirror. Each chamber 34″ square. In the collection of Howard Lipman. Photograph courtesy of Finch College Museum of Art, Contemporary Study Wing.

Leo Valledor: *Skeedo*. 1965. Acrylic on shaped canvas. 60″ x 128″. Photograph courtesy of Park Place Gallery, New York.

thing. Robert Grosvenor's giant structures mock other giantist sculpture in a Mannerist way. Where the classical construction denotes solidity, purity, weight, space, Grosvenor's *Tapanga*, painted silver and mustard, rises from the ground about ten feet then plunges in a diagonal to within three inches of the floor, and stops. The imbalance is unbearable. It cannot possibly stand, but it does, secretly weighted, we suppose, or attached.

In the new Mannerism the diagonal often replaces the vertical. The diagonal is used not to denote space, but for dramatic impact. Valledor's parallelograms lean forward, in a way mocking geometric stability yet retaining symmetry. Interlocking acid darts, in two tones, reverse directions. There is no end to the Mannerist love of reversal, double meaning, and spoof.

Dan Flavin uses the diagonal. He uses fluorescent tubes that stand alone or are attached to other tubes without extraneous material. Sometimes they form triangles. Or they are hung singly at an angle away from the wall. The elegance here, the elongation and exaggeration combine with a pseudoreligiosity that escapes being Gothic because of its utter coldness and lack of detail. Rather it is a disquiet of mind that we gather, not fervor. The use of this highly artificial medium, as in the use of aluminum, star-spangled iron, plastic, mirrors, and acrylics, adds enormously to the Mannerist artificiality, sense of polish and dramatic impact. Flavin's tubes are a far cry from the scientism of artists who use phased lights in a very serious way. Their use of light as motion is purposeful. Flavin's light pulses and flows. It doesn't know where it is going. He never attempts to compete with science. His works have a hidden intellectuality too diverse and subtle to be found in experimental laboratories or scientific workshops.

To return to Hinman. These contorted, dramatic structures are actively decorated with bright colors—one to a vane—to enumerate the sides. This contortion of shape and emphasis on certain aspects only, such as apexes and sides, is a topological idea. Topology is the Mannerist of the mathematical sciences. It distorts dramatically, keeping only essentials. Torus becomes teacup, there is no difference. Space, scale are discarded, even structure is malleable. Content is entirely intellectual, even where playful. Topology surely mocks plane geometry. Abstract Mannerism can be extremely com-

plicated while maintaining an outward simplicity. The complication is inferred, inellectual, where in previous Mannerist work it often was expressed as detail.

Contemporary Mannerist work sometimes gets so extreme in its use of acid color, exaggeration of shape, and in its drama that it appears hysterical. Indeed in today's reaction against Romanticism, against Freudian explanation, against purist logic, these artists see themselves as useless members in a society where everybody is useless. Where art was once the only useless thing, now everything has lost meaning. If the artist himself feels he is losing meaning, no wonder he reacts with hysteria. He does super works with the directionless energy of a hysteric—and the result is often hysteria's attendant paralysis. The coldness, the lack of motion, the acidity of color, the lack of detail (expression), are Mannerist symptoms felt before in other centuries in times of mounting disbelief. Bronzino's frozen gestures are pure paralysis. The only hope is that this nonhuman contemporary view will break out into horizons broader than hitherto, views not seen entirely from the human scope. It would be a true Mannerist convention that works done despairingly, that desperately parody, should turn out to be truly significant.

The scientist offers a hopeful world, a world where inevitable progress discovers more and more, a world that gets better and better. This world is sane, stable, and knows where it is going. The Mannerist counters with a world in intellectual hysteria, punctuated by frozen inactivity, a world where space–time cease to have meaning, a world of soundless gestures, where humans do not live.

A SYSTEMATIC REVERY FROM ABSTRACTION TO NOW* by David Lee

David Lee is a painter, and in this article he discusses art from the point of view of the artist. He notes that "Artists have left the seclusion of abstractions. . . . When we write it is for our own purposes; if we try to communicate, it is out of fondness for life and mankind." And he points out: "The *idea* is dissolved in the complexity of experience."

When people do not trust their senses, they lack confidence in themselves. That is the same as not trusting their experience to provide a standard for knowing how to act. If the world does not seem constant, if a person does not *feel* a synthetic communion between yesterday and today, then before he can act he must analyze. When it seems to people that the structure of life is not enduring, they seek explanations. And they get them. Not trusting their experience, they ignore it. When people ignore their experience, that is, the facts, there is no limit to the wonders they can invent and the logical conclusions they can reach.

For the last few centuries, people have lacked confidence in themselves. This period is characterized by metaphysical divisions and rationalistic inventions. Man's synthetic powers failed him and he placed his faith in the explanations that proceeded from his disembodied reasoning. Mind was divided from sense, art from science, and god from man. A list of such divisions would be very long. So would a list of concomitant inventions. As a rationalist, man has great resources. His bag of abstractions is bottomless. For example, man rejected god because god was inexplicable, but then man quickly sought to endow himself with the characteristics of god. Misfortune was renamed justice and it was assumed that what happened did not hurt so much. Such was his complete faith in explana-

* Revised version of article originally published in *A Pamphlet of Essays Occasioned by an Exhibition of Painting at the Guggenheim Museum, Fall 1966, New York.*

tion. Being unhappy with his own time, as usual, man invented the discovery that it was better than the past and then he logically foresaw an even better future. To prove it he invented the march of progress and the origin of species. Instead of doubting why he worked so hard, he invented goals the achievement of which would permit him to retire from the competition. Being insecure, man sought security and named it ambition. The terms of the problem rapidly became the solution. Everything was divided into categories. From "pure geometric" to "expressionist biomorphic," every abstraction had its abstraction. Every change was sanctioned in the name of protest against the past. Necessity was his standard apology, but desire continued to be the mother of invention.

A rationalist is like a person who looks in the mirror every day trying to decide that he is good-looking. He will analyze his features separately and together and then think whatever he wants to think. Each subsequent look will deepen this conviction. Such a gazer into mirrors will not be able to conclude that other people agree with him. He will remark this division of opinion and he will try to understand it. He will not succeed. He will name his madness schizophrenia.

Nevertheless science has been attaining many advances during the last few centuries. The attainments of science seemed to confirm man's faith in "truths." People took the idea of scientific truths quite literally. Subtlety of meaning in language deteriorated. The name "logic" came to be used interchangeably with "reason." This "reason," which was really only logic, became the popular passion. Passion led people to believe anything might be subjected to experimentation. Abstract or logical truths, of which there are an infinite number, became confused with experimental or rational truths, of which there are scarcely any. Completely unreasonable, unscientific premises became the basis for a logic that led the way to universal truths. That happened because people ignored their experience. Intuitions were dignified as scientific premises. Preferred significances were found where they were desired. Of all the things on earth, abstract rationalism alone seemed proscribed to no one. It became the preemptive virtue. Thus people were permitted to believe that everyone was the same as everyone else. It permitted them in their abstract liberalism to believe that every man, woman, and German

was just a man, a man outside history. Their great desire was for such universal truths and this desire became the ideal of their abstract rationalism. If science claimed man's freedom from man and the prospect of freedom from nature, it also, in unhappy contradiction, sought freedom in the totalitarianism of universal truth. If truth was universal, then everyone was subject to it. Such doctrines of necessity freed man from responsibility for himself. It permitted, even induced, everyone to think of himself as an object. People who lacked confidence could sublimate themselves in this faith.

The situation is exemplified in a theatre where there is a proscenium arch. It is assumed that if the members of the audience will look through it, they will all see the same sight. All they must do is look in the right direction. That is tantamount to denying that everyone sits in a different place and that everyone brings with him a different set of experiences. This theatre, like universal truth, exists entirely outside any particular man. It is a theatre and a view of life for people who prefer to be like objects, to be acted upon.

The self-confidence of artists has increased noticeably. The things that artists make reflect an attitude toward experience that is noticeably different than before. The frame, the painter's proscenium, has disappeared. Painters, composers, writers, choreographers, and even filmists are becoming less contentious. They are not concerned about attributing values to things. Their presentation of things is direct, without exterior significance. Writers do not, as Proust did, analyze their experience, they just present it. Their writing is their experience, which is nevertheless not realistic. The things that artists make reflect an acceptance of their experience that is greater than before. By experience I mean daily life. This and this and this. One thing after another. It is the process of the series. Simplicity and complexity are no longer *a priori* aesthetic positions. Artists are less contentious. They have their experience and they delight in their intuition of its forms.

As artists have grown in confidence, we have discarded the rationalistic mode. We have forsaken "design" with its questions and arguments. This process has been slow. At first, design was not discarded, but only its questions and arguments. We made paintings of unquestionably perfect design, paintings that were symmetrical in every direction. The area of the painting was often analyzed in ac-

cordance with its integrity as an object. In some paintings by Frank Stella, this analysis is ruthless. Others made objects of equally fault-less design by the device of presenting the model itself as the work. Yves Klein, Jasper Johns, and Robert Rauschenberg did that, and Marcel Duchamp, and Jackson Pollock foreshadowed the ten-dency.

Artists have ceased thinking of a piece as separable from its parts. The *idea* of a piece no longer exists. The parts may be only paint and canvas or spoons and a plastic or they may be anything. Some parts may exist physically so that even a blindman might count them, and some parts may not. The sensible existence of the parts may be only visual. They may be the painted presentation of a unit, such as a geometric shape or a photograph of a superstar. But in any case the spectator's experience is, among other things, real and im-mediate.

We have confidence in our experience. We know it is not possible to comprehend a million in its own terms, a million of ones. We know there are all these parts to everything. We are interested in every part. We are not much interested in any one part. We avoid the false problems implicit in the banality of the single object; in other words, taking the banal object to be the characteristic one. We deal with a complex of information without much respect for its parts. A photograph printed on canvas is a simple example. A row or several rows of things is another example. A row of things is a series. Artists who like that scheme for structuring their pieces have usually used the simplest series possible. They have simply repeated one thing a number of times: one to one to one. The piece is more complicated if the series is one to two to three and so on, or if one series is imposed on another. We have ceased giving our work a focus. There is no place for the spectator to be from where he can see it all happen. The spectator is not directed toward a point in the piece at which its parts are balanced, nor is there any attempt to play policeman by leading the spectator's eye around in the composition. The spectator is not invited to take home with him a static mental picture of the piece. The *idea* is dissolved in the complexity of experience.

It is likely that a piece will in some dimension break the specta-tor's field of vision. Or, by its irregular shape, it may include some of

the wall on which it hangs within the conventional perimeter. Or an artist may permit the wall a place between the parts. When we do things like that, it is not because we want to contend with the spectator, or interrupt his field of vision or bother his bad habits. Any such contention would be pointless because it is only by means of an insensible rationalization that people for centuries have pretended to see only a rectangle and not also the wall. When we do this sort of thing, it is because we have intentions toward the wall, not the spectator. We do it because we wish to inform the wall, or the space in front of it.

When a piece has mirrors, or a vibrant combination of colors, it compounds the complexity of sensible space. When an artist varies the volume of space behind the surface, as I do, it inhibits the establishment of a preferable point of view. What is left is each particular point of view. They are all good and there is no agreement among them. We are delighted by that; we are responsible. Our pieces are apt to have unending visual possibilities and where these possibilities conjoin with our intentions, the work will be perfectly finished. To this end we employ the most appropriate technology.

Artists have left the seclusion of abstractions. Our culture is one of sensibility and self. We are subjective and unsentimental. Private and impersonal. For us, explanation means to smooth out, to make everything flat. When we write it is for our own purposes; if we try to communicate, it is out of fondness for life and mankind. If we find agreement, we are not surprised, but agreement is not necessary to us. After all, it is not a revolution. An acquaintance complained, after reading the first pages of this revery, by remarking, "It's not about artists, it's about everybody." Well, the self-confidence of artists has increased noticeably. We no longer apologize. We are dignified. We have broken the mask of a rationalistic servitude. We have given the game away.

MINIMAL ART AND PRIMARY MEANINGS* by Allen Leepa

In Minimal Art Allen Leepa finds ". . . an effort to deal as directly as possible with the nature of experience and its perception through visual reactions." He considers phenomenological problems, and relates them to experience. He writes: "The Minimal artist attempts to state point blankly in visual form what philosophers and writers have been saying verbally—phenomenology is the basis for experience."

Dr. Leepa is Professor of Painting at Michigan State University, and is the author of *The Challenge of Modern Art*. He is a painter, and his work was included in the "Young American Artists" exhibition at the Museum of Modern Art in 1953.

———————————

Man is in the paradoxical position of existing in a state of consciousness but not being able to understand the world in which he lives. The dilemma of this position has never been more painfully evident than today. Never has he been more poignantly conscious of his inability to know the meanings of his existence. It is not that rational thinking has failed him. Rather it is that he is limited by the nature of knowledge and the construction of himself and is unable to penetrate the mysteries of nature.

The search for essentials in the world and in experience is not new. To the early Greeks, for instance, an ideal nature existed; and art was the approved way of trying to realize it. In the Middle Ages, the truth about life was in the hereafter; and life in the present was dedicated to it. In the nineteenth century, essential truth was found through reason; the rationalists believed that mathematics was an infallible way to explain the secrets of nature. In the twentieth century, the atomic theory of matter seemed to offer the ultimate knowledge necessary for unlocking life's secrets, but it was destroyed by field-force investigations. In the arts, Gauguin emphasized "truth to the surface"; the Impressionists juxtaposed contrast-

* Excerpts from Professor Leepa's forthcoming book *Problems in Contemporary Painting*.

ing spots of color in order that at a distance they would appear to mix in the eye; Cézanne insisted on a formalistic interpretation of nature in terms of "cones, cubes, and cylinders"; Mondrian believed that "in plastic art, reality can be expressed only through the equilibrium of *dynamic movement* of form and color, and pure means afford the most effective way of attaining this." Efforts to deal with basic elements in the construction of a work continue today. Keen abilities to theorize and a willingness to carry experimentation to its logical conclusions are very much in evidence in art and other fields. For example, while Mondrian used lines and colors to deal directly with visual experiences related to primary forms on the canvas, some artists today feel he diluted their meaning and intent when he used them to achieve a romantic objective, namely the creation of "reality," rather than dealing with sensations having to do with the primary forms themselves.

In recent years, art has come to play an increasingly important role in the search for new meanings. In human experience, what can be perceived but cannot be clearly understood can often be expressed in art. The feedback that results frequently leads to new insights. Art is like a seismograph that sensitively records man's condition in the world at a particular time. In its efforts to deal with the question of what constitutes existential experiences in a visual medium today, Minimal Art calls attention to the ways such experiences can be formed visually.

In the comments that follow, Minimal Art is seen as an effort to deal as directly as possible with the nature of experience and its perception through visual reactions. The theories examined in support of this thesis are that traditional functions attributed to art must be re-examined in the light of the new art developments; that the nature of language and how it is used are basic to the kinds of meanings and communications created; that such concepts as clarity of idea, precision of means, standardization of elements, and impersonality of statement are essential aspects of efforts to base art on a direct and primal kind of visual experience; and that Minimal Art is an effort to relate the observer to the thing observed at that point where human perception brings them together—in the *magic* of the phenomenon of experiencing itself.

Before discussing these theories, it is important to differentiate

immediately between two kinds of functions that art can perform. The first is that of recording, reproducing, and re-creating familiar ideas, feelings, and scenes in easily recognizable forms. A landscape painted Impressionistically, Expressionistically, or Abstractly is generally acceptable today, a particular artist's interpretation notwithstanding. What happens is that the work of art hands back to the spectator the feelings and ideas he already knows and to which he can react positively. His frame of reference for understanding both the content and form is a familiar one. A second kind of function that art can fulfill is that of expressing deeply felt awarenesses for which no generally acceptable form exists. The form is created as the awarenesses are clarified. The opposite also occurs; once a form is established its manipulation can lead to new insights and experiences. This kind of art work usually makes substantial breaks from the familiar and requires new rationales and new modes of evaluations. When Mondrian began to limit himself to verticals and horizontals and the primary colors it was because this kind of form contained his ideas most directly. The philosophic basis consistent with his objectives had then to be accepted in order for his work to be understood.

Reducing the number of factors dealt with in any particular work of art in order to zero in better on how they can be used most directly in a visual medium is the task undertaken by the Minimal artist. This is an attack on meaning, first, because what he is attempting is the elimination of any and all experiential meanings not closely related to the means used in forming the meaning itself, and secondly, he is examining and manipulating the means itself, namely the visual elements, in order to clarify the nature of its function in experience.

To understand the Minimal artist and why he ignores the traditional, accepted meanings in art, it is necessary to examine the dynamics of how meaning in general is developed. We need to start with the role of language because it is basic to the formulation of ideas: what happens to language, how it is organized, and the way in which it is used affects the nature of meaning. When we consider that language is the symbolic representation of experience, that it is essential to communication and the process of recall, we can understand how fundamental it is in forming our perceptions of the

world. The child enters the world without language and only later learns to associate verbal symbols with his felt responses. Once he has accepted the sounds to which others respond, he uses them to register his wants and experiences. Soon, however, he reverses this process and begins to experience and retain in his repertoire of responses those for which he has a verbal formula: words become "the receptacles of experience."[1] Words, in other words, restrict experiences and ideas as well as develop and organize them. We become slaves to the limitations imposed on us by our use of language, at the same time that we organize ourselves in essential ways because of it. (Minimal Art, as we shall see, attempts to avoid this dilemma by a more direct confrontation with the essential elements of perception itself.)

Thinking has long been conceived as an interior process, private and inaccessible. Yet, the meaning that is given to a word was originally derived from the existential object to which it was applied and not because of some exclusive inner process. In other words, to understand a word it is necessary to see how it is applied. Understanding is not a private awareness of an image that is later applied to an operation and gives it its key: an image cannot determine its own application. It is not its own symbol to be used arbitrarily. Rather the meaning of a word is determined by the way in which it is employed and how it is applied. (Minimal Art focuses on sensations based on direct perception of objects, which in painting are the lines, colors, planes, forms, and not on symbolic interpretation of them, as when a line is used to express a subjective emotional state of the artist.)

Another characteristic of language is its abstraction from reality. Symbols are employed. Names are given to real objects. A cat is a *cat*. It is an animal of a particular shape and with some special characteristics. When we speak of cats in general, rather than a particular cat, we are one step further away from the actual object. We are still further away when we refer to a carnivorous mammal. As we become more abstract, our meanings become less clear. Abstraction in language is necessary when we think in hypothetical terms. We can refer to the future or to the past, to time and to

[1] E. G. Sacachtel. "On Memory and Childhood Amnesia," *Psychiatry*, Vol. 10, 1947, pp. 1–26.

space—elements without physical substance. But the more the abstraction, the less there is reference to actual events and the chance of valid testing. Unquestioning acceptance of abstract definitions, for instance, when applied to whole groups of people, maintains prejudices and circumvents the ability to relate to actual situations except in hypothetical terms. (Minimal Art attempts to avoid the escalation of abstraction by dealing with the nature of perceptions directly.)

The effort to use language to define and analyze in order to clarify often leads to confusion—one of the reasons why the Minimal artist usually describes his work factually rather than attempting to explain it. The reason language definitions can lead to confusion is perhaps best described in the following quotation, from Ludwig Wittgenstein's *Philosophical Investigations*, which explains the nature of definition. It begins with an analogy to games.

> I mean board-games, card-games, ball-games, Olympic games, and so on. What is common to them all? Don't say: "There must be something common, or they would not be called 'games'"; but *look and see* whether there is anything common to *all*—for if you look at them you will not see something that is in common to all, but similarities, relationships, and a whole series of them at that. . . . But what does it mean to say that we cannot define elements, but only name them? This might mean, for instance, that when in a limiting case a complex consists of only one square, its description is simply the name of the colored square.

Similarities exist among objects that give them, as a group, an identity. There is no essential quality, for instance, in a work of art that makes it, by virtue of this quality, art. There are no eternal essences that a work of art contains; rather, what should or should not be called art is an existential question.

Is there any way of circumventing the limitations that language imposes on us? Can we somehow avoid meanings that are foggy, lacking in clarity, faulty in preciseness, confused and undisciplined in purpose? In art, a step is taken in this direction when lines and colors are not used to represent a realistic object but are themselves looked on as objects with which direct experiences can occur. The Minimal artist dramatically underlines our need to examine more

precisely the importance of how meaning itself is created. He makes an effort to deal with the visual equivalents of precisely examined sensations and with the relational or contextural meanings that they require. To do this successfully, the number of elements and relationships used are reduced to an absolute minimum. Experiences most closely associated with what are felt to be primary visual reactions are clearly distinguished from those considered to be derivative; for example, those that are classical or romantic in origin. When a line is drawn at the edge where two surfaces meet in a piece of sculpture, the meaning and clarity of the line are exact and precise. But when a line is randomly splashed across such surfaces, its function is ambiguous, arbitrary, and subjective.

The Minimal artist attempts to state point blank in visual form what philosophers and writers have been saying verbally—phenomenology is the basis of experience; to deal with experience directly, we must stop misusing language to construct ambiguous meanings. (Phenomenalism is the process of reducing to a statement of fact actual or possible sense-impressions; taking a phenomenon as given and experiencing it operationally, not merely observing it casually in order to clear one's mind of presuppositions and adopt an attitude of disciplined naiveté. Nothing in the imagination, for example, cannot first be discovered in sense reactions.) How does the Minimal artist deal with phenomenological experience?

The Minimal artist asks himself the question, "What are the elements of the visual situation when I am in the most direct confrontation with it?" He proceeds then to attempt to consider only essential factors of his perceptions. This is basically an existential problem. No longer sure of his position in this universe, the existential person insists that, as Sartre has said, "Man is nothing but what he makes of himself." He turns up on this planet and then proceeds to define himself. Therefore, "existence precedes essence"; the chicken precedes the egg. Facets of the new art follow quite closely the tenets of this position. There are no "essences" or universals by which to define man or art. Any and all traditional assumptions about art are suspect. The unique and personal in art, for instance, can not be accepted because these are acts that are part and parcel of everyday experiential situations and are not primarily of the visual painting situation. Such experiences are not sufficiently part of the phenome-

nological relationship of the artist to his canvas and are therefore extraneous. Emotional acts *per se,* when arbitrarily applied to the work of art, usurp more primary sensations in the visual situation. The position of the Minimal artist, however, differs from that of the existential artist, in that the existentialist feels he can define himself whereas the Minimalist believes no definitions of self or of art are possible.

If we ask the new artists what questions or problems they are trying to answer or solve, their first reply is "None," because to raise a question or to name a problem suggests the *a priori* possibility of formulating abstract concepts apart from his concern with his own perceptions in relation to the painting object. Definition, as was pointed out earlier, accepts the possibility of something absolute, which then preconditions and regulates all future perceptions and art forms. The new existential artist's position is perhaps best represented by Alain Robbe-Grillet: "The world is neither meaningful nor absurd. It simply is." Rather than deal with meanings that are abstracted from their referents, the Minimal artist deals with a more immediate objective, an "impersonal" world of phenomenological meanings. (How different the approach of the Minimal artist is from the ones with which we are most familiar, from that of Picasso, for instance, to whom problems in art are vital: "Do you think it concerns me that a particular picture of mine represents two people? They were transformed into all kinds of problems.")

The following is a typical composite of the positions of the Minimal artists:

> The obvious way of balancing a picture two-dimensionally is symmetry. But symmetrical forms do not balance spatially. There is illusionistic space. This can be handled if it is made to advance forward at an exact rate. I found that the rhythm of a regular pattern will do this. Lines that create concentric forms, one inside the other, for instance, produce the kind of regularity needed to control space movements. . . . A thing must be shown with the greatest clarity. One way of achieving this is to present an object in the context that shows it off most clearly. White cylinders against a black wall, for instance, accomplish this. The results are then the most obvious. Clarity is maximal; the means used are mini-

mal. The focus is on clarity itself. The structural approach to a painting is another way to achieve clarity. It is also a way to avoid the dilemmas of the past. Dilemmas must be eliminated. If exact relationships are precisely controlled, confusion is avoided and clarity is emphasized. Mechanistic configurations with a controlled number of variables can also be used to produce clarity. At the same time, the idea of continuation vs. differentiation can be examined. This occurs when the same color is repeated from one object to another. Repetition produces the continuity; separate objects the differentiation. But I do not know the meaning of either continuity or differentiation; I only deal with them as phenomena; I do not pretend to understand them. . . . By producing sculpture larger than man-scale, I try to achieve the *presence* of natural phenomena, such as a tall building, a high waterfall, a great dam. The scale produces a heroic sensation but a depersonalized one. This is important. I want to deal only with objective sensations. If I place two tremendously tall columns near each other I can achieve a heroic sensation. . . . Spontaneity, the unconscious, the irrational have no place in art; the vacant and disinterested mind with its own symmetry—this is the basis for art. Then the emphasis is where it should be: in the mind of the observer. I use standardized, repetitious, boring forms because they are most primal and ageless. . . . The line of demarcation between the two- and three-dimensional is clarified when standardized three-dimensional forms are attached to a flat canvas with some forms left incomplete but painted to appear complete. These differentiations in techniques and materials do not change the fact that the painting and the three-dimensional forms are valid figures in themselves.

The variety of attitudes about perception, in general, range between the theory that the self can know nothing but its own modifications and inner states to an absolute belief in materiality with object-based sensations in complete control. While in any given Minimal work we can ask to what degree the subjective or objective intention is emphasized, this question seems to serve no reasonable purpose, assuming, of course, that the actual intention can be ascertained. A work of art simultaneously possesses content and context, message

and form, subject and object. Precisely where, then, in phenomeno-
logical experience does the synthesis take place between man's inner
and outer worlds? While this question has no discernible answer, it
nevertheless points to an underlying concern that has frequently oc-
cupied the critical attention of the newer artists. It becomes the new
"object" and the new "reality" of their work. If the meeting point
between inner and outer worlds is placed in the mind's eye of the
observer, the work itself becomes, for all intents and purposes,
redundant. If the meeting point is in the work, then crystal-clear,
concrete statements of fact and preciseness of relationships are
paramount.

The Minimal artist has brought to art concerns that many may
feel more properly belong to the field of semantics, criticism, or art
philosophy. But the trend that we have been exploring here is part
of a continuing and persistent movement in twentieth-century art
and cannot be ignored. It is a manifestation of man's search for
basic roots and meanings in a world that appears to have none. The
more the dilemmas of life crowd in on us, the more pertinent and
critical is the need for us to look at ourselves as we actually are. We
are profoundly conscious of the need for a clearer presentation of all
facets of our life as we find them today. As we look at ourselves ever
more closely, we can come nearer to knowing ourselves. Art offers
this possibility.

EROS PRESUMPTIVE* by Lucy R. Lippard

Erotic content is not new to art. In recent years new manifestations of eroticism have appeared, and the communicative function of art has concerned itself with the distribution of erotic information.

Minimalist language is not totally devoid of figurative content, nor is it without erotic implications. Quite possibly, all good art being created at this time is *of* this time—it is Minimal.

In *Silence* John Cage writes: "Nothing has been said about Bach or Beethoven."[1]

Lucy Lippard is the author of *Pop Art*. She has written about art for many publications, including *Art International* and *The Hudson Review* and has written several museum catalogues. A contributor to the critical anthology *The New Art*, she is now writing a book on Ad Reinhardt.

Ideally, eroticism in the visual arts is a curious combination of specific and generalized sensation. Universally understood rhythms or symbols become meaningful only to the individual viewer. In this sense, the erotic is always particular, but its particularities alter depending upon who views them, when, and how. Recognition of obvious erotic subject matter, or any subject matter at all, can be beside the point. The broader the framework within which the erogenous forms or surfaces occur, the greater its appeal to a greater number of people. The possibility of abstract eroticism may seem far-fetched, but with few exceptions, the best erotica being made today is abstract to a greater or lesser degree, concentrating on a purity of sensation that in turn engenders a stronger response. It can be argued that abstraction is by definition an intellectualized perception and hence removed from the immediacy of the sensual. There will be connoisseurs who will cry pedanticism! and castration! at the very mention of a totally abstract eroticism. Yet it would seem that

* Slightly revised version of an article published under the same title in *The Hudson Review*, Spring, 1967.

[1] John Cage, *Silence*, Middletown, Connecticut: Wesleyan University Press, 1961, p. 158.

an audience visually sophisticated enough to appreciate and at times prefer non-objective works of art as concrete objects in themselves, rather than associative look-alikes, will also prefer the heightened sensation that can be achieved by an abstractly sensuous object.

Many observers noted with lip-licking anticipation that the 1966–67 season was going to be the "Erotic Season," like the Pop, Op, Primary Structure seasons past. For at least two years rumors have been rife of wickedness stored up in the studios waiting for the Trend to break. It never has, and won't, for the simple reason that subject matter without style does not make a trend. And most of the erotic art that has appeared so far is stylistically trite and outdated —third-rate Pop and warmed over neo-Surrealism, for the most part. Organizers of recent erotic exhibitions have shown a distinct concern for titillation, but it remains unfulfilled because either courage, taste, or material are lacking. Such shows are attended by a surprising, and amusing, number of clearly non-art visitors—well-dressed men whose occasional snickers belie their apparent sophistication, but who are obviously disappointed, like the reviewer who observed that one exhibition was more Hard Edge than hard-on, or more put-on than take-off.

Obviously the individual nature of the erotic response precludes any conclusions on the subject, but in this day of obscenity trials and 42nd Street stag movies, the contradictory effects of the erotic arts are worth investigation. For instance, why have so few art shows been raided, while books and films are constantly banned? Perhaps because one picture can *not* replace a thousand words? Sexual stimulation, response, and activity are sequential. A book, proceeding in time, is more likely to evoke the rhythms of this sequence than a single painting or sculpture, the viewing of which is more vulnerable to outside distractions. A book has the additional advantage over film (the most potentially potent erotic art form) in that it permits privacy, and the imaginative reader has more scope for personal fantasy, substitution of faces and settings drawn from the reader's own experience or subconscious, while the picture is a finished and self-contained object complete in itself; one detail might destroy the attraction for any single viewer. On the other hand, pornography, or a genuine erotic art intended to arouse, is perhaps best served by painting, or rather by illustration, since it is more "instructive,"

conducive to imitation, like the pillow books. Because of its sequence, a series of mediocre illustrations may be more persuasive than a single masterpiece. One of the problems of current figurative erotica is the fact that it so rarely transcends illustration, and when it does, it tends to lose its sensuous appeal in the process. Illustration, and to some extent any figuration, is easily exhausted in evocative terms. The abstract artist has an advantage in that he can focus and expand, in several simultaneous directions, the sensuous element that may be submerged in anecdote or decoration within a representational context.

It might be thought that, because of its abstraction, there is no such thing as pornographic or truly erotic music. But music sets a mood in the same manner as a picture of a scene, or a scene described in a book. The least tangible of the arts, it nevertheless has as much hold on the emotions, and therefore the senses, as any other, and it is, of course, the rhythmic and sequential art *par excellence*. Plato worried about "lascivious music," equating it with "vulgar and lawless innovation," and spoke of music freeing men from fear: "the absence of fear begets shamelessness" (*Laws II*, 700–701). There is today a dominant group of abstract painters and sculptors equally opposed to the sensuous, the Dionysian, or for that matter to any reference to life, biology, anthropomorphism in art. Stylistically, many artists working in abstraction with sensuous and erotic overtones are allied to these "neo-Platonic" structurists. But by refusing to rule out all instinctive and sensuous effects, this second group takes a position that is formally sympathetic but theoretically opposed to the structurists' conceptual rigor and literalism.

Many makers of sensuous abstraction are wholly uninterested in eroticism *per se*, but their work includes general allusive factors that recall apsects of nonliterary Surrealism and, indirectly, of sexual activity. When Keith Sonnier made two identical triangular forms, one of white cotton duck, one of white painted wood, and connected them by an accordionlike tube, he presented geometric and organic form without departing from geometry. The soft shape inflates and deflates very slowly, and while the implication is forcibly understated, the process of distention and release are easily associated with erotic acts. Jean Linder has made a six-and-a-half-foot-high booth of soft white and clear vinyl painted with rhythmic patterns

overtly sexual in origin. These labyrinthine patterns are, nevertheless, not central to the sculpture's sensuous attraction. The booth as an abstract environment, an open and closed space, provides a concrete analogy, full scale, of sensual experience.

Because of its physical presence, sculpture is a more suitable medium for erotica than painting. The Surrealists, with their objects of affection and disaffection, were among the first to apply Freudian object identification to works of art, though Ruskin had already noted that "sculpture is essentially the production of a bossiness or pleasant roundness." Younger artists today, however, no longer depend on symbols, dream images, and the "reconciliation of distant realities"; they minimize the allusive factor in an attempt to fuse formal and evocative elements. Ideally, form and content are an obsolete dualism. Union of the two is particularly important to erotic art, and in this regard McLuhan's "medium is the message (massage)" is relevant. Materials, or medium, become more important when pure sensation is stressed over interpretive symbolism or the realistic portrayal of recognizable objects. Don Potts, for example, has employed fur and leather—traditionally evocative materials—so that the luxury surfaces lose their literary connotations and are fused with the understated ebb and flow of the sculptures themselves. By eliminating reality as an intermediary, sensuous immediacy is intensified.

The most effective erotica of the first half of the twentieth century already depended upon mood, supported by exotic juxtapositions and deceptively conventional frameworks, upon generalized association rather than realistic rendition. Max Ernst and Balthus, for example, rarely found it necessary to be anatomically graphic in their erotic fantasies of the 1930's. The *ambiance* of the latter's pantomimes of adolescent sexuality and the former's disturbing collage novels are more erotically charged than the endless procession of lurid neo-Surrealist collages and paintings by which current erotic art shows are sustained. After the last war, a new attitude emerged that took the blatant representation of supposedly erotic subject matter to extremes of the absurd. Mere representation of genitalia, breasts, thighs, sado-masochistic paraphernalia, new positions, have little erotic or even pornographic force in an era of topless nightclubs and girlie advertising. In 1951, Marcel Duchamp made a totally

Alberto Giacometti: *Disagreeable Object*. 1931. Wood. 19". In the collection of Mr. and Mrs. James Johnson Sweeney. Photograph courtesy of The Museum of Modern Art, New York.

Keith Sonnier: Untitled. 1966. 3' high.

Charles Stark: *Painting.*

realistic (but unfamiliar, and consequently abstract) cast imprinting a vulva in bronze (*Feuille de vigne femelle*) and some ten years later, Robert Morris imprinted penis and vulva in lead reliefs, as well as making a box relief that opens to reveal a photograph of the artist— expressionless, stark and frontally naked. Comparison of these works and Giacometti's *Disagreeable Object* of 1931 clarifies the change. *Object* is Surrealist, consciously subconsciously inspired, bristling, literally, with erotic violence and hostility. There is nothing erotic about Morris's objects, nor was there about a still more radical gesture he made in a dance piece in which he and Yvonne Rainer, both nude, and in close but dispassionate embrace, were moved mechanically across the stage, neutralizing nudity into a condition like any other condition, embrace into an act like any other act. Such isolation and demythologizing of conventional ideas about erotic subject matter questioned the necessity of such subjects. Any residue of sexual stimulus in Duchamp's or Morris's work evokes a cerebral rather than an emotional response.

The abstracting Surrealists (Miró, Masson, Ernst, even Tanguy), and the Abstract Expressionists after them, utilized biomorphic forms for their sexual inferences. If there is nothing definitely erotic in such twining, embracing, swelling, and relaxing shapes, there is, nevertheless, a sensuous character inseparable from the broadly understood erotic experience. Visceral shapes do induce a physical identification in most viewers. "Body ego," and narcissism, are implicit in the erotic. Isolation of the caressability, the sensuous attraction (or repulsion) of a form from its particular biological function or anatomical placement frees that form from limited meaning. A baglike or spherical shape can be read as uterus, breast, or testicle, or it can be read nonallusively, accepted on a purely sensory level. For a Freudian, of course, such correspondences are endless and omnipresent. Norman Brown (whose approach to the subject must be taken with a pillar of salt) finds "a penis in every convex object, and a vagina in every concave one" (*Love's Body*, p. 250).

From an aesthetic point of view, abstraction is capable of broader formal power, since the shapes are not bound to represent any particular thing or coincide in scale with other forms. The experience provoked may relate to, but is not dependent upon, the realistic or symbolic origins of the form. This is not to say that figurative art is

incapable of formal and erotic success, but simply that such distillation is today far more rare in figuration, where erotic subject matter rather than erotic effect tends to dominate the attention. One of the purest erotic artists working today never deals in abstraction. Claes Oldenburg's utilitarian inanimate objects are not literally sexual. They are, in fact, the contrary of Morris's deadpan anti-eroticism. His capacity for fantasy and the purity of his sensuous approach endow rough cloth or vinyl orange squeezers, Dormeyer mixers, baseball bats, or bathtubs with rich and inescapable organic and sexual implications. As eroticism, Oldenburg's works *are* abstract; the stimuli arise from pure sensation rather than from direct association with the objects depicted. His soft sculptures—flexible, kinesthetic, passive, but potentially arousable, potentially dynamic—have a few minor precedents in Surrealist objects from the thirties, but their scale and wholeness is incontestably contemporary in spirit. Oldenburg asks for his objects "no standards, no values. I wish to be like Nature—creative but unphilosophic, mindless, machinelike . . . setting an example of how to use the senses."

Mindlessness and systematization, are characteristic of the art of the mid-sixties. Despite its detachment, an aggressive vacuity can establish a tremendous intimacy with the patient viewer. Sex is, after all, the fundamental mystical experience, and the cool tone—deceptively near neutral—of current eroticism is also that of the mainstreams of traditional erotic art. The great precedent is ancient Hindu temple sculpture, the yab/yum of Tantric yoga, where opposites were not conceived as active and passive male and female, but as an incorporation of the two: dynamic male and welcoming static female as well as passive male activated by the dynamic female. On the temple façades, obsessive but precisely constructed pattern is fused with an ineffable sense of volume, physicality, substance. Everything seems in slow motion, the figures freed from an everyday into a timeless reality.

While there is no question of direct influence or even interest, repetition, inactivity, simultaneous detachment and involvement, understatement and self-containment are qualities shared by the arts of India and of today, as well as the purely ornamental arts of the Near and Far East. Emotive or expressionist energy is foreign to the makers of sensuous abstraction. Artists like Sonnier confront oppos-

ing aspects of the same form or surface and systematize the resulting concept of change. As in classic Indian sculptures, momentary excitement is omitted in favor of a double-edged experience; opposites are witnesses to the ultimate union or the neutralization of their own opposing characteristics.

The danger is that total union or wholeness, the decrescendo and crystallization of baroque activity applied to an accepted sexual dynamism, will drain it of all empathic interest. Yet the rhythms of erotic experience can be slowed to a near standstill and convey all the more effectively a languorous sensuality. In contrast to the expressionist viewpoint—the spontaneous imprisonment of the moment of ecstasy in which paint, form, and color are sent spinning in Wagnerian approximation of orgasm—the cool approach depends on pervasive mood, the electric stasis of sexual attraction, the roots rather than the results of desire. The cool sensibility that approves understatement, detachment, the anticlimactic in art, tends to approach the erotic non-romantically, even non-subjectively. Such an approach may be the consequence of something as radical as a change in morality and sexual ethics brought about by the generation now in its twenties and thirties, but sociology aside, it is well served aesthetically by an antidynamic or at least post-dynamic sensuousness characteristic of provocation, fore or after play, rather than of climax. A controlled voluptuousness, as concerned with the ebb as with the flow of energy, is formally manifested by the predominance of a long, slow, deliberately regular curve, bulky parabolic forms, exaggeratedly luxurious or obsessive surfaces and patterns, all presented within a framework of simplicity, and even austerity, eminently suited to the static nature of the "frozen" arts.

Figurative art is at a disadvantage in the erotic arena when lascivious TV commercials, girdle ads, Hollywood movies, girlie, nudist, or fetish magazines are available to any American with a couple of dollars in his pocket. Life has literally outstripped art. When the camera rendered invalid much figurative painting, erotic art was affected as much, perhaps more, than other subjects. It is notable that a good deal of the supposedly erotic painting seen in galleries and studios today imitates photographic techniques. For this sort of erotica, descriptive detail is of the utmost importance. Richard Lindner's work, and some Pop Art, are exceptions, for they

fill the lacunae with harsh, vibrating color. Lindner's brutal amazons in leather jackets, cat-eyed sunglasses, purple gloves, their metallic flesh inviting, insatiable, and perhaps impregnable, are "real" largely in their insistent physicality.

Yet for pictorial reality, the camera is unbeatable, and when it is manipulated with aesthetic skill and sensitivity, sensory reality can be equally well served. Arthur Bardo's photographs of women masturbating, included in a recent exhibition, make neither excuses nor pretensions for their medium; their effectiveness is due to aesthetic quality rather than prurience. When photography imitates painting, on the other hand, it is usually negligible, as in the woozy "impressionistic" color photographs by Emil Cadoo that contributed to the confiscation of an issue of *Evergreen Review*.

Dissonant color, tasteless garish pattern, wild combinations of visceral form and tactile effects, more chaotically employed than is usual in Pop Art, are among the characteristics of funk, a style that has been called "the aesthetics of nastiness" which has its most radical exponents on the West Coast. These deliberately unattractive qualities applied to erotic content have given rise to a perverse (and to some observers an unhealthy and offensive) tendency. Combined with aspects of the cooler depersonalized styles, it can approach the insistent neglect, or castration, of form as a life-giving force that epitomized Art Nouveau. The *fin-de-siècle* artists used pattern to suppress, break up, and systematize, as do many of the contemporaries, but they also suppressed physicality—an element paramount in today's sensuous art. Despite its ornamental attractiveness and superficial sensuality, Art Nouveau has in it a suggestion of death-like chill, a morbid confrontation of lust and death that can be found to a greater or lesser degree in much Surrealist poetry and painting. In Lucas Samaras's elegant and deadly pin and needle fetishes, Yayoi Kusama's phallus-studded chairs (where endless repetition commands the obsessive attention that is an integral part of eroticism), Eva Hesse's black, bound organs, and Lindsey Decker's putrescent plastic extrusions, the opposition and eventual union of Eros and Thanatos is one more contradiction to be absorbed by form. Metamorphosis is still the subject. Although quite different in effect, the dry and unnuanced eroticism of Art Nouveau is analogous to the firm-fleshed calm of the Indian sculptures, the

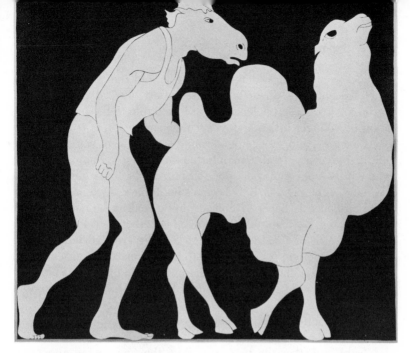

John Wesley: *Camel.* 1966. Acrylic on canvas. 40″ x 46″. Photograph courtesy of Elkon Gallery, New York.

Tom Wesselmann: *Seascape #17 (Two Tits).* 1966. Oil on canvas. 60″ x 72″. Photograph courtesy of Sidney Janis Gallery, New York.

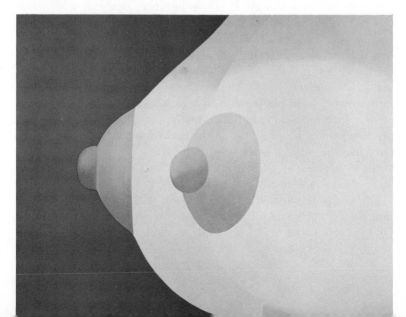

slowed sensuality of Oldenburg's objects and the work of the abstract "eccentrics"—all of which are robust, instead of sterile. An eroticism cleansed of violence is not unsuitable to the pacifist orientation of younger artists today; by the same token it is difficult to assert a sunny, altogether life-affirming art in time of war.

Still, perversity is also manifested humorously (now and then even wittily); one finds pink popular humor, the black humor of sick jokes and sight gags, or Rabelaisian blue humor. A sophisticated or jaded audience is likely to find all erotic realism humorous rather than arousing, but Henry Miller's mood of ludicrous celebration, the euphoric spirit of the Indian "Great Delight," real ribaldry, or the idealistic tenderness of *Lady Chatterley's Lover* are absent from most recent art, although a combination of pink, black, and blue wit in deceptively mild guise is found in Jack Wesley's good-humored hybrids.

Given the anti-sexuality of some so-called erotic art that is erotic in subject alone, one might ask where the line is drawn between "cool" and "cold," whether the two arise from the same or an altogether different approach. The decisive factor is, finally, the sensuous element. The distinction between pornography and eroticism no longer seems valid, and can, in turn, only be judged in the context of the individual. The question is now merely a legal one, of interest to the general public only in view of civil rights and the hope of a more naturally oriented society. It is, for instance, doubtful whether an obscenity case could be made against an abstraction. Yet where pornography is generally defined as art intended to stimulate active sexual response and lacking any aesthetically redeeming factors, the matter of personal taste on the erotic as well as the aesthetic level immediately enters in. A painter whose work is often called erotic insists that it takes intelligence to be erotic; intelligence and refinement, which are lacking in the pornographic. (I would add that it is the intelligence to refine the instinctual rather than to destroy it.) On a more superficial level, what is titillating or offensive to a sixty-year-old Iowan may be unexciting to a thirty-year-old New Yorker, and personal taste in any case resists analysis.

I'm hardly recommending it, but there is no reason why abstraction should not be as subject to obscenity bans as any other style. Oblique references to the physical, sensuous, or symbolic are likely

to have an erogenous effect on some viewers, sometimes, and that is, after all, the most that can be said of any erotic art in any context. The most blatant pornography arouses only a small percentage of its viewers to action. Suppressed as the psychological and anthropomorphic elements may be in much recent art, the implicit power of mere references is not imaginary, and it can outdistance overt description, which time has exhausted aesthetically. It seems important that the field of erotica no longer be limited to depiction of a narrowly limited sexual subject matter, that there be a greater flexibility of visual response and an art production admitting the personal and ultimately abstract quality of the erotic experience.

NOTES ON SCULPTURE* by Robert Morris

Robert Morris is considered by many artists and critics to be one of the leading sculptors working in the new Minimal style. His works and ideas have helped to delineate a variety of problems inherent in Minimal sculpture. In the following notes, in two parts, Morris discusses some of these problems, including those of viewer participation, size, scale, surface, and of gestalt.

Part I

"What comes into appearance must segregate in order to appear."

—GOETHE

There has been little definitive writing on present-day sculpture. When it is discussed it is often called in to support a broad iconographic or iconological point of view—after the supporting examples of painting have been exhausted. Kubler has raised the objection that iconological assertions presuppose that experiences so different as those of space and time must somehow be interchangeable.[1] It is perhaps more accurate to say, as Barbara Rose has recently written, that specific elements are held in common among the various arts today—an iconographic rather than an iconological point of view. The distinction is helpful, for the iconographer who locates shared elements and themes has a different ambition than

* Part I of this article is reprinted from *Artforum*, February, 1966; Part II is reprinted from *Artforum*, October, 1966.

[1] "Thus *Strukturforschung* presupposes that the poets and artists of one place and time are the joint bearers of a central pattern of sensibility from which their various efforts all flow like radial expressions. This position agrees with the iconologist's, to whom literature and art seem approximately interchangeable." George Kubler, *The Shape of Time*, Yale University, 1962, p. 27.

the iconologist, who, according to Panofsky, locates a common meaning. There may indeed be a general sensibility in the arts at this time. Yet the histories and problems of each, as well as the experiences offered by each art, indicate involvement in very separate concerns. At most, the assertions of common sensibilities are generalizations that minimize differences. The climactic incident is absent in the work of John Cage and Barnett Newman. Yet it is also true that Cage has consistently supported a methodology of collage that is not present in Newman. A question to be asked of common sensibilities is to what degree they give one a purchase on the experience of the various arts from which they are drawn. Of course this is an irrelevant question for one who approaches the arts in order to find identities of elements or meanings.

In the interest of differences it seems time that some of the distinctions sculpture has managed for itself be articulated. To begin in the broadest possible way it should be stated that the concerns of sculpture have been for some time not only distinct from but hostile to those of painting. The clearer the nature of the values of sculpture become the stronger the opposition appears. Certainly the continuing realization of its nature has had nothing to do with any dialectical evolution that painting has enunciated for itself. The primary problematic concerns with which advanced painting has been occupied for about half a century have been structural. The structural element has been gradually revealed to be located within the nature of the literal qualities of the support.[2] It has been a long dialogue with a limit. Sculpture, on the other hand, never having been involved with illusionism could not possibly have based the efforts of fifty years upon the rather pious, if somewhat contradictory, act of giving up this illusionism and approaching the object. Save for replication, which is not to be confused with illusionism, the sculptural facts of space, light, and materials have always functioned concretely and literally. Its allusions or references have not been commensurate with the indicating sensibilities of painting. If painting has sought to approach the object, it has sought equally

[2] Both Clement Greenberg and Michael Fried have dealt with this evolution. Fried's discussion of "deductive structure" in his catalogue, "Three American Painters," deals explicitly with the role of the support in painting.

hard to dematerialize itself on the way. Clearer distinctions between sculpture's essentially tactile nature and the optical sensibilities involved in painting need to be made.

Tatlin was perhaps the first to free sculpture from representation and establish it as an autonomous form both by the kind of image, or rather non-image, he employed and by his literal use of materials. He, Rodchenko, and other Constructivists refuted Appollinaire's observation that "a structure becomes architecture, and not sculpture, when its elements no longer have their justification in nature." At least the earlier works of Tatlin and other Constructivists made references to neither the figure nor architecture. In subsequent years Gabo, and to a lesser extent Pevsner and Vantongerloo, perpetuated the Constructivist ideal of a non-imagistic sculpture that was independent of architecture. This autonomy was not sustained in the work of the greatest American sculptor, the late David Smith. Today there is a reassertion of the non-imagistic as an essential condition. Although, in passing, it should be noted that this condition has been weakened by a variety of works that, while maintaining the non-imagistic, focus themselves in terms of the highly decorative, the precious, or the gigantic. There is nothing inherently wrong with these qualities; each offers a concrete experience. But they happen not to be relevant experiences for sculpture, for they unbalance complex plastic relationships just to that degree that one focuses on these qualities in otherwise non-imagistic works.

The relief has always been accepted as a viable mode. However, it cannot be accepted today as legitimate. The autonomous and literal nature of sculpture demands that it have its own, equally literal space—not a surface shared with painting. Furthermore, an object hung on the wall does not confront gravity; it timidly resists it. One of the conditions of knowing an object is supplied by the sensing of the gravitational force acting upon it in actual space. That is, space with three, not two coordinates. The ground plane, not the wall, is the necessary support for the maximum awareness of the object. One more objection to the relief is the limitation of the number of possible views the wall imposes, together with the constant of up, down, right, left.

Color as it has been established in painting, notably by Olitski and Louis, is a quality not at all bound to stable forms. Michael Fried has pointed out that one of their major efforts has been, in fact, to free color of drawn shape. They have done this by either enervating drawing (Louis) or eliminating it totally (recent Olitski), thereby establishing an autonomy for color that was only indicated by Pollock. This transcendence of color over shape in painting is cited here because it demonstrates that it is the most optical element in an optical medium. It is this essentially optical, immaterial, non-containable, non-tactile nature of color that is inconsistent with the physical nature of sculpture. The qualities of scale, proportion, shape, mass, are physical. Each of these qualities is made visible by the adjustment of an obdurate, literal mass. Color does not have this characteristic. It is additive. Obviously things exist as colored. The objection is raised against the use of color that emphasizes the optical and in so doing subverts the physical. The more neutral hues, which do not call attention to themselves, allow for the maximum focus on those essential physical decisions that inform sculptural works. Ultimately the consideration of the nature of sculptural surfaces is the consideration of light, the least physical element, but one that is as actual as the space itself. For unlike paintings, which are always lit in an optimum way, sculpture undergoes changes by the incidence of light. David Smith in the "Cubi" works has been one of the few to confront sculptural surfaces in terms of light. Mondrian went so far as to claim that "Sensations are not transmissible, or rather, their purely qualitative properties are not transmissible. The same, however, does not apply to *relations* between sensations. . . . Consequently only *relations* between sensations can have an objective value . . ." This may be ambiguous in terms of perceptual facts but in terms of looking at art it is descriptive of the condition that obtains. It obtains because art objects have clearly divisible parts that set up the relationships. Such a condition suggests the alternative question: Could a work exist that has only one property? Obviously not, since nothing exists that has only one property. A single, pure sensation cannot be transmissible precisely because one perceives simultaneously more than one property as parts in any given situation: if color, then also dimension; if flatness, then texture, etc. However, certain forms do exist that, if they do not negate

the numerous relative sensations of color to texture, scale to mass, etc., do not present clearly separated parts for these kinds of relations to be established in terms of shapes. Such are the simpler forms that create strong gestalt sensations. Their parts are bound together in such a way that they offer a maximum resistance to perceptual separation. In terms of solids, or forms applicable to sculpture, these gestalts are the simpler polyhedrons. It is necessary to consider for a moment the nature of three-dimensional gestalts as they occur in the apprehension of the various types of polyhedrons. In the simpler regular polyhedrons, such as cubes and pyramids, one need not move around the object for the sense of the whole, the gestalt, to occur. One sees and immediately "believes" that the pattern within one's mind corresponds to the existential fact of the object. Belief in this sense is both a kind of faith in spatial extension and a visualization of that extension. In other words, it is those aspects of apprehension that are not coexistent with the visual field but rather the result of the experience of the visual field. The more specific nature of this belief and how it is formed involve perceptual theories of "constancy of shape," "tendencies toward simplicity," kinesthetic clues, memory traces, and physiological factors regarding the nature of binocular parallax vision and the structure of the retina and brain. Neither the theories nor the experiences of gestalt effects relating to three-dimensional bodies are as simple and clear as they are for two-dimensions. But experience of solids establishes the fact that, as in flat forms, some configurations are dominated by wholeness, others tend to separate into parts. This becomes clear if the other types of polyhedrons are considered. In the complex regular type there is a weakening of visualization as the number of sides increases. A sixty-four-sided figure is difficult to visualize, yet because of its regularity one senses the whole, even if seen from a single viewpoint. Simple irregular polyhedrons, such as beams, inclined planes, truncated pyramids, are relatively more easy to visualize and sense as wholes. The fact that some are less familiar than the regular geometric forms does not affect the formation of a gestalt. Rather, the irregularity becomes a particularizing quality. Complex irregular polyhedrons (for example, crystal formations) if they are complex and irregular enough can frustrate visualization almost completely, in which case it is difficult to maintain one is

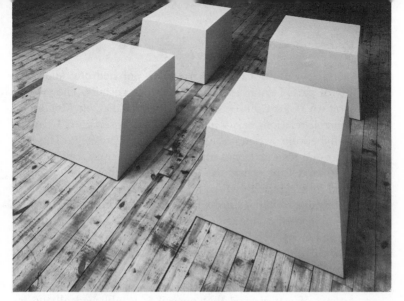

Robert Morris: Untitled. 1965. Fiberglass. 3' x 3' x 2'. In the collection of the Dwan Gallery. Photograph courtesy of Leo Castelli Gallery, New York.

Robert Morris: Untitled. 1967. Steel. 31" x 109" x 109". In the collection of the Dwan Gallery, New York. Photograph courtesy of Leo Castelli Gallery, New York.

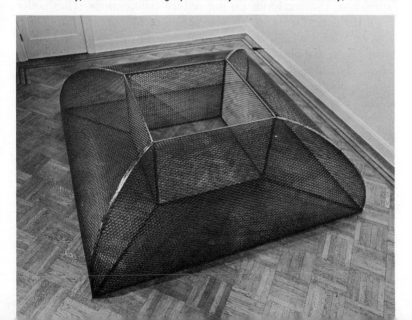

experiencing a gestalt. Complex irregular polyhedrons allow for divisibility of parts insofar as they create weak gestalts. They would seem to return one to the conditions of works that, in Mondrian's terms, transmit relations easily in that their parts separate. Complex regular polyhedrons are more ambiguous in this respect. The simpler regular and irregular ones maintain the maximum resistance to being confronted as objects with separate parts. They seem to fail to present lines of fracture by which they could divide for easy part-to-part relationships to be established. I term these simple regular and irregular polyhedrons "unitary" forms. Sculpture involving unitary forms, being bound together as it is with a kind of energy provided by the gestalt, often elicits the complaint among critics that such works are beyond analysis.

Characteristic of a gestalt is that once it is established all the information about it, *qua* gestalt, is exhausted. (One does not, for example, seek the gestalt of a gestalt.) Furthermore, once it is established it does not disintegrate. One is then both free of the shape and bound to it. Free or released because of the exhaustion of information about it, as shape, and bound to it because it remains constant and indivisible.

Simplicity of shape does not necessarily equate with simplicity of experience. Unitary forms do not reduce relationships. They order them. If the predominant, hieratic nature of the unitary form functions as a constant, all those particularizing relations of scale, proportion, etc., are not thereby canceled. Rather they are bound more cohesively and indivisibly together. The magnification of this single most important sculptural value—shape—together with greater unification and integration of every other essential sculptural value makes, on the one hand, the multipart, inflected formats of past sculpture extraneous, and on the other, establishes both a new limit and a new freedom for sculpture.

Part II

Q: Why didn't you make it larger so that it would loom over the observer?

A: I was not making a monument.

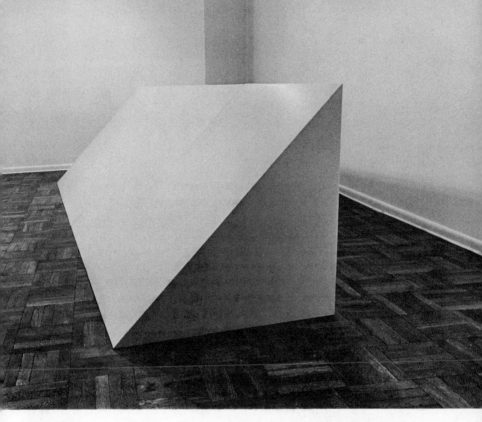

Robert Morris: Untitled. 1967. Fiberglass. Eight sections: four sections (47" x 48" x 47½"); four sections (47½" x 85" x 47½"). Photograph courtesy of Leo Castelli Gallery, New York.

Q: Then why didn't you make it smaller so that the observer could see over the top?
A: I was not making an object.
—Tony Smith's replies to questions about his six-foot steel cube.

The size range of useless three-dimensional things is a continuum between the monument and the ornament. Sculpture has generally been thought of as those objects not at the polarities but falling between. The new work being done today falls between the extremes of this size continuum. Because much of it presents an image of neither figurative nor architectonic reference, the works have been described as "structures" or "objects." The word *structure* applies either to anything or to how a thing is put together. Every rigid body is an object. A particular term for the new work is not as important as knowing what its values and standards are.

In the perception of relative size the human body enters into the total continuum of sizes and establishes itself as a constant on that scale. One knows immediately what is smaller and what is larger than himself. It is obvious, yet important, to take note of the fact that things smaller than ourselves are seen differently than things larger. The quality of intimacy is attached to an object in a fairly direct proportion as its size diminishes in relation to oneself. The quality of publicness is attached in proportion as the size increases in relation to oneself. This holds true so long as one is regarding the whole of a large thing and not a part. The qualities of publicness or privateness are imposed on things. This is because of our experience in dealing with objects that move away from the constant of our own size in increasing or decreasing dimension. Most ornaments from the past, Egyptian glassware, Romanesque ivories, etc., consciously exploit the intimate mode by highly resolved surface incident. The awareness that surface incident is always attended to in small objects allows for the elaboration of fine detail to sustain itself. Large sculptures from the past that exist now only in small fragments invite our vision to perform a kind of magnification (sometimes literally performed by the photograph) that gives surface variation on these fragments the quality of detail it never had in the original

whole work. The intimate mode is essentially closed, spaceless, compressed, and exclusive.

While specific size is a condition that structures one's response in terms of the more or less public or intimate, enormous objects in the class of monuments elicit a far more specific response to size *qua* size. That is, besides providing the condition for a set of responses, large-sized objects exhibit size more specifically as an element. It is the more conscious appraisal of size in monuments that makes for the quality of "scale." The awareness of scale is a function of the comparison made between that constant, one's body size, and the object. Space between the subject and the object is implied in such a comparison. In this sense space does not exist for intimate objects. A larger object includes more of the space around itself than does a smaller one. It is necessary literally to keep one's distance from large objects in order to take the whole of any one view into one's field of vision. The smaller the object the closer one approaches it and, therefore, it has correspondingly less of a spatial field in which to exist for the viewer. It is this necessary greater distance of the object in space from our bodies, in order that it be seen at all, that structures the non-personal or public mode. However, it is just this distance between object and subject that creates a more extended situation, for physical participation becomes necessary. Just as there is no exclusion of literal space in large objects, neither is there an exclusion of the existing light.

Things on the monumental scale, then, include more terms necessary for their apprehension than objects smaller than the body, namely, the literal space in which they exist and the kinesthetic demands placed upon the body.

A simple form like a cube will necessarily be seen in a more public way as its size increases from that of our own. It accelerates the valence of intimacy as its size decreases from that of one's own body. This is true even if the surface, material, and color are held constant. In fact it is just these properties of surface, color, material, that get magnified into details as size is reduced. Properties that are not read as detail in large works become detail in small works. Structural divisions in work of any size are another form of detail. (I have discussed the use of a strong gestalt or of unitary-type forms to

avoid divisiveness and set the work beyond *retardataire* Cubist—
esthetics in *Notes on Sculpture, Part I,* above.) There is an assump-
tion here of different kinds of things becoming equivalent. The term
"detail" is used here in a special and negative sense and should be
understood to refer to all factors in a work that pull it toward
intimacy by allowing specific elements to separate from the whole,
thus setting up relationships within the work. Objections to the em-
phasis on color as a medium foreign to the physicality of sculpture
have also been raised previously, but in terms of its function as a
detail a further objection can be raised. That is, intense color, being
a specific element, detaches itself from the whole of the work to
become one more internal relationship. The same can be said of
emphasis on specific, sensuous material or impressively high finishes.
A certain number of these intimacy-producing relations have been
gotten rid of in the new sculpture. Such things as process showing
through traces of the artist's hand have obviously been done away
with. But one of the worst and most pretentious of these intimacy-
making situations in some of the new work is the scientistic element
that shows up generally in the application of mathematical or engi-
neering concerns to generate or inflect images. This may have
worked brilliantly for Jasper Johns (and he is the prototype for this
kind of thinking) in his number and alphabet paintings, in which the
exhaustion of a logical system closes out and ends the image and
produces the picture. But appeals to binary mathematics, tensegrity
techniques, mathematically derived modules, progressions, etc.,
within a work are only another application of the Cubist aesthetic of
having reasonableness or logic for the relating parts. The better new
work takes relationships out of the work and makes them a function
of space, light, and the viewer's field of vision. The object is but one
of the terms in the newer aesthetic. It is in some way more reflexive
because one's awareness of oneself existing in the same space as the
work is stronger than in previous work, with its many internal rela-
tionships. One is more aware than before that he himself is establish-
ing relationships as he apprehends the object from various positions
and under varying conditions of light and spatial context. Every
internal relationship, whether it be set up by a structural division, a
rich surface, or what have you, reduces the public, external quality
of the object and tends to eliminate the viewer to the degree that

these details pull him into an intimate relation with the work and out of the space in which the object exists.

Much of the new sculpture makes a positive value of large size. It is one of the necessary conditions of avoiding intimacy. Larger than body size has been exploited in two specific ways: either in terms of length or of volume. The objection to current work of large volume as monolith is a false issue. It is false not because identifiable hollow material is used—this can become a focused detail and an objection in its own right—but because no one is dealing with obdurate solid masses and everyone knows this. If larger than body size is necessary to the establishment of the more public mode, nevertheless it does not follow that the larger the object the better it does this. Beyond a certain size the object can overwhelm and the gigantic scale becomes the loaded term. This is a delicate situation. For the space of the room itself is a structuring factor both in its cubic shape and in terms of the kinds of compression different sized and proportioned rooms can effect upon the object–subject terms. That the space of the room becomes of such importance does not mean that an environmental situation is being established. The total space is hopefully altered in certain desired ways by the presence of the object. It is not controlled in the sense of being ordered by an aggregate of objects or by some shaping of the space surrounding the viewer. These considerations raise an obvious question. Why not put the work outside and further change the terms? A real need exists to allow this next step to become practical. Architecturally designed sculpture courts are not the answer nor is the placement of work outside cubic architectural forms. Ideally, it is a space without architecture as background and reference, that would give different terms to work with.

While all the aesthetic properties of work that exists in a more public mode have not yet been articulated, those which have been dealt with here seem to have a more variable nature than the corresponding aesthetic terms of intimate works. Some of the best of the new work, being more open and neutral in terms of surface incident, is more sensitive to the varying contexts of space and light in which it exists. It reflects more acutely these two properties and is more noticeably changed by them. In some sense it takes these two things into itself as its variation is a function of their variation. Even

its most patently unalterable property—shape—does not remain constant. For it is the viewer who changes the shape constantly by his change in position relative to the work. Oddly, it is the strength of the constant, known shape, the gestalt, that allows this awareness to become so much more emphatic in these works than in previous sculpture. A Baroque figurative bronze is different from every side. So is a six-foot cube. The constant shape of the cube held in the mind but which the viewer never literally experiences, is an actuality against which the literal changing, perspective views are related. There are two distinct terms: the known constant and the experienced variable. Such a division does not occur in the experience of the bronze.

While the work must be autonomous in the sense of being a self-contained unit for the formation of the gestalt, the indivisible and undissolvable whole, the major aesthetic terms are not in but dependent upon this autonomous object and exist as unfixed variables that find their specific definition in the particular space and light and physical viewpoint of the spectator. Only one aspect of the work is immediate: the apprehension of the gestalt. The experience of the work necessarily exists in time. *The intention is diametrically opposed to Cubism with its concern for simultaneous views in one plane.* Some of the new work has expanded the terms of sculpture by a more emphatic focusing on the very conditions under which certain kinds of objects are seen. The object itself is carefully placed in these new conditions to be but one of the terms. The sensuous object, resplendent with compressed internal relations, has had to be rejected. That many considerations must be taken into account in order that the work keep its place as a term in the expanded situation hardly indicates a lack of interest in the object itself. But the concerns now are for more control of and/or cooperation of the entire situation. Control is necessary if the variables of object, light, space, body, are to function. The object itself has not become less important. It has merely become less *self*-important. By taking its place as a term among others the object does not fade off into some bland, neutral, generalized or otherwise retiring shape. At least most of the new works do not. Some, which generate images so readily by innumerably repetitive modular units, do perhaps bog down in a form of neutrality. Such work becomes dominated by its own means

through the overbearing visibility of the modular unit. So much of what is positive in giving to shapes the necessary but non-dominating, non-compressed presence has not yet been articulated. Yet much of the judging of these works seems based on the sensing of the rightness of the specific, non-neutral weight of the presence of a particular shape as it bears on the other necessary terms.

The particular shaping, proportions, size, surface of the specific object in question are still critical sources for the particular quality the work generates. But it is now not possible to separate these decisions, which are relevant to the object as a thing in itself, from those decisions external to its physical presence. For example, in much of the new work in which the forms have been held unitary, placement becomes critical as it never was before in establishing the particular quality of the work. A beam on its end is not the same as the same beam on its side.

It is not surprising that some of the new sculpture that avoids varying parts, polychrome, etc., has been called negative, boring, nihilistic. These judgments arise from confronting the work with expectations structured by a Cubist aesthetic in which what is to be had from the work is located strictly within the specific object. The situation is now more complex and expanded.

LITERALNESS AND THE INFINITE by Toby Mussman

The following article comprises two parts, not necessarily related. The first deals with a phenomenological approach to the literal, especially as seen in the works of Robert Rauschenburg. The second part was originally written as a review of Robert Smithson's first one-man show held in 1966 at the Dwan Gallery in New York. As Mussman points out, Smithson's writing is closely linked to his concrete visual statements.

Toby Mussman has written art criticism for *Arts Magazine*, *Artforum*, and *Art and Artists*. He is a contributor to the critical anthology *The New American Cinema*.

I

The premise of this article is the fact that art is a reflection and thus an analysis of the world the way it presents itself to us. Of course, the artist must decide what part and how much of the world he is going to allow to present itself to him. Through the ages the artist has looked at the world through his own glasses; that is, when he makes the conscious decision to become an artist, he says to himself, "If I want to make art, I ought to know what art is or at least what it has been in various instances up to now." Individual artists come to their own styles after a certain amount of learning or apprenticeship with established painters or what they see in art museums, schools, magazines, etc.

The subject of the degree of knowledge an artist must have of the rules of his art has been discussed by Clement Greenberg in his essay "Modernist Painting," and by "modernism" he means a kind of "Kantian self-criticism." The principal difficulty with Greenberg's thesis is that it is not in fact relevant anymore for us to assume that the world is divided up into mutually exclusive areas of intellectual (analytical) concern. When you make a line dividing one area from another (painting from sculpture, for example), how do you go about making that line? It seems clear enough to me that any line drawn has to be an arbitrary one. In intellectual thought we often

set up special limits so that we can work out all the possibilities within this more or less specific and delimited space, but we also recognize that our limits are arbitrary ones and in fact only provisory or temporary. The limits are provisory because they are set up originally according to such and such a number of "knowns," but since man lives in a changing world, we must always be ready to accept a change in our number of "knowns"; one day we may come to see that we know more than we thought we did when we began to give study to such and such an area of concern.

Greenberg's idea is that "Scientific method alone asks that a situation be resolved in exactly the same terms as that in which it is presented—a problem in physiology is solved in terms of physiology, not in those of psychology. . . ."[1] This may be nice clean logical reasoning, but it tends toward a circularity, and what is worse, it is irrelevant to the kind of analysis that will lead to a real understanding of art. Art is not logical or scientific even though it may use an intellectual system for its springboard. Art cannot be reduced to a matter of problem-solving; Frank Stella or Larry Poons may use mathematical systems to work out various formal possibilities, but how does that make them different from the systems-like usage by Max Ernst of rubbing or Yves Tanguy of doodling or Jasper Johns's own special Wittgensteinian game-play? Art has nothing to do with the mystical, but it is mysterious in the sense that it does not provide us with answers. The job of science is to come up with answers, to predict an outcome under precisely defined conditions. The question here is of course, as Wittgenstein might have said, how do you define those conditions in the first place? The job of art, like philosophy, is to ask questions through such and such a framework, or set up such and such a framework which asks questions of us.

Simply stated, I do not think a problem in physiology may necessarily be "solved" to our real satisfaction in terms of physiology. A comment from Merleau-Ponty from his major work, *Phenomenology of Perception,* is especially appropriate here. In talking about the ability of a person to feel the "phantom existence" of an arm or leg which has only recently been amputated, he stated, "What has to be understood, then, is how the psychic determining factors and the

[1] Clement Greenberg. "Modernist Painting," *The New Art,* ed. Gregory Battcock, E. P. Dutton, New York, 1966.

physiological conditions gear into each other: it is not clear how the imaginary limb, if dependent on physiological conditions and therefore the result of a third-person causality, can *in another context* arise out of the personal history of the patient, his memories, emotions, and volitions."[2] In other words, if you were going to approach the problem or phenomenon of the existence of an imaginary limb and if you were Clement Greenberg, you would have to decide first which discipline, physiology, or psychology, you would put the subject of your analysis in. It seems that this sort of choice-making is a very large part of the "modernist" thesis, and to me it seems much too large to be reasonable. After all, once you have made that choice you are forever committed to working out your thesis within that logical train, and how could you ever be certain that your choice was the optimal one? Do you call Frank Stella's latest paintings, which are on four-inch-thick stretcher bars, painting or sculpture? Do you call any of Rauschenberg's work painting or sculpture? And now we see how arbitrary and ultimately worthless this choice is. I will engage a second quote here because I find it so dramatic in pointing up the falseness of attempting to section off the world absolutely by various intellectual disciplines. The quote is from the recent report by Masters and Johnson, *Human Sexual Response,* and I am compelled to use it in my argument because sex is so universal an element of human experience and one which with all our science we still know very little about. Still another reason is that Dr. William Masters and his associate, Virginia Johnson, proceeded throughout their study with a pronounced "clinical" (to use their word) and thus physiological bias. The quote follows, and although it refers specifically to the functioning of the clitoris, I think it carries with it a clear implication of wider significance: ". . . regardless of the effectiveness of the somatogenically oriented stimuli, the psychogenic overlay inherent in any approach to female sexual stimulation is of constant import."[3] Masters and Johnson, who have approached their analysis entirely scientifically, are willing to recognize that their findings are only limited ones; they realize that other

[2] M. Merleau-Ponty. *Phenomenology of Perception,* Humanities Press, New York, 1967, p. 77.

[3] Drs. William Masters and Virginia Johnson. *Human Sexual Response,* Little, Brown, Boston, 1966, p. 61.

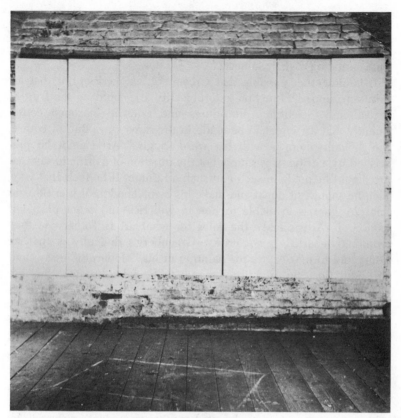

Robert Rauschenberg: *White Painting*. 1951. House paint on canvas. 72″ x 126″.
In the collection of the artist. Photograph courtesy of Leo Castelli Gallery, New
York.

disciplines must be given consideration in order to arrive at a fuller understanding of their subject.

It is altogether possible that Greenberg, as a critic, felt that art criticism, since its function is to objectify art, could be the fruit of logical and "scientific" procedures and that he reasoned consequently that art ought to be made in the same way. But, of course, the difficulty here is with the word "ought." Art cannot be prescribed by a critic. It is simply not the function of a critic to say that art should be made in such and such a fashion. If he feels that way, then he should sit down and make his own. The job of a critic is to analyze what is available to him in galleries and other places of exhibition. Artists make the rules for what art is (otherwise they wouldn't be artists), not critics. Greenberg's difficulty is that he attempted to make rules for painting in his "Modernist" essay; and the limitations he established prove to be false because they are based on impossible assumptions. By way of illustration, we take his assumption that painting must take place on a flat surface, an assertion he attempted to qualify by sometimes using the term "virtually flat." "Flatness" is a relative term, since nothing in the physical world is actually flat in the same way geometrical flatness is. Unfortunately, it seems that Greenberg's "flat" surface was the geometrical or theoretical concept, which is impracticable to art work itself. Flatness, like the circle, is an abstraction which can be described but which can never, in actual fact, have an equivalent existence. All painting takes place in a three-dimensional actuality. Canvas stretched across stretcherbars does not make a perfectly or geometrically flat surface; nor can paint applied in any way imaginable to that surface yield anything but a relief, even though it be all but imperceptible.

Greenberg's difficulty seems to have resulted from the confusion he made between the "picture plane" and the literal surface of a painting. It is significant that Greenberg's understanding of the "picture plane" comes out of the study and consideration he gives to analytic cubism and the concomitant *papiers collés* of Picasso and Braque. I say it is significant because Greenberg has couched much of his reasoning in an art historical reference; and he went back to implications in analytic cubism for his own rules of "modernist" painting. But here again it depends on how one decides to read the

conditions of a particular situation. Clement Greenberg decided that the implications of analytic cubism are entirely directed toward a study around and an affirmation of the integrity of the "picture plane." However, it is apparent that when the texture of brushed-on paint and pasted-on scraps of paper are integral elements of an analytic cubist painting, an implication of surfaceness is just as easily decipherable. The surfaceness of a painting is the concept of literalness I am concerned with in this essay. And surfaceness is not, unlike the "picture plane," flatness and a circle, an abstraction; it is a concrete thing.

Michael Fried, in recent essays, has also given some consideration to the concept of literalness. However, at the outset, I should say that for all his diligence, his assumptions are just as difficult to reckon with as Greenberg's. Fried feels that that which "appeals to the eye alone"[4] in a painting is the literal, and thus the only, thing with which painting should concern itself. However, the difficulty here is that one's eye simply does not operate in a vacuum of isolated conditions, for whatever the eye sees the brain will also interpret and the heart will respond to. By maintaining that it is the formal elements alone (color, line, and shape) which painting should be concerned with, Fried has done no more than lower the number of operable variables. He has used the Greenbergian thesis of "Kantian self-criticism" to arrive at the conclusion that a formalist doctrine is a literalist one. His reasoning surpasses Greenberg's in that he is willing to deal with the optical nature of painting rather than color, opticality being a more accurate way of describing what happens between various hues, values, and tones.

What is crucial to understand is that the formalist position is a limited one. It cannot encompass all of painting; it can only hope to deal with one of the several possible sides. I find Michael Fried's writing most illuminating when he maintains a thoroughly phenomenological analysis, when, for instance, he describes the multiple aspects available in one particular painting situation (as in his discussion of Frank Stella's work). What I find untenable in his reasoning is his implied assertion that this is the true, or only, sort of art possible via self-criticism. It is clear enough to me that self-

[4] Michael Fried. "Jackson Pollock," *Artforum*, September, 1965.

criticism is a method of reducing our comprehension of the world toward greater significance and accuracy. But it is important to see that self-criticism is only a method, and it is the same method which Merleau-Ponty and others call the phenomenological method. The difference may be in the application of this method. Merleau-Ponty explains that self-criticism is by definition subjective because it must begin inside a person and each individual person is different from the next. As Nicolas Calas has pointed out, Greenberg would assume that art can have a self[5], that is, he would say that art is an objective thing which stands outside man, and underlying this statement is the idea that there are objective standards in the world. Merleau-Ponty would deny, and I would as well, that there can ever be anything like objective standards; there may be several things which many, or even most, men concur on, but those are not objective standards which remain true in every case, those are merely concurrences. To assume objective standards is to cast a human, or at least mental, control over and against the world which ignores two very important elements—what is not known and chance.

Michael Fried began his thesis on literalness with Jackson Pollock, saying that inasmuch as Pollock's works were designed to create a field they were meant to be strictly optical. The optical-field theory of Pollock's paintings tends to ignore the manner in which that field was produced. It also ignores the concrete nature of individual forms and shapes within each painting. Because Pollock's material was liquid paint he could never rid himself of a concern with how it would manifest itself when applied to a surface. When spilled paint hits a surface, it does so in a more or less specific way, and that became the general shape which Pollock used whenever he was not indicating some form of figuration. His "overall style" is the repetition of that spilled paint splotch over a large canvas area, or as in other cases, the repetition of a finger or brush swirl through gooey oil paint. There are at least two ways of looking at Pollock's paintings, from far away or up close. To look at them one way and not another is to ignore part of them. From far away, the consideration of opticality is certainly a crucial one; but close to, the issue of opticality vanishes, and one is absorbed with how the pools of dried

[5] An observation made to me by Mr. Calas in conversation, June, 1967.

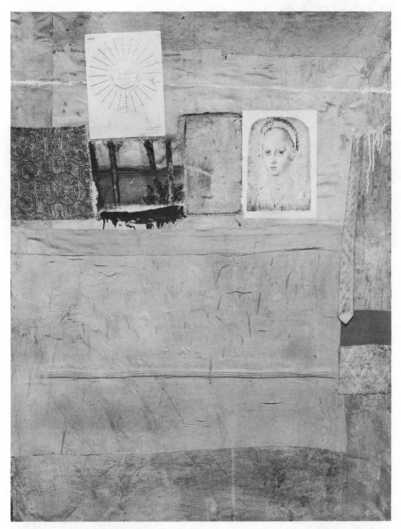

Robert Rauschenberg: Untitled. 1955. Combine painting. 56″ x 43″. In the collection of Lois Long. Photograph courtesy of Leo Castelli Gallery, New York.

Robert Smithson: *Alogon #2.* 1966. Stainless steel, painted. Ten units, of which the square surfaces measure (from right to left): 2½", 3", 3½", 4", 4½", 5", 5½", 6", 6½", 7". Photograph courtesy of Dwan Gallery, New York.

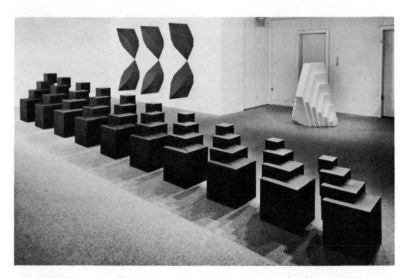

Robert Smithson: Installation, December 1966. Foreground: *Plunge.* 1966. Stainless steel, painted. Ten units, of which the square surfaces measure 14½", 15", 15½", 16", 16½", 17", 17½", 18", 18½", 19". Hanging: Doubles. 1966. Stainless steel, painted. 6½' long x 6½' high x 27" deep. Background: *Terminal.* 1966. Stainless steel, painted. 53" long x 60" wide x 26" deep.

paint have formed and how one color may have become mixed with another.

Perhaps then, there are at least two literalist elements available to us in Pollock's work, one being opticality and the other the way in which spilled paint manifests itself on a surface. We know also that Pollock made most of his paintings while the canvas was stretched out horizontally on the floor, which means that in the making of them he was very much concerned with what they looked like close to. But if Pollock is a literalist in his concern for the way in which paint hit the surface, he is so by a kind of default because he used each individual spilled paint splotch to signify a link in the overall repetitive pattern.

To my mind, a comprehension of literalness and the literal nature of material worked with can gain much from a consideration of the work of Robert Rauschenberg in general and, more specifically, his *White Painting* of 1951. Self-criticism in phenomenological terms means questioning the way in which one perceives his consciousness. That is, one must first recognize what it is that he is thinking about, and then why it is that he is thinking in that particular way. Self-reflective thinking on a specific fact of life or phenomenon will eventually reduce one's consciousness of that thing to the point where a new, more accurate understanding is achieved. If we take painting as the subject of our consciousness and question it, we can reduce it to something which hangs on a wall, and because it does hang on a wall, thus intruding on our normally functional world, we can say that it is something that not only hangs on a wall but also demands our investigation and contemplation. Rauschenberg's *White Painting* seems to me to be the most obvious way of stating this reduction that I can imagine. Even if we attempt to look at the *White Painting* through Friedian eyes, what could possibly state more plainly "the literal character of the picture-support"[6] covered by canvas than a piece of painted white canvas covering that picture-support? If, indeed, Greenberg's statement that "the first mark on a surface destroys its virtual flatness"[7] seems logical enough, then Rauschenberg contradicts this dictum by painting a picture whose

[6] This phrase was used by Michael Fried in an essay on Frank Stella, "Shape as Form," in *Artforum*, November, 1966.

[7] *Op. cit.*, note 1.

first and only mark is an all-over white one. The *White Painting* is in seven equal sections, which prohibits one from saying that the over-all whiteness may be seen as an infinitely deep space. White, of course, is the one color carrying in it the potential for all other colors, just as the use of no programmed sound by John Cage in his ten-minute piece of silent music carries in it the potential for any sound.

Earlier I mentioned that I felt that Clement Greenberg had con-fused the "picture plane" with surfaceness; his confusion was paral-leled by Pollock, whose work rides on an ambivalence between opticality and materiality. I think that this ambivalence can be seen as a reflection of the fact that Pollock's career and generation were too much tied to a Cubist and Picasso-figuration aesthetic. It is evident that Rauschenberg saw that a Cubist commitment to the theoretical picture plane was no longer relevant. The *White Painting* is a statement without equivocation that a new "picture plane" had been prepared for investigation, but this time it was not a theoreti-cal one, it was a material, literal one.

All of Rauschenberg's work through the fifties, from the black paintings to the red ones to the assemblage "combines," represent a thoroughgoing articulation of the surface structure of a painting. With the *White Painting* as his foundation, anything was possible. With the understanding that all of Rauschenberg's work has dealt with the manipulation of surface material, we see that formalist considerations like shape, line, and color are only of a subordinate, secondary importance and become a consequence of the combina-tion of materials used. Since any number of articles may be called into play in one of his paintings, Rauschenberg has often created limitations for a work which, because they were so obvious (in a model of self-criticism), called attention to their arbitrariness. Thus in some paintings he limited himself to one color, and more gener-ally, since painting is in a sense the establishment of a limit against the rest of the world, he applied his paint to a surface in the most straightforward, mechanical, and literal way possible. Typically in a Rauschenberg, a swatch of oil paint, whether on a section of canvas or a stuffed bird, can hardly be looked at as anything other than a quantity of paint applied to that surface at such and such a brush or tube orifice's width.

Since Rauschenberg's paintings have never pretended to be flat, he has not had to take the option of working to "neutralize the flatness of the picture–support by the new, exclusively optical illusionism,"[8] as Michael Fried has discussed is the case in Frank Stella's paintings. Because he has always been concerned with literal surfaceness, readings of spatial depth are never in essence at issue in his work. Even though individual objects or painted areas are used in combination and interconstruction, they have been placed in such a way as to deny a suggestion of recession behind the "picture plane"; and instead, each element in a Rauschenberg is allowed to maintain its own concrete and irreducible presence. Pollock submerged pennies, tacks, pieces of wire, cigarette butts, etc., in skeins of paint in *Full Fathom Five* (1947), but this, as it happens, is a demonstration of his material literalness by default, for to submerge an assortment of objects is to fail to allow them to establish themselves in their own right. In a sense, it seems to me that *Full Fathom Five* was an attempt by Pollock to confront the self-imposed and arbitrary boundary in the making of a picture that assumes that it has to be done with paint. It is clear that Rauschenberg's experience with surfaceness steered him away from the false problem of the "picture plane" and made it possible to incorporate nearly anything beyond cloth and colored liquid substances in a painting. A clock, running water, dirt, a human body, film projection, literally anything can be used; and then a painting became called a happening. Even in his silk-screen painting and transfer drawings, the fact that one is aware that photographs are the material used and that one is made especially aware of the process of applying the image to the surface prohibits the possible spatial suggestion in favor of the presence of the individual images.

II

Robert Smithson has come forward auspiciously enough with his own fully developed brand of the New Sculpture (to date labeled "ABC," "Primary Structures," "Minimal," etc.). Smithson is especially concerned in this show with working out a play, by exclusively abstract means, of the metaphor of mirror images. In an article written for *Arts* (November, 1966), he counterposed to Clement

[8] *Op. cit.*, note 6.

Greenberg that most "abstract" space as it has occurred in painting, and particularly Abstract-Expressionist space, is limited by being "the same order of space as our bodies" (Greenberg's phrase) to an anthropomorphic expressionism. And it is true enough that most painting and sculpture through the forties and fifties until the advent of Pop Art, even though it may have called itself abstract, has been an intentionally hand-manipulated, or gestural, art; to the extent that the artist's hand is demonstrably in the work, it remains anthropomorphic. Even today we find Greenberg preoccupied with the question of the "artist's touch," and if it is not clearly evident in the work, does this not lead to too "impersonal" an expression (see *Vogue*, April 1, 1967)? The tendency of a large number of younger artists today, like Smithson, is to dismiss the worry about "impersonality" as a false one in order to deal with what they consider a more accurate, less cumbersome meaning of the term "abstract."

Smithson went on to say in his article in *Arts*, "Kubler suggests that metaphors drawn from physical science rather than from biological science would be more suitable for describing the condition of art," and quoted Norbert Weiner to the effect that it is actually mathematics which presents the most valid metaphor for dealing with abstract concepts in art. What I find compelling about this argument is that mathematics is already a purely conceptual (abstract) language, and to concretize it within a solid, obdurate art object provokes an immediate and consistent tension—Hegel's Proverb, "Extremes meet." In *Nausea* Sarte said, "A circle is not absurd, it is clearly explained by the rotation of a straight line around one of its extremities. But neither does it exist." That is, a circle can never be drawn as perfectly true as the conceptual one, as the one which is defined mathematically by πr. Jasper Johns played out Sartre's paradox when he made a circle absurd (concrete) in *Device Circle* by painting it literally within its definition. Robert Morris also often works with this tension between the conceptual and the perceived, as in his sculptured piece which is nothing more than a flat gray box divided in four equal parts. In our mind's eye it is clear that the box was originally whole and that it has been doubly bisected so that when the quarters are then put back, one would naturally expect them to fit cohesively enough to re-establish the primary box. But in actual fact, the integrity of the original box is never reaffirmed. Bisection is an abstract principle just as πr is,

and the viewer is left to fend for himself to do the best he can to reconcile this difference between the abstract and the concrete.

Smithson's exercises with the mirror image encompass unequivocally the mathematics metaphor he is searching for. A mirror reproduces the original object before it; and it carries with it the implication that once there are two of anything, there can then be an infinite number more of them, as in a hall of mirrors. A small work standing on a pedestal, *Ziggurat Mirror* (24" x 10"), is constructed of a series of higher and higher sections of ordinary reflecting glass. Its steplike structure rises by equal measures on either side so that the mirror surfaces are back to back. One senses that the scale is not unalterable. The piece, perhaps, could have been much larger in size and risen upward to an infinite height; striking a parallel to our office buildings in Manhattan, *Ziggurat Mirror*, via a simple repetition, reaches for the vastness of the sky and outer space. In other small pieces, Smithson worked out an obverse to *Z.M.* by inverting the mirror glass to make prismlike constructions into which, when the viewer looks, he finds an imperturable maze of reflective surfaces.

The main body of Smithson's recent show at the Dwan Gallery, in December, 1966, consisted of four large sculptures made of stainless steel and painted overall in matte, unobtrusive colors. A white piece, titled *Terminal,* works with a narrow five-sided polygon which echoes itself, like *Ziggurat Mirror*, in a back-to-back fashion. The wall piece, *Double,* is symmetrical along its horizontal axis, and again the feeling of infinite duplication and extension is elicited from the three identical sections. Both large floor works, *Alogon #2* and *Plunge,* remind one, initially at least, of children's blocks stacked neatly in order, except that the order is too clean, too mathematical. But then only on its elementary level is mathematics indeed too ordered and too clean cut. The mystery of mathematics is, as any student of calculus knows, a function of the mystery of infinite possibility.

Smithson has also been occupied currently with the principle in physics of entropy, or energy drain, as it relates to our comprehension of time and space. In the *Arts* article, he quoted J.T. Frazier as follows, ". . . others like Grunbaum tend to believe that entropy is the cause of time in man," and in an article written for *Artforum* (June, 1966) he quoted P.W. Bridgman, saying, "Like energy,

entropy is in the first instance a measure of something that happens when one state is transformed into another." That is, we are able to experience time, and likewise change, of which time is a function, via a perception of energy transmission to and/or loss from one substance to another. Time can be looked at abstractly; that is, we can set up arbitrary units by which to make measurements of it; but our experiences of it depend on our perception of (energy) change. One thinks here of Duchamp, whose painting was involved with depicting the process of passing through varying emotional states and, in particular, whose *Large Glass/The Bride Stripped Bare by Her Bachelors Even* was left incomplete and finally subtitled "Delay in Glass." It is as though Duchamp, who at this same time gave up painting as an inconclusive form of expression, allowed time to grind to a halt around *Large Glass* and crystallize the *Bride and Her Bachelors* in the midst of their activities.

Following this line of thought it is interesting to note that Smithson's arrangement of blocks in *Alogon #2* and *Plunge* is progressive but at the same time aclimactic. In *Alogon #2* the blocks have been conveniently placed one on top of another and side by side as if their positioning has been arrived at by taking the path of least resistance. In making the arrangement, the expenditure of energy was very low, and consequently, there is little to be lost. If the energy level is already low, the perception of energy changes, and thus our experience of time will be minimal. Each individual section of *Alogon #2* and *Plunge* is merely a telescoped version of the one next to it. The stairlike, progressive quality of both the floor pieces invites the viewer to confront their implication of movement and development by a means which is both visual (the eye follows the repetitive jumps from block to block and section to section) and abstract (the theory of construction by repetition of a form as familiar as the cube is conveniently recognizable). The two floor pieces signify a sort of structure which is only partially completed, as with the Duchamp "Delay in Glass," and which never in fact can be "completed." As objects occupying a limited space, we sense that they could be extended infinitely at will. They imply that space is a function of time. If time were compressed to an instant, brought to a standstill, the recognition of their infinite extension would be immediately possible.

MINUS PLATO* by Brian O'Doherty

This article considers conceptualism at a crucial moment—the start of the 1966–67 season—when it finally engaged the dynamism of a "scene" based on obsolescence cycles. It also indicates the context of ideas within which the art will be considered.

Brian O'Doherty came to the United States from Cambridge University where he was working on visual perception. He has been an art critic for *The New York Times,* published widely, and initiated two television series. *Object and Idea,* a collection of his criticism, was published in 1967. His first one-man show was at the Byron Gallery in 1966.

The primary interest in the coming New York season undoubtedly is seeing how those in possession of the ball run with it. The not-so-new object makers (typically they have succeeded in avoiding a catch-phrase title for suitable mass-media marketing) ended last season with something close to total triumph, a dangerous thing in a city where current art has tended, since 1962, to mimic the obsolescence of last year's Detroit models.

"Primary Structures: Younger British and American Sculptors" at the Jewish Museum confirmed that position, a position quietly reinforced by "Art in Process" at Finch College, a discriminating exhibition that included the best of the New York contingent. Both exhibitions, coming at the close of the season, gave a tremendous forward impetus to this non-movement movement instead of ending it—as museum shows here have developed a habit of doing. "The Responsive Eye" at the Modern Museum in 1965 turned out to be the headstone of Op, and the same museum's "Americans 1963" gave Pop a fatal push. (In fact the Museum of Modern Art is now in the impossible position where anything it does is wrong—which suggests that public expectations of its role deserve as much clarification as the museum's interpretation of its own position.) But the diffuse, eclec-

* Reprinted from *Art and Artists,* September, 1966.

tic mélange of stripped-down artifacts and artifices, covered by such blanket titles as Primary Structures, Low-Boredom Art, Reductive and Minimal Art, Cool Art, etc. seems to be shunting forward into the new season insulated from obsolescence by certain remarkable new attitudes.

This high survival quotient, if one can call it that, is due I think to an acute estimation of those forces that destroy and discredit new artistic ideas, and the development of a way of coping with these forces. Thus the artists seem to have made a careful study of recent obsolescence cycles, have confronted what has become the illusion of avant-gardism, have developed a sort of intellectual connoisseurship of non-commitment. They have made a diagnosis on the current social situation through which a piece of art is manipulated via the prejudices and indifferences, the expectations and non-expectations of the audience: this includes taking into account the habits of museums and collectors and tickling the hipper-than-thou mass media to pass on the context of ideas in which the new work is seen. It was inevitable that the artist would learn to deal with the so-called "corruptions" that surround the work of art and use them *for* its survival. The capacity to adapt is, after all, the criterion of survival.

What has emerged instead of a movement is a mode of thinking with certain implicit prescriptions, a mode that projects a kind of mental furniture which has in it the key to survival—for this aesthetic furniture can be all things to all men while remaining totally unchanged. The latest objects, which *pretend* to be inert or non-emotional (this is simply a brilliant convention of camouflage within which art is functioning now) have clearly patented a way of avoiding all the expectations about how "new" art should behave when it appears. "You are remarkably modern, Mabel," says Lady Markby in *An Ideal Husband*. "A little too modern, perhaps. Nothing is so dangerous as being too modern. One is apt to grow old-fashioned quite suddenly. I have known many instances of it." The most intellectually rigorous New York art now (the very best work of such very different artists as Donald Judd, Robert Smithson, Ronald Bladen, Robert Morris, Robert Grosvenor, among others) cancels clichés of avant-gardism and sidesteps the expected dialectic. It is through these exact cancellations that the objects are brought into

their state of marvellous paralysis, that has reduced some criticism to phenomenology.

Basically these cancellations attack liberal humanism and psychology, on the one hand, and the idea of history on the other. Art is not about life or the "human condition"; it is about art. If art is about "expression" or "feelings," cancel this by producing things the layman (anyone who doesn't understand a speciality is a layman) is absolved from puzzling at, thus subverting his anxious inquiry with regard to the etiquette of response ("What am I supposed to *feel*?"). If art is about revolution, avoid even counter-revolution. If art is about invention, avoid invention by camouflaging it in an apparent simplicity. If art history is about development, avoid development and subvert scholarship. There are no problems. Systems fall apart into their components; it is as if all the integers that went into the common denominator had risen above the line.

Robbe-Grillet is the theoretician-in-residence: "The world around us turns back into a smooth surface, without signification, without soul, without values, on which we no longer have any purchase. Like the workman who has set down the tool he no longer needs, we find ourselves once again facing *things*." The gratuitous act is replaced by the gratuitous object. Absurdity, by definition concerned with relationships, is succeeded by a placid contemplation of surfaces which keep out profundity. Insight is out.

This is seemingly a pretty barren area from which to make art. But it is a great area for just making. Making, however, requires certain models, and since the results are "art-like" and thus useless, the models can be as arbitrary as any artist can think of (*e.g.* solid geometry, bad industrial design, topology, structural engineering, fourth-dimensional paradoxes etc.); as models, of course, you use them but don't *believe* in them—they are simply the artist's conceptual landscape of "nature." What offers results from this sort of thing are eclectic inventions which have, as Peter Hutchinson points out elsewhere in this issue, certain Mannerist aspects. But such products are also strongly academic, and the ideas of such "academic" later Mannerists as Lomazzo and Zuccaro, and of course the Carracci, have some limited application if one wishes to apply this model to the present.

An academy, strangely enough, is usually more concerned with

what art cannot be, rather than what it should be. Academic rules if one reads them in a mirror, deal more with what an object is not, rather than what it is. Thus the apparent total permission for artists in New York, which results in forms that look as if they had been passed through an eclectic engine for formal styles and then industrially finished, is not a total permission at all. It only appears to be so. Painting, figuration, and the textural correlates for memory and nostalgia are proscribed. Also certain kinds of new materials have become obligatory, and thus other materials have become difficult to use. Dazzled by eclectic possibilities that make concealed invention the subtlest kind of orthodoxy, we have become somewhat blind, in New York, to what the prevalent art has made impossible. And finally, with its strongly anti-avant-garde attitudes, we can speak with confidence of an academy. A new kind of academy that requires more definition, but still an academy. To be avant-garde now is to be old-fashioned.

This academism, far from being the weakness of the present art, is in fact its strength. This art moves into the new season as a conscious Academy geared for survival in the lethal New York gallery climate. There are tremendous implications here, for the cycle that began, as William Seitz pointed out, with Baudelaire's preface to his Salon of 1846, addressed "To The Bourgeois"—the beginning of the split between artist and audience which produced the phenomenon of avant-gardism—is ending. After all, art like show jumping, has a reasonably large immediate public, and a vast remote one. The work of art now, smuggling in under its smooth surface the dazzling ideas the layman isn't able to read (and doesn't have to), sits blandly within the gates, announcing that it is not ahead of its time (therefore, arousing no shock), and that the future is simply *now*. A critic once called Pop "Capitalist Realism." Perhaps one could call this development "Democratic Nominalism." This is going to be a tough academy to displace.

This art raises a huge number of questions, and like much modern art is often more interesting to talk about than to look at. The quickest route to the important questions is that this art has apparently no memory and no expectations. It invests itself in multiplying paradoxes, and this excess of paradox leads to stasis. This stasis is the most interesting thing about the current academic structures.

It suggests that we deal with this art not in terms of *facts* (what they are) but in terms of *states* (the conditions that maintain them). Which brings us to areas that will keep cropping up in the coming season—the many models which can be applied to illuminate the art; the concepts of time to which this anti-Newtonian art brings us; ideas of scale (this art simply has no scale) and of gravity, which this work contemptuously subverts; the metaphysics of boredom (already a cliché subject); the surface tension of hysteria and occasional mysticism; the trans-illusion or supra-illusion with which these works annihilate the brokendown dialectic of "reality and illusion"; the indifference which they have to their creators; and the mode in which their creators realize their ideas through third-party technicians who simply carry out the plans. This last does away with any moral bonus the artist used to get from working with his hands. Now he works with his mind instead—a scholar artist whose thoughts are carried out by others. Thus the artist becomes, on the one hand, the draughtsman of a useless environment (on an architectural model); and on the other an aristocrat like Villiers de l'Isle-Adam's Axel: "As for making art? Our technicians will see to that for us." And this amalgamated philosopher-artist-draughtsman-aristocrat seems to lead us to an Academy once again, a sort of Platonic Academy—minus Plato.

MINIMAL ABSTRACTS* by John Perreault

In this essay John Perreault examines several characteristics of Minimal Art, noting that "Minimal artists use a rational and conceptional method of composition," and that "The best Minimal works are the most radical and tend to be 'wholistic' and unitary, stripped of incident and accident. . . ." In his consideration of Dan Flavin, Perreault concurs with others who find Flavin's work generally subversive; he writes "There is an attack on bourgeois sensibilities and a violence done to the 'art' context. . . ."

John Perreault is the art critic for *The Village Voice*. He is an Associate Editor at *Art News*, and has published a book of poems called *Camouflage*.

I: Minimal Art Represents Several Solutions

Minimal Art represents several solutions to a problem of composition faced by many unrelated artists who desire to create new works of art. Among these artists whom the museums, gallery directors, and art writers have so hastily placed together there are undoubtedly several who are as far apart from each other as we now understand de Kooning and Pollock to be and as far apart as Roy Lichtenstein and Andy Warhol. Among many of them, however, there is at least a "family resemblance."

As an example of these horizontal "family resemblances," Ronald Bladen's pieces, because of their severe geometry—particularly his large, white, tilted box in the Whitney Biannual and his giant, apex-balanced, wedge-shaped *Black Triangle*—bear a "family resemblance" to Tony Smith's large black cubes. On the other hand, Bladen's concern with "inside and outside" is related to Sol LeWitt's "monkey-bar" constructions, which, rather than implying an interior structure, expose it. Bladen's pieces, although more overtly dramatic because they seem to express the ineffable, are also related to Robert

* Reprinted from *Arts Magazine*, March, 1967; *Art International*, March, 1967; and *The Village Voice*, January 12, 1967.

Morris's uncanny, off-white works. The "silence" and the concern for unified composition relate Donald Judd's boxes to Morris's equally "wholistic" approach to composition. But, on the other hand, because of their segmentation and use of manufactured components, they also relate to Carl Andre's brick inventions and Flavin's fluorescent light arrangements.

Nevertheless, just as *in general* it can be said that the Abstract Expressionists shared a concern with scale, accident, and "self-expression," and that Pop artists, inspite of radically different techniques of execution and composition, resemble each other in their use of Mass Culture iconography, so it can be said that the Minimal artists share a certain cluster of stylistic characteristics.

As opposed to a material or intuitive method, Minimal artists use a rational and conceptional method that is not unrelated to Pop Art approaches to the problem of composition. In many instances they perhaps share with Pop artists a desire to create instant aesthetic impact. The materials involved (and the new industrial materials employed by some of the Minimalists represent a great breakthrough for sculpture, freeing it not only from the pedestal, the chisel and the casting procedure, but from the blow-torch as well) are completely subservient to the intent of the composition. The artist is often once removed from the actual execution of the work so that the automatism of the artist's hand does not interfere with the rationalism of the readymade or manufactured units involved. The composition or anti-composition itself is often mathematically derived, modular, or based on permutations of geometric elements. There is, therefore, an automatism of geometry and necessary efficiency rather than of materials or direct emotion.

The best Minimal works are the most radical and tend to be "wholistic" and unitary, stripped of incident, accident, or anything that might distract from the subtlety, the efficiency, or the clarity of the all-over effect. If the work is segmented, as in Smithson, Judd, and others, the components are nonrelational. They are usually exact repetitions or repetitions based on rather simple permutations and are not related to each other in any traditional compositional, adjusted way, but related to the work as a whole. The expressive elements—and Minimal Art *is* expressive and sometimes unfortunately wholly Mannerist in effect if not in intent—are completely

conceptual and not dictated by the demands of the materials or the actual process of execution.—"A Minimal Future?" *Arts*, March, 1967.

II: Dan Flavin's New Arrangements

Dan Flavin's new arrangements of white fluorescent lights at the Kornblee continue the cool, calculated risk he has been taking by limiting himself to one narrow field of operation. This procedure has worked for others and amazingly enough it seems to be working for him. Blake wrote that if a fool would persist in his folly he would soon be wise. Flavin is no fool, nor is he at this point particularly wise. Nevertheless, he persists in his "folly" and continues to produce very controversial works that attempt to stretch the boundaries of art with great detachment and adventurousness. This season's arrangement was of fluorescent lights in vertical groups of twos and threes, all of varying size, mounted on the walls and in the corners of the gallery. To the uninitiated the gallery might have seemed empty and the ornate fireplace curiously outstanding. But if one knew what to expect, the effect was not without value. How often does one really notice the light sources that have transformed our lives? How often does one remember that insight, usually gained while shaving, that fluorescent light drains human flesh of color? Mr. Flavin, of course, is after more subtle ends. This particular show by virtue of its vertical arrangements eliminates one more possibility: the pieces do not interact with the walls and do not construct, by implication, areas of environmental composition. They are almost completely neutral lines of light. How often have there been works of art, if I am allowed a pun that must follow Flavin around like an autumn fly, that have been so completely "illuminating?" Flavin's fluorescent lights are more than just Minimal. There is an attack on bourgeois sensibilities and a violence done to the "art" context that I find annoyingly interesting. Flavin's commitment to his fluorescent "signature" may prove enslaving, but in the meantime fluorescent lights have the virtue, like Tinker Toys, of being capable of an infinite number of arrangements.—"New York Letter," *Art International*, March, 1967.

III: No One Has Clearly Pointed Out

. . . . No one has clearly pointed out how much the Judd–Morris aesthetic owes to the Duchamp, neo-Dada, Cage tradition. Morris's earlier works, as I remember them, were quite visibly influenced by Duchamp and Johns. Robert Morris is the genius of negative presence and the perversity of odd proportions that are subliminal in their aggressiveness. Works of art can in some sense be defined as those man-made objects that are designed solely to call attention to themselves. In this age of bombast, chatter, and random activity, that which does not move and that which is silent is often that which compels our attention and stimulates our awareness most effectively. Donald Judd, too, appears to have this "anti-art," pro-silence bias, and his works, although scrupulously elegant, are a well-formulated attack on "artistic" cliché.

The "mystery" in Duchamp's work, particularly the "Large Glass," derives from suggestions of a fourth-dimensional perspective and a private mythology of Eros and machinery. In Judd's work it is the implied IBM numerology and the icy, science-fiction surfaces of Flash Gordon bank vaults or, in his piece at the Whitney, classic proportions made into aesthetic therapy by suave color and cool repetitions.

Others I might add to this grouping would be Flavin (non-art arrangements of fluorescent lights) and Carl Andre (mathematical arrangements of readymade bricks). But here the link to Dada and the attempt at aesthetic shock is more self-evident.

Bladen's 1967 Fischbach show consists of just one piece—*Black Triangle, An Experimental Piece for Metal Construction*. It is a nine-foot-high black wedge, balanced on what would normally be its apex. It confirms that the common denominator of his work is balance. It is precisely this concern with "balance" and the aggressiveness of his works that make me link him, at least tentatively, with Judd and Morris. The balance in his works is a physical metaphysical balancing act. He plays games with the notion that a work of sculpture must at least look as if it is self-supporting. These works cannot possibly do what they are so obviously able to do. They should fall, but they don't. They have "insides." They have a secret. They provoke our curiosity and yet, because they also provoke our

fear, they ignite our awareness by forcing us to consider their interiors and to consider what their smooth geometry makes invisible.

Ronald Bladen does not have Donald Judd's sensitivity for sleek, new materials or his propensity for polemic; nor does Bladen approach an art as subtle and as dangerous as Robert Morris's. But what he lacks in sleekness or subtlety he makes up for in showmanship and in an ability to test out equilibrium by oblique references to the invisible.—*The Village Voice*, January 12, 1967.

IV: The Term Minimal

The term "Minimal" seems to imply that what is minimal in Minimal Art is the art. This is far from the case. There is nothing minimal about the "art" (craftsmanship, inspiration, or aesthetic stimulation) in Minimal Art. If anything, in the best works being done, it is maximal. What is minimal about Minimal Art, or appears to be when contrasted with Abstract Expressionism or Pop Art, is the *means,* not the end.

Minimal Art is really not as cold, boring, and inhuman as its opponents claim. Minimal Art is only cold if by "cold" we mean a minimum degree of self-expression. But it should be remembered that "self-expression" is often merely a cover-up term for self-indulgence. If relatively impersonal forms of composition and creativity are to be eliminated from art, then not only must we eliminate Donald Judd and Robert Morris, but also most of the world art that we have at last admitted into aesthetic categories. Anything made by a human being is human. Minimal Art is no more inhuman than Egyptian architecture, Tibetan banners, or Sung paintings, all instances of relatively impersonal artistic expression.

Minimal Art, in spite of the polemics, is emotional, but the emotions and the experiences involved are new and unexpected. It must be remembered that the rational and the conceptual are also capable of evoking emotion. There is also the emotion and the aesthetic pleasure of efficiency and clarity and of surprising proportions.

Some art called Minimal Art is boring and it is bad art. But a great deal of the boredom associated with Minimal Art is in the mind of the beholder. The viewer will be bored if he does not know what to look for or if he expects something that is not there. Judd's rows of boxes are no more boring than Mondrian's right-angles,

Albers's squares, or Monet's haystacks; and in Robert Morris's work, for instance, there is much to occupy sensuous and aesthetic inspection. . . .—"A Minimal Future" *Arts*, March, 1967.

V: The Reason

The reason for Tony Smith's sudden emergence as one of our most important sculptors can be seen these days behind the Main Branch of the New York Public Library in Bryant Park: eight plywood sculptures (painted black) based on modular principles of composition, all "Minimal," all severely geometrical, and all quite beautiful. Tony Smith studied architecture with Frank Lloyd Wright and has been a friend of many of the leading Abstract-Expressionist painters. The "Minimal" geometry that Smith employs and his modular use of tetrahedrons are a means to an end, and that end is not severity for its own sake, but severity in the service of poetry and a well-articulated expressiveness.

Like the works of the much younger artist Robert Morris, their lack of incident and their "simplicity" of form allow a unified perception of mass, weight, and structure and a clear control of the effects of light on flat, uncluttered planes. Seen outdoors, as in Bryant Park, they are seen to their best advantage, for the variety of planes is complicated enough to make the works consistently interesting under various angles of natural daylight.

Unlike Morris, who appears to be concerned with keeping his works within a sylistic framework of scale that permits his pieces to be too large or too low to be furniture and too small to be monumental or architectural, Smith's works do not utilize this keenness of restraint and severe brinkmanship that is so nervewracking and radial. Smith's works leap romantically into a public scale that fits perfectly into the public landscape. The modular basis of their severity is not anti-organic, but based on the same principle that is at the center of the organic.—*The Village Voice*, February 9, 1967.

VI: Minimal Art Has Also Been Read

Minimal Art has also been read as a reductionist effort to determine the essence of a particular medium. How much can an artist elimi-

nate of the traditional ingredients of his medium and still produce art? Minimal Art becomes the Minimal Style, and the Minimal Style relates to a larger tendency that might be termed the Minimal Sensibility, a Quixotic search for an essence, perhaps more among art writers than artists, in spite of Wittgenstein (a philosopher much in favor with Minimalists). Other examples in other media would be Robbe-Grillet's so-called elimination of psychology, character, and traditional narrative form from fiction; John Cage's elimination of traditional instruments, notation, and "composition" from music; and in poetry, the nonrelational poems of the Concretists and Aram Saroyan's witty one-word poems. In the Underground Cinema we have no-talking, no-acting, no-editing, no-motion motion pictures, loop films, strobe films, and even films made without film.

Paradoxically, the closer an artist gets to the mythological "essence" of his particular medium the faster his medium becomes something else. Frank Stella's shaped-canvases become a kind of flat sculpture for the wall. Cage's "music" becomes theatre. Concretist poems become graphic art. Prose becomes poetry or music. Film becomes a kind of projected painting. Architecture as it tries more and more to be simply architecture becomes sculpture. And sculpture as it strives for "sculptureness" becomes architecture or merely interior design. This paradoxical "media transposition" indicates perhaps that just as there is no ideal gameness that relates all games, there is no ideal art or essence of painting or sculpture, no "nature."—"A Minimal Future?" *Arts*, March, 1967.

A QUASI SURVEY OF SOME "MINIMALIST" TENDENCIES IN THE QUANTITATIVELY MINIMAL DANCE ACTIVITY MIDST THE PLETHORA, OR AN ANALYSIS OF TRIO A by Yvonne Rainer

Yvonne Rainer is one of the major figures of the highly experimental and influential Judson Dance Theatre in New York. In this essay based on her dance in five parts called *The Mind Is a Muscle*, she discusses ideas concerning smoothness of continuity in dance. Repetition, phrasing, and energy are redefined; formal content and progression in dance are challenged. As Kenneth King points out: "What the new dance-theater does is RE-PROGRAM symbolic actions, subjects, and movement. Dance need no longer be a minor art with segregated specialization of mere movement."

Miss Rainer was born in San Francisco in 1934, and has performed her works in several American cities, as well as in Europe. Her most recent choreography includes *The Mind Is a Muscle* and *Carriage Discreteness*, the latter being a work for twelve performers using electronic equipment devised by Bell Laboratory scientists, which was presented at the 69th Regiment Armory in New York as part of the series called "Nine Evenings: Theatre and Engineering."

Objects	Dances
eliminate or minimize	
1. role of artist's hand	phrasing
2. hierarchical relationship of parts	development and climax
3. texture	variation: rhythm, shape, dynamics
4. figure reference	character
5. illusionism	performance
6. complexity and detail	variety: phrases and the spatial field
7. monumentality	the virtuosic movement feat and the fully-extended body
substitute	
1. factory fabrication	energy equality and "found" movement
2. unitary forms, modules	equality of parts
3. uninterrupted surface	repetition or discrete events
4. nonreferential forms	neutral performance
5. literalness	task or tasklike activity
6. simplicity	singular action, event, or tone
7. human scale	human scale

Although the benefit to be derived from making a one-to-one relationship between aspects of so-called minimal sculpture and recent dancing is questionable, I have drawn up a chart that does exactly that. Those who need alternatives to subtle distinction-making will be elated, but nevertheless such a device may serve as a shortcut to ploughing through some of the things that have been happening in a specialized area of dancing and once stated can be ignored or culled from at will.

It should not be thought that the two groups of elements are mutually exclusive ("eliminate" and "substitute"). Much work being done today—both in theatre and art—has concerns in both categories. Neither should it be thought that the type of dance I shall discuss has been influenced exclusively by art. The changes in theatre and dance reflect changes in ideas about man and his environment that have affected all the arts. That dance should reflect these changes at all is of interest, since for obvious reasons it has always been the most isolated and inbred of the arts. What is perhaps unprecedented in the short history of the modern dance is the close correspondence between concurrent developments in dance and the plastic arts.

Isadora Duncan went back to the Greeks; Humphrey and Graham[1] used primitive ritual and/or music for structuring, and although the people who came out of the Humphrey–Graham companies and were active during the thirties and forties shared sociopolitical concerns and activity in common with artists of the period, their work did not reflect any direct influence from or dialogue with the art so much as a reaction to the time. (Those who took off in their own directions in the forties and fifties—Cunningham, Shearer, Litz, Marsicano, et al.—must be appraised individually. Such a task is beyond the scope of this article.) The one previous area of correspondence might be German Expressionism and Mary Wigman and her followers, but photographs and descriptions of the work show little connection.

Within the realm of movement invention—and I am talking for the time being about movement generated by means other than

[1] In the case of Graham, it is hardly possible to relate her work to anything outside of theatre, since it was usually dramatic and psychological necessity that determined it.

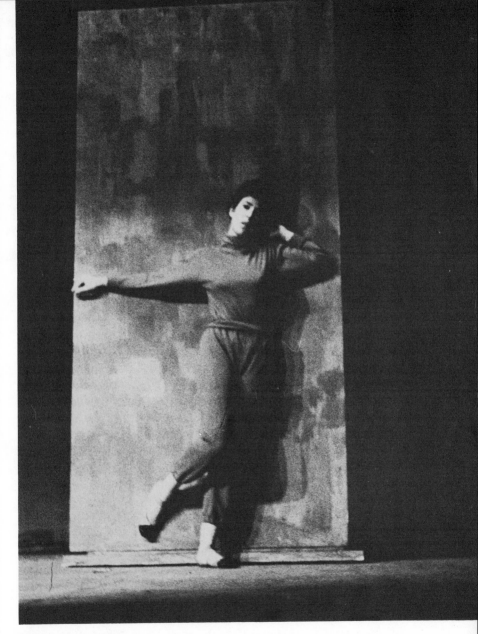

Deborah Hay in "Rise," 1965.

accomplishment of a task or dealing with an object—the most impressive change has been in the attitude to phrasing, which can be defined as the way in which energy is distributed in the execution of a movement or series of movements. What makes one kind of movement different from another is not so much variations in arrangements of parts of the body as differences in energy investment.

It is important to distinguish between real energy and what I shall call "apparent" energy. The former refers to actual output in terms of physical expenditure on the part of the performer. It is common to hear a dance teacher tell a student that he is using "too much energy" or that a particular movement does not require "so much energy." This view of energy is related to a notion of economy and ideal movement technique. Unless otherwise indicated, what I shall be talking about here is "apparent" energy, or what is seen in terms of motion and stillness rather than of actual work, regardless of the physiological or kinesthetic experience of the dancer. The two observations—that of the performer and that of the spectator—do not always correspond. A vivid illustration of this is my *Trio A:* Upon completion two of us are always dripping with sweat while the third is dry. The correct conclusion to draw is not that the dry one is expending less energy, but that the dry one is a "non-sweater."

Much of the western dancing we are familiar with can be characterized by a particular distribution of energy: maximal output or "attack" at the beginning of a phrase,[2] followed by abatement and recovery at the end, with energy often arrested somewhere in the middle. This means that one part of the phrase—usually the part that is the most still—becomes the focus of attention, registering like a photograph or suspended moment of climax. In the Graham-oriented modern dance these climaxes can come one on the heels of the other. In types of dancing that depend on less impulsive controls, the climaxes are farther apart and are not so dramatically "framed." Where extremes in tempi are imposed, this ebb-and-flow of effort is also pronounced: in the instance of speed the contrast

[2] The term "phrase" must be distinguished from "phrasing." A phrase is simply two or more consecutive movements, while phrasing, as noted previously, refers to the manner of execution.

between movement and rest is sharp, and in the adagio, or sup-
posedly continuous kind of phrasing, the execution of transitions
demonstrates more subtly the mechanics of getting from one point
of still "registration" to another.

The term "phrase" can also serve as a metaphor for a longer or
total duration containing beginning, middle, and end. Whatever the
implications of a continuity that contains high points or focal cli-
maxes, such an approach now seems to be excessively dramatic and,
more simply, unnecessary.

Energy has also been used to implement heroic more-than-human
technical feats and to maintain a more-than-human look of physical
extension, which is familiar as the dancer's muscular "set." In the
early days of the Judson Dance Theatre someone wrote an article
and asked "Why are they so intent on just being themselves?" It is
not accurate to say that everyone at that time had this in mind. (I
certainly didn't; I was more involved in experiencing a lion's share
of ecstacy and madness than in "being myself" or doing a job.) But
where the question applies, it might be answered on two levels: 1)
The artifice of performance has been reevaluated in that action, or
what one does, is more interesting and important than the exhibition
of character and attitude, and that action can best be focused on
through the submerging of the personality; so ideally one is not even
oneself, one is a neutral "doer." 2) The display of technical vir-
tuosity and the display of the dancer's specialized body no longer
make any sense. Dancers have been driven to search for an alterna-
tive context that allows for a more matter-of-fact, more concrete,
more banal quality of physical being in performance, a context
wherein people are engaged in actions and movements making a less
spectacular demand on the body and in which skill is hard to locate.

It is easy to see why the *grand jeté* (along with its ilk) had to be
abandoned. One cannot "do" a *grand jeté;* one must "dance" it to get
it done at all, i.e., invest it with all the necessary nuances of energy
distribution that will produce the look of climax together with a still,
suspended extension in the middle of the movement. Like a ro-
mantic, overblown plot this particular kind of display—with its
emphasis on nuance and skilled accomplishment, its accessibility to
comparison and interpretation, its involvement with connoisseur-
ship, its introversion, narcissism, and self-congratulatoriness—has fi-

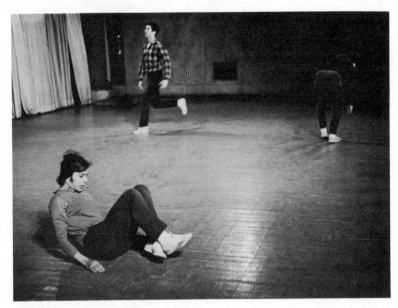

Yvonne Rainer, William Davis, and David Gordon in *The Mind Is a Muscle, Trio A,* by Yvonne Rainer, 1966. Photograph by Peter Moore.

"Rule Game 5" by Trisha Brown, 1964.

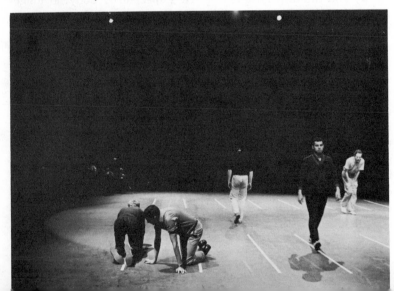

nally in this decade exhausted itself, closed back on itself, and perpetuates itself solely by consuming its own tail.

The alternatives that were explored now are obvious: stand, walk, run, eat, carry bricks, show movies, or move or be moved by some *thing* rather than oneself. Some of the early activity in the area of self-movement utilized games, "found" movement (walking, running, etc.), and people with no previous training. (One of the most notable of these early efforts was Steve Paxton's solo, *Transit*, in which he performed movement by "marking" it. "Marking" is what dancers do in rehearsal when they do not want to expend the full amount of energy required for the execution of a given movement. It has a very special look, tending to blur boundaries between consecutive movements.) These descriptions are not complete. Different people have sought different solutions.

Since I am primarily a dancer, I am interested in finding solutions primarily in the area of moving oneself, however many excursions I have made into pure and not-so-pure thing-moving. In 1964 I began to play around with simple one- and two-motion phrases that required no skill and little energy and contained few accents. The way in which they were put together was indeterminate, or decided upon in the act of performing, because at that time the idea of a different kind of continuity as embodied in transitions or connections between phrases did not seem to be as important as the material itself. The result was that the movements or phrases appeared as isolated bits framed by stoppages. Underscored by their smallness and separateness, they projected as perverse *tours-de-force*. Everytime "elbow-wiggle" came up one felt like applauding. It was obvious that the idea of an unmodulated energy output as demonstrated in the movement was not being applied to the continuity. A continuum of energy was required. Duration and transition had to be considered.

Which brings me to *The Mind is a Muscle, Trio A*. Without giving an account of the drawn-out process through which this 4½-minute movement series (performed simultaneously by three people) was made, let me talk about its implications in the direction of movement-as-task or movement-as-object.

One of the most singular elements in it is that there are no pauses

between phrases. The phrases themselves often consist of separate parts, such as consecutive limb articulations—"right leg, left leg, arms, jump," etc.—but the end of each phrase merges immediately into the beginning of the next with no observable accent. The limbs are never in a fixed, still relationship and they are stretched to their fullest extension only in transit, creating the impression that the body is constantly engaged in transitions.

Another factor contributing to the smoothness of the continuity is that no one part of the series is made any more important than any other. For four-and-a-half minutes a great variety of movement shapes occur, but they are of equal weight and are equally emphasized. This is probably attributable both to the sameness of physical "tone" that colors all the movements and to the attention to the pacing. I can't talk about one without talking about the other.

The execution of each movement conveys a sense of unhurried control. The body is weighty without being completely relaxed. What is seen is a control that seems geared to the *actual* time it takes the *actual* weight of the body to go through the prescribed motions, rather than an adherence to an imposed ordering of time. In other words, the demands made on the body's (actual) energy resources *appear* to be commensurate with the task—be it getting up from the floor, raising an arm, tilting the pelvis, etc.—much as one would get out of a chair, reach for a high shelf, or walk down stairs when one is not in a hurry.[3] The movements are not mimetic, so they do not remind one of such actions, but I like to think that in their manner of execution they have the factual quality of such actions.

Of course, I have been talking about the "look" of the movements. In order to achieve this look in a continuity of separate phrases that does not allow for pauses, accents, or stillness, one must bring to bear many different degrees of effort just in getting from one thing to another. Endurance comes into play very much with its necessity for conserving (actual) energy (like the long-distance

[3] I do not mean to imply that the demand of musical or metric phrasing makes dancing look effortless. What it produces is a different kind of effort, where the body looks more extended, "pulled up," highly energized, ready to go, etc. The dancer's "set" again.

runner). The irony here is in the reversal of a kind of illusionism: I have exposed a type of effort where it has been traditionally concealed and have concealed phrasing where it has been traditionally displayed.

So much for phrasing. My *Trio A* contained other elements mentioned in the chart that have been touched on in passing, not being central to my concerns of the moment. For example, the "problem" of performance was dealt with by never permitting the performers to confront the audience. Either the gaze was averted or the head was engaged in movement. The desired effect was a worklike rather than exhibitionlike presentation.

I shall deal briefly with the remaining categories on the chart as they relate to *Trio A*. Variation was not a method of development. No one of the individual movements in the series was made by varying a quality of any other one. Each is intact and separate with respect to its nature. In a strict sense neither is there any repetition (with the exception of occasional consecutive traveling steps). The series progresses by the fact of one discrete thing following another. This procedure was consciously pursued as a change from my previous work, which often had one identical thing following another— either consecutively or recurrently. Naturally the question arises as to what constitutes repetition. In *Trio A*, where there is no consistent consecutive repetition, can the simultaneity of three identical sequences be called repetition? Or can the consistency of energy tone be called repetition? Or does repetition apply only to successive specific actions?

All of these considerations have supplanted the desire for dance structures wherein elements are connected thematically (through variation) and for a diversity in the use of phrases and space. I think two assumptions are implicit here: 1) A movement is a complete and self-contained event; elaboration in the sense of varying some aspect of it can only blur its distinctness; and 2) Dance is hard to see. It must either be made less fancy, or the fact of that intrinsic difficulty must be emphasized to the point that it becomes almost impossible to see.

Repetition can serve to enforce the discreteness of a movement, objectify it, make it more objectlike. It also offers an alternative way

of ordering material, literally making the material easier to see. That most theatre audiences are irritated by it is not yet a disqualification.

My *Trio A* dealt with the "seeing" difficulty by dint of its continual and unremitting revelation of gestural detail that did *not* repeat itself, thereby focusing on the fact that the material could not easily be encompassed.

There is at least one circumstance that the chart does not include (because it does not relate to "minimization"), viz., the static singular object versus the object with interchangeable parts. The dance equivalent is the indeterminate performance that produces variations ranging from small details to a total image. Usually indeterminacy has been used to change the sequentialness—either phrases or larger sections—of a work, or to permute the details of a work. It has also been used with respect to timing. Where the duration of separate, simultaneous events is not prescribed exactly, variations in the relationship of these events will occur. Such is the case with the trio I have been speaking about, in which small discrepancies in the tempo of individually executed phrases results in the three simultaneous performances constantly moving in and out of phase and in and out of synchronization. The overall look of it is constant from one performance to another, but the distribution of bodies in space at any given instant changes.

I am almost done. *Trio A* is the first section of *The Mind Is a Muscle*. There are six people involved and four more sections. *Trio B* might be described as a VARIATION of *Trio A* in its use of unison with three people; they move in exact unison thruout. *Trio A* is about the EFFORTS of two men and a woman in getting each other aloft in VARIOUS ways while REPEATING the same diagonal SPACE pattern throughout. In *Horses* the group travels about as a unit, recurrently REPEATING six different ACTIONS. *Lecture* is a solo that REPEATS the MOVEMENT series of *Trio A*. There will be at least three more sections.

There are many concerns in this dance. The concerns may appear to fall on my tidy chart as randomly dropped toothpicks might. However, I think there is sufficient separating out in my work as well as that of certain of my contemporaries to justify an attempt at organizing those points of departure from previous work. Compar-

ing the dance to Minimal Art provided a convenient method of organization. Omissions and overstatements are a hazard of any systematizing in art. I hope that some degree of redress will be offered by whatever clarification results from this essay.

A B C ART* by Barbara Rose

ABC Art was one of the first major essays devoted to a definition of Minimal style and its characteristics. The author traces the development of the style through Abstract Expressionism, and points out related Minimal features in the various art forms of the day. She writes: ". . . one might as easily construe the new, reserved impersonality and self-effacing anonymity as a reaction against the self-indulgence of an unbridled subjectivity, as much as one might see it in terms of a formal reaction to the excesses of painterliness."

Barbara Rose was educated at Smith, Barnard, and Columbia. She teaches at Sarah Lawrence, and is Contributing Editor for *Artforum* and *Art in America*. She has just completed a *History of American Art Since 1900*.

"I am curious to know what would happen if art were suddenly seen for what it is, namely, exact information of how to rearrange one's psyche in order to anticipate the next blow from our own extended faculties. . . . At any rate, in experimental art, men are given the exact specifications of coming violence to their own psyches from their own counterirritant or technology. . . . But the counterirritant usually proves a greater plague than the initial irritant, like a drug habit."
— MARSHALL MCLUHAN, *Understanding Media*, 1964

"How do you like what you have. This is a question that anybody can ask anybody. Ask it."
— GERTRUDE STEIN, *Lectures in America*, 1935

On the eve of the First World War, two artists, one in Moscow, the other in Paris, made decisions that radically altered the course of art history. Today we are feeling the impact of their decisions in an art whose blank, neutral, mechanical impersonality contrasts so vio-

* Reprinted from *Art in America*, October–November, 1965.

lently with the romantic, biographical Abstract-Expressionist style which preceded it that spectators are chilled by its apparent lack of feeling or content. Critics, attempting to describe this new sensibility, call it Cool Art or Idiot Art or Know-Nothing Nihilism.

That a new sensibility has announced itself is clear, although just what it consists of is not. This is what I hope to establish here. But before taking up specific examples of the new art, not only in painting and sculpture, but in other arts as well, I would like briefly to trace its genealogy.

In 1913, Kasimir Malevich, placing a black square on a white ground that he identified as the "void," created the first suprematist composition. A year later, Marcel Duchamp exhibited as an original work of art a standard metal bottle-rack, which he called a "readymade." For half a century, these two works marked the limits of visual art. Now, however, it appears that a new generation of artists, who seem not so much inspired as impressed by Malevich and Duchamp (to the extent that they venerate them), are examining in a new context the implications of their radical decisions. Often, the results are a curious synthesis of the two men's work. That such a synthesis should be not only possible but likely is clear in retrospect. For, although superficially Malevich and Duchamp may appear to represent the polarities of twentieth-century art—that is, on one hand, the search for the transcendent, universal, absolute, and on the other, the blanket denial of the existence of absolute values—the two have more in common than one might suppose at first.

To begin with, both men were precocious geniuses who appreciated the revolutionary element in Post-Impressionist art, particularly Cézanne's, and both were urban modernists who rejected the possibility of turning back to a naïve primitivism in disgusted reaction to the excesses of civilization. Alike, too, was their immediate adoption and equally rapid disenchantment with the mainstream modern style, Cubism. Turning from figurative manners, by 1911 both were doing Cubist paintings, although the provincial Malevich's were less advanced and "analytic" than Duchamp's; by 1913 both had exhausted Cubism's possibilities as far as their art was concerned. Moreover, both were unwilling to resolve some of the ambiguities and contradictions inherent in Analytic Cubism in terms of the more ordered and logical framework of Synthetic Cubism,

Richard Artschwager: Untitled. 1966. Formica on wood. 59″ x 18″ x 30″. Photograph courtesy of Leo Castelli Gallery, New York.

the next mainstream style. I say unwilling rather than unable, because I do not agree with critic Michael Fried's view that Duchamp, at any rate, was a failed Cubist. Rather, the inevitability of a logical evolution toward a reductive art was obvious to them already. For Malevich, the poetic Slav, this realization forced a turning inward toward an inspirational mysticism, whereas for Duchamp, the rational Frenchman, it meant a fatigue so ennervating that finally the wish to paint at all was killed. Both the yearnings of Malevich's Slavic soul and the deductions of Duchamp's rationalist mind led both men ultimately to reject and exclude from their work many of the most cherished premises of Western art in favor of an art stripped to its bare, irreducible minimum.

It is important to keep in mind that both Duchamp's and Malevich's decisions were renunciations—on Duchamp's part, of the notion of the uniqueness of the art object and its differentiation from common objects, and on Malevich's part, a renunciation of the notion that art must be complex. That the art of our youngest artists resembles theirs in its severe, reduced simplicity, or in its frequent kinship to the world of things, must be taken as some sort of validation of the Russian's and the Frenchman's prophetic reactions.

More Is Less

The concept of "Minimal Art," which is surely applicable to the empty, repetitious, uninflected art of many young painters, sculptors, dancers, and composers working now, was recently discussed as an aesthetic problem by Richard Wollheim (*Arts*, January, 1965). It is Professor Wollheim's contention that the art content of such works as Duchamp's found-objects (that is, the "unassisted readymades" to which nothing is done) or Ad Reinhardt's nearly invisible "black" paintings is intentionally low, and that resistance to this kind of art comes mainly from the spectator's sense that the artist has not worked hard enough or put enough effort into his art. But, as Professor Wollheim points out, a decision can represent work. Considering as "Minimal Art" either art made from common objects that are not unique but mass-produced or art that is not much differentiated from ordinary things, he says that Western artists have aided us to focus on specific objects by setting them apart as the "unique posses-

sors of certain general characteristics." Although they are increasingly being abandoned, working it a lot, making it hard to do, and differentiating it as much as possible from the world of common objects, formerly were ways of insuring the uniqueness and identity of an art object.

Similarly, critic John Ashbery has asked if art can be excellent if anybody can do it. He concludes that "what matters is the artist's will to discover, rather than the manual skills he may share with hundreds of other artists. Anybody could have discovered America, but only Columbus *did*." Such a downgrading of talent, facility, virtuosity, and technique, with its concomitant elevation of conceptual power, coincides precisely with the attitude of the artists I am discussing (although it could also apply to the "conceptual" paintings of Kenneth Noland, Ellsworth Kelly, and others).

Now I should make it clear that the works I have singled out to discuss here have only one common characteristic: they may be described as Minimal Art. Some of the artists, such as Darby Bannard, Larry Zox, Robert Huot, Lyman Kipp, Richard Tuttle, Jan Evans, Ronald Bladen, and Anne Truitt obviously are closer to Malevich than they are to Duchamp, whereas others, such as Richard Artschwager and Andy Warhol, are clearly the reverse. The dancers and composers are all, to a greater or lesser degree, indebted to John Cage, who is himself an admirer of Duchamp. Several of the artists—Robert Morris, Donald Judd, Carl Andre, and Dan Flavin—occupy to my eye some kind of intermediate position. One of the issues these artists are attacking is the applicability of generalizations to specific cases. In fact, they are opposed to the very notion that the general and the universal are related. Thus, I want to reserve exceptions to all of the following remarks about their work; in other words, *some of the things I will say apply only in some cases and not in others.*

Though Duchamp and Malevich jumped the gun, so to speak, the avenue toward what Clement Greenberg has called the "modernist reduction," that is, toward an art that is simple, clear, direct, and immediate, was traveled at a steadier pace by others. Michael Fried (in the catalogue "Three American Painters," Fogg Art Museum, 1965) points out that there is "a superficial similarity between modernist painting and Dada in one important respect: namely that

just as modernist painting has enabled one to see a blank canvas, a sequence of random spatters, or a length of colored fabric as a picture, Dada and Neo-Dada have equipped one to treat virtually any object as a work of art." The result is that "there is an apparent expansion of the realm of the *artistic* corresponding—ironically, as it were—to the expansion of the pictorial achieved by modernist painting." I quote this formulation because it demonstrates not only how Yves Klein's monochrome blue paintings are art, but because it ought finally to make clear the difference in the manner and kind of reductions and simplifications he effected from those made by Noland and Jules Olitski, thus dispelling permanently any notions that Noland's and Olitski's art are in any way, either in spirit or in intention, linked to the Dada outlook.

Although the work of the painters I am discussing is more blatant, less lyrical and more resistant—in terms of surface, at any rate, insofar as the canvas is not stained or is left with unpainted areas—it has something important in common with that of Noland, Olitski, and others who work with simple shapes and large color areas. Like their work, this work is critical of Abstract-Expressionist paint-handling and rejects the brushed record of gesture and drawing along with loose painterliness. Similarly, the sculpture I am talking about appears critical of open, welded sculpture.

That the artist is critic not only of his own work but of art in general and specifically of art of the immediate past is one of the basic tenets of formalist criticism, the context in which Michael Fried and Clement Greenberg have considered reductive tendencies in modern art. But in this strict sense, to be critical means to be critical only of the formal premises of a style, in this case Abstract Expressionism. Such an explanation of a critical reaction in the purely formal terms of color, composition, scale, format and execution seems to me adequate to explain the evolution of Noland's and Olitski's work, but it does not fully suffice to describe the reaction of the younger people I am considering, just as an explanation of the rise of Neo-Classicism which considered only that the forms of the Rococo were worn out would hardly give one much of a basis for understanding the complexity of David's style.

It seems clear that the group of young artists I am speaking of were reacting to more than merely formal chaos when they opted

not to fulfill Ad Reinhardt's prescription for "divine madness" in "third generation Abstract Expressionists." In another light, one might as easily construe the new, reserved impersonality and self-effacing anonymity as a reaction against the self-indulgence of an unbridled subjectivity, as much as one might see it in terms of a formal reaction to the excesses of painterliness. One has the sense that the question of whether or not an emotional state can be communicated (particularly in an abstract work) or worse still, to what degree it can be simulated or staged, must have struck some serious-minded young artists as disturbing. That the spontaneous splashes and drips could be manufactured was demonstrated by Robert Rauschenberg in his identical action paintings, *Factum I* and *Factum II*. It was almost as if, toward the *Götterdämmerung* of the late fifties, the trumpets blared with such an apocalpytic and Wagnerian intensity that each moment was a crisis and each "act" a climax. Obviously, such a crisis climate could hardly be sustained; just to be able to hear at all again, the volume had to be turned down, and the pitch, if not the instrument, changed.

Choreographer Merce Cunningham, whose work has been of the utmost importance to young choreographers, may have been the first to put this reaction into words (in an article in *trans/formation*, No. 1, 1952): "Now I can't see that crisis any longer means a climax, unless we are willing to grant that every breath of wind has a climax (which I am), but then that obliterates climax, being a surfeit of such. And since our lives, both by nature and by the newspapers, are so full of crisis that one is no longer aware of it, then it is clear that life goes on regardless, and further that each thing can be and is separate from each and every other, viz: the continuity of the newspaper headlines. Climax is for those who are swept by New Year's Eve." In a dance called "Crises" Cunningham eliminated any fixed focus or climax in much the way the young artists I am discussing here have banished them from their works as well. Thus Cunningham's activity, too, must be considered as having helped to shape the new sensibility of the post-Abstract-Expressionist generation.

It goes without saying that sensibility is not transformed overnight. At this point I want to talk about sensibility rather than style, because the artists I'm discussing, who are all roughly just under or just over thirty, are more related in terms of a common sensibility

than in terms of a common style. Also, their attitudes, interests, experiences, and stance are much like those of their contemporaries, the Pop artists, although stylistically the work is not very similar.

Mainly this shift toward a new sensibility came, as I've suggested, in the fifties, a time of convulsive transition not only for the art world, but for society at large as well. In these years, for some reasons I've touched on, many young artists found action painting unconvincing. Instead they turned to the static emptiness of Barnett Newman's eloquent chromatic abstractions or to the sharp visual punning of Jasper Johns's objectlike flags and targets.

Obviously, the new sensibility that preferred Newman and Johns to Willem de Kooning or his epigoni was going to produce art that was different, not only in form but in content as well, from the art that it spurned, because it rejected not only the premises, but the emotional content of Abstract Expressionism.

The problem of the subversive content of these works is complicated, though it has to be approached, even if only to define why it is peculiar or corrosive. Often, because they appear to belong to the category of ordinary objects rather than art objects, these works look altogether devoid of art content. This, as it has been pointed out in criticism of the so-called contentless novels of Alain Robbe-Grillet, is quite impossible for a work of art to achieve. The simple denial of content can in itself constitute the content of such a work. That these young artists attempt to suppress or withdraw content from their works is undeniable. That they wish to make art that is as bland, neutral, and as redundant as possible also seems clear. The content, then, if we are to take the work at face value, should be nothing more than the total of the series of assertions that it is this or that shape and takes up so much space and is painted such a color and made of such a material. Statements from the artists involved are frequently couched in these equally factual, matter-of-fact descriptive terms; the work is described but not interpreted and statements with regard to content or meaning or intention are prominent only by their omission.

For the spectator, this is often all very bewildering. In the face of so much nothing, he is still experiencing something, and usually a rather unhappy something at that. I have often thought one had a sense of loss looking at these big, blank, empty things, so anxious to

cloak their art identity that they were masquerading as objects. Perhaps, what one senses is that, as opposed to the florid baroque fullness of the *Angst*-ridden older generation, the hollow, barrenness of the void has a certain poignant, if strangled, expressiveness.

For the present, however, I prefer to confine myself mostly to describing the new sensibility rather than attempting to interpret an art that, by the terms of its own definition, resists interpretation. However, that there *is* a collective new sensibility among the young by now is self-evident. Looking around for examples, I was struck by the number of coincidences I discovered. For example, I found five painters who quite independently arrived at the identical composition of a large white or light-colored rectangle in a colored border. True, in some ways these were recapitulations of Malevich's *Black Square on White* (or to get closer to home, of Ellsworth Kelly's 1952 pair of a white square on black and black square on white); but there was an element in each example that finally frustrated a purist reading. In some cases (Ralph Humphrey's, for example) a Magritte-like sense of space behind a window-frame was what came across; other times there seemed to be a play on picture (blank) and frame (colored), though again, it was nearly impossible to pin down a specific image or sensation, except for the reaction that they weren't quite what they seemed to be. In the same way, three of the sculptors I'm considering (Carl Andre, Robert Morris, and Dan Flavin) have all used standard units interchangeably. Again, the reference is back to the Russians—particularly to Rodchenko in Andre's case—but still, another element has insinuated itself, preventing any real equations with Constructivist sculpture.

Rather than guess at intentions or look for meanings I prefer to try to surround the new sensibility, not to pinpoint it. As T.E. Hulme put it, the problem is to keep from discussing the new art with a vocabulary derived from the old position. Though my end is simply the isolation of the old-fashioned *Zeitgeist*, I want to go about it impressionistically rather than methodically. I will take up notions now in the air that strike me as relevant to the work. As often as possible I will quote directly from texts that I feel have helped to shape the new sensibility. But I do not want to give the impression that everything I mention applies indiscriminately to all the artists under consideration. Where I do feel a specific cause and

Ronald Bladen: *Black Triangle*. 1966. Painted wood (to be made in metal). 9'4" x 10' x 13'. Photograph courtesy of Fischbach Gallery.

effect relationship exists between influences of the past and these artists' work, I will illustrate with examples.

Meaning in the Visual Arts

"Let us, then, try to define the distinction between subject matter *or* meaning *on the one hand, and* form *on the other.*

"When an acquaintance greets me on the street by removing his hat, what I see from a formal point of view is nothing but the change of certain details within a configuration that forms part of the general pattern of color, lines and volumes which constitutes my world of vision. When I identify, as I automatically do, this as an event *(hat-removing), I have already overstepped the limits of purely* formal *perception and entered a first sphere of subject matter or* meaning . . . *we shall call* . . . *the factual meaning."*

—ERWIN PANOFSKY, *Studies in Iconology,* 1939

The above text and some of the subsequent passages in which Professor Panofsky further differentiates among levels of meaning in art was read by Robert Morris in a work (I hesitate to call it a dance although it was presented in a dance concert at the Surplus Theatre in New York) titled *21.3.* Morris is the most overtly didactic of all the artists I am considering; his dances, or more precisely his events, seem to represent a running commentary on his sculpture as well as a running criticism of art interpretation. At the Surplus Theatre concert he stood before a lectern and mouthed the Panofsky text, which was broadcast from a tape simultaneously. From time to time he interrupted himself to pour water from a pitcher into a glass. Each time he poured out water, the tape, timed to coincide with his action, produced the sound of water gurgling.

Until recently, in his glass and lead pieces, Morris was fairly explicit about putting subject matter (mostly Duchampesque speculations on process and sex or illustrations of Cartesian dualism) into his art. But now that he is making only bloated plywood constructions, which serve mostly to destroy the contour and space of a room by butting off the floor onto the wall, floating from the ceiling, or appearing as pointless obstacles to circulation, he seems to be concentrating on meaning. This victory for modernism has coincided with his retirement from the performing arts in order to concentrate

on his role as theoretician. That he chose the passage from Panofsky, which deals with slight changes of detail and the difference between factual and expressive meaning, is significant for the purpose of isolating the kind of matters that preoccupy many of these artists. For the painters and sculptors whom I am discussing here are aware not only of the cycle of styles but of levels of meaning, of influences, of movements, and of critical judgments. If the art they make is vacant or vacuous, it is intentionally so. In other words, the apparent simplicity of these artists' work was arrived at through a series of complicated, highly informed decisions, each involving the elimination of whatever was felt to be nonessential.

Art for Ad's Sake

"Nowhere in world art has it been clearer than in Asia that anything irrational, momentary, spontaneous, unconscious, primitive, expressionistic, accidental, or informal, cannot be called serious art. Only blankness, complete awareness, disinterestedness; the 'artist as artist' only, of one and rational mind, 'vacant and spiritual, empty and marvelous,' in symmetries and regularities only; the changeless 'human content' the timeless 'supreme principle,' the ageless 'universal formula' of art, nothing else . . .

"The forms of art are always preformed and premeditated. The creative process is always an academic routine and sacred procedure. Everything is prescribed and proscribed. Only in this way is there no grasping or clinging to anything. Only a standard form can be imageless, only a stereotyped image can be formless, only a formulaized art can be formulaless."

—AD REINHARDT, "Timeless in Asia," *Art News,* January 1960

"Fine art can only be defined as exclusive, negative, absolute, and timeless."

—AD REINHARDT, "Twelve Rules for a New Academy," *Art News,* May, 1957

No one, in the mid-fifties, seemed less likely to spawn artistic progeny and admirers than Ad Reinhardt. An abstract painter since the thirties, and a voluble propagandist for abstract art, Reinhardt was always one of the liveliest spirits in the art world, though from time to time he would be chided as the heretical black monk of

Abstract Expressionism, or the legendary Mr. Pure, who finally created an art so pure it consisted of injecting a clear fluid into foam rubber. His dicta, as arcane as they may have sounded when first handed down from the scriptorium, have become nearly canonical for the young artists. Suddenly, his wry irony, aloofness, independence, and ideas about the proper use and role of art, which he has stubbornly held to be noncommercial and nonutilitarian, are precisely the qualities the young admire. It is hard to say how much Reinhardt's constant theorizing, dogmatizing, and propagandizing actually helped to change the climate and to shift the focus from an overtly romantic style to a covertly romantic style.

Of course Reinhardt's "purity" is a relative matter, too. The loftiness is ultimately only part of the statement; and as he made of impersonality one of the most easily recognized styles in New York, so the new blandness is likely to result in similarly easy identification, despite all the use of standard units and programmatic suppression of individuality. In some ways, it might be interesting to compare Reinhardt with the younger artists. To begin with, in Reinhardt's case, there is no doubt that his is classic art (with mystical overtones, perhaps), and there is no doubt that it is abstract, or more precisely that it is abstract painting. Both the concepts of a classical style, toward which an art based on geometry would naturally tend, and that of a genuinely abstract style, are called into question frequently by the ambiguous art of the younger artists. First of all, many use a quirky asymmetry and deliberately bizarre scale to subvert any purist or classical interpretations, whereas others tend to make both paintings and sculptures look so much like plaques or boxes that there is always the possibility that they will be mistaken for something other than art. Their leaving open this possibility is, I think, frequently deliberate.

A Rose Is a Rose Is a Rose: Repetition as Rhythmic Structuring

". . . the kind of invention that is necessary to make a general scheme is limited in everybody's experience, every time one of the hundreds of times a newspaper man makes fun of my writing and of my repetition he always has the same theme, that is, if you like, repetition, that is if you like the repeating that is the same thing, but once started expressing this thing, expressing any thing there can be

Allan D'Arcangelo: *Safety Zone*. 1962. Acrylic on canvas. Photograph courtesy of Fischbach Gallery, New York.

Michael Steiner: Untitled. 1966. Aluminum. 8' high x 10' square. Photograph courtesy of Dwan Gallery, New York.

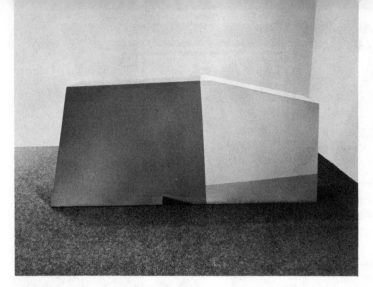

Anne Truitt: *Late Snow*. 1964. Aluminum, painted. 40¼" x 80". Photograph courtesy of Andre Emmerich Gallery, New York.

Andy Warhol: *Brillo*. 1964. Silkscreen ink on wood. 17" x 17" x 14". Photograph courtesy of Leo Castelli Gallery, New York.

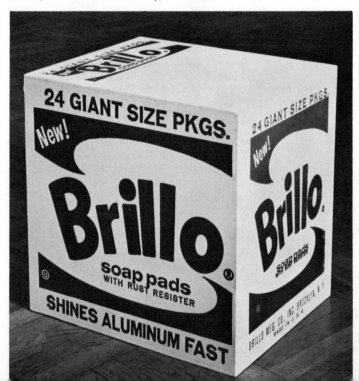

no repetition because the essence of that expression is insistence, and if you insist you must each time use emphasis and if you use emphasis it is not possible while anybody is alive that they should use exactly the same emphasis."

—GERTRUDE STEIN, "Portraits and Repetition" in
Lectures in America, 1935

"Form ceases to be an ordering in time like ABA and reduces to a single, brief image, an instantaneous whole both fixed and moving. Satie's form can be extended only by reiteration or 'endurance.' Satie frequently scrutinizes a very simple musical object; a short unchanging ostinato accompaniment plus a fragmentary melody. Out of this sameness comes subtle variety."

—ROGER SHATTUCK, *The Banquet Years*, 1955

In painting the repetition of a single motif (such as Larry Poons's dots or Gene Davis's stripes) over a surface usually means an involvement with Jackson Pollock's all-over paintings. In sculpture, the repetition of standard units may derive partly from practical considerations. But in the case of Judd's, Morris's, Andre's, and Flavin's pieces it seems to have more to do with setting up a measured, rhythmic beat in the work. Judd's latest sculptures, for example, are wall reliefs made of a transverse metal rod from which are suspended, at even intervals, identical bar or box units. For some artists—for example, the West Coast painter Billy Al Bengston, who puts sergeants' stripes in all his paintings—a repeated motif may take on the character of a personal insignia. Morris's four identical mirrored boxes, which were so elusive that they appeared literally transparent, and his recent L-shape plywood pieces were demonstrations of both variability and interchangeability in the use of standard units. To find variety in repetition where only the nuance alters seems more and more to interest artists, perhaps in reaction to the increasing uniformity of the environment and repetitiveness of a circumscribed experience. Andy Warhol's Brillo boxes, silk-screen paintings of the same image repeated countless times, and films in which people or things hardly move are illustrations of the kind of life situations many ordinary people will face or face already. In their insistence on repetition both Satie and Gertrude Stein have influenced the young dancers who perform at the Judson Memorial

Church Dance Theatre in New York. Yvonne Rainer, the most gifted choreographer of the group (which formed as a result of a course in dance composition taught by the composer, Robert Dunn, at Merce Cunningham's New York dance studio) has said that repetition was her first idea of form:

"I remember thinking that dance was at a disadvantage in relation to sculpture in that the spectator could spend as much time as he required to examine a sculpture, walk around it, and so forth—but a dance movement—because it happened in time—vanished as soon as it was executed. So in a solo called *The Bells* [performed at the Living Theatre in 1961] I repeated the same seven movements for eight minutes. It was not exact repetition, as the sequence of the movements kept changing. They also underwent changes through being repeated in different parts of the space and faced in different directions—in a sense allowing the spectator to 'walk around it.'"

For these dancers, and for composers like La Monte Young (who conceives of time as an endless continuum in which the performance of his *Dream Music* is a single, continuous experience interrupted by intervals during which it is not being performed), durations of time much longer than those we are accustomed to are acceptable. Thus, for example, an ordinary movement like walking across a stage may be performed in slow motion, and concerts of the *Dream Music* have lasted several days, just as Andy Warhol's first film, *Sleep,* was an eight-hour-long movie of a man sleeping. Again, Satie is at least a partial source. It is not surprising that the only performance of his piano piece *Vexations,* in which the same fragment is ritualistically repeated 840 times, took place two years ago in New York. The performance lasted 18 hours, 40 minutes and required the participation in shifts of a dozen or so pianists, of whom John Cage was one. Shattuck's statement that "Satie seems to combine experiment and inertia" seems applicable to a certain amount of avant-garde activity of the moment.

Art as a Demonstration: The Factual, the Concrete, the Self-evident

"But what does it mean to say that we cannot define (that is, describe) these elements, but only name them? This might mean, for instance, that when in a limiting case a complex consists of only one

square, its description is simply the name of the colored square.
"There are, of course, what can be called 'characteristic experi-
ences' of pointing to (e.g.) the shape. For example, following the
outline with one's finger or with one's eyes as one points.—But this
does not happen in all cases in which I 'mean the shape,' and no
more does any other one characteristic process occur in all these
cases."
 —LUDWIG WITTGENSTEIN, *Philosophical Investigations*, 1953

If Jasper Johns's notebooks seem a parody of Wittgenstein, then
Judd's and Morris's sculptures often look like illustrations of that
philosopher's propositions. Both sculptors use elementary, geometri-
cal forms that depend for their art quality on some sort of presence
or concrete thereness, which in turn often seems no more than a
literal and emphatic assertion of their existence. There is no wish to
transcend the physical for either the metaphysical or the meta-
phoric. The thing, thus, is presumably not supposed to "mean" other
than what it is; that is, it is not supposed to be suggestive of any-
thing other than itself. Morris's early plywood pieces are all of ele-
mentary structures: a door, a window-frame, a platform. He even
did a wheel, the most rudimentary structure of all. In a dance he
made called *Site*, he mimed what were obviously basic concepts
about structure. Dressed as a construction worker, he manipulated
flat plywood sheets ("planes," one assumes) until finally he pulled
the last one away to reveal behind it a nude girl posed as Manet's
Olympia. As I've intimated, Morris's dances seem to function more
as *explications du texte* of his sculptures than as independent dances
or theatrical events. Even their deliberately enigmatic tone is like his
sculpture, although he denies that they are related. Rauschenberg,
too, has done dances that, not surprisingly, are like three-dimen-
sional, moving equivalents of his combine constructions and are
equally littered with objects. But his dance trio called *Pelican* for
two men on roller-skates and a girl in toe shoes has that degree of
surprise that characterizes his best paintings.

Art as Concrete Object
"Now the world is neither meaningful nor absurd. It simply is.
 "In place of this universe of 'meanings' (psychological, social,

*functional), one should try to construct a more solid, more immedi-
ate world. So that first of all it will be through their presence that
objects and gestures will impose themselves, and so that this pres-
ence continues thereafter to dominate, beyond any theory of ex-
plication that might attempt to enclose them in any sort of a senti-
mental, sociological, Freudian, metaphysical, or any other system of
reference."*
> —ALAIN ROBBE-GRILLET, "Une voie pour le roman futur," 1956,
> from *Pour un Nouveau Roman*

Curiously, it is perhaps in the theory of the French objective novel
that one most closely approaches the attitude of many of the artists
I've been talking about. I am convinced that this is sheer coincidence,
since I have no reason to believe there has been any specific point of
contact. This is quite the contrary to their knowledge of Wittgen-
stein, whom I know a number of them have read. But nonetheless
the rejection of the personal, the subjective, the tragic, and the
narrative in favor of the world of things seems remarkable, even if
or even because it is coincidental.

But neither in the new novels nor in the new art is the repudiation
of content convincing. The elimination of the narrative element in
dance (or at least its suppression to an absolute minimum) has been
one of Merce Cunningham's most extraordinary achievements, and
in this the best of the young choreographers have followed his lead.
Although now, having made dance more abstract than it has ever
been, they all (including Cunningham in *Story*) appear to be rein-
troducing the narrative element precisely in the form of objects,
which they carry, pass around, manipulate, and so forth.

Art as Fact, Document, or Catalogue
*"Researchers measured heart beat, respiration, and other intimate
body responses during every stage of the sexual excitation cycle. In
addition, motion-picture cameras captured on color film not only
surface reactions (down to the most fleeting change of skin color)
but internal reactions, through a technique of medical photography.*
> —Recent newspaper ad for *The Sexually Responsive Woman*

I could have picked any number of statistical quotations about the population explosion, or the number of college graduates in Wilmington, Delaware, but the above quotation illustrates better how we can now treat all matters statistically, factually, scientifically, and objectively. One could bring up in this context not only the flood of art with sexual themes and explicit images, but Warhol's *Kiss* and *Couch* movies as well. Morris's *I* box, in which he exposes himself behind an *L*-shaped flesh-colored door, or his nude dance might also be brought up here. Mainly the point is what we are seeing everywhere is the inversion of the personal and the public. What was once private (nudity, sex) is now public and what was once the public face of art at least (emotions, opinions, intentions) is now private. And as the catalogue, of things again mainly, has become part of poetry and literature, so the document is part of art. As an example I might use Lucas Samaras's documentation of his years in a tiny, cell-like bedroom in West New York, New Jersey, transplanted in its entirety to the Green Gallery, or George Segal's quite literal plaster replicas of real people in familiar situations. In a similar inversion, whereas the unusual and the exotic used to interest artists, now they tend to seek out the banal, the common, and the everyday. This seems a consequence of the attitude that, among young artists today, nothing is more suspect than "artiness," self-consciousness, or posturing. To paraphrase Oscar Wilde, being natural hence is not just a pose, it is being natural. Not only do painters paint common objects, and sculptors enshrine them, but poets seek the ordinary word. (Carl Andre has said that in his poetry he avoids obscene language because it calls attention to itself too much, and because it is not yet sufficiently common.) Along these same lines, one of the most interesting things the young dancers are doing is incorporating non-dance movements into their work.

Black Humor, Irony, and the *Memento Mori*
"I could die today, if I wished, merely by making a little effort, if I could wish, if I could make an effort."
 —SAMUEL BECKETT, *Malone Dies*
"I'l n'y a pas de solution parce qu'il n'y a pas de problème."
 —MARCEL DUCHAMP

It is part of the irony of the works I'm discussing—and irony plays a large part in them—that they blatantly assert their unsaleability and functionlessness. Some, like Artschwager's pseudofurniture or Warhol's Brillo boxes, are not too unwieldy to be sold, but since they approximate real objects with actual uses, they begin to raise questions about the utility of art, and its ambiguous role in our culture. On the one hand art as a form of free expression is seen as a weapon in the Cold War, yet on the other there appears no hope for any organic role for art in the life of the country. The artists, scarcely unaware of the provisional nature of their status, are responding in innumerable peculiar ways, some of which I've mentioned. Now, besides making difficult, hostile, awkward, and oversize art, an increasing number of artists seem involved in making monumental art, too large to fit into existing museums. This is quite amusing, as there is no conceivable use in our society as it exists for such work, although it may endure as a monumental *j'accuse* in the case of any future rapprochement. Thus, part of what the new art is about is a subversion of the existing value structure through simple erosion. Usually these acts of subversion are personal rather than social, since it seems to be the person rather than the society that is in danger of extinction at this point.

Using irony as a means, the artists are calling bluffs right and left. For example, when Yvonne Rainer, using dramatic speeches in her dances as she has been, says one thing while she is doing another, she is making a statement about how people behave as well as performing a dance. In fact, the use of taped narratives that either do not correspond with or contradict the action is becoming more frequent among the dancers. The morbidity of the text Rainer chose as "musical accompaniment" for *Parts of Some Sextets,* with its endless deaths and illnesses and poxes and plagues (it was the diary of an eighteenth-century New England minister) provided an ironic contrast to the banality of the dance action, which consisted in part of transporting, one by one, a stack of mattresses from one place to another. Such a setting up of equations between totally dissimilar phenomena (death and play, for example) can be seen in a number of cases. Dan Flavin describes several commemorative sculptures he made this way: "*Icon IV. The Pure Land* is entirely white. The surmounting light is 'daylight' that has a slight blue tint. I built the

structure in 1962, finishing it late in the fall. I believe that the conception dates from the previous year. *The Pure Land* is dedicated to my twin brother, David, who died October 8, 1962. The face of the structure is forty-five inches square. It was made of a prefabricated acrylic plastic sheeting that John Anderson cut to size for me." The factual tone does not alter when he describes (in a lecture given in Columbus, Ohio) his marriage: "After I left *Juan Gris in Paris* unfinished in 1960, there was a pause of many months when I made no work. During this period I married Sonja Severdija, who happens to be a strong carpenter."

Or consider Carl Andre's solution for war: "Let them eat what they kill." Andy Warhol, whose morbid interest in death scenes has led him to paint innumerable Marilyn Monroes, electric chairs, and car crashes, claims that "when you see a gruesome picture over and over again, it doesn't really have any effect." Dan Flavin, in a journal entry of August 18, 1962, makes it clear that sentimental notions of immortality are to be ignored as motivations: "I can take the ordinary lamp out of use and into a magic that touches ancient mysteries. And yet it is still a lamp that burns to death like any other of its kind. In time the whole electrical system will pass into inactive history. My lamps will no longer be operative; but it must be remembered that they once gave light."

As a final example, I cite Robert Morris's project for his own mausoleum. It is to consist of a sealed aluminum tube three miles long, inside which he wishes to be put, housed in an iron coffin suspended from pulleys. Every three months, the position of the coffin is to be changed by an attendant who will move along the outside of the tube holding a magnet. On a gravel walk leading to the entrance are swooning maidens, carved in marble in the style of Canova. (This opposition, of the sentimental to the icecold, is similar to the effect he produced in a dance in which two nude figures inch solemnly across the stage on a track to the accompaniment of a particularly lush aria from *Simon Boccanegra*.)

The Infinite: Negation and Void
"I have broken the blue boundary of color limits, come out into the white, beside me comrade—pilots swim in this infinity. I have established the semaphore of Suprematism. I have beaten the lining of

*the colored sky, torn it away and in the sack that formed itself, I
have put color and knotted it. Swim! The free white sea, infinity, lies
before you."*

—KASIMIR MALEVICH, *Suprematism*, 1919

The art I have been talking about is obviously a negative art of
denial and renunciation. Such protracted asceticism is normally the
activity of contemplatives or mystics. Speaking of the state of blank-
ness and stagnation preceding illumination, usually known (after St.
John of the Cross) as the mystic's Dark Night, Evelyn Underhill
says that the Dark Night is an example of the operation of the law
of reaction from stress. It is a period of fatigue and lassitude follow-
ing a period of sustained mystical activity. How better to describe
the inertia most of these works convey, or their sense of passivity,
which seems nonetheless resistant rather than yielding. Like the
mystic, in their work these artists deny the ego and the individual
personality, seeking to evoke, it would seem, that semihypnotic state
of blank consciousness, of meaningless tranquility and anonymity
that both Eastern monks and yogis and Western mystics, such as
Meister Eckhart and Miguel de Molinos, sought. The equilibrium of
a passionless nirvana, or the negative perfection of the mystical
silence of Quietism require precisely the kind of detachment, renun-
ciation, and annihilation of ego and personality we have been observ-
ing. Certain specific correlations may be pointed out to substantiate
such allusions. The "continuum" of La Monte Young's *Dream Music*
is analogous in its endlessness to the Maya of Hindu cosmology; titles
of many of Flavin's works are explicitly religious (*William of
Ockham, Via Crucis*). In fact, Flavin calls his works "icons," and it is
not surprising to learn that he left a Catholic seminary on the verge
of being ordained.

Of course, it is not novel to have mystical abstract art. Mondrian
was certainly as much a mystic as Malevich. But it does seem un-
usual in America, where our art has always been so levelheaded and
purposeful. That all this new art is so low-key, and so often con-
cerned with little more than nuances of differentiation and executed
in the *pianissimo* we associate with, for example, Morton Feldman's
music, makes it rather out of step with the screeching, blaring,
spangled carnival of American life. But, if Pop Art is the reflection

of our environment, perhaps the art I have been describing is its antidote, even if it is a hard one to swallow. In its oversized, awkward, uncompromising, sometimes brutal directness, and in its refusal to participate, either as entertainment or as whimsical, ingratiating commodity (being simply too big or too graceless or too empty or too boring to appeal), this new art is surely hard to assimilate with ease. And it is almost as hard to talk about as it is to have around, because of the art that is being made now, it is clearly the most ambivalent and the most elusive. For the moment one has made a statement, or more hopeless still, attempted a generality, the precise opposite then appears to be true, sometimes simultaneously with the original thought one had. As Roger Shattuck says of Satie's music, "The simplest pieces, some of the humoristic works, and children's pieces built out of a handful of notes and rhythms are the most enigmatic for this very reason: they have no beginning middle and end. They exist simultaneously." So with the multiple levels of an art not so simple as it looks.

DEFINING ART* by Harold Rosenberg

In this essay, Harold Rosenberg writes: ". . . the minimovement affirms the independent existence of the art object as meaningful in itself. Unlike the other vanguard movements of the past fifty years, this one is dedicated to art and to nothing else."

Harold Rosenberg has written about vanguard art for two generations, and his essays on Abstract Expressionism and recent art have been published in *The Anxious Object*. He has been sensitive to the real problems faced by the modern artist. In his book *The Tradition of the New*, he has written: "Since the only thing that counts for Modern Art is that a work shall be NEW, and since the question of its newness is determined not by analysis but by social power and pedagogy, the vanguard painter functions in a milieu utterly indifferent to the content of his work."[1]

A bow in the direction of the Dadaist subversion of art has been part of the etiquette of aesthetic innovation since the First World War. The avant-gardist must behave as if art were to him a matter of indifference, if not of outright annoyance. Among minds seeking liberation from the past, the erasing of a de Kooning drawing by Robert Rauschenberg is the most significant creative gesture of the last two decades. The rule followed is: If it's art, it's obsolete. To be new, paintings and sculptures must disguise themselves as ordinary objects; at the recent Whitney Annual almost half the sculptures endeavored to pass as machine or building parts, as those of two or three years earlier passed as billboards or comic strips. Art's denial of its identity ought not, however, be taken at face value. Rauschenberg's erased de Kooning was done in imitation of Duchamp's "Mona Lisa" with a mustache, of some forty years earlier, and both "works," signed, were included in the recent "Art in the Mirror" exhibition at the Museum of Modern Art. (Duchamp is currently showing at Cordier & Ekstrom.) The building blocks, the segments of staircases, the discs, and the vacuum hoses at the Whitney re-

* Reprinted from *The New Yorker*, February 25, 1967.

[1] New York: Grove Press, 1961, p. 37.

ferred back to solidly established aesthetic precedents. Many years have passed since artists have seriously wished to do away with art. Certainly collectors, dealers, and museum directors do not want to do away with it. "There is no such thing as painting, sculpture, music, or poetry," cried the Futurist Boccioni in 1912. Ah, but there is, there is. Today, renunciation of art has become a ceremonial gesture. A kind of collusion is involved between artist and spectator —the pretense that "this time things have gone too far." Both know, however, that the violation is a formality—that the spectator recognizes the art-historical background of the "atrocity," and that artists, whatever else they dedicate themselves to, have an eye on the museum and on their place in art history. The bland display by conservative curators of relics of subversion like the bemustached "Mona Lisa" and the obliterated de Kooning (de Kooning himself obliterated a good many de Koonings) has the effect of heightening the cohesion of the art world. The repudiation of art by art makers and art lovers may prevent an answer to the question: What is art today? But the absence of a theoretical definition bothers only outsiders and does not at all prevent art from being defined quite strictly in practice—indeed, much too strictly. To judge by art magazines and museum programs, nothing new has been done in the past few years but Happenings, optical displays, and so-called primary structures and reductive paintings. Yet many other modern styles, presumably finished long ago, are constantly being brought back to life in the studios and galleries. To say which of these styles, if any, is the "newest" would require an examination of the dynamics of revival, a subject that we shall have to save for another occasion. The emphasis on certain modes at any given moment is determined by the public relations of art and the influence of prevailing social conditions. Beyond this, though, everyone is aware that works are accredited as art by art history and that art history includes objects that thumb their noses at art.

Having closed a retrospective exhibition of the all-black (not quite) paintings of Ad Reinhardt, the Jewish Museum is now displaying all-blue paintings by Yves Klein. Evidently the public is to be given a thorough indoctrination in one-color aesthetics. Klein, who died five years ago, at the age of thirty-four, is an excellent example of what may be called ritualistic vanguardism. He was

artist to the art world in the sense that one speaks of tobacconist to the king. A highly inventive showman, he used art, art ideas, and vanguard-audience attitudes to build a career in painting and sculpture as spectacular as one in Hollywood or the Via Veneto. His best-known works, profusely represented at the Jewish Museum, are the monochrome paintings, sponge sculptures, and reliefs saturated in a color close to what is popularly known as royal blue but which Klein, perhaps introducing a slight tint of his own, re-entitled International Klein Blue and publicized throughout the globe as IKB. The blue is one of the lushest of colors, and it is laid on canvas after canvas in thick, uneven icings studded with lumps like almonds and caramels.

(Some parallel streaks were to be noted here and there, but whether this was a departure from IKB or the result of fading could not be determined.) IKB was also the pigment in which Klein arranged to have nude girls dip themselves and then imprint their torsos and thighs on unprimed canvases. The blue served Klein as a trademark by which he could, simply by the act of staining, appropriate as his art any object he found attractive; besides the girls, his bluing took over antique casts, Michelangelo's "Dying Slave," and the "Victory of Samothrace." From IKB, Klein advanced to gold, a color no more modest in its appeal than the blue. He also "painted" by burning the surfaces of canvases and by exposing them to the wind and rain, and he wrote copiously about his poetic and metaphysical conceptions, which centered on the notion of living dangerously and keeping himself in a state of psychic incompletion. Undoubtedly, Klein was touched by the poetry of the empty sky and the Heraclitean elements; this was enough to set in motion the post-Dada machinery that lay ready at hand. His works have a gross romanticism of the order of taste that keeps an ocelot for a pet. Anticipating adverse judgment, Klein referred to his works as "ashes" and pointed away from them to the experiences that had brought them into being. "No matter what one thinks," he wrote, "all this is in very bad taste, and that is indeed my intention. I howl it from the rooftops: 'Kitsch, Corn, Bad Taste'; this is the new notion in art. And while we are about it, let's forget art altogether." This gesture toward the "void" is said to have been the prelude to the self-

destroying sculpture of Tinguely, which, logically, failed to destroy itself in the garden of the Museum of Modern Art.

Klein's talent lay neither in his works nor in the originality of his ideas but in his way of staging them and himself. For one of his shows he completely redid his Paris dealer's gallery and devised a spectacular, including blue cocktails, that brought thousands to his opening. Literature distributed by the Jewish Museum declares that he is now considered "one of the prophetic artists of his generation." I prefer to think of him as a forerunner not of the artist of the future but of the new museum director, who is adept at using whatever works come to hand to establish a glamorous décor.

Another artist whose works, accessories to his showmanship, also presuppose the anti-art etiquette of the vanguard audience is Red Grooms, a pioneer of the Happening. His exhibition at the Tibor De Nagy Gallery is now over, but Grooms, who, though an art-world veteran, is only thirty, will return, and the trend he represents is illuminating. His "act" is at the pole opposite to Klein's intellectual pretentiousness; he plays the country boy, and the word for him is "fresh." In his exhibition were broadly sketched portraits of early movie personages—Fairbanks, Pickford, Chaplin, Griffith—and props for a short film, "Fat Feet," whose jerky Mack Sennett Comedy rhythms, as well as the participation in the cast of Grooms's "family" of friends, carried out the theme of childhood and nostalgia. The film was shown every afternoon, and all that was lacking was ice-cream cones and lollipops. Both the artwork and the film were executed in a lighthearted, sophisticated primitivism that belied their painstaking craftsmanship. As human actors, wearing Grooms's enormous papier-mâché shoes, mingled on the tiny screen with his cutout props and figures against the painted stage sets, the effect had the charm of a puppet show when the puppeteer himself rises into it like an unreal giant of flesh. Grooms's originality consists in continuing the game of mixing art and reality brought into prominence by Surrealism and Pop Art, yet without being stylistically bound to either. His work is a step closer than Yves Klein's toward a frank melding of painting and sculpture into an entertainment medium for the audience recruited in recent years for vanguard art.

In the same category of new-media entertainment, though relying

on completely different effects, are exhibitions that convert art galleries into hallucinatory environments or science pavilions (depending on the degree of audience participation exacted) through high-intensity light beams, prismatic distortions, color suffusions, film projections, sound effects. In the "Lights in Orbit" group show at the Howard Wise Gallery, several of whose exhibitors have come to art directly from the laboratory, art splits its identity between sober technical demonstrations and appeals to our delight in shiny, moving things.

In its struggle for existence against the two great powers of contemporary society—technology and the mass media—art is constantly engaged in pilfering from these powers effects developed by them in connection with purposes that have nothing to do with art. "My initial interest in kinetic sculpture," writes Charles Mattox, a West Coast maker of machines with marvellously moody movements, "was stimulated by a desire to explore aspects of our technology and apply them to art forms." Of course, technology itself had borrowed forms from art, whether in designing machines or in turning paintings into picture postcards. If the mustache on the "Mona Lisa" was the defilement of a masterpiece, it was, literally speaking, the recovery for art of a reproduction turned out by the millions of copies. The incessant interplay of art and non-art causes each act of self-immolation by painting—through burning canvases, gashing them, pasting objects into them, writing on them—to take on the character of an act of creation, as it does the fabrication of any image, object, or spectacle that does not fall into any other category. Through negative and positive processes, art enters into a state of limitless expansion. At the same time, the identification of objects as art by their aesthetic qualities becomes increasingly uncertain through, among other things, the constant fallout of works into their mass-production doubles—for example, the reappearance of Albers's "Homage to the Square" as a panel design on a dress fabric.

In our time, every vanguard, in widening the horizons of art, introduces the threat of an ultimate dilution that will do away with art entirely, whether that widening takes the form of turning art toward industrial design (one of Howard Wise's merry men has just done the lighting fixtures for a skin-blemish establishment), psychic

action, or movie comedies. To some, it is the dilution, not the broadening, that is the issue: it seems to represent a corruption of standards that is all but synonymous with moral depravity. The suspicion of hoax and fraud hovers at the edge of modern art movements like the abyss of the medieval mariners. In the past decade, overnight reputations and the accelerated turnover of styles have thickened the atmosphere of wirepulling and dissipation of values. To this state of affairs what is called Minimal or Reductive Art has been offered as an antidote. The assumption of its fundamentalist aesthetics is that at least art ought to define what it is not. It is Ad Reinhardt's tireless promotion of this assumption, through his repeated lists of negative definitions (art is not nature, not life, not self-expression), and his doleful tirades against corruption that have, as much as his square black all-alike paintings, qualified him to be the ancestor of the new art-for-art's-sake. As against art as decoration, as action, as self-revelation, as Happening, the Minimovement affirms the independent existence of the art object as meaningful in itself. Unlike the other vanguard movements of the past fifty years, this one is dedicated to art and to nothing else. In this sense, Minimalism is post-vanguard; it reflects the new situation of art as an activity that, having left the rebellious semi-underworld of bohemia, has become a profession taught at universities, supported by a public, discussed in the press, and encouraged by the government. As a profession, it ought to know what it is about.

"Basic" paintings and constructions are simple in design and usually composed of a few geometrical elements in primary or neutral colors. Explanations of their aims vary from artist to artist, but the novelty of the movement, which during the past two years has preoccupied leading New York galleries and contemporary-art museums, lies in its materialistic interpretation of painting rather than in the paintings themselves; like other "new" styles, geometric painting and sculpture consisting of a few simple elements go back at least half a century. The Minimasters and their critical allies redefine painting in terms of the stretcher (its size and shape), the canvas, the liquid density of the paint, the lines that affirm the borders of the painting as an "object." The exclusion of images or textures likely to stimulate feelings and associations is intended to produce a response that is exclusively aesthetic. "They exhibit," writes a prac-

ticing Minimalist of the works he finds basic to "the recent history of painting," "a penchant for presenting materials factually and for employing a numerical set as something signifying nothing but itself. The content of these paintings is a certain quantity, an accumulation, and they are sometimes quite witless." (Witlessness in the art world is not taken as a lack of wit.) The concern of Minimal artists is with problems of quantitative relations; in general, the spirit of engineering prevails among the younger "object" artists, though, unlike the art of the Wise Gallery kineticists and electronics specialists, their work is confined to wall decorations and freestanding solids. Like many engineers, an artist of this school will occasionally reflect on the spirituality of space and numbers. But the deliberately dehumanized aestheticism of Minimal Art is summed up by another of its practitioners, Tadaaki Kuwayama: "Ideas, thoughts, philosophy, reasons, meanings, even the humanity of the artist do not enter into my work at all. There is only the art itself. That is all."

The attempt to cut art down to the bare bones of its material elements is a recurrent recourse of artists in the confusion of a changing culture. According to a celebrated anecdote, Mallarmé once advised Degas that poems were made of words, not ideas. Most significant painting (though not all) since Matisse's "Joie de Vivre" (1905–06) has been reductive. Reductivism does not belong to any one style; it is as operative in painting conceived as a gesture as in painting cut down to a line or a square. The traditional aim of reduction, however, even at its most extreme, has been to augment through compression the emotional or intellectual statement. In slicing away residues of imagery or manner that have lost their relevance, the artist seeks, as a European writer recently put it, to transform the apple into a diamond. The novelty of the new Minimalism lies not in its reductionist techniques but in its principled determination to purge painting and sculpture of any but formal experiences, and even of resonances of experience. There is left the void—not Yves Klein's empty sky (though formalist critics have not been slow to link IKB monochromes with the red or white "color fields" of the Minimalists) but empty art, correct and clean. It is a void that seeks the cancellation of art as it has been until now and its supplanting by works from which adulterating impulses have been purged. The inspiration of the Minimasters is art criticism;

many of these painters and sculptors began as writers on art. Describing a recent Minimal exhibition, a reviewer noted that of the artists represented "four at least have been fairly systematically engaged in critical writing." The rigor of the engineering concept is complemented by a polemical intensity through which runs the vein of a moral crusade against romanticism and impurity. Regardless of formal resemblances, the true historical background for this approach is not the tradition of the pure colorists and geometricians— Malevich, Mondrian, Albers—but the Dada assault on art, here mistaken for a return to aesthetic fundamentals. If Warhol's Brillo boxes are Dada, the boxes without Brillo of Robert Morris, the most subtle of the Minimalist dialecticians, are super-Dada. The point is reinforced by the practice of many of the primary-structure makers of having their ideas ("Ideas . . . do not enter into my work at all") executed in carpentry or machine shops, while others advertise as a radical departure that they nail their pieces together themselves.

Obviously, serious intellectual response to works of this kind, as to those of Klein and Grooms and light-and-film spectacles, depends upon the collusion of the art world in accepting them as phenomena retinted in the vat of art history. Without the omnipresent memory of Dada, nothing could induce the celebration as a new "advance" in art of Reinhardt's black squares, with their dead, fish-eye glint, or the painted planks and stair steps at the Whitney.

The difference between historic Dada and the current fundamentalist version lies in their treatment of the spectator; instead of goading him into indignation at the desecration of art, the new Dada converts him into an aesthete. The monotonous shapes and bleak surfaces presented to him as objects wrapped in their own being compel him, if he is not to back out of the gallery, to simulate a professional sensitivity to abstruse contrasts of tone, light, and dimension. The more a work is purged of "inessentials" the closer the scrutiny required to "see" it and the more precious the sensibility required to react to it. A reviewer of paintings consisting of a few large forms recently put the matter in blunt terms: "To appreciate this difference [in the thickness of their contours] fully it is necessary to get very close to these sizable canvases and examine them as if for blackheads." Similarly, the author of the Jewish Museum catalogue for the Reinhardt exhibition complains that, as a result of

"overlighting" the gallery, "noses and fingers are rubbed against the surfaces [of the paintings] . . . the impatient viewer sees nothing immediately and feels constrained to touch instead of look." (Apparently, this overstimulated critic has not considered McLuhan's thesis that over-all painting like Reinhardt's represents the obsolescence of "eye culture" and calls for a response of the central nervous system.) What the new aestheticism, in its didactic insensitivity to the ironies inherent in twentieth-century art, fails to take into account is that to its ideal spectator art would have become unnecessary. A table top of three boards hung on a wall could yield an almost inexhausible supply of the aesthetic minutiae discovered in Minimal masterworks —effects of the slight unevenness of the surface, the illusion of depth thus created, the differences in width of the crevices between the boards, the function of these crevices as lines, their control of the surface as parallels and as verticals and horizontals (depending on which way the work is hung), the relation of these lines to the edges of the table, the character of those edges (whether worn, bevelled, or sharp) and the degree of austerity they communicate to the whole, the color of the table as against that of the wall, the changes produced by framing the table or exposing its thickness, the—and so forth. Minimal Art is Dada in which the art critic has got into the act. No mode in art has ever had more labels affixed to it by eager literary collaborators; besides being called Minimal Art, it is known as "ABC Art," "Primary Structures," "Systemic Painting," "Reductive Art," "Rejective Art," and by half a dozen other titles. No art has ever been more dependent on words than these works pledged to silent materiality. The subtleties with which the retinal sensations of examining a set of gray cubes or a graph-paper composition are broken down and recombined in a rhetoric pieced out with historical analogies have produced a literature of sententious comedy worthy of Molière or Ionesco. It is as if Walt Whitman's apostrophe to an axehead were rewritten by a German art historian who imagined himself Oscar Wilde. The rule applied is: The less there is to see, the more there is to say.

In contrast to the polemically depleted works of the Minimalists are the eight monumental "presences" of Tony Smith on view in Bryant Park. Smith's simple shapes, which draw on the geometric and Constructivist sculpture of the early decades of this century,

were assembled out of precut plywood sheets painted black. When put together, they create, except up close, an impression of massive solidity (in being thus illusory, the hollow structures negate the first rule of Minimal Art: factuality). Taken as a group, Smith's constructions, for all their feeling of weight, communicate a sense of intangibility alien to this park enclosed by high buildings and heavy traffic. The geometrical compositions, all different, are beautifully angled to infuse into their immediate surroundings a sense of gentle motion, as of a ship at anchor. In scale larger than man but not huge, the black structures refrain from overwhelming. Again unlike most "primary" constructions, the forms often suggest incompleteness; in several a plinthlike section thrusts outward in a gesture of seeking. Smith's refusal to close his structures may produce a preliminary feeling of frustration, but it has the virtue of communicating, like a sketch or partly unpainted canvas, the openness of the creative act. To accomplish this with ready-made parts and in an idiom of monumentality is no easy feat. An architect, draftsman, teacher, old-time friend of Jackson Pollock, and aficionado of *Finnegans Wake,* Smith, after long meditations on art and spirit, found in the simplifications of Constructivist aesthetics a subtle vocabulary that suddenly projected him a few months ago, at the age of fifty-five, into an authoritative position in American sculpture.

With the Symbolists of the turn of the century, "pure art" was an art of metaphysical essences. Smith's structures are pure in this Symbolist sense, as quiet and solitary as the space under a viaduct at midnight. Minimalist constructions have an exactly opposite character; stripped of metaphysical intimations, they assert their purity by confronting the art public with an aggressive challenge to its expertness, like something offered "as is." Primary art is environmental and audience-participation art to no less a degree than a kinetic fun house or a Happening. In it aesthetic education has taken the place of eye-dazzle and unfamiliar doings. An exhibition of ABC paintings and structures transforms the gallery into a lecture hall. At the opening of such an exhibition, what is most in evidence is the crowd; with the crowd gone, there are the benches and blackboards. The solemn efficiency of the setting is not enough to dispel the traditional presence of the Dada joke.

GESTURE AND NON-GESTURE IN RECENT SCULPTURE* by Irving Sandler

As Irving Sandler points out in the following essay, the modern sculptor is engaged in ". . . shaping a form so that it exists in its own isolated space." This new approach to volume is, of course, different from traditional sculpture, in that the sculptor today ". . . construct(s) mass, continuing the constructival aesthetic, the most fruitful in twentieth-century sculpture." The author discusses several Minimal artists, as well as several who are not usually considered Minimal, such as Sugarman, Weinrib, and Chamberlain.

Irving Sandler has written criticism for numerous publications, including *Art International* and *Art News*. He was art critic for the *New York Post*, and is credited for bringing a new distinction to the area of journalistic art criticism. He teaches at New York University.

The dominant tendency in abstract sculpture during the 1950's was open, welded construction. The metalworkers who matured in that decade—Herbert Ferber, David Hare, Ibram Lassaw, Seymour Lipton, Theodore Roszak—generally drew ambiguous, organic images in space. Since then, a number of sculptors, including John Chamberlain and Mark di Suvero, have extended this gestural vein. Others, such as Robert Morris and Donald Judd, have reacted strongly against it. George Sugarman, David Weinrib, Ronald Bladen, Tom Doyle, and Robert Grosvenor have veered off in new directions between the two poles.

These sculptors of the sixties have developed highly varied styles, yet they share certain formal concerns. All are disposed to articulate structure and to define form clearly. Therefore, they tend to favor simple volumes, signaling a rebirth of monolithic sculpture. However, they differ from traditional carvers and modelers in that they construct mass, continuing the Constructivist aesthetic, the most

* Revised version of an article published in the exhibition catalogue *American Sculpture of the Sixties*, Los Angeles County Museum of Art, 1967.

fruitful in twentieth-century sculpture. But in their desire for struc-
tural lucidity and volume (a classicizing bent), they also diverge
from the metalworkers of the fifties, who preferred to assemble
intricate and active linear elements and to use the oxyacetylene
torch like a brush, producing richly detailed textures, erupting crusts
that focus attention on the surface, thereby denying mass and the
immediacy of structure. The recent inclination to monolithic con-
struction has even affected those younger artists who build open or
semitransparent sculptures. The rectilinear scaffolds of Sol LeWitt
and Larry Bell section and contain space, turning it into masses of
air—negative solids—unlike the constructions of the 1950's, which
pierce and cut into space vigorously.

Classicizing sculptors today have been influenced by the strict
forms preferred by David Smith, notably in his late polychromed
and stainless steel pieces, and Alexander Calder, in his stabiles
rather than the mobiles. The young sculptors are also interested in
the ideas of contemporary painters. There are strong affinities
among Morris, Judd, and Frank Stella; and among Sugarman,
Weinrib, Bladen, Doyle, Grosvenor, and Al Held. In fact, as in the
case of Smith, several (Bladen, Judd, Grosvenor, Morris) began
their careers as painters.

The most provocative of the sculptors who have emerged in the
1960's are occupied with nonrelational design. The idea of shaping a
form so that it exists in its own isolated space has been developed in
two antithetical directions. It is carried to an extreme in the unitary
objects of Morris and Judd, on the one hand, and on the other, in
the disassociated, extended sculptures of Sugarman, Weinrib, and
Doyle. The two kinds of nonrelational organization are new, and
both differ from earlier Cubist-oriented abstraction, including the
welded construction of the fifties, the unifying principle of which is
the rhythmic iteration of sculptural elements about a central core.

As an alternative to balancing varied shapes and colors, Morris
and Judd build a single geometric solid or repeat identical units in
symmetrical arrangements. As Judd remarked, he aims to create
sculptures that are "seen at once and not part by part." Morris also
tries to effect a total apprehension of a volume, to make its gestalt
immediately apparent. "Characteristic of a gestalt is that once it is

established, all information about it, *qua* gestalt, is exhausted." To stress the factual attributes of objects, Morris and Judd prefer elementary polyhedrons, because these are instantaneously visualized.

In contrast, Sugarman, Weinrib, and Doyle juxtapose disparate, polychromed masses, unfolding them in sequence. Their approach requires the invention of a great variety of forms, and they improvise organic as well as geometric ones. It enables them to incorporate into a single sculpture a surprising diversity of spatial and emotional events. In unitary objects, parts are eliminated to emphasize the whole; in disassociated structures, the whole tends to be subordinate to the parts. (To a degree, Sugarman's *Two in One* [1966], the largest and most complex piece he has created, is a polemic against the idea of Minimal sculpture.)

Unitary objects convey a different order of feelings and thoughts from disassociated sculptures. The inert, contained volumes of the one are impassive and aloof. The off-axis, extended masses of the other are dynamic, "conquering" the space the viewer is in dramatically, instead of "occupying" it, to borrow two of Lucy Lippard's words. Dissimilar, individuated shapes appear less self-effacing than generalized, geometric ones. Like the gestures in Action Painting, they become signs of the artist's particular creative process and temperament. In this sense, Sugarman, Weinrib, and Doyle continue the self-affirming, romantic spirit of Abstract Expressionism, but in a fresh, classicizing vein.

Forms that move into space actively resemble human gestures. But Judd spurns as outworn what he calls "anthropomorphic sculpture," that is, sculpture reminiscent of bodily motions. Furthermore, *T*-square shapes are less evocative of human physiology than biomorphic masses. One naturally associates geometry with "the man-made world . . . one that man constructs and upon which he meditates—abstractly, from a position once removed," as William Rubin has observed.

However, Judd and Morris deny that their objects relate to architecture, technology, or mathematics. Instead, they emphasize their occupation with formal problems, with the "autonomous and literal nature of sculpture," as Morris has written. This approach was summed up by dancer Yvonne Rainer: "In the studio, I work with aesthetics like a shoemaker works with leather."

Unitary objects appear as if they were reduced by the logic of purist aesthetics, by the subtraction of any references—to image, painting, relief, and architecture—that are not deemed intrinsic to sculpture be massive, indivisible, tactile, and stable, and that it Clement Greenberg, but the latter has opted for a Cubist-oriented open construction, "liberated" from the monolithic, and allowed "to be as pictorial as it pleases." Conversely, Morris has insisted that sculpture be massive, indivisible, tactile, and stable, and that it approach the object, an intention "diametrically opposed to Cubism."

The bareness of unitary objects forces attention to the irreducible limits of sculpture, to qualities and allusions that have been renounced. These matter-of-fact objects seem thought-up rather than felt-through in the process of working. Coolly intellectual, they strike one as the opposite of art, which in Barzun's words, simulates "life . . . throbbing in your veins or panting in your face." Neutral in shape, color, and surface, they reveal no trace of the artist's hand, his active presence. Stringently ABC, as Barbara Rose characterized them, they seem vacant. But much as Morris and Judd try to construct things that assert their physical attributes only, these do invite contemplation and evoke extra-aesthetic associations in an understated way. Judd's hollow, galvanized iron cubes call to mind mass-produced artifacts. Morris's polyhedrons are like Pandora's box; their off-white finish, though blank, has an enigmatic cast, Surrealist rather than Purist.

To Morris, color has no place in sculpture, for as an "optical element," it "subverts the physical." Not so to Sugarman, Weinrib, and Doyle, for to disassociate the parts of their sculpture, they paint each a different, generally strong, hue. They recognize that the wedding of color and mass raises difficult problems—the possible incompatability between the bulk of a shape and its thin skin of pigment. But the difficulties only make the attempt to fuse the two more challenging.

They, along with Calder, Smith, Chamberlain, Bladen, Robert Hudson, and a few others, have projected color in three dimensions with a daring unprecedented in Western sculpture since the Gothic era. With the exception of Hudson, they apply pigment in uniform

coats to conceal surface effects that would blunt the visual (and emotional) impact of color and mass.

Chamberlain, di Suvero, Sugarman, Weinrib, Bladen, Doyle, and Grosvenor often work on a huge scale. All share a desire for immediacy and grandeur, to which their massive forms contribute. They also dislike sculpture that looks like precious, coffee-table *objets*. Amy Goldin has written: "Sugarman believes that if a piece of sculpture feels like a *thing*, even a beautiful thing, it's a failure. He wants a more energetic relationship between the work and the space it creates, for the sake of vivid response."

There are, however, varied motives for essays into outsize construction. Bladen and Grosvenor want epic sculpture that has a powerful impact. Sugarman and Weinrib are not interested in monumentality, but their disassociated structures require extended space. Grosvenor and Doyle are attracted by the idea of environmental sculpture that can be walked into or over. Grosvenor plans his mammoth pieces for specific places; he conceives of them as "ideas that operate in the space between the floor and the ceiling. They bridge the gap."

By working large these artists can eliminate pedestals, which they feel are meant only to carry pieces and are sculpturally meaningless. By preference, they place their works directly on the floor or suspend them from the ceiling. Sugarman in his sprawling *Inscape* and *Two in One*, and Doyle in his ramplike construction, *Over Owl's Creek*, are interested in a low center of gravity. The manner in which these pieces hug the ground suggests the floor as the logical base. Morris also rests his pieces on the floor. "The ground plane . . . is the necessary support for the maximum awareness of the object." Conversely, Weinrib and Grosvenor, in order to defy gravity, project their forms off the wall or ceiling.

Sugarman, Weinrib, and Doyle are as romantic as Chamberlain and di Suvero, but since the early 1960's, they have preferred volumes that are neither indeterminate nor organized centripetally. Sugarman, who pioneered the disjunctive approach, has been the most audacious in his use of it. He paints each form a different hue to isolate it and to render its gesture unique, although all are robust, a

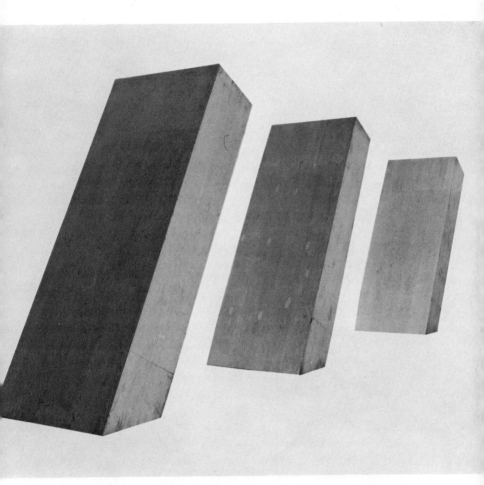

Ronald Bladen: Untitled. 1965. Aluminum and painted wood. Three units, each measuring 108″ x 48″ x 21″. Photograph courtesy of The Jewish Museum, New York, "Primary Structures" exhibition.

Mark di Suvero: *Loveseat* (in foreground). 1965. Steel, tires, and rope. 46″ x 62″ x 34″. Photograph courtesy of Park Place Gallery, New York.

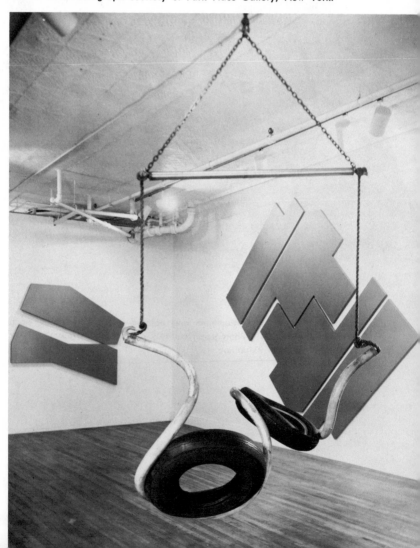

quality that has always characterized his style. The coating of liquitex is not an added or decorative element but augments the masses and helps clarify their positions in space. Recently, Sugarman has modified the principle of disassociation. His forms are still distinctive, but they are also variations on a theme, unfolding like an abstract narrative embodying continuity as well as change.

To achieve an effect of buoyancy, Weinrib has floated sinuous, vividly colored shapes, none of which is repeated, off the walls or ceiling. In the past, he used a great variety of materials, but during the last few years, he has limited himself to plastic. No sculptor who has worked in this medium can make it come alive as Weinrib can. His opulent volumes, the progeny of Arp and Miró, are lighthearted. The translucent and polychromed plastic adds to this mood, for he uses it to produce a play of dissonant colors and bouncing lights.

Lately, Weinrib has cast plastic into luminescent, bulbous shapes, which he stands on ground planes. Casting has enabled him to create a quality of color new in art—a colored light that at once articulates contour and is volumetric, visible in the depths of mass. Semi-transparency also acts to dissolve solids, making them seem to levitate. Weinrib accents this volatility by poising the parts on points, enhancing the airiness of his sculpture.

In 1964, Doyle simplified the rough-hewn wood and rock forms of his earlier carvings. He began to assemble curved planes of Masonite reinforced with fiberglass, and to disjoin and paint them in the manner of Sugarman and Weinrib. But unlike the other two, he wrapped his planes around space, partly enclosing it, sweeping air (and the viewer's imagination) into ample hollows. Doyle extends his weighty, saillike sheets so that they appear about to keel over—to look "impossible," as he puts it. And they are painted in equally improbable colors—exotic pinks, purples, grasshopper green.

In some of his wood constructions, Bladen has used color to disassociate his forms, and so he relates to Sugarman, Weinrib, and Doyle. However, he favors geometric volumes that tend toward unitary objects, particularly in his latest work, a row of three free-standing, nine-foot-high rhomboids. Nevertheless, in spirit this work is poles apart from Minimal sculpture. Bladen's rhomboids (they are actually rectangular volumes whose bottoms are cut off at a 65° angle) are more particular and individuated than Morris's or Judd's

simple polyhedrons. The asymmetrical thrust of his masses causes them to appear dynamic, precariously balanced, and on the verge of toppling. The slant is a human gesture, suggesting falling or bowing, signs of vulnerability, or marching, more the latter, for together, the giant rhomboids in a line form an awesome procession of anthropomorphic menhirs. The incline of Bladen's monoliths is also past art's heroic diagonal in a contemporary vein. Indeed, they loom like a section of Stonehenge, geometricized as if conceived by a master of International Style architecture.

Although Bladen does not intend it, his sculpture evokes modern buildings and industrial structures. Such allusions are suggested by the rectangular forms, painted in ordinary red, yellow, black, or white, and by the enamel or lacquer finish, a paint-job polish that looks machine made. In one untitled piece, Bladen, engineer-like, cantilevers elements over a distance of eighteen feet, employing a system of weights, structural stresses and counter-stresses to hold an off-balance plane in suspension.

Grosvenor has also developed the possibilities of suspension in sculpture. In *Transoxiana*, he spans a bulky, red-and-black V over a distance of thirty-one feet. Bolted to a single point on the ceiling, it trajects down, almost to the floor, then up, stopping just short of the ceiling. To stretch a form as far as it will go, and Grosvenor does just that, is a feat of engineering. In fact, he treads the line where art and engineering meet. *Transoxiana* is a big gesture, like Bladen's monuments, dramatic and heroic. Its thrust is physical and forceful, dominating the space occupied by the viewer; its torsion, excruciating; and its loftiness, elating.

Inherent in the idea of modernism is the continual challenging of accepted ways of seeing. Chamberlain's and di Suvero's use of massive, found objects, color, and kinetics has led to one kind of expansion of perception. The nonrelational aesthetic has provided other means of breaking habits, of forcing art out of the known into the unknown, of evolving fresh forms to embody insights into art and life. It is largely responsible for the continuing vitality of contemporary sculpture.

LUMINISM AND KINETICISM* by Willoughby Sharp

Light and movement are among the many media artists are utilizing today. In the following two-part essay Willoughby Sharp examines the history and development of Luminism and Kineticism.

Willoughby Sharp is the author of a monograph *Günther Uecker— 10 Years of a Kineticist's Work* and numerous articles on kinetic and luminic art.

Introduction

All is flux.—Heraclitus

Kineticism is the art of physical movement. Luminism is the art of real light. The art of light and movement is the only totally new art of our time. Since this art was only recently created, it has a short history. Since it is the only art which adequately reflects the new age in which we live, it has a great future. The new age, the electric age, has created an environment that has reconfigured our senses. Seeing is no longer the primary means of knowing. Hearing, tasting, touching, and smelling have now become more important. Our five senses are rapidly becoming more completely integrated. We now demand greater participation in situations and events. This radically alters our aesthetic needs. Today painting and static sculpture are no longer wholly satisfying. We need an art of greater energy. We need an art of total environment. We need an art that unites us with the real rhythms of our era. The art of light and movement is dynamic, environmental, and inclusive. It involves all of our senses. This is only one feature that separates it from older art. The old art

* Part 1: *Luminism.* Revised introduction to exhibition catalogue *Light, Motion, Space,* Walker Art Center, Minneapolis, Minnesota, 1967.

Part 2: *Kineticism.* Revised version of the introduction to an unpublished exhibition catalogue "Kineticism," Goethe House, New York City, 1967.

saw time as lineal. The new art sees time as configurational. The old art depicted space as uniform and enclosed. The new art perceives space as organic and open. The old art was an object. The new art is a system. The configuration of the movement is more important than the shape of the object. The message of a kinetic and luminic work is the light and movement it produces. It has no other message. It has no meaning besides movement. The art of light and movement is nonfigurative. It does not aim to tell a story. It does not want to be decorative. It cannot be durable since its parts quickly become obsolete. In its most advanced state it is immaterial or disposable. Consequently, much of it is uncommercial. The art of light and movement does not aim at satisfying former aesthetic ideals. It does not reconfirm our picture of reality; it reveals the actual space-time rhythms of reality. Aside from its unique aesthetic role, the single most important function of the art of light and movement is to facilitate our acclimation to the rapidly changing kinetic climate of our age.

Part I: Luminism

BEGINNINGS: THE COLOR ORGAN
Nisi videro non credam—Inscription on Castel's *Clevessin Oculaire*

Luminism[1] was born on St. Thomas Day, December 21, 1734. Father Louis Bertrand Castel (1688–1757), Jesuit philosopher and mathematician, demonstrated, to a small group of friends gathered in his Paris study, his *Clevessin Oculaire,* the world's first color organ. In *Esprits, saillies et singularités du Père Castel* (1763), Castel writes:

> A clevessin . . . is a series of stretched chords which conform in their length and their thickness to certain harmonic proportions

[1] This is the first time that the word *luminism* has been used to describe the movement of light art. In 1964 I coined the word *kineticism* to describe the "movement movement." The following year, the Amel Gallery, New York, published my catalog documenting the various contributions to Kineticism. Light was one of the four categories listed. Today light art is such a large artistic movement that it deserves a name of its own. I consider Luminism a branch of Kineticism since luminist works are always kinetic but kinetic works are not always luminic.

which . . . by moving the fingers as in an ordinary piano . . . make the color combinations which correspond precisely to those of music.[2]

Castel's system was simple. A five-octave harpsichord keyboard was connected to a set of transparent colored tapes, which were illuminated by candlelight.

D. D. Jameson was the second luminist. In 1844 he published a pamphlet, *Colour-Music*, which, while indebted to Castel's *La Musique en Couleurs* (1720), suggested a new color organ system whereby light controlled by mechanical shutters was projected through glass containers of colored liquid set into the walls of a room lined with tin plates. This was the first luministic audio-visual environment.

Around 1870, Frédéric Kastner (1852–82) invented the *Pyrophone*, a color organ employing hydrogen-filled glass tubes. Seven years later, an American painter, Bainbridge Bishop, built an instrument that projected, first by daylight and then by arclight, mixed colors onto a hemispherical screen. For a short while this large color organ was exhibited as a curiosity at the P. T. Barnum Museum on Broadway in New York.[3] On June 6, 1895, Alexander Wallace Rimington (1854–1918), Professor of Fine Arts at Queen's College, London, inspired by Turner's painterly use of color, gave a private demonstration at St. James Hall of his color organ. Fourteen arclights housed in a large wooden cabinet projected a "restless flicker" of color onto a white silk curtain.[4]

A. B. Hector, an Australian, was probably familiar with Rimington's work when he constructed a color organ with incandescent lamps and X-ray tubes, which was first demonstrated on December 21, 1912, at the Sydney Town Hall.

[2] Quoted in A. B. Klein, *Coloured Light: An Art Medium*, London, 1937, pp. 183–84. This is the best source on the history of light art up to 1920. Also see Philip Steadman, "Colour Music," *Kinetic Art*, Motion Books (London), 1966, pp. 16–25, Nan R. Piene, "Light Art," *Art in America*, May–June, 1967, pp. 24–47, and Frank Popper, *Lumière et Mouvement* (exhibition catalogue), Musée d'Art Moderne de la Ville de Paris, mai–août, 1967.

[3] For an illustration of this work see Frank Popper, "L'art de la lumière artificielle," *L'Oeil*, No. 144, December, 1966, p. 34.

[4] Rimington wrote two books on color-music: *A New Art—Colour-Music*, London, 1895, and *Colour-Music—The Art of Mobile Colour*, London, 1911.

Like Rimington, A. B. Klein (born 1892) was an Englishman stimulated to study light by Turner's use of color. In 1921 he designed a projection instrument that he describes as:

> a large auto-collimating monochromatic illuminator with an elaborate variable-focus objective projection system, used in conjunction with a separate white light projector.[5]

Using naval searchlights, the most intense light then available, Klein was able to "project a patch of coloured light of any given constitution and to alter it with the greatest celerity to any other color of any desired hue."

SPECTACLES: THE RUSSIANS
According to the old aesthetic, art did not take part in the construction of the contemporary world.[6]—Kasimir Malevich

The electric age has created a new environment constituted of such media as the telegraph, telephone, radio, and TV. These media have restructured our sense ratios. Seeing is no longer the only sense of knowing. Visually oriented patterns of perception are rapidly being superseded by a multi-sense involvement in a total field reality. The first artists to respond to the new environment were the Russian Suprematists, Constructivists, and advocates of "total theatre." During the performance of his symphony, *Prometheus, the Poem of Fire,* at Carnegie Hall, New York, on March 20, 1915, the Russian composer Alexander Scriabin (1872–1915) attempted to synthesize sound, light, and theatre into one compelling spectacle. If sound could fill the whole auditorium, why couldn't colored light? The composer persuaded a large electrical company to build a *Clavier à Lumières.* Unfortunately, this had such a small screen that the final effect was unimpressive. Scriabin died several months later, leaving

[5] A. B. Klein, *op. cit.,* p. 36.

[6] Camilla Gray, *Kasimir Malevich,* Whitechapel Art Gallery, London, 1959, p. 13. While the Russians were the first to be tuned in to the new environment, it should be remembered that the Futurists proclaimed "the rule of the divine Electric Light" and Boccioni's Technical Manifesto of Sculptures states: "Outside or inside lights can indicate planes, inclinations, tones, semitones of a new reality."

unrealized his most ambitious work, *The Mystery*, a total theatrical spectacle including music, dance, speech, smell, and light with a cast of 2,000.

Four years later, W. Baranov-Rossiné (born 1888), an abstract painter, synchronized sound and moving color with his *Optophone* for an audience at the Meyerhold Theatre, Moscow.

The Russian Constructivist El Lissitzky (1890–1941) also wanted to create a light spectacle. In 1923 he wrote:

> We are constructing a scaffolding in a public square . . . SPECTA-CLE MACHINERY . . . (in which) beams of light follow objects, fractured by prisms and mirrors.[7]

Lissitzky called on architects and engineers to help him build this *Electrical-Mechanical Spectacle*. Plans and detailed drawings were made, but the monument was never erected.

THOMAS WILFRED

Shall we . . . use the new art as a vehicle for a new message (and) express the human longing which light has always symbolized, a longing for a greater reality, a cosmic consciousness, a balance between the human entity and the great common denominator, the universal rhythmic flow?[8]—Thomas Wilfred

All of the previous experiments were isolated attempts to interpret music visually. A more revolutionary approach to the new art of light was taken by Thomas Wilfred (born 1889). Starting in May 1905 "with a cigar box, a small incandescent lamp, and some pieces of glass," Wilfred developed a new aesthetic medium, totally abstract and completely independent of music, which he called Lumia. Using relatively uncomplicated means, rotating mirrors, a single screen, and a pianolike keyboard with sliding scales and stops, Wil-

[7] El Lissitzky, "The Electrical-Mechanical Spectacle," *Form* (London), No. 3, December 15, 1966, pp. 12–14.

[8] Thomas Wilfred, "Composing in the art of Lumia," *Journal of Aesthetics and Art Criticism*, Vol. VII, No. 2, December, 1948, p. 90. The most complete study of Wilfred's contribution is Donna Michele Stein, "Lumia, the Art of Light and the Work of Thomas Wilfred," unpublished master's thesis, 1965, Institute of Fine Arts, New York University.

fred has realized almost 200 works, the most impressive of which are the 210 foot long *Mobile Mural* (1929) at the Hotel Sherman, Chicago, and *Lumia Suite*, Op. 158 (1964) at the Museum of Modern Art, New York.

THE BAUHAUS CONTRIBUTION

Light will bring forth a new form of visual art.[9]—Laszlo Moholy-Nagy

Many of the most important contributions to Luminism in the 1920's derived from the experimental work done at the Weimar Bauhaus. In the summer of 1922, Ludwig Hirschfeld-Mack (1893–1964), working with Joseph Hartwig (1880–1955) and Kurt Schwerdtfeger (born 1897), started to develop their *Reflektorische Farblichtspiele*. Hirschfeld-Mack describes the initial inspiration:

> Originally we had planned a quite simple shadow-show for a Lantern Festival. Accidentally, through the replacement of one of the acetylene lamps, the shadows on the transparent paper screen doubled themselves, and because of the many differently coloured acetylene flames, a 'cold' and 'warm' shadow became visible. Immediately, the thought came to mind to double the sources of light, or even to increase them six-fold and to put coloured glass in front of them . . .[10]

Hirschfeld-Mack eventually arrived at a system of rheostat-controlled moveable colored lights and templates that projected geometric colored shapes onto a transparent screen. On several occa-

[9] Laszlo Moholy-Nagy, *Vision in Motion*, Chicago, 1947, p. 166. For a detailed discussion of the kinetic content of Moholy-Nagy's work see Hannah Weitemeier, "Moholy-Nagy," *Avantgarde Osteuropa*, 1910–1930 (exhibition catalogue), Kunstverein, Berlin, October–November, 1967. One of Moholy-Nagy's most interesting kinetic works, *New Principles* (1939), is illustrated in Athena Tacha Spear, "Sculptured Light," *Art International*, Vol. XI, No. 10, December, 1967, p. 33.

[10] Basil Gilbert, "The Reflected Light Compositions of Ludwig Hirschfeld-Mack," *Form* (London), No. 2. September 1, 1966, pp. 10–11. Also see *Bauhaus* 1919–1928 (ed. by Herbert Bayer et al.), Museum of Modern Art, New York, 1938, p. 67.

sions, this was accompanied by specially composed music and presented in public performances in Berlin, Leipzig, Vienna, and Weimar as *Reflected Light Plays*.

While Turner (1775–1851) inspired the "tachist" side of Luminism, the Russian Suprematist Kasimir Malevich (1878–1935) has been the guiding light of the Constructivist branch. Laszlo Moholy-Nagy (1895–1946) saw Malevich's "White on White" (1918) as:

the ideal screen for light and shadow effects which reflect the surrounding world in the painting. The manual picture is suppressed by the painterly possibilities of light projection.[11]

Moholy-Nagy's major kinetic contribution was the *Light Display Machine* (1922–30), started the year before he joined the Bauhaus. In *Vision in Motion*, he writes:

This moving sculpture had 140 light bulbs connected with a drum contact. This was arranged so that within a two-minute turning period, various colored and colorless spotlights were switched on, creating a light display on the inside walls of a cube.[12]

Moholy-Nagy's caption under the photograph of this work in *The New Vision* (1938) reads:

This kinetic sculpture was designed for automatic projection of changing chiaroscuro and luminous effects. It produces a great range of shadow interpenetrations and simultaneously intercepting patterns in a sequence of slow flickering rhythm. The reflection surfaces of the apparatus are discs made of polished metal slotted with regularly spaced perforations and sheets of glass celluloid and screens of different media. It seems easy to prophesy that

[11] Sibyl Moholy-Nagy, *Moholy-Nagy*, N.Y., 1950, p. 30. For the influence of Malevich on other artists see Willoughby Sharp, *Günther Uecker—10 Years of a Kineticist's Work*, New York, 1966, p. 76, and Lev Nusberg, "Statements by Kinetic Artists," *Studio International*, Vol. 173, No. 886, February, 1967, p. 60.

[12] Laszlo Moholy-Nagy, *op cit.*, p. 238. Moholy-Nagy's film, *Light display, black, white and gray* (1925–30) was made with the *Light Display Machine*. The origins of the abstract cinema have not been adequately studied. The cinematic contributions of artists like Marcel Duchamp, Fernand Léger, Len Lye, and Man Ray are almost completely unrecognized. A study of these films of the pioneers in relation to their kinetic contribution would be helpful.

such types of constructions in many cases will take the place of static works of art.

Unlike former luminist works, Moholy-Nagy's work looked modern. In 1924, another Bauhaus associate, Herbert Bayer, drew up a project for an exhibition pavilion at a German industrial fair that included a forty-foot globe with exposed light bulbs programmed for simple alphabetic messages. It was never executed.

LIGHT AS AESTHETIC ENVIRONMENT
A new aesthetic is taking shape: luminous forms through space.[13]— Lucio Fontana

Fireworks are the oldest environmental light art. The ninth-century Chinese realized that, with the invention of gunpowder, large areas of space could be aesthetically activated. Today the electric age has created a totally new environment. Naum Gabo (born 1890) was the first to realize that modern technology provided electric light in sufficient strength to restructure this environment. *Light Festival*, a drawing from 1929, indicates how Gabo proposed to illuminate a Berlin architectural site.[14] Although this project was not carried out, the Nazi architect, Albert Speer, took Gabo's basic idea in 1938 to create a light environment for the NSDAP on their Party Day in Nuremberg. Speer lit the sky with more than fifty high-powered searchlights:

> *The Light Cathedral* was an experiment in making architecture with light. The refraction of light from the searchlights circulated through the clouds and merged fifteen kilometers up in the sky. It was a fantastic thing, like a Gothic cathedral.[15]

Lucio Fontana (born 1899) is a pioneer of the new art. His *Black Light Environment* (1949), which created a totally unique spatial

[13] Frank Popper, *Kunst Licht Kunst*, Stedelijk van Abbemuseum, Eindhoven, Holland, 1966. (Fontana section)

[14] See *Gabo*, Harvard University Press, 1957, plate 46. It is interesting to note that Yves Klein wanted to flood the Place de la Concorde in *Blue Light* during the opening of his 1957 exhibition at Galerie Colette Allendy, Paris. The government refused his request.

[15] *Kunst* (Mainz), No. 25, 1967, p. 422 (photograph).

situation, was the first use of artificial light in an enclosed environment. He has continued to activate space with thin lines of neon in several subsequent works: Milan (1951), Turin (1961), and, most recently, the Walker Art Center, Minneapolis (1966). Fontana, the main exponent (after Yves Klein's death) of Malevichian ideals[16] has had a profound influence on a generation of purist-oriented European artists and is considered to be the "Spiritual Father" of the Zero movement.

Otto Piene, founder with Heinz Mack of Group Zero in Düsseldorf (1958), created one of the most poetic luminist experiences. Piene describes the first *Light Ballet* (1959):

> At first I used hand-operated lamps whose light I directed through the stencils I had used for the stencil paintings. Controlled by my hands, the light appeared in manifold projections around entire rooms . . .[17]

The next year Piene mechanized this system by using perforated revolving globes containing handlamps and boat searchlights. In 1961 Piene was joined by Mack and Günther Uecker in the first Zero *Demonstration*, a kind of outdoor happening in which the spectator participated in a dynamic event utilizing aluminum foil, soap bubbles, white balloons, and light.

Active physical participation rather than docile contemplation is a basic tenet of the Groupe de Recherche d'Art Visuel (Garcia Rossi, Le Parc, Morellet, Sobrino, Stein, Yvaral). Their *Labyrinths* in Paris, New York, and Eindhoven used light to engage the spectator in a new involvement with the environment:

> Our Labyrinth is only a first experiment deliberately directed toward the elimination of the distance which exists between the spectator and the work of art.[18]

[16] The extent of the Malevichian legacy was recently demonstrated by the exhibition, "White on White," Bern Kunsthalle in 1966. The forthcoming exhibition of Russian art organized by Douglas MacAgy for the Albright-Knox Art Gallery, Buffalo, New York, will undoubtedly contribute to a greater understanding of this important period of art history.

[17] *Piene* (catalog), Howard Wise Gallery, New York, 1965.

[18] *Image* (London), "1962/63: text by Parc/Paris Biennale" Winter/Spring, 1966, p. 21.

The Moscow "Dvizdjenje (Movement) Group" formed in 1962 by
Lev Nusberg is also interested in creating environmental situations
utilizing light elements as well as temperature changes, air currents,
and odor movements. Obviating almost fifty years of Social Realism
and finding its artistic roots in the Suprematist–Constructivist tradi-
tion, Dvizdjenje has set out to change the climate of Russian art by
establishing the World Institute of Kineticism[19]

FIRE AS AN AESTHETIC ELEMENT

*. . . and she tried to imagine what the flame of a candle looks like
after the candle is blown out, for she could not remember ever
having seen such a thing.*—Lewis Carroll, *Alice in Wonderland*

Fire is the oldest light medium. Without fire, life is impossible.
There is no record of any human community without the use of fire.
In Zoroastrianism it is a god. To the Greeks it was one of the four
elements. While fire has long been recognized as an indispensable
and mysterious force, the modern artist has been the first to isolate it
as an aesthetic element. Four artists working in Paris and an Ameri-
can have done important works with fire. Almost simultaneously,
Yves Klein (1928–62) and Takis "discovered" this element. In 1957
Klein exhibited the first fire painting, a monochrome blue panel with
rows of Bengal lights that, when ignited, gave off brilliant blue
flames. The following year he designed *Fire Fountains*, which are
now installed at the Museum Haus Lange, Krefeld.[20]

In 1957 Takis started making *Fireworks*. He says:

I used the rocket action of fire to increase the kinetic content of
my *Signals*.[21]

[19] See Lev Nusberg, *op. cit.*, p. 60. For more about the Russians see Lev
Nusberg, "What is Kinetism?" *Form* (London), No. 4, April 15, 1967, pp. 19–
22, and Lev Nusberg, "van waarnemen tot handelen!" *Integration* (Arnhem),
No. 7/8, February, 1967, and *Sputnik* (Moscow), No. 6, 1967, pp. 152–63
(reprint in English from *Komsomolskaya Pravda*).

[20] For documentation concerning Klein's *Fire Fountains* see Paul Wember,
Yves Klein (catalog), Museum Haus Lange, Krefeld, 1961, and *Antagonismes
2: L'Objet*, Musée des Arts Décoratifs, Paris, 1962, pp. 76–77.

[21] In a conversation with the author, March 18, 1967. For photographs of
these *Fireworks* see Luce Hoctin "Takis: Conversations dans l'atelier/12,"
L'Oeil, November, 1964, pp. 36–43.

To life-sized *Signals*, metal rods topped with weighty objects like small road signs, wire brushes, hammerheads, and electric lights, Takis attached an explosive that flung seven minutes of flames into public places like the Place de la Concorde and the Luxembourg Gardens.

On a larger scale, Jean Tinguely used the garden of the Museum of Modern Art to demonstrate his *Homage to New York* (1960), a gigantic assemblage of bicycle wheels, piano parts, broken planks, rubber balloons, automobile tires, and string that violently consumed itself in flames.

The Parisian, Bernard Aubertin is the first luminist to make fire his principal medium. In 1961 he started a series of *Fire Disks*, metal tondos containing thousands of kitchen matches that are lit and spun. The following year he invented the *Red Cage of Smoke*, a perforated metal box containing two electric lamps. In *The Manifesto of my Pyromaniacal Activity* (1962), Aubertin writes:

> First, I turn on the two red lights. Then, I open the top and place the smoke powder on the point of a nail in the inside of the box. I light the smoke powder and close the cover. Soon, the smoke leaves the box through the perforations and crosses the rays of red light accompanied by the sound of the burning powder. A strong smell fills the space. The powder stops burning. Silence. Inside the box, visible through the holes, brilliant red and orange smoke smolders.

John van Saun, who has worked with artificial light and various inflammable materials such as plastic, synthetic yarns, and combustible metals declares:

> In my *Light Boxes* I try to capture the pure essence of electric light. In my *Fire Works* I try to capture the essence of life itself.

PROJECTED AND SCREENED LIGHT
There is no real time, no real space, no real light.[22]—Heinz Mack

A large body of luminist activity is devoted to the projection and screening of colored light in small-scaled situations. The basic idea is to liberate color from form, to float color in space, and to create a

[22] Peter Selz, *Directions in Kinetic Sculpture*, University of California, Berkeley, 1966, p. 49.

dynamic sense of time-flow. Scores of artists have consciously or unconsciously been inspired by Wilfred's work, and several light boxes utilizing screens show his influence: John Healey's *Box 3* (1963), Frank Malina's *Message II* (1962), Abraham Palatnik's *Sequencia Vertical S-30* (1965), Earl Reiback's *Kinetic Luminage* (1967), and W. Christian Sidenius's *Horizontal Sequence* (1967). Sidenius has written:

> What I have been trying to do is duplicate the several dozen instruments that Thomas Wilfred used in his theatre, plus adding some of my own invention.[23]

This statement can be taken as an accurate description of the present direction of lumia research.[24]

Several artists using contained light systems have achieved more structured situations. Davide Boriani's *P. H. Scope* (1966) is a finely programmed phosphorescent work, which he calls "a structuralization of changing temporal and spatial conditions." Martha Boto's *Interférences Optiques* (1965) casts slivers of silver light around polished aluminum tubes. Richard Hogle's *56 Light Cubes* (1967) is a container of dynamically moving monochromatic light. Heinz Mack's *Prism Whirl* (1965) ripples white light in rotating geometric patterns. Thomas Tadlock's *Quadrilateral Light Case* (1967) presents a flashing façade of randomly changing geometric configurations in infinite sequence.

Bruno Munari, whose *Useless Machine* (1934) is an important contribution to Kineticism, pioneered the use of polarized light. In 1953, he started the "Direct Projection" of slides containing cellophane, mica, and different plastics, which created changing color configurations by means of polarized light.[25]

[23] In a letter to the author, March 29, 1966.

[24] In reviewing the *Kunst Licht Kunst* exhibition (*Art and Artists*, December, 1966, p. 22), the Parisian critic Jean Clay writes: "There is something else which we can learn from Eindhoven: the appearance of a new Tachist academicism, which is now springing up everywhere in the form of moving screens, most of which are in no way an innovation and repeat the work of Wilfred in 1919. . . ."

[25] For the development of this work see Bruno Munari, "Projection directe en lumière polarisée," *Revue International de l'Éclairage*, Année XII, No. 6, 1961, pp. 288–89.

DIRECT ELECTRIC LIGHT
The medium bears the artist. . . .[26]—Dan Flavin

Contemporary attitudes concerning the found object coupled with an increased awareness of the inherent beauty of electric light as both medium and message have stimulated artists with a diverse range of aesthetic aspirations to use light directly.[27] Kosice's *Light Relief* (1948) is several lengths of white neon twisted into geometric shapes mounted on a solid support. Agam's *Light Painting* (1955) is a circuited system of tiny white bulbs that create linear light patterns. Günther Uecker's long series of *Light Disks* (1960–67) began with a naked light bulb suspended above a large white "nail relief." In *Light Rain* (1966), he covers eight-foot fluorescent lamps with aluminum tubes slit down the center. Julio Le Parc's *Cylindre Continuel Lumière* (1962–66) is a tondo containing shimmering shafts of white light. Karl Gerstner's *Times Square* (1965) is a flashing panel of colored lights controlled by eight different systems. Paul Williams's *Light Hemisphere* (1967) is a blinking ring of tiny bulbs in a plexiglas dome. Takis's *Electro-Signal* (1966) is a single shaft of metal which holds a small light aloft. Boyd Mefferd's *Untitled Electronic Device* (1966) is an aluminum and plexiglas structure containing eight cubes that emit light at random intervals.

Several artists have used neon. Some use it figuratively. Martial Raysse, who has been working in this medium since the early 1960's, has made a large piece entitled *America, America* (1964) which depicts a huge hand in the process of snapping its fingers. Chryssa's *Times Square Sky* (1962), in the collection of the Walker Art Center, relates to her fascination "with the lights and signs of Broadway and Times Square."[28] Of the artists who use neon non-figuratively

[26] Dan Flavin, "some remarks . . . ," *Artforum*, Vol. V, No. 4, December, 1966, p. 27.

[27] Most of the Pop-oriented artists have made at least one work with light: Apple: *Rainbow Motif* (1965), Indiana: *Eat Sign* (1965), Jasper Johns: *Painting with Neon Letter* (1964), Lichtenstein: *Sunset* (1966), Rauschenberg: *First Landing Jump* (1961), Rivers: *Lamp Man Loves It* (1966), Rosenquist: *Doorstop* (1963), Segal: *The Dry Cleaner* (1965), Warhol: *Balloon Farm Light Environment* (1966), and Wesselmann: *Nude* (1966).

[28] For this quotation see *Art in Process*, Finch College Museum of Art, New York, 1966.

Stephen Antonakos wants his work like *White Hanging Neon* (1966) to create "the shock of the unexpected" through "silent screams of color." Gilles Larrain's *Black Module* (1967) employs neon tubes the color of which can be modulated by turning a dial. Victor Millonzi's *Standing Blue* (1966) exemplifies his statement:

> Neon sculpture generates its own excitement. . . . Its very core is the concept of light. The sculpture of light has become an *oeuvre* that goes beyond theory in its beauty and impact.

Of all the work done with light, Dan Flavin's is the most direct. He uses factory-made fluorescent lights in regulation lengths and colors. He takes light as it is given, as a found object. He uses light conceptually. His artistic act is the choice of installation. Flavin writes:

> I know now that I can reiterate any part of my fluorescent light system as adequate. Elements of parts of that system simply alter in situation installation. They lack the look of history. I sense no stylistic or structural development of any significance within my proposal—only shifts in partitive emphasis—modifying and addable without intrinsic change.[29]

SPECTACLE
There's nothing really to turn off.—Bob Dylan

Nicolas Schöffer speaks of his luminodynamic works as "a spectacle."[30] But his "Luminodynamic Spectacles" in Saint-Cloud Park, Paris (1954) and in Liège (1961) do not involve the spectator in as total an experience as does his "spazio-dynamic" situation at the Saint-Tropez discothèque, "Voom-Voom." The heightened sensory

[29] Dan Flavin, *op. cit.* See also Dan Flavin, " 'in daylight or cool white' an autobiographical sketch," *Artforum*, Vol. IV, No. 4, December 1965, pp. 20–24, Elizabeth C. Baker, "The Light Brigade" (Antonakos, Chryssa, and Flavin), *Art News*, Vol. 66, No. 1, March, 1967, pp. 52–55, 63–66, and Dan Flavin, "some other comments . . . ," *Artforum*, Volume VI, No. 4, December, 1967, pp. 20–25.

[30] Reg Gadney, "Aspects of Kinetic Art and Motion," *Kinetic Art*, Motion Books (London), 1966, p. 36.

Laszlo Moholy-Nagy: *Light-Display Machine.* 1922–30. Metal, wood, and plastic, motorized. The Busch-Reisinger Museum, Harvard University.

Heinz Mack: *Light Tower*. 1960–62. Aluminum, glass, water, lights.

Dan Flavin: *Daylight and Cool White.* 1964. Fluorescent light. 8′ x 10″. In the collection of Philip Johnson. Photograph courtesy of Kornblee Gallery, New York.

Julio Le Parc: *Continual Light* (detail). 1960–66. Wood and metal, motorized. 60" x 30" x 10". In the collection of Mr. and Mrs. Howard Wise. Photograph courtesy of Howard Wise Gallery, New York.

Stephen Antonakos: *White Hanging Neon.* 1966. Neon and metal. 35" x 48" x 35".
In the collection of the Milwaukee Art Center. Photograph courtesy of Fischbach
Gallery, New York.

Naum Gabo: *Kinetic Construction: Virtual Volume*. 1920. Wood and metal, motorized. 58.5 cm. high. The Tate Gallery, London.

Marcel Duchamp: *Rotative Demi-Sphere*. 1925. Wood, metal, and glass, motorized. 150 cm. high.

Gianni Colombo: *Pulsating Structuralization*. 1959. Wood and Styrofoam, motorized. The Museum of Modern Art, New York.

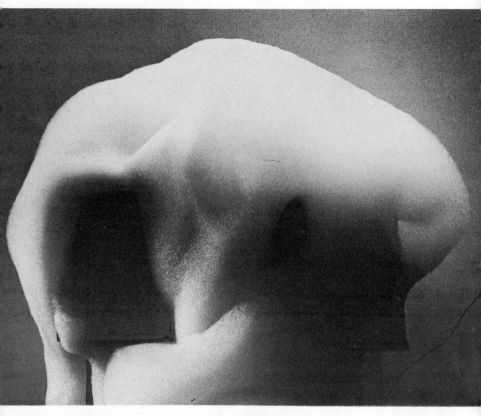

David Medalla: *Cloud Canyon*. 1964. Wood and foam, motorized.

Hans Haacke: *Ice Stick.* 1966. Wood, stainless steel, copper, and refrigeration unit, motorized. 12″ x 12″ x 70″.

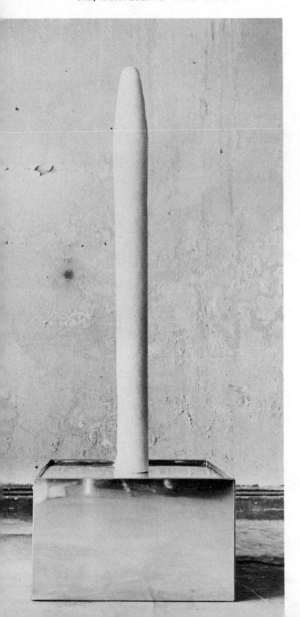

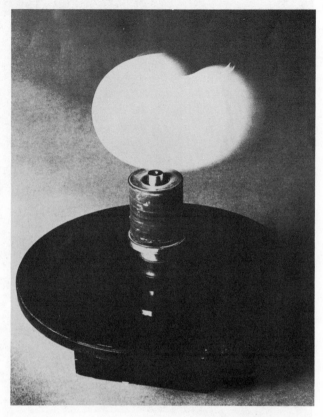

Takis: *Electro-magnetic Sculpture.* 1959. Wood, metal, and magnet, motorized.

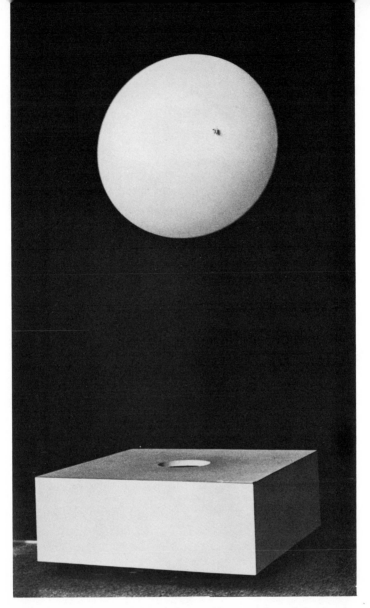

Hans Haacke: *Floating Sphere.* 1966. Rubber, wood, and formica, motorized. Diameter of sphere is 3'; box is 3' x 3'.

Zero Group: *Demonstration*. 1961. Düsseldorf, Germany.

satisfaction of "Voom-Voom" derives from the deeper immersion into life's action it provides.

Deeper immersion. A new generation of artists has sensed that the vanishing point has vanished. They strive toward total integration—the Self merged with the One.[31] This is accomplished through the simultaneous mixture of media: live music (generally rock), canned music (multi-speaker audio set-ups), closed-circuit TV, spots filtered through gel wheels, multi-screen projections, multi-film presentations, slide screens, and a great variety of light works. A new movement of Luminists, which began in California but has quickly moved across America, is creating whole field spectacles of total participation. The leaders of this movement are mostly underground figures, but some have surfaced and several are represented in this exhibition. USCO, besides creating *Strobe Environment* (1967), has performed Be-ins across the country and created an audio-visual multimedia "World" in Garden City, New York, which featured twenty-one screens and a crowd of 3,000. Cassen-Stern have used "psychedelic visuals" to stimulate an LSD experience in their *Trips Festival* (1966) at the Dom on St. Mark's Place in New York's East Village.[32]

We are in the process of moving away from the physical view of reality as that which exists to a kinetic view of reality as that which seems to happen. This is a shift from being to becoming.

Time is now measured as the spectator's perception of the duration of a witnessed activity. Duration begins with divisions of time into units. Since a luminic work is not segmental, measured time is not experienced. Luminic objects destroy the lineal conception of time and the idea of enclosed space. Luminic works do not contain time, they create time. Luminic works do not exist in space, they create space.

[31] The American art dealer, Howard Wise, who has committed himself to kinetic and luminic art, writes: "The critical and public response to the "Lights in Orbit" show amazed me. I think the reason must be that light in movement gratifies a newly developed sensitivity within ourselves engendered by modern life."

[32] The best study of LSD and Light Art is Warren Hinckle, "The Social History of the Hippies," *Ramparts*, Vol. 5, No. 9, March, 1967, pp. 5–26, which contains many excellent color photographs of light work.

A spectacle makes the spectator abandon the closed, definitive, static state of older attitudes. It reinvigorates the spectator because he has a role to play in the event. A spectacle demands total audience involvement. We have reached the end of disinterestedness, impartiality, and contemplation. We are embarking on a new phase of artistic awareness in which interest, partiality, and involvement are the chief characteristics.

Part II: Kineticism

THE KINETIC CONTENT OF FUTURISM

A racing car . . . is more beautiful than the Victory of Samothrace.— *Initial Manifesto of Futurism*[33]

The Futurists were the first to identify physical movement as the main element of the new aesthetic. The *Initial Manifesto of Futurism*, written by Filippo Tommaso Marinetti (1876–1944), the founder of Futurism, in 1909 declares:

> The world's splendor has been enriched by a new beauty; the beauty of speed. . . . Time and space died yesterday. Already we live in the absolute, since we have already created speed . . .[34]

The following year, Marinetti convinced five artists to join the Futurist movement. This resulted in the *Technical Manifesto of Futurist Painting* (1910), signed by Balla, Boccioni, Carra, Russolo, and Severini, which demanded "that all subjects previously used must be swept aside in order to express . . . speed" and "that movement and light[35] destroy the materiality of bodies."[36] Marinetti's attack on the professors, May 1910, declared:

[33] Joshua C. Taylor, *Futurism*, The Museum of Modern Art, New York, 1961, p. 124.

[34] *Ibid.*, p. 124.

[35] Light also preoccupied the Futurists, who in this manifesto proclaimed themselves "Lords of Light" and who elsewhere advocated "interior or exterior electric lights [to] indicate the planes, the tendencies, the tones and half-tones of a new reality." (See Robert L. Herbert, Ed., *Modern Artists on Art*, 1964, p. 54.) In fact, Marinetti once even considered calling Futurism "Electricism." (See Taylor, *op. cit.*, p. 9.)

[36] *Ibid.*, pp. 126–27.

LUMINISM

YEARS	NATURAL	ENVIRONMENTAL	PROJECTED
1734	Castel *Clevessin Oculaire*		
1844		Jameson *Color Music*	
1870			
1877			
1880			
1895			
1905			
1912			
1915			
1919			
1920			
1921			
1922			Schwerdtfeger *Color Organ*
1923			Smith *Mutochrome*
1924			Lovstrom *Projector*
1925			Klein *Color Projector*
1926			
1927			Hausmann *Optophone*
1929		Gabo *Light Festival*	
1930			Moholy-Nagy *Light-Display Machine*
1932			Pesánek *Color Harpsicord*

1933			
1934			Shamah *Visical Piano*
1935			Benthan *Light Console*
1938		Speer *Light Cathedral*	
1947			
1949		Fontana *Black Light Environment*	Vardanega *Illuminated Half-Sphere*
1951			
1953			Munari *Direct Projections*
1954			
1955			
1956			
1957	Takis *Fireworks*	Klein *Blue Lights*	
1958	Klein *Fire Fountain*		
1959		Piene *Light Ballet*	
1960	Tinguely *Homage to New York*		Goodyear *Light Modulator*
1961	Aubertin *Fire Disk*		Mari *Oggetto Luminoso*
1962			Dantu *Light Projections*
1963		GRAV *Labyrinth*	Albrecht *Composition*
1964		Dvizdjenje *Environment*	Biasi *Kinetic Space*
1965	Van Saun *Falling Fire*	von Graevenitz *Kinetic Wall*	Rabkin *Hop-Scotch*
1966		Stafford *Environmental Machine*	Salvadori *Eclipse*
1967		Whitman *Laser*	Tsai *Vibrations*

LUMINISM

SCREENED	DIRECT	SPECTACLE	YEARS
			1734
			1844
Kastner *Pyrophone*			1870
Baimbridge *Instru-ment*			1877
Bishop *Color Organ*			1880
	Rimington *Mobile Color*		1895
Wilfred *Color Box*			1905
Hector *Color Organ*			1912
		Scriabin *Promethus*	1915
		Baranov-Rossiné *Optophone*	1919
Wilfred *Clavilux*		Ricciardi *Color Theatre*	1920
Greenewalt *Color Organ*			1921
Hirschfeld-Mack *Reflected Light Plays*			1922
	Braum *Light Study*	Lissitzky *Spectacle Machinery*	1923
Barnes *Colored Light*	Bayer *Light Ball*		1924
		Schwabe-Hasait *Cyclorama*	1925
Laszlo *Piano-Colored Light*		Carol-Berand *Color Symphony*	1926
		Desmongel *Color Symphony*	1927
		Wilfred *Mobile Mural*	1929
			1930
			1932

Patterson *Electric Circuit*			1933
			1934
			1935
			1938
	Kosice *Light Relief*		1947
			1949
Palatnik *Cinechromatic Work*		Hoppe *Light Performances*	1951
		Schöffer *Luminodynamic Spectacle*	1953
Healey *Light Box*			1954
Malina *Jazz*	Agam *Light Painting*		1955
Calos *Luminous Painting*			1956
Boto *Luminated Liquid*			1957
Mack *Light Dynamo*		Le Corbusier *Electrical Poem*	1958
Anceschi *Colored Structure*			1959
Livinus *Lumodynamic Machine*	Uecker *Light Disk*	Rot *Spectacle*	1960
Demarco *Light Vibrations*	Flavin *Icon*	Metzger *Light Destruction*	1961
Lassus *Ambiance*	Le Parc *Continual Light*	Sidenius *Lumia Theatre*	1962
Garcia-Rossi *Luminous Box*	Raysse *J.M.*	USCO *Be-in*	1963
Tadlock *Kinetic Light Construction*	Berns *No. 1*	Müller *Machine M*	1964
Hogle *Dot Box*	Chryssa *Ampersand*	Paik *World Theatre*	1965
Boriani *P. H. Scope*		Cassen-Stern *Trips Festival*	1966
Reiback *Luminage Projector*	Williams *Light Hemisphere*	Group Image *Light Show*	1967

New men are on the march. They are nearing with their engines that pierce the sky, that penetrate the ocean, that sweep across the plains. Soon they will rout with light and motion. The ghostly worshippers of the Dead Muses. . . . They will sing of engines and metals until the day when the machine itself will be the supreme and sole work of art. . . .[37]

His obsession that "all things move, all things run" found expression not only through his writing but also through what may be the first mobile, his *Self Portrait* of 1914, a polychrome wood figure with moveable limbs suspended from the ceiling by a wire, which gives the impression of a man running through the air.[38]

Another attitude towards movement was expressed in the *Technical Manifesto of Futurist Sculpture* (1913), written by Umberto Boccioni (1882–1916):

One can renew art only by seeking the *style of movement*. . . . Consequently, if a sculptural composition needs a special rhythm of movement . . . then one could use a little motor that would provide a rhythmic movement. . . .[39]

This suggestion was taken. *The Futurist Reconstruction of the Universe* (1915) not only refers to another mobile, Giacomo Balla's *Coplessi plastici mobili*, but to Balla and Fortunato Depero's *Complessi motorumoristi*, the first motorized kinetic sculpture.[40]

[37] Rosa Trillo Clough, *Looking Back at Futurism*, New York, 1942, p. 49. For the interesting idea that "art tends fatally towards its own destruction" see "Soffici's Principii," *ibid.*, p. 69.

[38] For a photograph of this work see Taylor, *op. cit.*, p. 110.

[39] Herbert, *op. cit.*, p. 55.

[40] Referred to by George Rickey, "The Morphology of Movement: A Study of Kinetic Art," in Gyorgy Kepes, ed., *The Nature and Art of Motion*, 1965, p. 82. Balla and Depero collaborated in Rome on a small body of kinetic work, mostly mobiles and machines, starting in 1915. For photographs of these see *Archivi del Futurismo* (ed. Maria Drudi Cambillo and Teresa Fiori), Rome, 1959–62, Vol. 2, No. 216, 222, 352, 356, etc., and Raffaele Carrieri, *Il Futurismo*, Milan, 1961, p. 94. Dr. Carlo Belloli has written me that he plans to publish his material on the kinetic contribution of the Futurists in his forthcoming book, "Temps + Mouvement = Metaformes."

MARCEL DUCHAMP AND MAN RAY

Draft is a force. If you capture it, you can make a piston move.—
Marcel Duchamp[41]

Movement has interested Duchamp since his earliest paintings, the most important of which, *Nude Decending a Staircase* (1912), describes the kinetic force of a figure moving through Cubist-Futurist space. In 1913 Duchamp stopped painting and made the first sculptural work employing actual physical movement. *Mobile: Bicycle Wheel* is a wood stool onto which a bicycle wheel has been mounted for the spectator to spin. The dematerialized spokes of the spinning wheel correspond to the kinetic conception of Duchamp's *Rotary Glass Plate* (1920), a motorized instrument containing five rectangular glass plates painted with black semicircles that give the optical illusion of a series of continuously rotating circles.[42] Movement reduces this three-dimentional structure to a two-dimensional optical situation. *Rotary Demisphere* (1925) exemplifies another optical idea. A series of eccentric circles painted on a motorized hemisphere spiral toward and away from the spectator, causing a vertiginous sensation.[43] *Rotorelief* (1935), a work that Duchamp has duplicated in many editions the most recent of which was 1963, develops this idea further by spinning printed polychrome discs on a phonograph turntable to simulate movement in three-dimensional space.

Man Ray (born 1890) has created at least three kinetic works. In 1920 he made two mobiles, *Object of Obstruction,* a configuration containing sixty-three wooden coat hangers suspended in mathematical progression from the ceiling, and *Spiral,* a thin white sheet of metal hung from a short stand.[44] The third work, *Object To Be De-*

[41] Harriet and Sidney Janis, "Marcel Duchamp: Anti-Artist (1945)," in Robert Motherwell, Ed., *The Dada Painters and Poets,* New York, 1951, p. 313.

[42] *Marcel Duchamp,* Pasadena Art Museum, 1963, No. 74.

[43] *Dokumentation über Marcel Duchamp,* Kunstgewerbemuseum, Zürich, 1960, p. 10.

[44] For an account of Man Ray's kinetic contribution see Man Ray, *Self Portrait,* 1963, pp. 69 and 96. Although it has been said that *Rotary Glass Plate* was a collaboration between Man Ray and Duchamp, Man Ray does not mention working on it.

stroyed (1923), was a metronome with a photo of an eye attached to the oscillating rod.[45]

THE RUSSIANS

We affirm in these arts a new element, the kinetic rhythms, as the basic forms of our perception of real time.—*Realist Manifesto*[46]

Several factors contributed to making Moscow a major art center during the 1914–22 period. By 1914, the Russian collector Sergei Shchukin had amassed 221 Impressionist and Post-Impressionist works, which were on permanent public view[47] "so that the most advanced ideas and movements of the last ten years were even more familiar in Moscow than in Paris itself."[48] Many of the most important Russian artists traveled widely. Vladimir Tatlin (1885–1953), impressed by Picasso's first Cubist work brought back by Shchukin,[49] decided to visit him in 1913. After spending a month in Picasso's studio late that year, Tatlin returned to Moscow and started a series of *Corner Constructions,* frameless assemblages of wood, metal, plastic, and glass that were suspended between two walls by wires.[50] Although these works owe much to Picasso's Cubist constructions, the presence of Marinetti in Moscow during the first two months of 1914 may have influenced their free-flying quality.[51] The idea of flight was prominent in Tatlin's mind, for at about this time he started a project that was to take the rest of his

[45] *Ibid.,* p. 390.

[46] Naum Gabo, *Gabo,* Harvard University Press, Cambridge, Massachusetts, 1957, p. 152.

[47] Camilla Gray, *The Great Experiment: Russian Art,* New York, 1962, p. 65.

[48] Fifty works were by Picasso and Matisse, who had a room to himself that he personally hung during his 1911 Moscow visit. *Ibid.,* p. 64.

[49] *Ibid.,* p. 144.

[50] *Ibid.,* pp. 126–28.

[51] For a photograph of Marinetti in Moscow see Carlo Belloli, *Il contributo russo alle avanguardie plastiche,* Galeria Del Levante, Milan, 1964, pl. 14. Marinetti had made a previous Russian tour in 1910 when he visited Moscow and St. Petersberg (Raffaele Carrieri, *op. cit.,* p. 122). For the influence of Italian Futurism on Russian art of the pre-revolutionary period, see *ibid.,* pp. 122–39.

life—designing a glider, the *Letatlin,* which never got off the ground.[52]

Another of Tatlin's projects was more ambitious. In 1918 Lenin suggested that monuments should be erected in Russian cities to celebrate the heroes of the Revolution. Early in 1919 Tatlin was commissioned to execute a *Monument to the 3rd International,* which was to be erected in the center of Moscow. It was to be a three-part spiral structure of glass and iron twice the height of the Empire State Building. It was to be completely kinetic. The whole monument was going to move. The bottom section was to revolve once a year, the middle section once a month, and the top cube once a day. Unfortunately this project did not progress further than Tatlin's huge wood and wire model.[53] Alexander Rodchenko (1891–1956) also made a kinetic contribution. After meeting Tatlin and Malevich in 1916, Rodchenko started to develop his *Hanging Constructions,* thin, wooden configurations suspended from the ceiling.[54] Although he continued to perfect these for the next few years, in 1917 he made another kind of mobile in metal, which balanced in mid-air.[55] Naum Gabo (1890) was not only the first to signal the kinetic content of art, he was the only Russian to make a motorized work. His *Kinetic Construction: Virtual Volume* (1920) was meant to introduce "time as a new element in plastic art."[56] Although Gabo drew up plans for another *Kinetic Construction* (1922), he did not finish this work.[57] In an essay of 1937, "Sculpture: Carving and Construction in Space," Gabo indicated why he did not continue making motorized kinetic works:

> Mechanics has not yet reached that stage of absolute perfection where it can produce real motion in a sculptural work without

[52] Gray, *op. cit.,* p. 147.

[53] For a detailed account of this see Gray, *op. cit.,* pp. 218–19 and pl. 168. For a contemporary criticism of Tatlin's *Monument* see Leon Trotsky, *Literature and the Revolution,* New York, 1924.

[54] See Gray, *op. cit.,* pls. 174 and 176.

[55] See Belloli, *op. cit.,* pl. 29. This work seems to belong to a series of small suprematist structures. For another, see Moholy–Nagy, *The New Vision, op. cit.,* p. 115.

[56] Gabo, *op. cit.,* pl. 15.

[57] *Ibid.,* pl. 16.

killing, through the mechanical parts, the pure sculptural content, because the motion is of importance and not the mechanism that produces it. Thus the solution of this problem becomes a task for future generations.[58]

ALEXANDER CALDER
It whirls, it whirls.—Alexander Calder[59]

Calder's concern with movement started with the animated wire toys of animals and people that he began to make for his *Circus* of 1926.[60] Calder gave regular performances, which quickly attracted the attention of the Paris art world. Both Miró and Mondrian saw the *Circus*. Calder in return was invited by both to their studios. This had a profound influence on his work. Recalling his visit with Mondrian, Calder wrote: "I thought at the time how fine it would be if everything there moved."[61] To make moving Mondrians, Calder relinquished the representational, adopted geometrical forms, painted them primary colors, and animated them with motors and hand cranks. *Dancing Torpedo Shape* (1932), one of the earliest motorized works, contains three forms, a white square, a blue circle, and a red cylinder, which slowly oscillate in the air. *Calderberry Bush* (1932), an early mobile, is a single shaft of wire supporting six aluminum circles and a white wooden ball.[62] During the last thirty-five years, Calder has produced hundreds of works that adhere to these basic kinetic ideas.

THE BEGINNING OF AN INTERNATIONAL KINETIC MOVEMENT
We can transform material into energy.—Takis[63]

The development of kinetic sculpture was virtually stopped by the World War II. It was not until the mid-1950's that artists again created kinetic works. The single most important event of that time

[58] *Ibid.*, p. 169.

[59] John Russell, *Vogue*, July, 1967, "Calder," p. 111.

[60] For photographs of the *Circus* see James Johnson Sweeney, *Calder*, Museum of Modern Art, New York, 1945, pp. 12–20.

[61] *Ibid.*, p. 28.

[62] Both these works are illustrated in Sweeney, *op. cit.*, pp. 26–27.

[63] Peter Selz, *op. cit.*, p. 59.

was the *Le Mouvement* exhibition in 1955 at the Denise René Gallery, Paris. For the first time a group of artists working with kinetic concepts was shown together. Besides the pioneers, Calder and Duchamp, five artists of different nationalities exhibited: the Israeli Yaacov Agam (born 1928), the American Robert Breer (born 1926), the Belgian Pol Bury (born 1922), the Venezuelan Jesus Raphael Soto (born 1923), and the Swiss Jean Tinguely (born 1925). These artists, plus the Frenchman Yves Klein (1928–62) and the Greek Takis (born 1925), constitute the first generation of kineticists. During the last decade these artists have created an *oeuvre* the significance of which is now just beginning to be appreciated.

THE GROUPS

. . . we collaborate . . . but we are convinced that teamwork is nonsense if it tries to . . . rule out individuality or personal sensibility.—Otto Piene[64]

There are more than a dozen artistic groups today that are devoted to movement. The Zero group, formed in Düsseldorf by Otto Piene and Heinz Mack in 1958 (Günther Uecker joined later), was the first artist collective concerned with movement after the Second World War.[65] Le Groupe de Recherche d'Art Visuel (Garcia Rossi, Le Parc, Morellet, Sobrino, Stein, and Yvaral) was founded in Paris in July 1960 "to consider artistic phenomena as a strictly visual experience stemming from physiological preception."[66] The Group T of Milan (Boriani, Colombo, De Vecchi, and Varisco) was founded at about the same time. Two other Italian groups were established shortly after that: Enne (Biasi, Landi, Massironi) and MID (Barese, Grassi, Laminarca, Marangoni). The Russian Dvizdjenje (Movement) group, with a membership of more than a dozen artists lead by Lev Nusberg, has been creating abstract

[64] Otto Piene, "Group Zero" (press release), Howard Wise Gallery, November, 1964.

[65] For a list of artists associated with the Zero group, see Willoughby Sharp, "Uecker, Zero, and the Kinetic Spirit," *Uecker* (catalogue), Howard Wise Gallery, November, 1966, Footnote No. 3.

[66] *L'Instability* (catalog), The Contempories, New York, November, 1962.

kinetic works in Moscow since 1962. The only American group, USCO, is a loose working cooperative based in Garnerville, New York, which is held together by Gerd Stern.

THE PRESENT

Everything that we call substance is nothing but movement.— Kasimir Malevich[67]

The present period is characterized by an international awareness that painting and static sculpture have lost much of their former vitality. People are beginning to realize that the prophetic cries that "painting is dead" contain some truth. Partially as a result of a lack of heart and a scarcity of innovative artistic ideas, and partially as a result of the changing needs of our reconfigured senses, painting and static sculpture have become almost anachronistic. Probably the most clear-sighted view is that the older art is in the process of being phased out. This situation arises at a time when several factors are beginning to have a great influence on kinetic and luminic art. The new art is a delicate growth. It has little tradition at its roots. It has almost no codified theory to sustain it against the storms of older art. It has been nurtured on a sprinkling of successful works, the accomplishment of which is not easily conveyed. More often than not, important early kinetic contributions were the isolated achievement of an artist whose major concentration lay in a non-kinetic area. Indeed, this is the case with the whole early period of the new art. Of the pioneers, Balla, Depero, Duchamp, Gabo, Rodchenko, Tatlin, Moholy-Nagy, and Calder, only the latter has produced an *oeuvre* of kinetic work. The new art has been handicapped by a scarcity of knowledge about the achievement of early kinetic works. Not only did it lack documentation and elucidation, it lacked people who understood what was happening well enough to be stimulated to writing intelligently about it. Until quite recently, the only serious discussion of kinetic aesthetics and accomplishments was carried on by the artists themselves. But during the last few years, the situation has changed. Starting about 1960, a trickle of articles concerning the emerging kinetic spirit has flowed from Europe. The English critic

[67] Kasimir Malevich, *Suprematismus—Die Gegenstandlose Welt*, Verlag M. Dumont Schauberg, Cologne, 1962, p. 208.

John Anthony Thwaites greatly contributed to the awareness that
the Zero movement was the most important development in German
art since The Bauhaus. The Italian critic Gillo Dorfles was an early
supporter of the Italian kinetic groups, and his articles provided the
needed encouragement to sustain their early struggles. The young
critic of *The Times* (London), Guy Brett, not only openly praised
the new kinetic sensibility, but he also actively supported the center
of kinetic activities in London, the Signals Gallery, and organized
several important exhibitions of kinetic art. In Paris, Frank Popper,
probably the first contemporary writer to realize the importance of
the new art, devoted his energy to a doctoral dissertation, "The
Image of Movement in Art Since 1860," which has just appeared in
book form as *The Birth of Kinetic Art*.[68] More recently, the young
French critic Jean Clay has committed himself to the clarification of
kinetic ideas and written several important articles, one of which
appeared in *robho*, the art journal devoted to kineticism that he has
just founded. The single individual responsible for the diffusion of
knowledge concerning kinetic art in America is the kinetic sculptor
George Rickey. His important articles in the early sixties were in-
strumental in bringing the idea of kinetic art to a large American
audience. The critical attention of serious critics has made an appre-
ciable impact on the new art. It has facilitated the awareness that
the art of light and movement is a major international movement
capable of great growth and achievement. Fortunately, this aware-
ness comes at a time when many of the most mature kineticists are
developing their work and ideas to the point of a real breakthrough.
The struggles of the last decade seem to be about to produce fruit.
It is impossible to cite every indication of this, but a few that come
to mind are Len Lye's "Tangible Motion Sculpture," the recent work
in Moscow of the Dvizdjenje group with large-scale kinetic work
utilizing both sound and smell, the recent work in Japan of the
Gutai group with natural kinetic elements, the mature work of the
Groupe de Recherche d'Art Visuel in Paris, the work of the Zero
group at Eindhoven, Holland, Uecker's recent accomplishments with
fluorescent light, and the new work of the three Italian groups,
MID, N, and T. Not only does the quality of the current work seem

[68] *Naissance de la Cinétique,* Paris: Gauthier-Villars, 1967.

KINETICISM

YEARS	NATURAL	MOTORIZED	SPECTACLE
1913	Duchamp Mobile: Bicycle Wheel		
1914	Marinetti Self Portrait		
1915	Balla Mobili	Balla & Depero Motorumorista	
1916	Tatlin Corner Construction		
1917	Rodchenko Metal Mobile		Taeuber-Arp Abstract Marionettes
1919	Rodchenko Hanging Construction		
1920	Man Ray Spiral	Duchamp Rotary Glass	Tatlin Monument
1920	Man Ray Object of Obstruction	Gabo Kinetic Construction	
1922		Gabo Kinetic Construction	Schlemmer Triadic Ballet
1923	Man Ray Object of Destruction		
1924		Archipenko Archipentura	
1925		Duchamp Rotative Demi-Sphere	
1926			Calder Circus
1930	Giacometti Suspended Ball		
1932	Calder Mobile	Calder Dancing Torpedo Shape	
1933	Munari Useless Machine 1		
1934		Munari Useless Machine 2	Bellmer Puppets
1935		Duchamp Rotorelief	
1937	Ferrant Danzas		
1944		Mortensen Kinetic Pictures	
1945	Vantongerloo Vector		
1946	Rickey Mobile		
1948		Tinguely Virtual Volume	
1951	Martin Mobile Construction		

KINETICISM

YEARS	NATURAL	MOTORIZED	SPECTACLE
1952	Lippold *Mobile*	Gabo *Blue Construction*	
1953	Bury *Plans Mobiles*	Tinguely *Métamécanique*	
1954	Soto *Metamorphosis*	de Rivera *Construction I*	
1955	Takis *Signal*	Bury *Erectile*	
1956	Boto *Mobile*	Klein–Tinguely *Blue Rotor*	Gutai Group *Sky Festival*
1957	Kosice *Hydrolic Sculpture*	Kramer *Signal*	
1958	Uecker *Light Globe*	Takis *Télémagnetic Sculpture*	
1959	Manzoni *Pneumatic Sculpture*	Lye *Fountain*	
1960	Mack *Light Forest*	De Vecchi *Triangle*	Zero Group *Demonstration*
1961	Haacke *Water Sculpture*	Colombo *Revolving Structure*	
1962	Goepfert *Reflectors*	Medalla *Cloud Canyon*	
1963	Le Parc *Continual Mobile*	Staakman *Motors*	
1964	Boriani *Magnets*	Tsai *Multi-Kinetics*	
1965	Peeters *Water Ceiling*	Haacke *Floating Sphere*	
1966	Asis *Vibrations*	McClanahan *Star Tree*	GRAV *Journée dans la rue*
1967	Morris *Steam*		Central Park *Kinetic Environment*

vastly improved, but the emphasis also seems to have shifted into the environmental area. Kinetic and luminic art seem less and less concerned with objects and more and more occupied with problems involving environmental scale. The appearance of light shows with rock music, first in California and now in the East, is a major undertaking of the new art, one that has as yet been unappreciated. The attempt to energize areas of nature aesthetically is another important direction. The "Kinetic Environment" recently done in New York's Central Park by Hans Haacke, Richard Hogle, Gilles Larrain, Preston McClanahan, and John van Saun, which tried to activate a quarter-mile cube of nature by using natural kinetic elements like air, fire, fog, ice, smell, smoke, and water, seems to indicate that the new art has chosen the ambitious task of reshaping our environment aesthetically. If one wants to characterize the present stage of the art of light and movement, one could say that due to the rapidly increasingly awareness of past accomplishments there is a strong feeling of confidence in the ability of the new art to reconstruct the world kinetically.

SCHEMATA 7* by Elayne Varian

In her introduction to the catalogue of the exhibition *Schemata 7*, at the Finch College Museum of Art, Elayne Varian writes: "The purpose of this exhibition is to show the attitude of contemporary sculptors to scale and enspheric space. . . . It is possible to have positive (enclosure) and negative (exclusion) attitudes to defined space, and each of the works represents a different attitude to what one might begin to call the ecology of the art-artist intercurrent situation."

Thus, what ties these artists together is not, as one might expect, the physical style of their art, but something else, equally important—namely, their approach to the surrounding space, the negative space. One may conclude, from this exhibition, that the Minimal sculpted statement belongs indoors, where a more aggressive spatial interaction is allowed, rather than outdoors, where no enclosure defines the negative space.

Elayne Varian is Director of the Contemporary Study Wing of the Finch College Museum of Art.

In the following interviews with the artists, the effects of their various backgrounds and college experiences on their personal philosophies were particularly explored, emphasizing their philosophy of teaching with the aim of clarifying their approach to aesthetic development.

Will Insley
You were teaching at Oberlin College, I believe, when you were awarded a grant by the National Foundation of Art and Humanities. Did you enjoy your teaching experience?

I enjoyed teaching and being with younger people. Sometimes we only see people with whom we agree and it gets a little cloistered after a while. At Oberlin I taught both painting and drawing.

* Excerpts reprinted from the exhibition catalogue *Schemata 7*, Finch College Museum of Art, Contemporary Study Wing, 1967.

The trouble is that schools still tend to divide art up into little packages of painting, drawing, and sculpture . . . and I don't believe in that . . . nor do most artists. Drawing is a means of putting down an idea, and I do not think that it is an end product in itself.

It might turn out to be an end product.

Yes, but that isn't the reason for making it. In the drawing classes I gave the students projects, for which some made plans or drawings and then a model. In the painting classes I gave problems, too, and explained that there were many opportunities for making a work of art. The first thing we did was to remove the easels from the room . . . though a few crept back in as time went on. Actually the last problem I gave them was to make a painting and they all felt quite relieved. Previously, they were assigned the problem of designing an environment, which they did by making scale models, because I wanted to get them to think in scale. I did try to open up their minds a little bit, and the students built some very interesting pieces.

What kind of scale?

Well, architecturally that one inch equals one foot, but also one has to think of the scale of a person. I had to keep an open mind and be sympathetic toward the ideas of others. One of the things was to rescue these people who were determined to go through Abstract Expressionism, inch by inch, which was simply wasting their time, because after they had finished one painting they should know the problems.

Had your earlier experience as a student affected your teaching attitude?

When I was of the age to go to art school, the courses were simply not preparing us for what we would now consider the legitimate direction of pure visual thinking. If there was something we wanted to do, we realized they would never have thought of it as art, and so we began to go into other fields and as we studied we saw the possibilities of using that kind of knowledge to create a different kind of art—I wouldn't call it new since in a sense, there's nothing new.

When I first came to New York as a painter, I hated it. I realized painting had no meaning for me, and I began using architectural

forms, forms that I was using at school, except that at school I used them for practical reasons. So that when I began thinking as an architect and not as what you might call a traditional artist, things began to make sense.

Was your philosophy challenged by the teachers at the college?

Yes, at all times. Well, there were two of the newer teachers who were sympathetic and that made it worthwhile. There was, though, an undercurrent of challenge (but no open battle) from the studio faculty who had settled in the art department years ago and their ideas hadn't really extended.

You keep speaking of architecture. Is this part of your background?

Yes, after getting a B.A. degree from Amherst I received a Bachelor in Architecture degree from the Harvard Graduate School. At first I wanted to be a painter but then turned to sculpture. These structures I am now working on are the completion of a cycle because I am now getting back to architecture. These I am showing are just a beginning since my other designs would be too big to build indoors. These models are meant for interiors—pure idea things. While they could be outdoors, I specifically designed them for exhibition purposes and even more specifically I designed this structure for one of your first floor galleries.

What is the title?

I think the title of a work of art is irrelevant, but for identification purposes we will call the piece in this show *Floor Structure*. I wanted something that was based on a 4′ x 8′ sheet of plywood. I like the interior space to be different from the outside space, a little bit more removed, so that people can go in it, but they might hesitate. So that it is a space that is denied to them. My structure at the Allen Art Museum is square and very few people want to walk into it; they want to go around it. I like the idea of people going around it and experiencing it visually. Children run through it and want to slide down it.

Then, that structure could be made larger?

Yes, but every time you change your scale, you are dealing with a different problem. At this point I no longer think there is any validity in designing individual pieces of sculpture. I do not think this

Will Insley: Drawing for *Floor Structure*. 1967. 4'10" x 8'2 1/5" x 17'10". Photograph courtesy of Finch College Museum of Art, Contemporary Study Wing.

Michael Kirby: Drawing of elevation for *Window Piece* (47" x 47"), *Floor Piece* (68" x 28" x 19"), and *Collection Frames* (each 9" x 6"). 1967. Photograph courtesy of Finch College Museum of Art, Contemporary Study Wing.

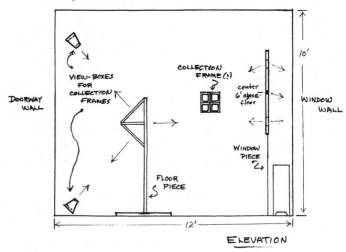

idea of plunking a piece of sculpture down in front of a building works. Now I'm thinking of working on a model for a city block, so we have a large enough environment for people to walk through it. It wouldn't be related to a building—but it would, of course, become part of the city.

Do you believe that structures could be used to conceal utilitarian constructions like an underground garage?

In the Midwest they have underground parking lots with parks on top and they always look silly because they don't seem to belong there.

The one in San Francisco, surrounded by municipal buildings, works like magic. I was completely unaware that this park was doing double duty.

My feeling is that you have built a structure underground and there is an old, nostalgic notion that you put grass and trees on top of it and pretend it isn't there. I would like it to be obvious that this is a structure and that there is something going on underneath. The top should become a pure three-dimensional environment. It wouldn't have any grass or trees. It would just be all a solid hard thing, cold and removed. All the old temples . . . though their religious function has no meaning to us today . . . still function as visual space—certain spatial relationships always have meaning—a universal language.

Your work has changed since I visited your studio last fall.

I am now interested in the space between the painting and the person looking at it. It is more architectural. Like a person seeing a door and knowing he can walk through it. That gives a more specific relationship between you and him. I am using this relationship in my painting and in my structures. I am going to continue my structures as mostly scale models, since no one is about to give me a city block. This is one more step in getting away from the consideration of "a painting" or "a sculpture" as an isolated object. Now the painting becomes the wall and the sculpture simply becomes exterior space.

The idea is to destroy our life history; the students I taught at Oberlin have the obligation to destroy what we are doing; and we are going to have to fight back.

Michael Kirby

As I understand it, your performances are structured. Do you use mixed media?

Yes. For example, the performance at Bennington College and Expo '67. One can use films and slide projections to produce an image and compare that image with a live figure performing a very simple act, like firing a pistol, with the slide representing action that is frozen, or the motion picture without sound to show the way different people perform the same act. In one performance there are ten different images, each lasting about three minutes; the tape recorder is the first image and is not a complete structure in itself . . . so that later when people see the scene they are going to remember the tape and will be involved with memory and expectancy. People begin to expect the next variation and we have to give them variations they do not expect. One image uses superimpositions and another image uses a fugue-type structure with two identical live performances going on at the same time. I think of the whole as Cubistic, looking at the material from unusual angles and points of view. We are using the material of traditional theatre with an entirely different ontological approach.

Your sculpture has a very personal and interesting concept.

Well, from the aesthetic point of view, I would agree with you. Of course, what I am working with is universal but I am investigating new ways of seeing and, from that point of view, I do believe that I am going in my own direction. When we look at a sculpture, here·in the gallery, we ignore the gallery, the walls, and everything around us. This is an unconscious mental attitude that operates habitually. I feel that art has dealt with states of mind and that is something I am working against. I am against the set of an hermetic work of art, a work of art cut off and self-sufficient. As the viewer becomes aware of the relationship of the sculpture to the room, a certain tension exists. All of my pieces have that kind of content in them.

I would like to see if I could describe to your satisfaction the piece of sculpture you will have in this exhibition. It consists of three parts, one of which has two elements. One part stands in the center of the gallery and has six faces. Each face is looking at a specific part of the room and this is reflected in the face by means of a

Les Levine: *Star Machine*. 1967. 84″ x 86″ x 120″. Photograph courtesy of Finch College Museum of Art, Contemporary Study Wing.

Ursula Meyer: *The Laws.* 1967. Two modules, 73" x 194" x 132". Photograph courtesy of Finch College Museum of Art, Contemporary Study Wing.

Brian O'Doherty: *Pair.* 1967. Two modules, 7' x 2' x 2 2/5' x 2 2/5'. Photograph courtesy of Finch College Museum of Art, Contemporary Study Wing.

photograph of that area of the room. Another part is a Window Piece *reflecting inside what may be seen outside the window, showing relative distances. Tremendous tension exists between each face reflecting each other and a specific area of the gallery. Does this sculpture have a name?*

I consider this not one piece of sculpture but three, namely, *Floor Piece, Window Piece,* and *Collection Frames.* Each piece has its own system of seeing. The *Floor Piece* and the *Window Piece* are definite, the other is really one piece now, in two parts. Sometimes the work is separated by space, but it's still the same piece. This is not one sculpture; the three are separate. It would be three pieces, in four parts. I create them individually and do not think of any relation, although sometimes I end up getting more and more elaborate, so that I may end with one piece that has ten or eleven different parts.

Are all pieces related to each other, with their photographs and mirrors?

Well, each piece relates to the room that it's in. If other pieces are in the room, naturally that piece will relate to the others, but there is nothing necessary about it. Although my sculpture uses representational material, I consider my work abstract. I'm not making any comment on the things represented themselves. The photographs are merely a device to create an abstract structure. A photograph is not really realistic, any more than acting is the thing itself—you never get that real in acting.

In my sculpture in this exhibition, some of the photographs are "mirror-photographs"; others are "window-photographs." The *Floor Piece* will reflect the four corners of the room, the opposite wall, the ceiling, and includes the imaginary section that is not there. The aluminum holding the photograph is buffed to a mirror finish so you get some reflection.

What would you like to do eventually with your structures?

I would like to place pieces outdoors in a landscape that could relate to views miles away, working also with the tension and pressure of time.

Les Levine

What was your purpose in making the Star Machine?

The purpose in making this piece was to make a piece that would be very close to not existing and yet exist. I have said many times that I wish I were completely invisible—that I were just an idea, rather than a physicality of any kind. In this piece, that is what I was trying to achieve more than anything, the idea that you sense space and you feel it the way you feel cloth or any textural thing like space—not a graphic image of space in the way painters will paint one square red and another blue, knowing that the red square, being the same size, is going to appear larger because red is a more intense color and is going to appear closer; that is a graphic demonstration of an illusionist space, whereas what I am after is the experience of the space. The *Star Machine* itself is purposely meant to be barely there—if it could be less there, I would be even happier.

Well, you are working with a kind of visual–nonvisual space.

I am trying to create an art that does not rely on contemplation—is not a contemplative device of any kind—but is one that involves the person in a kinetic experience. By kinetic I mean a relationship of movement to his own body, not kinetic in the fact of art that moves, probably in the sense that you feel your arm moving out and that is a sensation of some sort. When you walk into the *Star Machine* you feel a type of space—you become totally aware of the space and then you realize all of a sudden that you can not see that space; you can feel that it is there, so that the work is concerned with sensation and experience rather than some kind of intellectual contemplation. Going along with that idea, the piece was made with no distortions at all. Some artists would say: "Well, if that were distorted, the room would move and so forth . . ." But you see, I am not interested in illusionistic things at all. I am interested in reality. It may be a very small reality, but it is that. It is like flopping into a chair—as real as that sensation; it is your body moving through space. Illusions are interesting, but they are not for me.

Did you watch the development of the Star Machine *at the factory?*

When I first started, I would go to the factory and get involved in being told "this can't be done." Most of the things that I have done in the plastic area are things that are being done for the first time.

Naturally, people would tell me: "It would be better if you did it this way," because they did not want to get involved in something that might end up a failure. Through dealing with them, I have learned their language, the technical words that are used by engineers, so that I can give my orders by phone. By not going I save myself the problem of somebody saying to me, "Will you change it?"

You had an exhibition called The Slipcover, *I believe.*

That was at the Ontario Gallery of Art, which is the Art Museum of Toronto. The whole room was completely mirrorized—floor, ceiling, walls—with a plastic that is metallized. In this room there were eight walls; two inflated and deflated all the time, so that you had this constant sensation of the space changing, getting larger and smaller. While this was going on, quietly there were six projectors constantly projecting images into the room—not just random images, but images of exhibitions that had taken place in that room for the past year—so that you had the new version of the room and all that space along with the memory of what it had been, and the room became information about itself.

Please tell me about the film you have made; I would like the opportunity of previewing it.

The film is called *Critic.* It was made by having fifteen New York critics come to my studio and I video-taped about three minutes of each of them talking. They were given a choice of topics, but most of them chose to talk about criticism. It was unrehearsed, unedited. My point was that criticism and art are two different things; reading criticism is a completely different experience from dealing with art. The idea of having critics once removed on television and removed from television onto film is the same kind of removal that you get when you look at art through the critic's eye.

Did each critic explain his bias?

I think their biases came out very clearly—they tended in some small way to let you know their bias.

For the finished film did you edit or add anything?

This is an enormous difficulty that people have, not only in my work in sculpture, but also in the television thing that I do. They do not understand what intellectual repose is. They do not understand that reality in itself is the strongest element that anyone can use.

Ursula Meyer

When I first saw your work two years ago, you were working in Cor-ten Steel and Masonite and your scale had changed from your early work. I was particularly interested in your large walk-through sculpture The Three Blues. *I had the freedom of walking in and around it and the proportions were so perfect.*

When you came to me and spoke of walk-in sculpture I thought of sculpture tailored to man. It made me think of the Renaissance statement: "Man is the mode and measure of all things." It became interesting to me to compare this notion with our contemporary concept. The buildings in the Renaissance—churches, palaces, ships, and machines—derived their dimensions from the proportions of man. Renaissance man was divine and, therefore, his proportions were considered ideal and of the utmost perfection and the dimensions of buildings evidenced this concept. Would it not be preposterous if contemporary architects and engineers were to apply anthropomorphic proportions to their buildings and machines? No longer is the man the measure of all things, but the things have become the measure of man. This reverse process is succinctly exemplified by the astronaut strapped to his seat in the "wraparound space" of his capsule. By the same token Marshall McLuhan calls the Volkswagen a "wraparound car." I believe that scale and proportion in sculpture relate to the image of man—as the artist perceives it—here and now.

How do you feel about color in sculpture?

I do not believe that color should be "superimposed," I mean added as a decorative touch. Color has to be an integral part of sculpture. If the piece is devoid of formal complexities color gives it a completion, which otherwise it would not have. I apply the "frontal approach" in the *Three Blues*, which you saw in my studio. In pieces that are utterly simple, "frontal approach" makes a great deal of sense. However, most of my sculpture is devoid of color. Thinking in terms of color relates very seldom to my concept of form. There is one neutral color in *The Laws* shown in this exhibition. This work may appear simple but it is not: it is not only what it is, but it is also all the possible variations of what it could be. The idea of inner logic of form or of related forms is paramount. Radical abstraction or

reduction calls for the understatement of material, color, and texture. The result is a no-material and a no-color treatment. I feel that too much concern with material, and for that matter craftsmanship, can get in the way of art.

How has your sculpture developed from the model I saw?

There was something in the model that did not satisfy me. I felt it was something too pleasing. I think that anything in art that has value comes more as a shocking than a pleasing experience. It makes me sceptical when a work is too easy and non-demanding.

What change did you actually make?

At first the organization of the two identical forms of *The Laws* was asymmetrical. Then I decided to use opposites, positioning the two forms symmetrically. This change made an enormous difference. It brought to mind the poet's line, "God, Thou great symmetry" quoted by Weyl in *Symmetry*.

I noticed that rather than being a compact whole your sculpture often consists of several elements or modules.

Yes. I am interested in the simplification, and the split you observed is a direct development of simplification. Formal relationships are expressed in terms of various discrete forms. I think if we work with modules we might just as well go all the way and present them as such, unconnected with each other. Rather than being part of a fixed whole, the module becomes "liberated" relating to other modules as form and value in its own right. *The Laws* consists of two modules, offering many different possibilities of positioning. The inherent complexity of relationships is so strong that this work can be arranged in thirty-six variations and many more. Confronted with this richness of possibilities it is up to the artist to make the final decision. I do not think I would offer a sculpture with thirty-seven possibilities as a "do-it-yourself" proposition. The choice signifies the artist's commitment.

What is the basic formal concept of your art?

Almost all of my sculptures relate in one way or another to the square, ergo the cube. For me the square is the most beautiful man-made form, lending itself to an endless wealth of ideas. All other geometric forms can be derived from or related to the square. Above and beyond its inherent form potential it is also charged with spiritual energy. The "most simple geometric forms" have fascinated

Western scientific minds since Plato in terms of their mathematical exploration. In the Orient for thousands of years devotees and philosophers have used the square or the square in the circle, called mandala, for meditation exercises. To me the contemplative aspect of art is essential.

The blocklike structure of my sculpture *The Laws* declines at an angle of thirty degrees, which lends energy to the concept. I thought of the tables of the laws, the laws of nature, the laws of logic, the laws of symmetry, the laws of society, strong and powerful, seemingly threatening us with their weight, yet immutable, immovable, impersonal and unconcerned. . . . In calling my sculpture *The Laws* I thought of all of this and none of this. A title is unimportant and should not be mistaken for a message. This title has endless meanings, hence none at all.

Brian O'Doherty
I am interested now in discussing your work as an artist and specifically your sculpture in this exhibition.

I am working in three series right now. One is a series of labyrinths, which are the main thing really. The other is a series of pairs, and sometimes the pairs are put together. The third is a series of paintings, which is very unusual for me, that arise out of the labyrinth idea. I have been thinking for some time that painting has got to learn to be just a surface again, to be very flat again. At the same time, I have had a certain interest in the recovery of deep space on the surface. I have sort of worked this out from the labyrinth design, translated onto just flat glass. It is painting on glass that I think does this, and I am working larger, three and four feet now. That's large for glass, which weighs a ton.

One of the things that strikes me about the whole development of non-romantic art here, is that it is so late. It happened in literature long ago. The fact that it is so late happening is evidence that art is not ahead of its time but behind it. The artists are just catching up with their time now. I think the reason for that was Abstract Expressionism with its apotheosis of the individual; it is really a frontier climax of Romanticism, Delacroix on the frontier. As such, it has a sort of attraction in a mythical fashion, just as Marshall Dillon

does. The degree of its success kept other things from happening, or masked them.

Well, it did give an aesthetic freedom that we had not had before.

It is a curious heroic movement, really, because it is so varied in fact and so monolithic in myth and so many things can be traced to it. I think in the next ten years, we will be able to see the way things passed through it. I like also the fact that once you remove the romantic narcissism of expressionist abstraction, the artist is allowed to be what he wishes to be; to be a scholar, to be a philosopher, to be a connoisseur, to be a thinker, to be like a lawyer or a shopkeeper without any moral depreciation.

I want to get back to talking about your work, Pair. Do you want to describe it?

It is two standing pieces, triangular in section, identical in form. Seven feet high at the back, at the apex of the wedge, 5½ feet high, there is an inclined section from the 7 to the 5½ feet. Part of the sides are covered with aluminum, so that they function both as space and as solid; virtual and actual; and also they are set up back to back so that there is a sliver of space used as a reflecting material also.

May one walk between them?

No, it is too tight for that. The work has two basic positions: back to back and leading edge to leading edge. The first position is preferable. *Pair* is a one of a series of "double" pieces. Sometimes the halves are identical, sometimes mirror images, that is, right- and left-handed. They are all made of an opaque (painted) and a reflecting surface ($\frac{1}{32}$-inch aluminum). The work is based on fractional (disproportionate) measurements.

Although the pieces are easily conceptualized, that is, "understood," actually looking at them denies rather than confirms this concept. Thus, they are more easily clarified in memory than in fact, with the eyes closed rather than with the eyes open. Thus, looking at the work becomes a form of not seeing it. I would hope that the undersophisticated would apprehend this instinctively, and the oversophisticated artificially. (I am not much interested in those that lie between.) Should this be understood as a dialogue between a whole and its parts, or as a system of relationships, or as a perceptual proposition or *Gestalt*, the work (and the viewer) fails. The work's

real nature could be emphasized by illuminating the work momentarily at intervals in a dark room containing the viewer, or by a series of photographs, but these "aids" should be denied.

Charles Ross

What happens when you teach? What kind of problems do you propose to your students?

I think the major effort in teaching is getting students to be able to see. The problems are dependent upon how the student's work is developing at the moment. I do give a lot of process problems. We set up some rules for a piece of sculpture, and the students work with the rules and the sculpture is as different as people are.

Tell me about the dance programs and what you did at the Judson Theatre.

Yvonne Rainer and I did a piece that was called *Room Service*. We both did the choreography and performed independently in it. I built the structure right though the dance; Yvonne and another dancer led two teams in a follow-the-leader fashion through the environment that I was filling with constructions so that the dancers would have to deal with the changing environment all the time. Three people in the line would pass; then, for instance, a wall would go up so that the other people would have to scramble over the wall to keep in the same path. It made a very interesting feed-back situation between what I was doing and what they were doing.

Would you give me a definition of what is meant by a "Process Situation"?

Yes. You define a procedure, a method of acting or rules for moving across the room; perhaps a different set of rules for each participant. The scheme is completely tightly formed; it is totally organized, without knowing the result. This summer I expect to be working with Group 212 in Woodstock. It is a group of artists, filmmakers, and dancers organizing a collaborative school. At that time, I hope to concentrate my energies on the process of setting up structures for generating movement situations using the natural environment.

Your sculpture was included in eleven important exhibitions in 1966–67. I would like to know something about the philosophy behind your new work in Prism Sculpture.

Charles Ross: *Islands of Prisms.* 1967. 9″ x 3′; 3′ x 3′. Photograph courtesy of Finch College Museum of Art, Contemporary Study Wing.

Tony Smith: Model for *The Maze*. 1967. Two modules: 6'8" x 10" x 30"; and two modules: 6'8" x 5' x 30". Photograph courtesy of Finch College Museum of Art, Contemporary Study Wing.

There are three aspects to my work, and they happen simultaneously. When you look at one of the prisms, you see the form of the piece, you see into it, and you see through it, all simultaneously. You experience two realities in one moment of time because things may be seen in natural space and in prism space. Neither you nor others may enter the space seen in the prisms, yet you may see others in that space. The pieces act as windows between the two realities. The space that you see in the prisms is not an illusion, it is an optical reality; a transformation of the existing space.

When I saw your show I felt this in the perpendicular, triangular pieces, but not in the horizontal ones.

It works differently with the horizontal pieces; they are conceived as islands of prisms in space, evenly distributed. As you approach these prisms, depending on your distance from them, you either see images of the ceiling, across the room, the floor, or the light broken down. This changes depending on your location. This puts you in touch with the space you are in in several different ways. When you are walking toward them and the floor turns into the ceiling, you experience a spatial shift in your own reading of the gallery.

Is this piece that you have described for this exhibition called The Island of Prisms?

They do not have names; they have descriptions. For instance, I would describe this as six sets of prisms with six prisms in each set. The prisms are three inches on a side and are spaced three inches apart within each set. That is, they are spaced evenly, the same distance apart as they are wide, producing a perfectly regular grid. The sets are identical except in length. Length is determined by consecutive halvings of the longest set: six feet, three feet, eighteen inches, nine inches, four-and-a-half inches, two-and-a-quarter inches. The sets are evenly distributed in space and hang at chest height in a plane parallel to the floor. The evenly distributed islands of prisms that you may walk among define a plane that slices the space into two parts.

The perception of space and light through the prisms changes character with the changes of length of the sets. The long set emphasizes a second optical space, the medium sets, a repetition of images, and the small set, bits of light. In this case, although the prisms do not control the space, their placement does, since it fills

and divides the room. The prisms have emerged out of my previous work with modular generating systems in sculpture and my environmental work with the dance.

Tony Smith

Your exhibition in Bryant Park gave not only gallery-goers but all of New York an opportunity to see your work. Congratulations on that exhibition and on your excellent one-man shows in 1966 and 1967 at the Institute of Contemporary Art, Philadelphia; the Wadsworth Atheneum, Hartford; the Los Angeles County Museum, and the Detroit Institute of Fine Art. Do you teach sculpture at Hunter College?

I teach painting and I try to relate my own experience to whatever problems we are dealing with and see in what way the student can verbalize it or give some kind of structure to it, which would be related to other ideas and knowledge generally. I can't stand exercises. I would rather have a student involved in some emotional way and do something that I would consider, well, perhaps, spontaneous or not fully realized, in order to see some of the unconscious potentials as well as something that has been developed in any way. I do not believe that I am particularly interested in the quality of work as such. I do not have standards of work. I am much more interested in the students' approach and attitude—am much more interested if I feel that the student is learning through the work and relating his experience to his developing knowledge as a general thing. I think my ideas are very much like a liberal arts approach for any other subject. It is simply an instrument—since every discipline has certain limitations—to make it possible to think about it with some clarity and at the same time relate it to other experience.

Recently I read a statement by you on "modules." Can you explain further the ordering of plans for structural regularity rather than bilateral symmetry?

For the last couple of thousand years most buildings have been based on symmetry of some kind; by far, most of them on bilateral symmetry. There were relatively few towers and, of course, almost no buildings were symmetrical at that point as total buildings. However, there were domes, which are symmetrical, but they were usually incorporated in structures that were basically either radial or

bilateral. Therefore, I think we can say that almost all buildings were based on bilateral symmetry. So this is the basis on which plans were regulated at this period of time. At the beginning of the twentieth century, factory buildings, commercial buildings, etc., began to be regulated according to bays, according to column centers, without any organic symmetry or anything based on point, line, or plane being imposed on them, so that it would just be a repetition of units. It did not make any difference where a building ended. For instance, Mies Van der Rohe has said of the repetition in New England factories that they run out; that is, that the bay sides, the small windows between the wall sections, are so small and repeated so often that it is impossible to comprehend the building as a complete unit. At the same time, architects began to take over this column-spacing as the basis on which buildings would be organized. This gave them far greater freedom and flexibility in regulating the plan. They were not reduced to introducing elements of false masks and all sorts of things just for the purposes of symmetry; they utilized as much of the building envelope as possible. As soon as we begin to think of front and back we are almost always involved in some form of bilateral symmetry, unless, of course, it lacks symmetry altogether, which is a much more contemporary idea.

Do you have the drawing of the design for the structure entitled The Maze *that you created for this exhibition?*

Yes. I realize it is not a maze in the sense of being confusing but I think the overall impression is that of a complicated structure. Instead of having any obvious order, it has a sense of many elements that are either opened or closed passages.

Are you aware that Brian O'Doherty is very interested in labyrinths and wells?

I do not know him but we are both Irish. This interest in labyrinths comes from New Grange, I suppose.

How high will the structure be?

It will be 6' 8". Leaving 3' and 30" on each end of the gallery, which is the width of an ordinary door on either side; the piece is 10' long by 30" wide by 58" high. When I was given the dimensions of this gallery, I decided to use a five-foot module, dividing that again in half, and thus making thirty inches the size of the units. I did not think of the symmetry of the piece as I was doing it, but I just

happened to notice when I was making this drawing that the central part is a five-foot square; the part including all the passages is a ten-foot square; then if you take the extension along the room, it is a fifteen-foot square; if you extend thirty inches on either end like that, the entire thing becomes a twenty-foot square. So that you see it is a lot of expanding squares. Then, on the other hand, if you take different divisions of the thing, for instance, if you take all these squares and carry them through, they make a grid which interpenetrates—the two sets of grids interpenetrate one another. In a certain sense, it is a labyrinth of the mind; you can see that it becomes quite complex, but at the same time, everything falls in very, very simply. In height, it is just a half of the height of the room in which it is being exhibited. I just noticed it after I did it. I did not design it that way. But I suppose, after a time, some kind of organization becomes second nature.

I think my pieces look best with very little light. In my studio I like to show them at dusk without any lights on and I have canvas stretchers over the windows so that there is a very subdued light. In my studio they remind me of Stonehenge. I like dawn or dusk light. Since there is nothing else in the room, I think that if light is subdued a little, it has more of the archaic or prehistoric look that I prefer. Actually, my work is best presented when it is outdoors, surrounded by trees and shrubs, where each piece can be seen separately by itself.

TALKING WITH TONY SMITH by Samuel Wagstaff, Jr.

The following notes are taken from conversations between Samuel Wagstaff and Tony Smith. Originally an architect, Smith turned to sculpture in 1960. Many artists consider him to be possibly the most important and influential sculptor and teacher working today.

Samuel Wagstaff is Curator of the Wadsworth Atheneum Museum in Hartford, Connecticut, where Tony Smith had his first one-man show in 1967.

In their *International Style in Architecture*, (1932) H. R. Hitchcock and Philip Johnson said that the style was characterized, among other things, by ordering the plan through structural regularity, rather than through unilateral symmetry. I had been familiar with the root rectangles of Jay Hambidge's *Dynamic Symmetry* since before I started high school. I had no experience in architecture, and the notion of planning according to regular bays, although all over the place, hadn't occurred to me. In painting, however, as I tried more and more schemes, I reduced the size of the format. I painted dozens of 8" x 10" panels, and began to use a 2-inch square module instead of the application of areas based upon the root rectangles.

When I saw the January, 1938, *Architectural Forum*, devoted to the recent work of Frank Lloyd Wright, one of the things that struck me most was his use of the modular system of planning. I spent the summer of 1938 in the Rockies and had an opportunity to design and build some small buildings based on plans from the Department of Agriculture, and on modular organization. By the time I began to work on the Ardmore Experiment (designed by Wright) in the spring of 1939, I began to see the limitations of systems based upon material sizes as units. At some point, the book, *Das Japanische Wohnhaus* made it clear that the *tatami* (or mat) modules of the Japanese had the same shortcomings. I hadn't heard of Beamis until the publication of the A62 guide. After this, most

building materials became available in sizes based upon a continuous space grid of four inches.

Meanwhile, I had been interested in the exposition of close-packing in D'Arcy Thompson's *On Growth and Form*. A large structure based on the tetrakaidecahedron was built by students at Bennington College in the spring of 1961. Another, based on the rhomboidal dodecahedron is shown as a mock-up in Philadelphia. Thompson was writing about the effects of mathematical and physical laws upon living form. He did not, therefore, go into space frames based on the tetrahedron, which is the basic unit of many of these figures.

The Honeycomb House on the Stanford University campus had been published in the January, 1938, *Forum*. A few years later I had the opportunity to design a large house on a hexagonal module. I used one twice the size of that used in Wright's house. Also, instead of pigeonholing the bricks at the 60° and 120° corners, I used rhomboidal bricks manufactured for the job. I was very pleased with the flow of large surfaces, and the substantiality of the paced unfolding of form in this house undoubtedly relates to some of the present work.

An article appeared in *Architectural Forum* by the engineer, Fred Severud. Several structures, including the Johnson Wax Administration building, were analyzed and alternate schemes demonstrated. For the Johnson columns and roof sections, Severud showed an inverted pyramid instead of Wright's shallow cones. I immediately tried to do something of the same sort on a hexagonal plan. The scheme for my church was ultimately an outgrowth of this exercise. The development was moving in the direction of close-packing in three dimensions.

It was at about this time that I saw, for the first time, the kites, towers, and other structures based upon the tetrahedron that Alexander Graham Bell had made in 1901. While the axes normal to the surfaces of a cube are three, those perpendicular to the planes of a space-lattice made up of tetrahedra and octahedra are seven. This allows for greater flexibility and visual continuity of surface than rectangular organizations. Something approaching the plasticity of more traditional sculpture, but within a continuous system of simple elements, becomes possible. The hexagon offers possibilities for greater flexibility in planning and, even construction, for certain

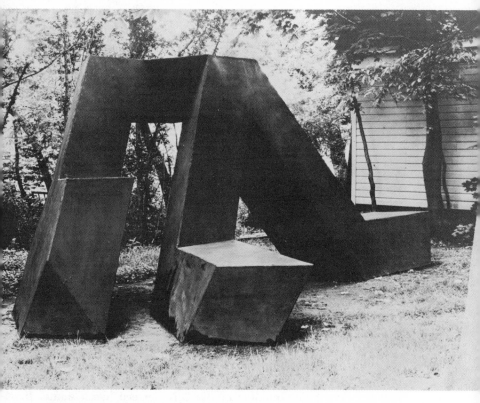

Tony Smith: *Willy*. 1962. Plywood, weather-proofed with black car undercoating. 7'8'' x 18' x 12'. Photograph courtesy of *Artforum*.

problems. But in spite of far greater advantages, for building at least, the tetrahedron was taking me farther and farther from considerations of function and structure toward speculation in pure form.

If I were to say what I had accomplished, one of them closest to me would be the French and Company gallery in the Parke-Bernet building. It was here that I perhaps realized my sense of scale and monumentality for the first time. (It's unrecognizable as it exists today.)

Corbusier is by far the greatest artist of our time—greater than Michelangelo—though he never did anything so great as the Medici Chapel. I'm not saying that Corbusier is finer. He is tougher and more available. The direct and primitive experience of the High Court Building at Chandigarh is like the Pueblos of the Southwest under a fantastic overhanging cliff. It's something everyone can understand.

Architecture has to do with space and light, not with form; that's sculpture. Craftsmanship and art are much closer than artists seem to be willing to admit, but the question is, where does the distinction seem to take place?

I view art as something vast. I think highway systems fall down because they are not art. Art today is an art of postage stamps. I love the Secretariat Building of the U.N., placed like a salute. In terms of scale, we have less art per square mile, per capita, than any society ever had. We are puny. In an English village there was always the cathedral. There is nothing to look at between the Bennington Monument and the George Washington Bridge. We now have stylization. In Hackensack a huge gas tank is all underground. I think of art in a public context and not in terms of mobility of works of art. Art is just there. I'm temperamentally more inclined to mural painting, especially that of the Mexican, Orozco. I like the way a huge area holds onto a surface in the same way a state does on a map.

I'm interested in the inscrutability and the mysteriousness of the

thing. Something obvious on the face of it (like a washing machine or a pump) is of no further interest. A Bennington earthenware jar, for instance, has subtlety of color, largeness of form, a general suggestion of substance, generosity, is calm and reassuring—qualities that take it beyond pure utility. It continues to nourish us time and time again. We can't see it in a second, we continue to read it. There is something absurd in the fact that you can go back to a cube in this same way. It doesn't seem to be an ordinary mechanical experience. When I start to design, it's almost always corny and then naturally moves toward economy.

When I was a child of four I visited the Pueblos in New Mexico. Back in the East, I made models of them with cardboard boxes. While still quite young I associated the forms of these complexes with the block houses that Wright built in and around Los Angeles in the early twenties. Later I associated them with Cubism, and quite recently thought of the dwellings at Mesa Verde in relationship to the High Court Building at Chandigarh. They seem to have been a continuing reference, even though they were never in my consciousness except as that. In any case they seemed real to me in a way that buildings of our own society did not.

I'm not aware of how light and shadow fall on my pieces. I'm just aware of basic form. I'm interested in the thing, not in the effects—pyramids are only geometry, not an effect.

My speculations with plane and solid geometry and crystal forms led me to making models for sculpture, but what I did always made use of the ninety-degree angle, like De Stijl. I only began to use more advanced relationships of solids after working with Wright and then related the thirty- and sixty-degree angles to the ninety-degree angles.

We think in two dimensions—horizontally and vertically. Any angle off that is very hard to remember. For that reason I make models—drawings would be impossible.

I'm very interested in Topology, the mathematics of surfaces, Euclidian geometry, line and plane relationships. "Rubber sheet

geometry," where facts are more primary than distances and angles, is more elemental but more sophicated than plane geometry.

When I was teaching at Cooper Union in the first year or two of the fifties, someone told me how I could get onto the unfinished New Jersey Turnpike. I took three students and drove from somewhere in the Meadows to New Brunswick. It was a dark night and there were no lights or shoulder markers, lines, railings, or anything at all except the dark pavement moving through the landscape of the flats, rimmed by hills in the distance, but punctuated by stacks, towers, fumes, and colored lights. This drive was a revealing experience. The road and much of the landscape was artificial, and yet it couldn't be called a work of art. On the other hand, it did something for me that art had never done. At first, I didn't know what it was, but its effect was to liberate me from many of the views I had had about art. It seemed that there had been a reality there that had not had any expression in art.

The experience on the road was something mapped out but not socially recognized. I thought to myself, it ought to be clear that's the end of art. Most painting looks pretty pictorial after that. There is no way you can frame it, you just have to experience it. Later I discovered some abandoned airstrips in Europe—abandoned works, Surrealist landscapes, something that had nothing to do with any function, created worlds without tradition. Artificial landscape without cultural precedent began to dawn on me. There is a drill ground in Nuremberg, large enough to accommodate two million men. The entire field is enclosed with high embankments and towers. The concrete approach is three sixteen-inch steps, one above the other, stretching for a mile or so.

I think of the piece as pretty much in a certain size and related to ordinary everyday measurements—doorways in buildings, beds, etc. All the pieces were seen in greenery in the past. I might change a piece that was to be on a plaza to accommodate its scale, size, and color. *Generation* is the first piece I thought of as a citified monumental expression. I don't think of it as personal or subjective. I attempted to make it as urbane and objective as possible.

MINIMAL ART* by Richard Wollheim

In this essay Richard Wollheim discusses work and effort in art. He con-
siders work both as a process of the building up as well as of the dis-
mantling of some image, and he observes that in Minimal Art, ". . . the
elements of decision or dismantling acquire a new prominence. . . ."
The author may well have been the first critic to apply the label "Mini-
mal" to recent art.

Richard Wollheim is Professor of Philosophy at University College,
London, and has contributed articles to *Partisan Review* and *Encounter*.

If we survey the art situation of recent times, as it has come to take
shape over, let us say, the last fifty years, we find that increasingly
acceptance has been afforded to a class of objects that, though
disparate in many ways—in looks, in intention, in moral impact—
have also an identifiable feature or aspect in common. And this
might be expressed by saying that they have a minimal art-content:
in that either they are to an extreme degree undifferentiated in
themselves and therefore possess very low content of any kind, or
else the differentiation that they do exhibit, which may in some
cases be very considerable, comes not from the artist but from a
nonartistic source, like nature or the factory. Examples of the kind
of thing I have in mind would be canvases of Reinhardt or (from
the other end of the scale) certain combines of Rauschenberg or,
perhaps better, the non-"assisted" ready-mades of Marcel Du-
champ. The existence of such objects, or rather their acceptance as
works of art, is bound to give rise to certain doubts or anxieties,
which a robust respect for fashion may fairly permanently suppress
but cannot effectively resolve.

In this essay I want to take these doubts and anxieties seriously, or
at least some of them, and see if there is anything they show about
the abiding nature of art.

* Reprinted from *Arts Magazine,* January, 1965.

In a historic passage Mallarmé describes the terror, the sense of sterility, that the poet experiences when he sits down to his desk, confronts the sheet of paper before him on which his poem is supposed to be composed, and no words come to him. But we might ask, Why could not Mallarmé, after an interval of time, have simply got up from his chair and produced the blank sheet of paper *as* the poem that he sat down to write? Indeed, in support of this, could one imagine anything that was more expressive of, or would be held to exhibit more precisely, the poet's feelings of inner devastation than the virginal paper? The interest for us of such a gesture is, of course, that it would provide us with an extreme instance of what I call Minimal Art.

Now there are probably a lot of reasons any one of us could find for regarding the gesture as unacceptable: that is to say, for refusing to accept *le vide papier* as a work of art. Here I want to concentrate on one. For it has some relevance to the more general problem.

Suppose that Yevtushenko sits down in Moscow and writes on a sheet of paper certain words in a certain order, and what he composes is accepted as a poem; now further suppose that someone in New York, a few weeks later, gets up and reads out those same words in the same order; then we should say that what the person read out in New York was the poem that Yevtushenko wrote in Moscow. Or rather we should say this provided that certain further conditions, which might be called, very roughly, continuity-conditions, were satisfied: that is to say, provided the man read out the words he did read out because Yevtushenko had previously written them down, and that he hadn't quite independently got the idea of conjoining them in Yevtushenko's order, etc.

A poem (one and the same poem) can, then, be written in one place, read out in another, printed in yet another, appear in many copies of the same book, be learnt by generations of children, be studied by critics in different countries: and all this without our having to assume that the poem somehow reproduces itself indefinitely by some process of division or fissure. For the poem, though it is, say, printed on a certain page, is not to be identified with those printed words. The poem enters into all the different occurrences—recitations, inscriptions, printings, punishments, memorizings—not because some common stuff is present on all these occasions, but

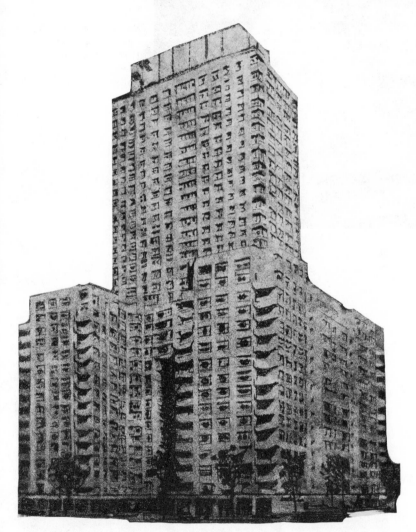

Richard Artschwager: *High Rise Apartment*. 1964. Liquitex on celotex with formica.
63″ x 48″ x 4½″. In the collection of Philip Johnson. Photograph courtesy of
Leo Castelli Gallery, New York.

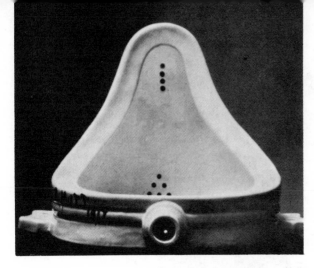

Marcel Duchamp:
Fontaine (Fountain).
1917. Ready-made:
urinal. 23 5/8" high.
Gallery Schwarz,
Milan.

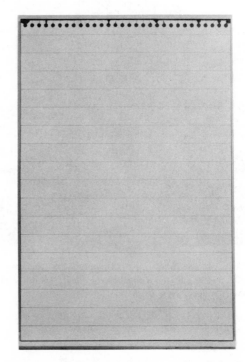

Alex Hay: *Stenographer's Sheet*. 1966. Spray lacquer and stencil on canvas.
71" x 48". Photograph courtesy of Kornblee Gallery, New York.

because of some common structure to which the varied stuff on the different occasions (different paper, different ink, different noises) conforms. It is this structure, which originates with the poet's act of creation, that gives the poem its identity.

Now we can see one overwhelming reason why Mallarmé could not have produced the blank sheet of paper as the poem he had in fact composed. For there is no structure here on the basis of which we could identify later occurrences as occurrences of that poem. We would have no right to say of anything, "Here is Mallarmé's poem." Alternately, we should have to regard every blank page in the world, or every blank space, or indeed just every blank, as carrying not potentially but actually Mallarmé's poem. It would have to be seen as inscribed in the interstices of every inscription in the world.

And now suppose that Rauschenberg in New York conjoins a bicycle and a wooden culvert, and this combination is accepted as a work of art; and further suppose that someone in Moscow, again after a period of time, also gets hold of a bicycle and a wooden culvert and brings them together in the same way as Rauschenberg did, and (for the sake of argument) exhibits it. Now I think it is evident that no one would say that what had been exhibited in Moscow was the combine that Rauschenberg had constructed in New York. And this would be so, even if something analogous to what I have called the continuity-conditions in the case of Yevtushenko's poem, were satisfied: that is to say, if the Russian artist put the objects together as he did because Rauschenberg had done so first, and he hadn't independently hit on the idea of doing so, etc.

Now all this, it will be appreciated, derives directly from the criteria of identity that we employ for distinguishing works of fine art (not "visual" art, for the criteria are evidently different in the case of, say, engravings or lithographs). What it has nothing to do with are purely artistic or aesthetic considerations. It has, for instance, nothing to do with what we think about the merits of copying: all it relates to is the question whether if copying does issue in works of art, the copy is or isn't an instance of the same work of art as the original.

And the identity of a work of fine art resides in the actual stuff in which it consists.

From which we can see that Mallarmé could, in principle, have got up from his desk and produced the blank sheet of paper as the painting or drawing in which he had been engaged. For then there would have been an actual object that we could have identified as Mallarmé's painting, even though there was nothing to be identified as Mallarmé's poem. The production of the blank sheet of paper as the poem in which he was engaged would find its parallel in the area of the fine arts not in the production of a blank canvas, but in something like the gesturing toward the content of an empty studio.

In philosophical language, a literary work of art is a *type*, of which your copy or my copy or the set of words read out in a particular hall on a particular evening are the various *tokens:* it is a type like the Union Jack or the Queen of Diamonds, of which the flags that fly at different mastheads and have the same design, or the cards in different packs with the same face, are the tokens.

But what *would* we say about the combine that the Russian Rauschenberg put together in Moscow to the exact specifications of the American Rauschenberg in New York? We have seen so far that we couldn't say that it just is Rauschenberg's combine, in the sense in which the thing read out in New York *is* Yevtushenko's poem. But could we treat it none the less as a work of art: that is to say, as a *new* work of art?

At this historical juncture it seems hard to pronounce definitively on this point. But certainly there would be tremendous resistance to our accepting this suggestion: resistance that we could perhaps break down in this case or that, but not universally I suspect without the total disintegration of our concept of "art" as we have it. The recognition of variants or copies within traditional Western art; the precedent of alien art traditions in which change or stylistic modification has been at a minimum; the parallel existence of etchings and lithographs that come in states and editions—all these provide us with temptations to capitulate, but temptations to which we are unlikely to succumb in any permanent way.

Now it will be apparent from what I have said about types and tokens, that the genuine Rauschenberg and the pseudo-Rauschenberg are tokens of the same type—though the type itself is not a work of art. If this is so, then it would seem that our existing concept

of a work of art has built into it two propositions, of which the first can be expressed as:

Works of fine art are not types, of which there could be an indefinite number of tokens;

and the second as:

There could not be more than one work of fine art that was a token of a given type.

This second proposition needs to be carefully distinguished from another proposition with which it has a great deal in common: i.e.

There could not be a work of fine art that was of a type of which there was more than one token;

which, I want to suggest, is clearly false.

For this third proposition would have such sweeping and totally objectionable consequences as that a work of art, once copied, would cease to be a work of art. It is indeed only when this sort of possibility is quite artificially blocked, by, say, a quasiempirical belief in the inimitability of genius, that this Draconian principle could even begin to acquire plausibility.

Yet there are occasions when the more moderate principle seems no less arbitrary in its working; indeed just because of its moderation, it seems, if anything, more arbitrary. In 1917 Marcel Duchamp submitted a urinal as a contribution to an exhibition of art. To many people such a gesture must have seemed totally at variance with their concept of art. But I am not concerned with them. If, however, we confine ourselves to those who found the gesture acceptable, then I want to suggest that what would have seemed quite at variance with *their* concept of art is that accepting the gesture committed them to rejecting in advance any of a similar kind subsequently made. Yet precisely this seems to be the consequence of our principle. By a simple action Duchamp deprived all objects of a certain kind save one of art-quality; and it might seem more arbitrary that he should have been able to do this than that he was able to secure it for that one.

Nor is this particular ready-made of Duchamp's likely to be a unique case. The problem then arises, How are we to delimit the cases where our principle gives rise to anomalies? For unless we can in some way delimit them, we shall find ourselves led back to the

Draconian principle that we have already rejected. We shall find ourselves asserting that what was wrong with Duchamp's urinal is that is is one of a type. But this, as we have seen, is not what is wrong with it.

Another and more specific suggestion might be that it is not just that there are other urinals exactly like Duchamp's, but that Duchamp's does not owe its differentiation from them (*it* is a work of art, *they* aren't) to any temporal priority to which it can lay claim. It isn't just that there are other tokens of the same type, but that there are, or very well might be, other tokens that preceded or anticipated it. And this indifference to time-order, respect for which is so carefully enshrined in the "original"–"copy" distinction of traditional thought, serves to single out a whole class of cases where we feel concern about accepting one but no more than one token of a certain type as a work of art.

Consideration of this kind of case suggests another. And this is where, though the facsimile does not in fact antedate the object that is accepted as a work of art, this fact seems to have very little significance. For the art object, or what passes for one, is so readily reproducible. The other tokens that aren't there could be with such little disturbance to anything. In such cases the object can't correctly be regarded as one of a stream of identical objects from which it has been arbitrarily abstracted. But there would be no difficulty in imagining such a stream to flow out: the object is a natural tap for its own likenesses.

And possibly there could be other cases where we might be tempted to feel the same kind of reserve. But I shall pause on these two kinds, and it will be apparent, I imagine, why they are of interest to me: for they totally overlap with the two sorts of object that at the beginning of this paper I identified as objects of Minimal Art.

But now, we might ask, why should objects of these two kinds give rise to any peculiar difficulties? Or, to put it another way, is there any common difficulty that we can see as lying in the way of accepting as works of art either artifacts of which there are or are likely to be preexistent facsimiles or highly undifferentiated objects? We don't mind, as we have seen, reproducibility; so why should we

mind facile reproducibility? Or is the whole matter, as Koestler once suggested, in a singularly unperceptive essay, just "snobbery"?

I suspect that our principal reason for resisting the claims of Minimal Art is that its objects fail to evince what we have over the centuries come to regard as an essential ingredient in art: work, or manifest effort. And here it is not an issue, as it was in certain Renaissance disputes, of whether the work is insufficiently or excessively banausic, but simply whether it took place at all. Reinhardt or Duchamp, it might be felt, *did* nothing, or not enough.

The connection between art and expression, which has been so elaborately reinforced in the art of the recent past, has of course in turn reinforced the connection between work and art. But I do not think that the former link is necessary for the latter, which quite independently (and I should say, quite rightly) enjoys such prestige in our aesthetic thinking that it is hard to see how objects of Minimal Art can justify their claims to the status of art unless it can be shown that the reason for holding that they inadequately exhibit work is based on too narrow or limited a view of what work is—or more specifically, of what work is as it occurs in the making of a picture.

And my claim, to which the rest of this essay will be devoted, is that this can be done. Indeed the historical significance of the art objects I have been concerned with is largely given by the way in which they force us to reconsider what it is to *make* a work of art: or, to put it linguistically, what is the meaning of the word "work" in the phrase "work of art." In different ways the ready-mades of Duchamp and the canvases of Reinhardt challenge our ordinary conceptions on this subject—and, moreover, challenge them in a way that makes it clear where these conceptions are insensitive or deficient.

The system upon which Marcel Duchamp selected his ready-mades he codified in the theory of *"rendez-vous."* At a certain time, at a certain place, he would chance upon an object, and this object he would submit to the world as a work of art. The confrontation of artist and object was arbitrary, and the creation of art was instantaneous.

Now if we ignore the whimsical, and equally the more disturbed,

aspects of these gestures, we can see them as isolating one of the two elements that traditionally constitute the production of an art object, and moreover the one that is often, indeed almost consistently, in ordinary reflection, overlooked in favor of the other. For the production of an art object consists, first of all, in a phase that might be called, perhaps oversimply, "work" *tout court:* that is to say, the putting of paint on canvas, the hacking of stone, the welding of metal elements. (In the next section we shall see that this picture even of the initial phase is too crude; but for the moment it will do.) But the second phase in artistic productivity consists in decision, which, even if it cannot be said to *be* literally work, is that without which work would be meaningless: namely, the decision that the work has gone far enough. Since the first phase is insufficient without the second, the whole process might in a broader sense be called work.

Now in Duchamp's ready-mades or in any form of art that directly depends upon preexistent material for its composition, it is this second phase in the total process of production that is picked out and celebrated in isolation. The isolation is achieved in the starkest fashion: that is, by entrusting the two phases to quite different hands. But, then, even this finds some kind of precedent within traditional art, in the role of the pupil or the *bottega*.

However, what might be objected to in Duchamp's practice, at any rate as we get it in the system of *"rendez-vous,"* is that not merely is there a division of labor between the construction of the object and the decision that the object is in existence, but that the decision taken about the object is not based on the appearance of the object at all. In other words, Duchamp makes a decision like an artist, but the decision that he makes is not like the artist's.

But even here it might be claimed, Duchamp's gesture displays some kind of continuity with traditional or accepted practice: it picks up something that the artist does. For though the artist may make his decision on the basis of what the object looks like, the decision is not fully determined by the look of the object. The artist is always free to go on or to stop, as he pleases, and though we may sometimes criticize the judgment he reaches by saying that it leaves the work still unresolved or alternatively that he has overworked it, the criticism that we make is not purely aesthetic. There enters into

it a measure of identification with the artist. To put it another way, when the artist says "That's how I wanted it," in part what he means is "That's how you're going to have it." What I have called Duchamp's whimsical gestures do serve to bring out this "master" aspect in the production of art.

But when we turn to the second kind of object whose acceptance as a work of art I have cited as problematic, the situation becomes more complex. For the challenge that these highly undifferentiated objects present to the conception we ordinarily have of work or effort, as this goes even into what I have identified as the first phase of picture-making, is very searching.

Roughly it might be said that in so far as we think these objects to exhibit to too low a degree the signs of work and on this basis come to dispute their fitness as art, work is conceived somewhat as follows: A man starts with a blank canvas; on this canvas he deposits marks of paint; each mark modifies the look of the canvas; and when this process of modification has gone on long enough, the painter's work is at an end, and the surface of the canvas bears the finished picture. Now of course it will ordinarily be the case that the marks, by and large, differ one from another. But there is in principle the possibility that the marks will be totally repetitive. However, this would naturally be thought to be a mere limiting case of constructivity, and therefore to the extent to which an art object is required to be a *work* of art, the resultant picture, which will be a mere monochrome surface, will be regarded as having a claim to the status of art that is only minimally ahead of the *tabula rasa* it supersedes.

But the question arises whether this account, which is evidently all right as far as it goes, goes far enough. For do we not bring to our perception of art a further notion of work: one that is quite distinct from that which I have set out, that stands indeed in stark contrast to it, and between the two of which there is a fruitful tension? So far I have spoken of constructive work: work that consists in building a picture, in "working it up" from the blank canvas in which it originates into an artifact of some complexity. But now I want to suggest that in our contemplation of art we often envisage another kind of activity as having gone on inside the arena of the

painting, which has also made its contribution to the finished state of the object. And this work, which is at once destructive and yet also creative, consists in the dismantling of some image that is fussier or more cluttered than the artist requires.

Perhaps I can clarify this point by considering briefly the notion of "distortion," or at any rate the use to which it is implicitly put even in traditional criticism. For if we take cases inside the historical canon where it is universally agreed that the distortion has occurred and occurred fruitfully—say Mannerist portraiture, or Ingres, or (to come to modern times) *Les Demoiselles d'Avignon*—what do we intend by saying this? Now all we might be thought to mean is that in these works of art there is a discrepancy between the actual image that appears on the canvas and what would have appeared there if an image had been projected on it in accordance with (roughly) the laws of linear perspective. But what I want to suggest now is that in these cases there is a further thought that insinuates itself into our mind, and that is inextricably involved with our appreciation of the object: and that is that the image before us, Parmigianino's or Picasso's, is the result of the partial obliteration or simplifying of a more complex image that enjoyed some kind of shadowy preexistence, and upon which the artist has gone to work. The "preimage," as we might call it, was excessively differentiated, and the artist has dismantled it according to his own inner needs.

My suggestion, now, is that the canvases of Reinhardt exhibit to an ultimate degree this kind of work, which we ordinarily tend to think of as having made some contribution to the object of visual art. Within these canvases the work of destruction has been ruthlessly complete, and any image has been so thoroughly dismantled that no *pentimenti* any longer remain.

But there is still a powerful objection. For it might be said, though there may (or perhaps must) go into the making of a picture work of the kind we have been considering, what reason is there to suppose that such work can legitimately be abstracted from conventional picture-making, and as I have put it, "celebrated in isolation." Now, even if we allow for the hyperbole contained in this last phrase of mine, there is obviously a challenge here. To some degree, it can, I think, be met. Here I can only sketch how.

In conceptual thinking we fragment the world, and we isolate from the continuum of presentation repeated things, categories of object, sorts. We are led to concentrate upon similarities and differences in so far as these are expressed in terms of general characteristics; and this tendency is cemented in us by many of the practical exigencies of life. In the visual arts, however, we escape, or are prised away from, this preoccupation with generality, and we are called upon to concentrate our attention upon individual bits of the world: this canvas, that bit of stone or bronze, some particular sheet of paper scored like this or like that.

It has, over the centuries, been, at any rate within the tradition of the West, a natural concern of the artist to aid our concentration upon a particular object by making the object the unique possessor of certain general characteristics. In other words, by differentiating the work of art to a high degree, the artist made its claim to individuality intuitively more acceptable. For it was now, in an *evident* way, not merely quantitatively but also qualitatively distinct from other objects.

Now this differentiation was, as we have seen, by and large achieved by placing in the object a great deal of what I have called "constructive" work. It was by means of a very large number of nonrepetitive brush-strokes that the highly individuated masterpieces of Van Eyck or Poussin were brought into being. But in the phase I am considering, where work of this kind recedes into the background and the elements of decision or dismantling acquire a new prominence, the claim of the work of art to individual attention comes to rest increasingly upon its mere numerical diversity.

Inevitably a point will be reached where this claim, which is so abstractly couched, can no longer be found acceptable, or even taken seriously. But until then, as we merely move closer into the area of bare uniqueness, we have progressively brought home to us the gravity, the stringency of art's demand that we should look at single objects for and in themselves. A demand that is not fortuitously reminiscent of that involved in a certain conception of love against which Pascal railed: *On n'aime donc jamais personne, mais seulement des qualités. Qu'on ne se moque donc plus de ceux qui se font honorer pour des charges et des offices, car on n'aime personne que pour des qualités empruntées.*

WRITINGS by Martial Raysse, Dan Flavin, Robert Smithson

These writings are as diverse as the art produced by these three artists. However, they reveal the unique yet intimately linked approach to art shared by all three.

Martial Raysse

Jesus Cola . . . and then there's still this word "painting" . . . it beheld a girl emerging from the waves and said oh what a beautiful Renoir.

So civilized, so accustomed to painting have people become that, whenever they see a beautiful picture, they salivate like Pavlov's dogs and exclaim, "Oh it's beautiful!" Mister Painting, I used to say, "how beautiful Mister Painting is, how wonderful," I went to see his shows. Painting Texture. People would argue about all that, and there was even a time when people, instead of backing off a couple of yards to look at painting, used to come close and touch it. All the paintings were black and people still talked about the texture. No one nowadays talks about texture anymore. Paintings are neat and slick, all the galleries look like clinics, paintings are white, colors are fluorescent and the more color the better.

Today, artistic expression evolves according to predictable laws and in our society even the mental image of the way a painter should look is a preconceived one. In the present-day art world, reflexes have been completely conditioned by the use of a rapid and drastic succession of movements and styles (a term still to be defined)—Bam Bam di Boom Bam Boom misery torture genocide.

The self-satisfying tendency in artistic circles has led individuals to base their work on the will to do the contrary of whatever exists—a formula that appears to be justified by the success—misery torture genocide—it has met with in the art history of recent years.

By now, the act of creating has degenerated into a kind of com-

mentary on the artistic output of a given group, and in a given city this is already rapidly bringing about starvation.

A thousand people who live—misery torture genocide—in a closed system, find enough to keep themselves busy in their own existences and in the interaction of their existences: the organization of an army camp functions on this principle, for that matter.

After the attractions of the tangible readymade object or of its image reproduced, now we come to readymade abstraction that is a surrender to the fetishistic regard for elementary forms. The result is all the more alluring because, through a subtle interchange, it happens to be the mirror image of the form that preceded it; and since the superior value ascribed to a given style, in order to proclaim its merits, is interchangeable, the qualities of one become the defects of the other, and vice-versa. Only the package has been changed only the package has been changed only the package has been changed.

An erotic film production, even before it reaches the public; goes through two stages of auto-censorship: the distributor's and the manager's; not to mention the fact that the projectionist, if he wants to, can put his hand in front of the image to deprive the spectator.

For a long time I used to visit supermarkets and I considered them as permanent exhibitions in a modern art museum. I was very poor and it was wonderful: voices announced the price of butter but in my ears they echoed like monkey's cries—vines marvelously colored . . . the jungle! happiness! chewy caramel happiness! so therefore new realism was the manifestation of a consumer society on the artistic level.

It is a weapon that serves intellectual imperialism, Oh, Gabonese, you also shall eat What's It Soup—Guernica in the museum. Picasso in a sleeping Moscow. Change changes nothing.

June, 1967

Dan Flavin

For a few years, I have deployed a system of diagramming designs for fluorescent light in situations. Of course, I was not immediately aware of that convenience and its inherently fascinating changes. I assume that it "developed" without my explicit or regular recognition. Also, a number of diagrams had to accumulate before a kind

of reciprocity could obtain. Now, the system does not proceed; it is simply applied. Incidentally, I have discovered that no diagram is inappropriate for my file. None need be prevented, suspended, or discarded for lack of quality. Each one merely awaits coordination again and again. Sometimes, adjustments or new variants are implied. Then, and only then, do I think to move my pencil once more. I am delighted by this understanding. . . .

Impromptu flickers from Billy Who?, lasers through the night, "Lights Canceling Orbits," numbered evenings of inept art on technotivity in the Armory do not inform me about my effort. That proposal is whole now and has been so. It requires no technological embellishment nor must it join the technocratic, "sci-fic," or art-as-progress cult for continuing realization. Moreover, I do not feel compelled to hope for a more wonderful day before the fact in promo-proto-art history. I am not anxious to prefer to speculate against posterity. I like thinking here and now without sententious alibis. . . .*

Robert Smithson
MINUS TWELVE

1. USELESSNESS
 A. Zone of standard modules.
 B. Monoliths without color.
 C. An ever narrowing field of approximation known as the Method of Exhaustion.
 D. The circumscribed cube.
2. ENTROPY
 A. Equal units approaching divisibility.
 B. Something inconsistent with common experience or having contradictory qualities.
 C. Hollow blocks in a windowless room.
 D. Militant laziness.
3. ABSENCE
 A. Postulates of nominalism.
 B. Idleness at the North Pole.

* Excerpt from "some other comments . . . ," *Artforum*, Vol. VI, No. 4, December, 1967, p. 21, © 1967 by Dan Flavin, All Rights Reserved.

Martial Raysse: *Identity, You Are Now a Martial Raysse.* 1967. Plastic, wood, television. 200 cm. x 150 cm. x 50 cm.

Dan Flavin: Untitled. 1967. Fluorescent light. 8'. Photograph courtesy of Kornblee Gallery, New York.

Robert Smithson: *Tar Pool and Gravel Pit* (model). 1966. Photograph courtesy of Dwan Gallery, New York.

C. Exclusion of space.

D. Real things become mental vacancies.

4. INACCESSIBILITY

A. Gray walls and glass floors.

B. Domain of the Dinosaurs.

C. Toward an aesthetics of disappointment.

D. No doors.

5. EMPTINESS

A. A flying tomb disguised as an airplane.

B. Some plans for logical stupefactions.

C. The case of the "missing-link."

D. False theorems and grand mistakes.

6. INERTIA

A. Memory of a dismantled parallelepiped.

B. The humorous dimensions of time.

C. A refutation of the End of Endlessness.

D. Zeno's Second Paradox (infinite regression against movement).

7. FUTILITY

A. Dogma against value.

B. Collapses into five sections.

C. To go from one extreme to another.

D. Put everything into doubt.

8. BLINDNESS

A. Two binocular holes that appear endlessly.

B. Invisible orbs.

C. Abolished sight.

D. The splitting of the vanishing point.

9. STILLNESS

A. Sinking back into echoes.

B. Extinguished by reflections.

C. Obsolete ideas to be promulgated (teratologies and other marvels).

D. Cold storage.

10. EQUIVALENCE

A. Refusal to privilege one sign over another.

B. Different types of sameness.

C. Odd objections to uncertain symmetries in regular systems.

D. Any declaration of unity results in two things.

11. DISLOCATION

A. Deluging the deluge.

B. The Great Plug.

C. The Winter Solstice of 4000 B.C. (a temporal dementia).

D. Toward innumerable futures.

12. FORGETFULNESS

A. Aluminum cities on a lead planet.

B. The Museum of the Void.

C. A compact mass in a dim passageway (an anti-object).

D. A series of sightings down escarpments.

Anastasi: *South Wall, Dwan Main Gallery.* 1967. Oil on canvas. 7'1½" x 19'.
Photograph courtesy of Dwan Gallery, New York.

Anastasi: *Coincidence.* 1967.
Plastic. 23¼" x 18 1/8" x ¼".

Carl Andre: Installation, Dwan Gallery, Los Angeles. March 1967. Concrete bricks. Photograph courtesy of Dwan Gallery, New York.

Stephen Antonakos: *Red Neon from Wall to Floor.* 1966. Programmed neon and metal. 10′ x 12′ x 14′. Photograph courtesy of Fischbach Gallery, New York.

Stephen Antonakos: *Orange Vertical Floor Neon.* 1966. Programmed neon and metal. 9' x 6' x 6'. Photograph courtesy of Fischbach Gallery, New York.

Richard Artschwager: *Table with Tablecloth*. 1964. Formica on wood. 26″ x 32″ x 32″. Photograph courtesy of The Jewish Museum, New York, "Primary Structures" exhibition.

Richard Baringer: Untitled. 1966. Polymer paint on aluminum. 7′6″ x 36″. Photograph courtesy of Fischbach Gallery, New York.

Larry Bell: Untitled. 1966. Metal and vacuum-plated glass. 20" cube. Photograph courtesy of Pace Gallery, New York.

Donald Bernhouse: Untitled. 1967. Aluminum extrusions. 2" x 147" x 72".
Photograph courtesy of Bykert Gallery, New York.

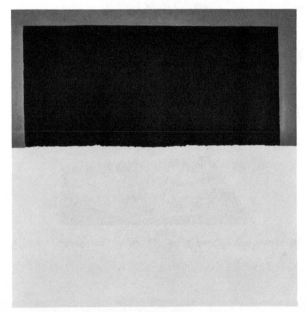

James Bishop: *Reading*.
1965. 77" x 77". In the
collection of Christophe
Thurman. Photograph
courtesy of Fischbach
Gallery, New York.

Mel Bochner: *Three Drymounted Photo-graphs and One Diagram.* 1966. Photographs drymounted on board. Each unit: 8″ x 8″. In the collection of the artist. Photograph courtesy of the artist.

Mel Bochner: *Photo-Graph: Series "A" (Single Point, 60° Elevation)*. 1967. Phtograph laminated on Styrofoam. 8" x 8". In the collection of the artist. Photograph courtesy of the artist.

Bill Bollinger: Installation, December 1966. Anodized aluminum channels. Photograph courtesy of Bianchini Gallery, New York.

Anthony Caro: *Eyelit*. 1965. Steel painted blue. 120″ x 3½′. Photograph courtesy of Andre Emmerich Gallery.

John Chamberlain: *Ray Charles*. 1963. Auto lacquer on board. 12" x 12". Photograph courtesy of Leo Castelli Gallery, New York.

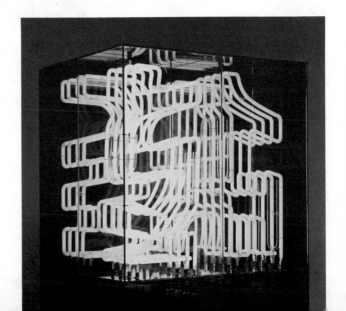

Allan D'Arcangelo: #5. 1965. Liquitex on canvas. 46" x 86". Photograph courtesy of Fischbach Gallery, New York.

Chryssa: *Fragment for the Gates to Times Square*. 1966. Neon and plexiglass. 43" x 34 1/16" x 27 1/16". Photograph courtesy of Pace Gallery, New York.

Tony Delap: *Triple Trouble II*. 1966. Acrylic plastic and lacquer. 13″ x 22½″ x 13″.

Walter De Maria: *Cage*. 1961–65. Solid stainless steel. 85″ x 14½″ x 14½″. In the collection of Mr. and Mrs. Robert C. Scull.

James Dine: *A Color Chart*. 1963. Oil on canvas. 72″ x 48″. Photograph courtesy of Sidney Janis Gallery, New York.

Tom Doyle: Installation, March 1966. Left: *La Vergne*. 1966. Steel and wood. 9′ x 9′. Right: *Over Owl's Creek*. 1966. Wood and linoleum. 18′ long x 9′ at widest. Photograph courtesy of Dwan Gallery, New York.

Dean Fleming: *Malibu II*. 1967. Enamel on masonite. 9′ x 11′. Photograph courtesy of Park Place Gallery, New York.

Paul Frazier: *Dyadic Split*. 1966. Painted copper and wood. 5¾" x 11¼" x 4".
In the collection of Mr. and Mrs. Howard W. Lipman. Photograph courtesy of Fisch-
bach Gallery, New York.

.Paul Frazier: *Dyadic Split*. 1966. Painted copper and wood. 5¾" x 11¼" x 4".
Photograph courtesy of Fischbach Gallery, New York.

Judy Gerowitz: *Rainbow Picket*. 1966. Painted plywood, canvas, and latex. 126″ x 110″. Photograph courtesy of The Jewish Museum, New York.

Robert Grosvenor: *Wedge*. 1966. Fiberglass, steel, and plywood, painted metallic yellow. 27' long. Photograph courtesy of Park Place Gallery, New York.

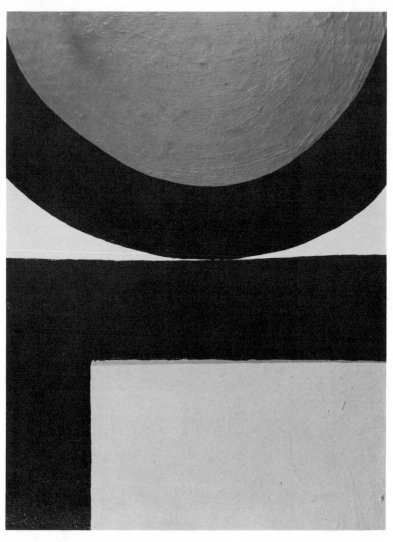

Al Held: *Blue Moon Meets Green Sailor*. 1965. Acrylic on paper on masonite. 23½" x 18½". Photograph courtesy of Andre Emmerich Gallery, New York.

Peter Hutchinson: *Double Triangle*. 1966. Acrylic on canvas. 40″ x 30″. In the collection of the artist. Photograph courtesy of A. M. Sachs Gallery.

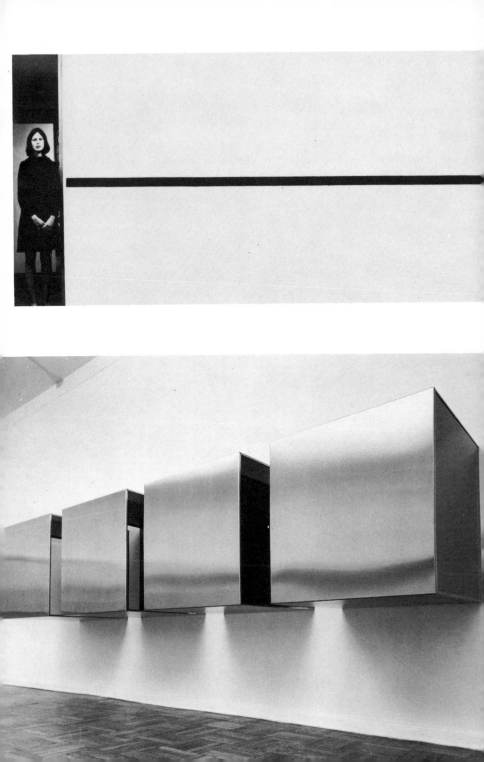

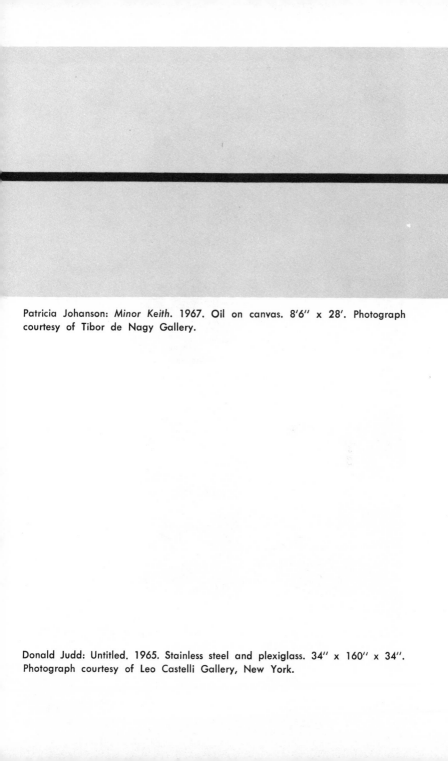

Patricia Johanson: *Minor Keith*. 1967. Oil on canvas. 8'6" x 28'. Photograph courtesy of Tibor de Nagy Gallery.

Donald Judd: Untitled. 1965. Stainless steel and plexiglass. 34" x 160" x 34". Photograph courtesy of Leo Castelli Gallery, New York.

Craig Kauffman: Untitled. 1966. Vacuum-molded plexiglass. 77" x 38½". Photograph courtesy of Pace Gallery, New York.

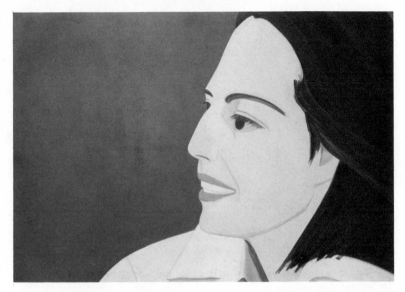

Alex Katz: *Red Smile*. 1963. Oil on canvas. 78″ x 116″. Photograph courtesy of Fischbach Gallery, New York.

Edward Kienholz: *The Cement Store #2*. 1963–67. Bronze and wood. 9¼″ x 11¾″. Photograph courtesy of Dwan Gallery, New York.

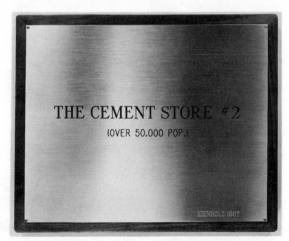

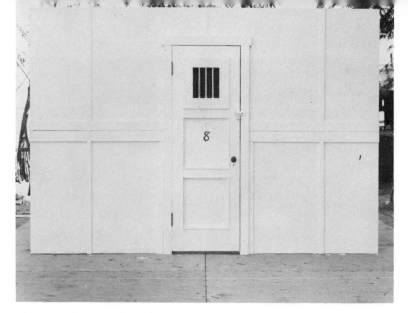

Edward Kienholz: *The State Hospital* (exterior). 1964–66. Mixed media. 8′ x 12′ x 10′. Photograph courtesy of Dwan Gallery, New York.

Edward Kienholz: *The State Hospital* (interior). 1964–66. Mixed media tableau. 8′ x 12′ x 10′. Photograph courtesy of Dwan Gallery, New York.

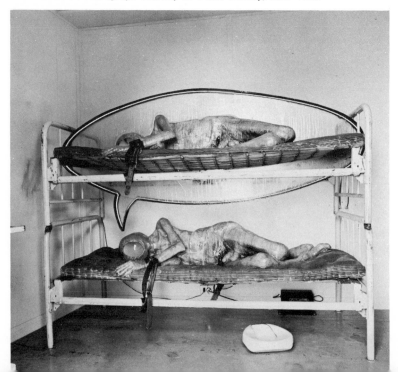

wa'ter[1] (waw-), n. **1.** Colourless transparent tasteless scentless compound of oxygen & hydrogen in liquid state convertible by heat into steam & by cold into ice, kinds of liquid consisting chiefly of this seen

Joseph Kosuth: *Art as Idea as Idea*. 1960–67. Photostat. 18″ x 24″.

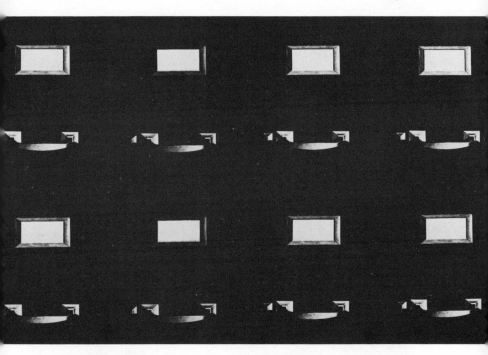

Aaron Kuriloff: *File Cabinet*. 1967. Foto-factual. 100″ x 60″. Photograph courtesy of Fischbach Gallery.

David Lee: *A Renewable Substitute: Bachelard, Badiou, Baudouin, Brunelle.* 1967. Acrylic on linen. 19'2" x 4'4" x 8". Photograph courtesy of the artist.

Les Levine: *Plug Assist #1.* 1966. Plastic. Each unit: 109" x 60" x 31". Photograph courtesy of Fischbach Gallery, New York.

Robert Mangold: *Pink Area*. 1965. Oil on masonite. 96″ x 96″. Photograph courtesy of Fischbach Gallery, New York.

Brice Marden: *Study*. 1966. Oil and wax on canvas. 30″ x 48″. Photograph courtesy of Bykert Gallery, New York.

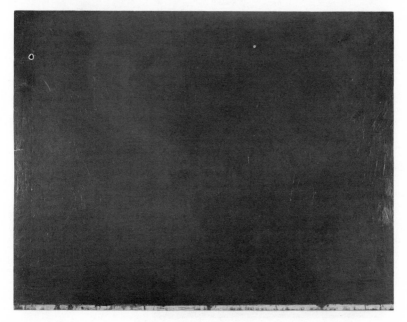

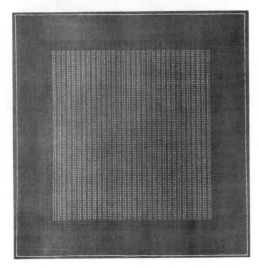

Agnes Martin: Untitled.
1963. Oil on canvas.
Photograph courtesy of
Robert Elkon Gallery,
New York.

Paul Mogensen: *Standard*. 1967. Acrylic on
dacron. 96" x 96". Photograph courtesy of
Bykert Gallery, New
York.

Marc Morrel: *Hanging*. 1966. Fabric construction. 65″ high. Photograph courtesy of Stephen Radich Gallery, New York.

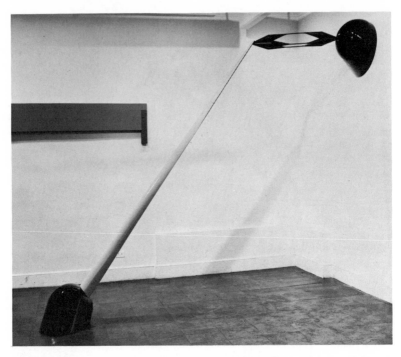

Forrest Myers: *Buick '69*. 1965. Aluminum, epoxy, plexiglass, and lacquer. 2' x 6'.
Photograph courtesy of Park Place Gallery, New York.

Robert Neuwirth: Untitled. 1966. Fluorescent tubes. 96" x 72". Photograph
courtesy of Bykert Gallery, New York.

David Novros: Untitled. 1967. Acrylic lacquer on dacron. 81" x 81". Photograph courtesy of Bykert Gallery, New York.

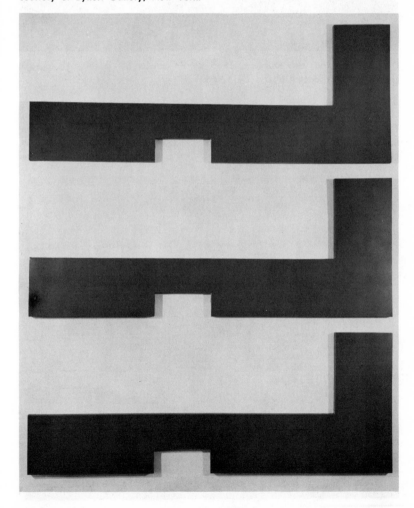

Doug Ohlson: *Sparrow's Red Rose*. 1966. Oil on canvas. 68" x 130". Photograph courtesy of Fischbach Gallery, New York.

Claes Oldenburg: Model for *Colossal Monument: Thames Ball*. 1967. Wood and liquitex. 12½" x 42¼" x 52¼". Photograph courtesy of Sidney Janis Gallery, New York.

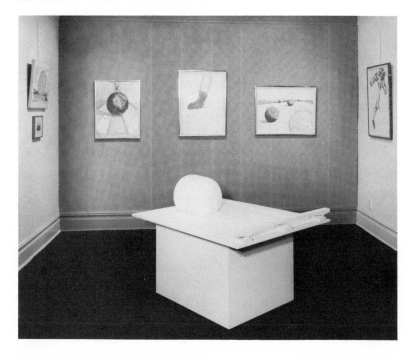

Claes Oldenburg: *Soft Tub.* 1966. Vinyl, plexiglass, and kapok. 80″ x 30″ x 30″. Photograph courtesy of Sidney Janis Gallery, New York.

Jules Olitski: *Maximum.* 1966. Acrylic on canvas. 92″ x 160″. Photograph courtesy of Andre Emmerich Gallery, New York.

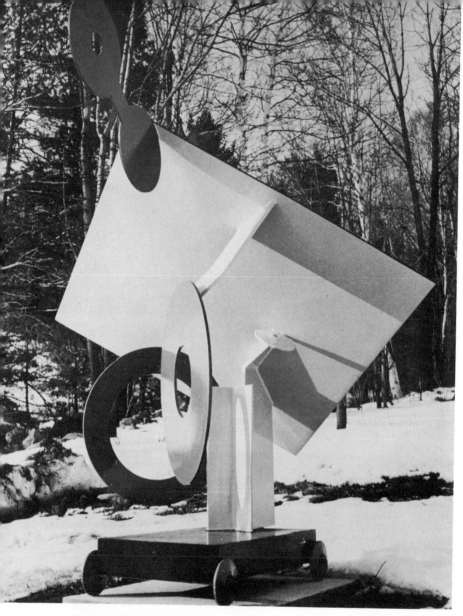

David Smith: *Zig VII*. 1963. Painted steel. 94¾″ x 100⅜″. Photograph courtesy of Marlborough-Gerson Gallery, New York.

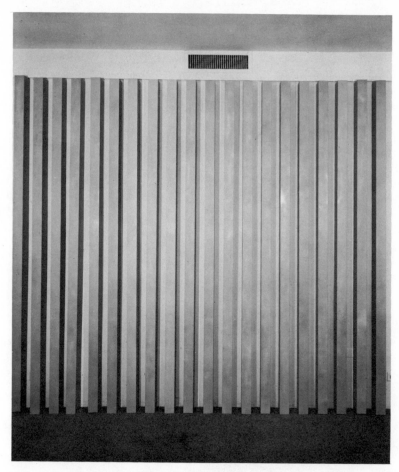

Michael Steiner: Untitled. 1966. Aluminum. 103″ x 120″. Photograph courtesy of Dwan Gallery, New York.

Frank Stella: *Conway I.* 1966. Fluorescent alkyd and epoxy paint on canvas. 80" x 122". In the collection of Mrs. Christophe Thurman. Photograph courtesy of Leo Castelli Gallery, New York.

Peter Tangen: *Incomplete Square: Orange.* 1965. Complete side is 36". Photograph courtesy of the artist.

Paul Thek: Untitled. 1966. Mixed media: wax, plexiglass, formica, mirror-finished aluminum, and rhodium-plated aluminum. 9½″ x 9½″ x 85″. In the collection of Mr. and Mrs. Albert List. Photograph courtesy of Pace Gallery, New York.

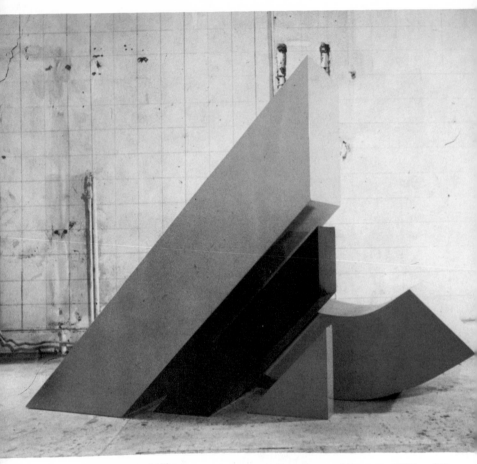

Chris Wilmarth: *Enormous.* 1966. Wood, fiberglass, and lacquer. 67½" x 96" x 48". Photograph courtesy of Park Place Gallery, New York.

INDEX

(Page numbers printed in *italics* identify illustrations of artworks.)

Agam, Yaacov, 329, 353
Agostini, Peter, 86
Ahlander, Leslie Judd, 56n
Albers, Josef, 261, 302, 305
Alloway, Lawrence, 31, 37, 45n, 92
Anastasi, William, 21, 31, 407
Andre, Carl, 31, 74, 92, 94, 103–04, 105, 106–08, 123, 130, 165, 170, 185, 257, 259, 278, 282, 289, 293, 295, 408
Annesley, David, 63, 67
Antonakos, Stephen, 330, 335, 408, 409
Anuszkiewicz, Richard, 166, 189
Apple, Billy, 329n
Arnason, H. H., 38, 39n
Arp, Jean, 315
Artschwager, Richard, 35, 64, 276, 278, 294, 389, 410
Ashbery, John, 278
Ashton, Dore, 32
Aubertin, Bernard, 327

Baer, Jo, 41, 74, 100
Baker, Elizabeth C., 330n
Balla, Giacomo, 345, 348, 354
Balthus, 212
Bannard, Darby, 165, 168, 184n, 186, 278
Baranov-Rossiné, W., 321
Bardo, Arthur, 218
Baringer, Richard, 411
Barry, Robert, 49, 165
Bart, Robert, 65, 82
Battcock, Gregory, 237n
Bell, Larry, 85, 309, 411
Belloli, Carlo, 348n, 350n, 351n
Benedikt, Michael, 61
Bengston, Billy Al, 289
Bennett, John F., 66
Benton, Fletcher, 87
Berlant, Tony, 80
Bernhouse, Donald, 412
Bill, Max, 149
Bishop, James, 412
Bladen, Ronald, 20, 22, 79, 123, 130, 185, 252, 256, 259–60, 283, 308, 309, 311, 312, 313, 315–16

Boccioni, Umberto, 299, 345, 348
Bochner, Mel, 31, 92, 413, 414
Bollinger, Bill, 414
Bolus, Michael, 63, 67, 69
Bonnard, Pierre, 62
Bontecou, Lee, 70, 71–72, 86
Boriani, Davide, 328, 353
Boto, Martha, 328
Bourdon, David, 104
Brancusi, Constantin, 104, 173
Braque, Georges, 240
Breer, Robert, 71n, 353
Brett, Guy, 355
Breuer, Marcel, 78
Bridgman, P. W., 249
Bronzino, 194
Brunelle, Al, 59
Bury, Pol, 353

Cadoo, Emil, 218
Cage, John, 209, 223, 246, 259, 262, 278, 290
Calas, Nicolas, 109, 242
Calder, Alexander, 309, 311, 352, 353, 354
Cambillo, Maria Trudi, 348n
Canova, Antonio, 295
Caro, Anthony, 61–63, 67, 73, 74, 75, 81, 119, 121, 130, 137–39, 145, 185, 186
Carra, Carlo, 345
Carrieri, Raffaele, 348n, 350n
Castel, Louis Bertrand, 318
Cavell, Stanley, 124n, 136n, 140n, 147n
Cézanne, Paul, 45, 50, 201, 275
Chamberlain, John, 308, 311, 312, 316, 416
Christo, 130n
Chryssa, 87, 329, 330n, 416
Clay, Jean, 328n, 355
Coates, Robert, 148
Colombo, Gianni, 338, 353
Colt, Priscilla, 60
Cote, Alan, 84
Coplans, John, 45n
Cornell, Joseph, 85, 86, 130n
Crampton, Rollin, 181

Dali, Salvador, 145n
Darbroven, Hanne, 100
D'Arcangelo, Allan, 287, 417
David, Jacques Louis, 279
Davis, Gene, 289
David, Ronald, 119n
Davis, Stuart, 90, 165, 168, 172
de Chirico, Giorgio, 145
Decker, Lindsey, 218
Degas, Edgar, 304
de Kooning, Elaine, 163
de Kooning, Willem, 32, 37, 38, 39, 115, 156, 162, 181, 256, 281, 298, 299
Delacroix, Eugène, 372
Delap, Tony, 82, 418
De Maria, Walter, 68, 71, 418
Depero, Fortunato, 348, 354
Dine, James, 86, 419
di Suvero, Mark, 80, 308, 312, 314, 316
Dorfles, Gillo, 355
Dougherty, Frazer, 84
Dove, Arthur, 172
Downing, Thomas, 48, 49, 56
Doyle, Tom, 81, 308, 309, 310, 311, 312, 315, 420
Duchamp, Marcel, 35, 55, 71, 173, 183, 198, 212, 215, 250, 259, 275, 277, 278, 284, 293, 298, 323, 337, 349, 353, 354, 387, 390, 393–97
Duran, Robert, 23

Ernst, Max, 212, 215, 237
Evans, Jan, 278

Feeley, Paul, 46n, 49n, 50, 56, 168, 172
Ferber, Herbert, 87, 308
Fiori, Teresa, 348n
Flavin, Dan, 23, 31, 35, 36, 74, 92, 99, 130n, 191, 193, 256, 257, 258, 259, 278, 282, 289, 294, 295, 296, 329, 330, 333, 401, 404
Fleming, Dean, 43, 420
Fleminger, Irwin, 189
Fontana, Lucio, 324, 325
Forakis, Peter, 190, 421
Francesca, Piero della, 161

445

Francis, Sam, 52
Frankenthaler, Helen, 40, 50, 52, 167
Frazier, J. T., 249
Frazier, Paul, 80, 421
Fried, Michael, 31, 37, 39n, 40, 51, 53, 116, 223n, 225, 241, 242, 245, 247, 277, 278, 279
Friedlaender, Walter, 188
Fry, Roger, 50, 51

Gabo, Naum, 118, 155, 156, 224, 324, 336, 350n, 351, 354
Gadney, Reg, 330n
Gauguin, Paul, 50
Geldzahler, Henry, 39n
Gerowitz, Judy, 422
Gerstner, Karl, 329
Giacometti, Alberto, 109, 145n, 173, 213, 215
Gilbert, Basil, 322n
Glaser, Bruce, 117n, 148
Goeritz, Mathias, 19, 20, 25
Goldin, Amy, 312
Goodyear, John, 87
Goossen, E. C., 37, 46, 49, 165
Gourfain, Peter, 58
Graham, Dan, 100, 175, 176, 177, 178, 179
Gray, Camilla, 320n, 350n, 351n
Green, Eleanor, 20
Greenberg, Clement, 32, 37, 39, 40, 49, 50, 51, 120, 123–24, 127, 137, 138, 161, 180, 188, 223n, 236–37, 238, 240–42, 245, 246, 248, 278, 279, 311
Greenberg, Joseph H., 37
Gris, Juan, 295
Grooms, Red, 301, 305
Grosvenor, Robert, 81n, 130, 193, 252, 308, 309, 312, 316, 423
Guston, Philip, 181

Haacke, Hans, 340, 342, 357, 358
Hare, David, 87, 308
Hartwig, Joseph, 322
Hatchett, Duane, 82
Hay, Alex, 35, 390
Hazlett, Sally, 181
Healey, John, 328
Hector, A. B., 319
Held, Al, 39n, 43, 49n, 58, 59, 162, 309, 424
Heller, Ben, 39, 49, 51

Herbert, Robert L., 345n, 348n
Heron, Patrick, 190
Hess, Thomas, 32n, 157
Hesse, Eva, 100, 218
Hinman, Charles, 188, 190, 193
Hirschfeld-Mack, Ludwig, 322
Hoctin, Luce, 326n
Hogle, Richard, 328, 358
Hudson, Robert, 82, 311
Huebler, Douglas, 82
Humphrey, Ralph, 39n, 44, 282
Huot, Robert, 49, 165, 278
Hutchinson, Peter, 187, 253, 425

Indiana, Robert, 329n
Insley, Will, 58, 359–61, 362, 363

Jacobs, David, 71n
Jameson, D. D., 319
Jensen, Alfred, 100
Johanson, Patricia, 165, 171, 426
Johns, Jasper, 39, 58, 100, 182, 198, 232, 248, 259, 281, 291, 329n
Judd, Donald, 68, 74, 76, 80, 89, 100, 117n, 118, 119, 122, 123, 130, 136, 142, 143, 144, 147n, 148–51, 152, 154–64, 185, 252, 257, 259, 260, 278, 289, 291, 308, 309, 310, 311, 315, 426

Kandinsky, Wassily, 52, 154, 167, 172
Kaprow, Allan, 71n, 130n
Kastner, Frédéric, 319
Katz, Alex, 429
Kauffman, Craig, 428
Kelly, Ellsworth, 24, 27, 31, 32, 39n, 42, 44, 45, 49n, 52, 80, 172, 186, 278, 282
Kienholz, Edward, 82, 130n, 429, 430
King, Kenneth, 263
King, Phillip, 63, 74
Kipp, Lyman, 79, 278
Kirby, Michael, 362, 364, 367
Klein, A. B., 319n, 320
Klein, Yves, 58, 89, 162, 164, 181, 184, 198, 279, 299–301, 304, 324n, 325, 326, 353
Kline, Franz, 32
Kolakoski, William, 100
Kosuth, Joseph, 431

Krushenick, Nicholas, 49n
Kubler, George, 222, 248
Kuehn, Gary, 82
Kuriloff, Aaron, 27, 35, 431
Kusama, Yayoi, 88, 130n, 218
Kuwayama, Tadaaki, 304

Lamis, Leroy, 86
Langsner, Jules, 42, 46
Larrain, Gilles, 330, 358
Lassaw, Ibram, 308
Le Corbusier, 134, 384
Lee, David, 195, 432
Leepa, Allen, 200
Léger, Fernand, 323n
Le Parc, Julio, 325, 329, 334, 353
Levine, Les, 365, 368–69, 432
LeWitt, Sol, 28, 74, 85, 92, 95, 96, 97, 98, 100, 101, 123, 130, 185, 256, 309
Liberman, Alexander, 42, 45, 46, 86
Lichtenstein, Roy, 28, 35, 37, 58, 256, 329n
Linder, Jean, 85, 211
Lindner, Richard, 217–18
Lippard, Lucy R., 82, 117n, 148, 209, 310
Lipton, Seymour, 308
Lissitsky, El, 321
Louis, Morris, 40, 50n, 52, 141, 154, 157, 163, 167, 168, 172, 185
Lukin, Sven, 77, 81, 162
Lye, Len, 323n, 355

Machlin, Sheldon, 87
Mack, Heinz, 325, 327, 328, 332, 353
Magritte, Rene, 145n, 282
Malevich, Kasimir, 46, 52, 148, 275, 278, 282, 296, 305, 320, 323, 325, 351, 354
Malina, Frank, 328
Mallory, Ronald, 87
Manet, Edouard, 123n, 136
Mangold, Robert, 74, 433
Marden, Brice, 433
Marinetti, Filippo Tommaso, 345, 350
Martin, Agnes, 42, 45, 74, 434
Masson, André, 215
Matisse, Henri, 172, 180, 304, 350n
Mattox, Charles, 302
McClanahan, Preston, 358
McCracken, John, 29, 74, 79, 130
McLaughlin, John, 45n
Medalla, David, 339

Mefferd, Boyd, 329
Mehring, Howard, 49, 56
Melchert, James, 85
Meyer, Ursula, 366, 370–72
Michelangelo, 134, 300, 384
Milkowski, Antoni, 165, 171
Millonzi, Victor, 330
Miró, Joan, 180, 215, 315, 352
Mogensen, Paul, 100, 434
Moholy-Nagy, Laszlo, 322, 323, 324, 331, 351n, 354
Mondrian, Piet, 46, 52, 108, 110, 148, 172, 190, 201, 202, 225, 228, 260, 296, 305, 352
Monet, Claude, 172, 185, 261
Morrel, Marc, 435
Morley, Malcolm, 35
Morris, Robert, 31, 68, 74, 79, 83, 89, 117n, 118, 119, 123, 125–27, 128, 129, 130, 132, 135, 143, 144, 156, 185, 215, 216, 222, 227, 229, 248, 252, 257, 259, 260, 261, 278, 282, 284, 289, 291, 293, 295, 305, 308, 309, 310, 311, 312, 315
Motherwell, Robert, 349n
Munari, Bruno, 328
Mussman, Toby, 236
Muybridge, Edward, 100
Myers, Forrest, 436

Neuwirth, Robert, 436
Nevelson, Louise, 80
Newman, Barnett, 37, 38, 40, 47, 48, 55, 109–10, 111, 112, 113–15, 124n, 163, 168, 172, 181, 184, 223, 281
Noland, Kenneth, 39, 40n, 48, 49, 50n, 51, 54, 55, 56, 60, 120, 123n, 144n, 145, 149, 150, 152, 158, 159, 160, 168, 172, 186, 278, 279
Novak, Giora, 80
Novros, David, 54, 437
Nusberg, Lev, 326, 353

O'Doherty, Brian, 251, 366, 372–74, 379
Ohlson, Douglas, 165, 438
O'Keeffe, Georgia, 172
Oldenburg, Claes, 25, 26, 30, 31, 71, 82, 90, 130n, 154, 216, 220, 438, 439
Olitski, Jules, 40n, 50, 52, 119n, 120, 123n, 124n, 133, 139, 144n, 145, 185, 225, 279, 439
Ortman, George, 86
Ossorio, Alfonso, 80

Padovano, Anthony, 81
Palatnik, Abraham, 328
Panofsky, Erwin, 223, 284, 285
Paris, Harold, 85
Parmigianino, Girolamo, 398
Pater, Walter, 51
Perreault, John, 37, 256
Pevsner, Nikolaus, 118, 155, 156, 224
Picasso, Pablo, 110, 173, 206, 240, 246, 350, 398, 401
Piene, Nan R., 319n, 325
Piene, Otto, 325, 353
Pistoletto, Michelangelo, 33
Pollock, Jackson, 32, 35, 37, 38, 40, 115, 156, 160, 167, 172, 181, 184, 198, 225, 241n, 242, 245, 246, 247, 256, 289, 307
Poons, Larry, 48, 52, 100, 150, 151, 189, 191, 237, 289
Popper, Frank, 319n, 324n, 355
Porta, Giacomo della, 189
Potts, Don, 212
Poussin, Nicolas, 156, 399

Rabkin, Leo, 86
Rainer, Yvonne, 215, 263, 265, 268, 290, 294, 310, 374
Raphael, 184
Rapoport, Anatol, 37
Rauschenberg, Robert, 39, 46, 130n, 141, 181, 182, 184, 198, 236, 238, 239, 243, 245–47, 280, 291, 298, 329n, 387, 391, 392
Ray, Man, 323n, 349
Raysse, Martial, 329, 400, 403
Reiback, Earl, 328
Reinhardt, Ad, frontispiece, 42, 48, 56, 58, 60, 74, 90, 91, 181, 182, 184, 190, 209, 277, 280, 285–86, 299, 303, 305–06, 387
Renoir, Pierre Auguste, 400
Resnick, Milton, 160
Rickey, George, 42, 79, 87, 348n, 355
Rimington, Wallace, 319, 320
Rivers, Larry, 86, 329n
Rockburne, Dorothea, 100
Rodchenko, Alexander, 118, 224, 282, 351, 354
Rose, Barbara, 31, 222, 274, 311
Rosenberg, Harold, 38, 50, 298
Rosenquist, James, 329n

Ross, Charles, 375
Rossi, Garcia, 325, 353
Roszak, Theodore, 308
Rothko, Mark, 38, 40, 91, 124n, 162, 167, 184
Rubin, William, 39, 42n
Ruscha, Ed, 100
Ruskin, John, 212
Russell, John, 352n

Samaras, Lucas, 86, 88, 130n, 218, 293
Sandler, Irving, 59, 308
Schöffer, Nicolas, 330
Schwerdtfeger, Kurt, 322
Scott, Tim, 63
Seawright, James, 87
Segal, George, 86, 130n, 293, 329n
Seitz, William, 50n, 254
Selz, Peter, 327n, 352n
Seurat, Georges, 50
Severini, Gino, 345
Schapiro, Meyer, 38, 163
Sharp, Willoughby, 317, 323n, 353n
Sidenius, W. Christian, 328
Smith, David, 87, 119, 130, 137, 145, 173, 180, 224, 225, 309, 440
Smith, Leon, 39n, 42, 45, 52
Smith, Tony, 20, 26, 45, 79, 83, 89–90, 128, 129–31, 133, 134–35, 140, 143–44, 145n, 169, 230, 256, 261, 306–07, 376, 381–82, 383, 384–86
Smithson, Robert, 31, 53, 74, 80, 100, 123, 130n, 185, 190, 192, 236, 244, 247–50, 252, 257, 402, 404, 405–06
Soffer, Sasson, 85
Solomon, Alan R., 39n, 51
Sonnier, Keith, 211, 213, 216
Sontag, Susan, 141n
Soto, Jesus Raphael, 353
Spencer, Niles, 90
Spitzer, Leo, 60n
Stark, Charles, 214
Steadman, Philip, 319n
Steiner, Michael, 68, 74, 84, 90, 123, 130, 185, 287, 441
Stella, Frank, 39, 40n, 42, 48, 49n, 50, 53, 55, 58, 59, 117n, 119, 120, 123n, 124n, 148–51, 153, 154–64, 168, 172, 180, 190, 198, 237, 241, 245n, 247, 262, 309, 442
Stern, Gerd, 354
Still, Clyfford, 38, 40, 124n, 167, 172, 184

Sugarman, George, 308, 309, 310, 311, 312
Sweeney, James Johnson, 352n
Sypher, Wylie, 188
Syverson, Terrence, 165

Tadlock, Thomas, 328
Takis, 326, 329, 341, 352, 353
Tangen, Peter, 442
Tanguy, Yves, 145n, 215, 237
Tatlin, Vladimir, 118, 224, 350, 351, 354
Taylor, Joshua C., 345n
Thek, Paul, 443
Thwaites, John Anthony, 355
Tillim, Sidney, 45
Tinguely, Jean, 19, 124, 183, 301, 327, 353
Tintoretto, 190
Tobey, Mark, 181
Todd, Michael, 79
Trova, Ernest, 81
Truitt, Anne, 120, 123, 185, 186, 278, 288
Tucker, William, 63

Turner, J. M. W., 319, 320, 323
Tuttle, Richard, 278

Uecker, Günther, 317, 323n, 325, 329, 353, 355

Valledor, Leo, 190, 192, 193
Van Buren, Richard, 34
van der Rohe, Mies, 155, 379
van Eyck, Jan, 399
van Gogh, Vincent, 40, 50
Varian, Elayne, 25, 359
Vasarely, Victor, 149, 150, 151, 155, 166
van Saun, John, 327, 358

Wagstaff, Samuel, Jr., 129n, 381
Warhol, Andy, 37, 58, 256, 278, 288, 289, 290, 293, 294, 295, 305, 329n
Weinrib, David, 308, 309, 310, 311, 312, 315
Weitemeier, Hannah, 322n
Wember, Paul, 326n

Wesley, Jack, 219, 220
Wesselmann, Tom, 219, 329n
Whistler, James A. McNeill, 51
Whitman, Robert, 71
Wilde, Oscar, 51
Wilfred, Thomas, 321
Willenbecher, John, 86
Williams, Neil, 48, 53
Williams, Paul, 329
Wilmarth, Christopher, 81, 84, 444
Witkin, Isaac, 63, 73, 74
Wölfflin, Heinrich, 50
Wolfson, Sidney, 42
Wollheim, Richard, 277, 387
Wray, Robert, 84

Youngerman, Jack, 39n, 58, 73

Zero Group, 343
Zox, Larry, 57, 278
Zuccaro, Federigo, 253
Zurbarán, Francisco de, 114